HISTORIC HOUSES OF
SOUTH AFRICA

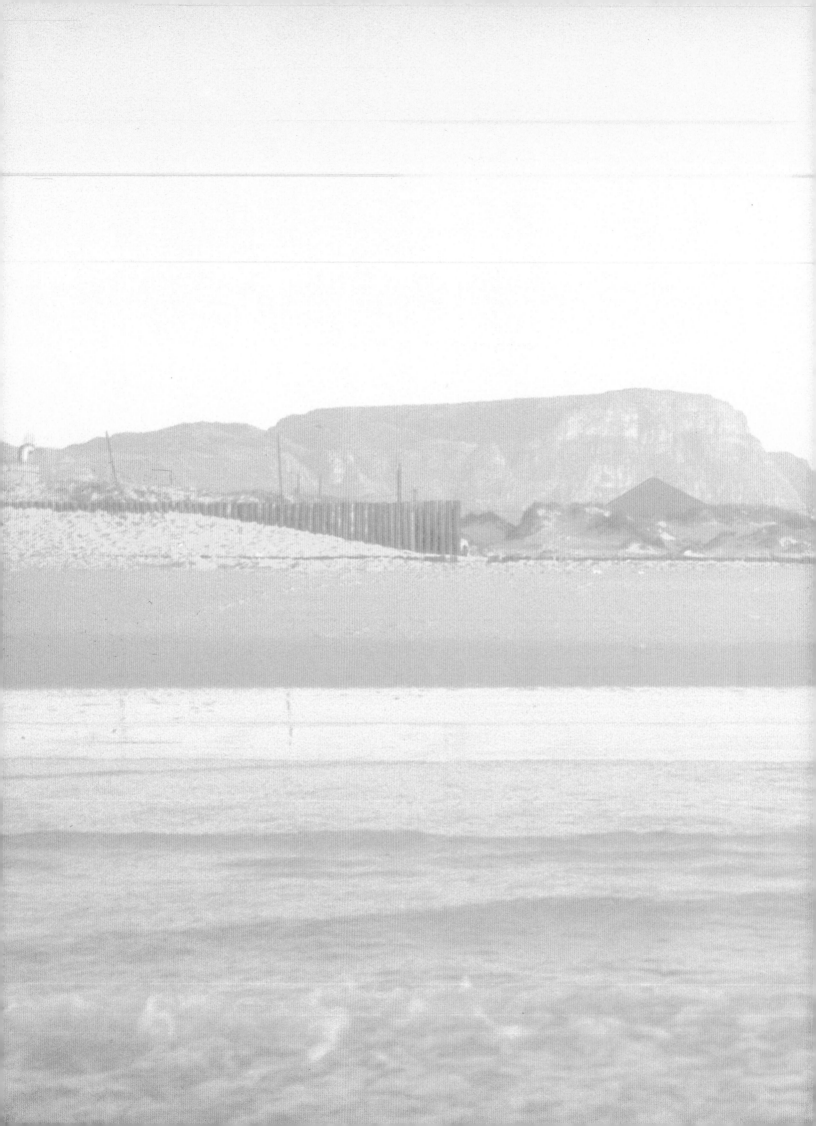

HISTORIC HOUSES OF
SOUTH AFRICA

GRAHAM VINEY ••• PHOTOGRAPHY BY ALAIN PROUST

ABBEVILLE PRESS PUBLISHERS
NEW YORK LONDON PARIS

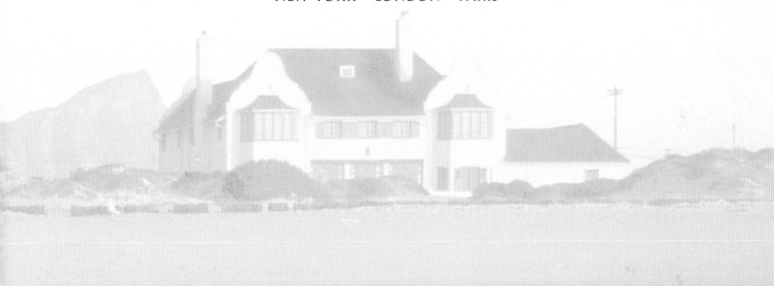

For my godfather, Ian McLaren

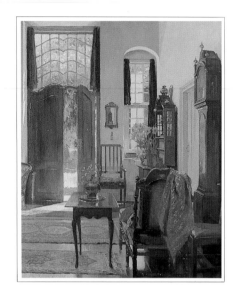

FIRST PUBLISHED IN THE UNITED STATES OF AMERICA IN 1997 BY
ABBEVILLE PRESS, 488 MADISON AVENUE, NEW YORK, NY 10022.

FIRST PUBLISHED IN SOUTH AFRICA IN 1987 BY
STRUIK WINCHESTER, A DIVISION OF STRUIKHOF PUBLISHERS (PTY) LTD.,
STRUIK HOUSE, OSWALD PIROW STREET, FORESHORE, CAPE TOWN, SOUTH AFRICA 8001.

FIRST EDITION
2 4 6 8 10 9 7 5 3 1

ISBN: 0-7892-0306-5

BOOK DESIGN BY JOANNE SIMPSON
JACKET DESIGN BY MOLLY SHIELDS

FRONT COVER: THE FRONT ENTRANCE OF VERGELEGEN
BACK COVER: THE DINING ROOM AT SIDBURY PARK

CONTENTS

TITLE PAGE. Vergenoeg, Muizenberg – Baker partnership, *circa* 1914. The Alpheus Williamses' beach house heroically sited on Muizenberg beach, its bays and gables facing the south-easter and the rows of False Bay breakers which roll resolutely towards them. IMPRINT PAGE. The South African interior. The hall or *voorkamer* of Welgelegen before the First World War. These were some of Baker's colonial Arts and Crafts interiors at their best, scandalously dispersed in recent times on the death of the last Miss Currey. (University of Cape Town). FOLLOWING PAGE. Wall painting at Libertas. PAGES 8 AND 9. The library, Vergenoeg.

FOREWORD

This book appears at a time of considerable interest in the architecture and decorative arts of the colonial period. Graham Viney has selected twenty-three widely divergent examples to recount the fascinating story of early South African houses which he examines against a background of styles and fashions prevailing at the time, not only in South Africa but elsewhere in the world. In this way we are able to see them in an entirely new light.

In addition to detailed descriptions, the author has provided equally pertinent insights into the attitudes and aspirations of the men who built them, as well as the opinions expressed about them by some of their contemporaries. Nor is this all. Although there are usually good records of the structural fabric of the older houses – much of which still survives – less is known about how they were furnished and decorated or of how people actually lived in them. By consulting a wide variety of sources, including eye-witness accounts, Graham Viney has filled in some of the many gaps in this important area.

This book will be welcomed by all who have an interest in colonial architecture in general and South African colonial architecture in particular. It is written with wit and perception and the courage to challenge some firmly held views. The text reveals not only careful research covering a wide range of interests, but also a grasp of the social history as well as an appreciation of the styles and tastes of the period.

The illustrations have been arranged and selected by the author with considerable skill, and the quality of Alain Proust's photography is consistently good.

A pleasure to look at and entertaining to read, this work makes a significant contribution to the history of South African architecture.

REVEL FOX

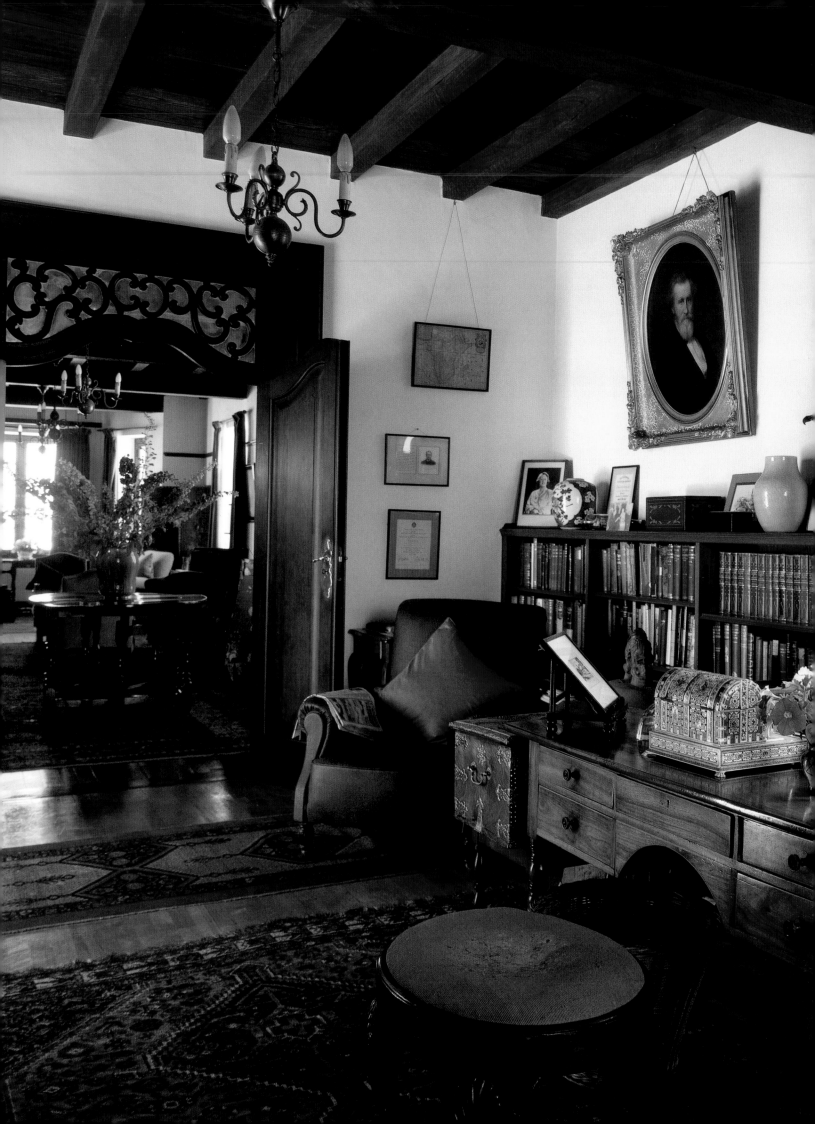

ACKNOWLEDGEMENTS

It is commonly, but quite erroneously, believed that owners of houses of architectural or historical interest are in some way under obligation to give free access to photographers and researchers. This being not at all the case, my first thanks are to the owners of the houses and their staff, for their willing co-operation and often prodigious hospitality to Alain Proust and myself, and to the owners of the many other houses – at least six times those appearing hereafter – who were equally welcoming to me on my researches. My only regret is that no more houses could be included.

My research has been enormously facilitated by being given access to private papers and my particular thanks go to Mrs Amelia Andersson for access to the Andersson Papers; Mr Roy Berrington for access to his papers on Sidbury Park; Major John Buist for access to the Logan/ Buist Papers and scrap books; Mr Percy Crookes and Mrs Beryl Cook for access to papers on the Crookes family; The Lady Mary Grosvenor for access to the Grosvenor Papers at Westminster; Mr and Mrs Ian Mackenzie for access to their papers on Stonehouse; Mr Neill Maisels and the Trustees of the Estate of the late Samuel Marks for access to the Marks Papers, which were recently lodged with the Kaplan Institute at UCT; Mr and Mrs Martin Melck for access to the Melck Papers; Miss Elizabeth Norton for access to the Dell/Norton Papers and material on Barville Park; and Mr Mark Wiley for access to the Chaplin Papers and photographs at Noordhoek.

My chief thanks go to Mrs Arlene Butchart and the endlessly helpful staff of the South African Library; Mr Vermeulen and the staff of the Cape Town City Library; Miss Leonie Twentyman-Jones and the staff of the manuscripts and archives division of the Jagger Library, UCT; Mrs Blanche Nagelgast and the staff of the Africana Library, Johannesburg; Mrs Elizabeth Paap and the staff of the William Fehr Collection; Miss Maryna Jooste and the staff of the Library of Parliament, Cape Town; Miss Judy Wengrowe and the staff of the Cape Archives, Cape Town; Mr Verne Harris of the Natal Archives Depot, Pietermaritzburg; Mr Jannie Ferreira of the Transvaal Archives Depot, Pretoria; Mr Matie Rossouw and the staff of the Deeds Office, Cape Town; and H W Neal of National Archives of Zimbabwe, Harare.

I am also greatly indebted to Mrs Margaret Cairns and Mrs Marian Robertson for their encouragement and access to a wealth of research, and to Mrs Jill Baikoff for access to her notes on Rustenberg. Further thanks go to Professor Arthur Davey, Dr Edna Bradlow, Mr Richard Mendelsohn and Miss Elizabeth van Heyningen of the History Department of the University of Cape Town who still willingly answer my questions on South African history.

Others who have willingly assisted in my researches are Mrs Dee Nash of the Albany Museum, Grahamstown; Miss Désirée Picton-Seymour; Dr Doreen Greig; Mr Revel Fox who also kindly agreed to write the foreword; Professor Ronald Lewcock of Clare College, Cambridge; Mrs Peggy Heap; Mrs Maryna Fraser, Group Archivist, Barlow Rand Ltd; Mrs Daphne Strutt of the Cultural History Museum, Durban; Mr Dirk Visser; Mr Brian Kearney; Dr Ben Cronje, a former director of the National Cultural History and Open Air Museum, Pretoria; Mrs Nancy Bialowons of the Presidensie Museum, Bloemfontein; Miss Nancy Tietz of the McGregor Museum, Kimberley; Mr Harry White, Household Manager of Groote Schuur; Mr Abe Schräder, Comptroller of the Presidensie; and Mr Wiets van der Westhuizen, former Comptroller of Tuynhuis.

I am most grateful to Mrs Phillida Brooke Simons for her careful scrutiny of the text and to my mother, Mrs John Viney, Miss Susan Loppert, Miss Lin Sampson, Mr Gary St. Leger Searle,

Mrs Hugh Bradlow, Mr Nicholas Schofield and Mrs Eric Kohler for their many valuable criticisms and suggestions, and also to Mrs Angus McGregor who has in addition greatly assisted with the preparation of the manuscript.

Among those from whom I received initial encouragement at the conception of this project I should like to thank Miss Min Hogg, Mr Mark Boxer, Mr Peter Fourie, Mrs Brian Meadows, Miss Jehanne Hamilton-Williams, Mr Anthony Feldman, Dr Joan Feldman, Dr Robert Irving, Mr Jonathan Ball and Miss Henrietta Dax of Clarke's Bookshop, Cape Town.

Many people have been kind enough to give me leads on colonial houses which they knew or remembered from childhood, and in this regard I should particularly like to thank my parents, Mr and Mrs John Viney, Mrs Lavinia de Klerk, Mr Jonathan Woods, Mrs Harry Oppenheimer, Major and Mrs Philip Erskine, Mr and Mrs Brin Field, Mrs Gordon Henderson, Mr Edward Carbutt, Mrs Charles Henderson, Mrs Beryl Cook, Mrs Pam Barlow, Mr William Barlow, Mrs Martin Melck, Mrs Eric Ismay, Mrs Susan Lind Holmes, Mrs Tony North, Justice and Mrs M T Steyn, and Mrs Charles Bale.

Institutions which have given us access to pictorial material have been acknowledged in the appropriate places. In addition to the owners of the houses who kindly gave me access to family and personal photographic records, I should like to thank Mr Tom Barlow for the photograph of the Theunissens; Mr Dudley Hopkins for the photograph of Mrs Leonard Hawkins; Mr Julian Melck for the photographs of Mrs van der Byl and Captain Spence; Mrs Bea Cooper for the photographs of Government House, Cape Town in the Freres' day; Mrs James Rawbone-Viljoen for the portrait of Mr James Rawbone and the photograph of the Rawbone-Viljoen wedding; Mr Michael Thatcher for permission to reproduce the cartoon of Westminster Polo Club and the photograph of himself and the Duchess of Westminster; Mr Mark Wiley for permission to reproduce the photographs of the Drummond Chaplins; and Mr and Mrs John Slatter for permission to reproduce the photograph of Holme Lacey. Additional photographs were taken by Mr Juan Espi, Mr Dick Bomford and Mr Nicholas Schofield; and the photographer and I wish to record our gratitude to Mr Axel Adelbert.

I am grateful to the following who kindly responded to my written requests for information: the Earl of Harewood, the Earl of Selborne, the Lady Mary Grosvenor, Mr Henry Baker, Mr and Mrs Michael Thatcher and Dr A J Böeseken. Others have been kind enough to pass on their reminiscences to me. I am grateful to Mrs Marieta Macnab for her childhood memories of Kersefontein; Mrs Gee and Mrs Oaklene Hewatt for their memories of Broadlands; Mr Guy Reynolds for his memories of Lynton; Mrs Cecily Niven for her memories of Hohenheim and Lady Phillips; Mr Martin Melck and Mrs Agnes Kotze for clarifying the role and status of rural white staff; Mrs Sheila Southey for her memories of the unchanged Victorian Karoo of the 1940s; Mrs Andrew Ovenstone; Mrs Jean Lawrence; Mrs Robert Enthoven; and Miss Lucy Bean for her perceptive memories of official and fashionable South Africa over many years.

Finally I should like to thank Sotheby's, South Africa, for their help in identifying some of the furniture illustrated.

GRAHAM VINEY, CAPE TOWN, 1987

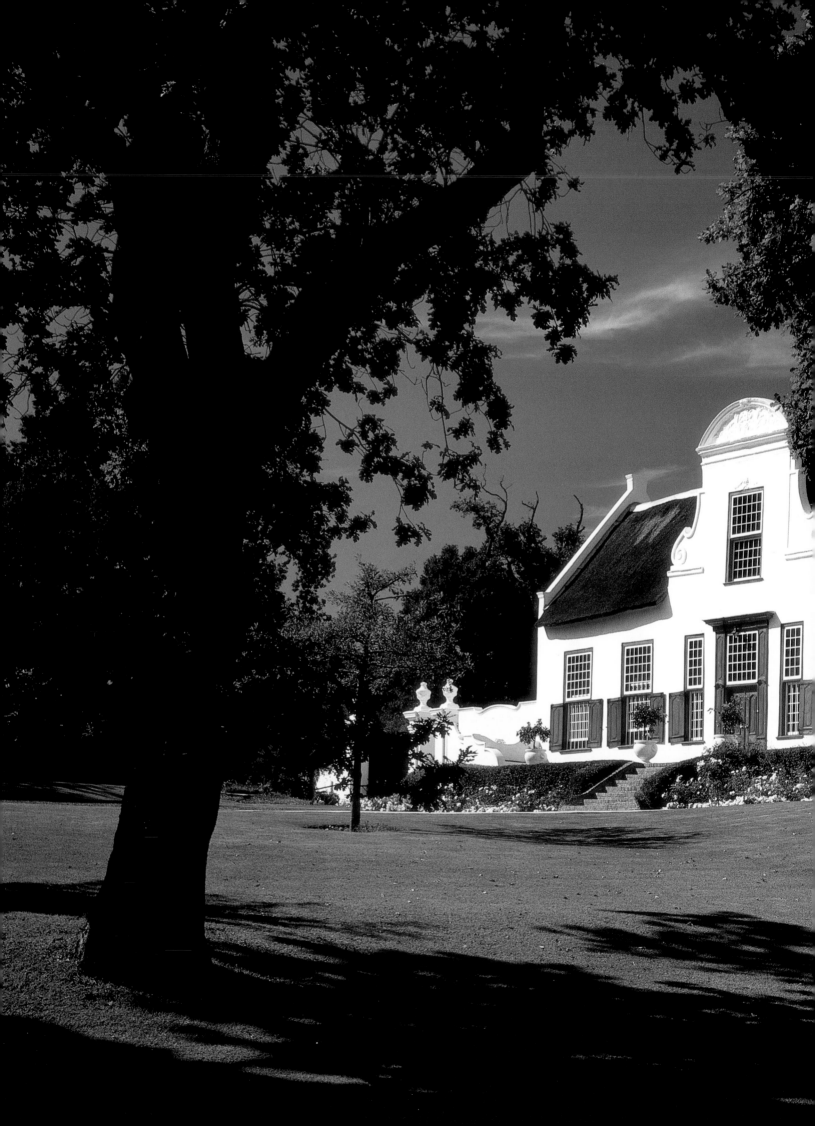

INTRODUCTION

In the last decade of the twentieth century, as the imperial age begins to fade from living memory, it is inevitable that the artefacts of empire be re-evaluated.

Not least amongst these is the era's architectural legacy. Initially some were inclined to view this as a delicate matter but, as the Soviets and other recently emerged proletarian states had discovered decades before, it has become apparent that the buildings of the *ancien régime* are not merely to be dismissed as monuments to a departed order. Rather they are freshly perceived as monuments, too, to the legions of often nameless builders whose labour and craft constructed and adorned them. As such they are objects of national pride and, therefore, worthy of preservation.

Either point of view, however, still breaks new ground. In terms of architecture the label 'colonial' – much like the label 'provincial' – has hitherto carried with it pejorative connotations. From any universal standard of excellence it was inevitable that this should be so. Colonial architecture, and especially colonial domestic architecture, was traditionally held to have been restricted, if not actually prejudiced (as some said) from the outset by a dearth of talented architects and skilled craftsmen, by limited availability of materials and by the practical requirements of an unaccustomed climate. Moreover, it was produced by a society less structured and less socially competitive than its metropolitan counterpart, a society deficient in the dazzling opportunities provided by established wealth and the creative stimulus of a discerning *cognoscenti*.

Not that it is correct to suppose that colonial society – in South Africa at any rate – was simply *parvenu* or merely, as Princess Alice put it to her sister-in-law Queen Mary, 'common and mediocre'.[1] On the contrary, the wide range of metropolitan classes it comprised (and the mobility between them which their new environment permitted) is apparent to the most cursory social historian. But it was a hostile climate for the rarer breeds, and a spirit of mediocrity was indeed distressingly pervasive and sufficient to cause the most formidable social identities to falter within a generation. The settler class of 'English county families . . . rapidly becoming middle class,'[2] which Evelyn Waugh encountered in twentieth-century southern Africa, were, in fact, undergoing an adjustment that others had suffered for decades before. For it was not mediocrity as a norm that dampened enterprise and effort, but mediocrity actually held to be a virtue. And in this, standards inevitably suffered.

Lack of skills and discriminatory standards is one thing; a fundamental shortage of ready money is quite another. Perhaps one should immediately acknowledge that domestic colonial architecture in South Africa produced almost no great houses. This is not an apology or a criticism, but a statement of fact entirely connected with economic forces. For until the discovery of diamonds and gold almost all houses in this country were modest – both in size and concept – not only by American standards, but by Anglo-Indian, and even Australian, ones as well. Doubtless Vergelegen, in the wilds of the Hottentots Holland, seemed impressive to the rather gushing Valentyn[3]. But of the Dutch period, only Papenboom, one of Louis Thibault's finest works, could have been described as elegant in the conventional sense of the word. It is not at all surprising that Lady Anne Barnard, by no means predisposed to sneer at all she saw, reckoned it to be thus.[4] By the end of the 1820's Lord Charles Somerset's alterations had transformed Government House in Cape Town into an English gentleman's country house of moderate size clad in colonial guise; and there is every indication that its interiors were as stylish as those at Newlands, the governor's summer residence, and similarly remodelled by the glamorous viceregal couple. But that is really as far as it went.

Fortunately, costly elegance is not the sole arbiter of modern taste, nor is charm constricted by technical skills and academic expertise. And I am sure that it is primarily this perception that has caused us to revalue colonial architecture with such pleasure. It is not simply a case of indulgence: as with provincial styles, the reflection of metropolitan fashions in colonial architecture is intriguing and, like the *leitmotiv* in a musical score, is rendered delightful by its apprehension in a remote environment.

Moreover, the development of a vernacular architecture has its own fascination and what, in the case of South Africa, has come to be known as 'Cape Dutch'* is a unique architectural style, the happy result of a wide variety of unlikely ingredients and forces. From the start, construction methods and materials had limited the design of the free burghers' houses so that the early, rude dwellings were enlarged single room by single room following the letter-of-the-alphabet plans: T, H and so on. With time and increased prosperity these were embellished with architectural details and plasterwork inspired by the traditions and circumstances of the owners, most of whom were northern Europeans, and by the craftsmen, many of whom came from Malaya. The charm of these simple whitewashed manors, surrounded by oak trees and set against the dramatic background of the Cape mountains, is by now universally acknowledged.

They belong to the first colonial occupation of the Cape of Good Hope, the Dutch having established a settlement there, in 1652, as a staging post to their Batavian Empire in the East, around the time they were founding New Amsterdam (New York) in North America. The Dutch period was to last until the end of the eighteenth century when, in 1795, the Cape was ceded to the British and finally, in 1806, forcibly incorporated into their empire during the Napoleonic wars.

Initially the houses of the British occupation were late Georgian or Regency imports, though inevitably adapted to local conditions. Concurrently, and not surprisingly, the Georgian conceits were absorbed by the vernacular form which survived the takeover, with decreasing popularity, by half a century. It was, however, unlikely to withstand the much changed way of life introduced by the new order.

*J van der Meulen challenged this term in his thesis 'The Origins of the Colonial Architecture at the Cape of Good Hope', suggesting 'Cape German' as an alternative. Trefois, in Belgium, has also argued in favour of 'Cape Flemish'.

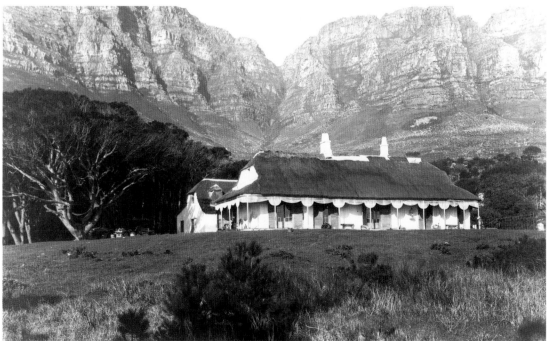

TOP: Papenboom, Newlands (*circa* 1795). Thibault's most elegant design for Mynheer van Rheenen based somewhat on the Petit Trianon: Cape neo-classicism at its best. (Sir John Barrow, African Museum, Johannesburg.)

CENTRE: Newlands House (*circa* 1824). Lord Charles Somerset regencyfied the Governor's summer residence, adding this bow-ended wing, which owed something, in spirit, to Holland's earlier (pre-Nash) design for the Brighton Pavilion. It contained the drawing room (decorated in the Louis Revival style) and library connected by an octagonal hall beneath the glass cupola. With its eighteen-foot-high ceilings and full sashes opening onto the verandah, this was without doubt one of the most elegant colonial houses ever. (Cape Archives)

BOTTOM: Lord Charles Somerset's Marine Villa, Camps Bay (*circa* 1826). The Cape vernacular regencyfied in accordance with contemporary English fashionable taste for the Picturesque. Traditional construction with half-hipped end gables, but the thatch sweeping down over a verandah with festooned fascias gives the whole a festive, seaside air. The French casements and Venetians set the vogue for much of nineteenth century South Africa. (A. Elliot, Cape Archives)

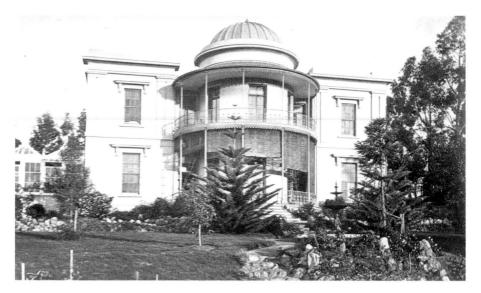

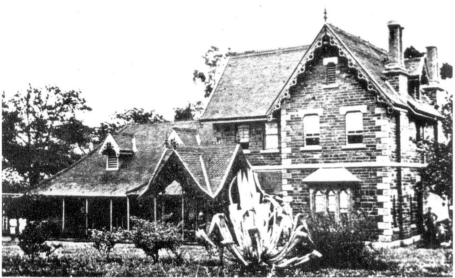

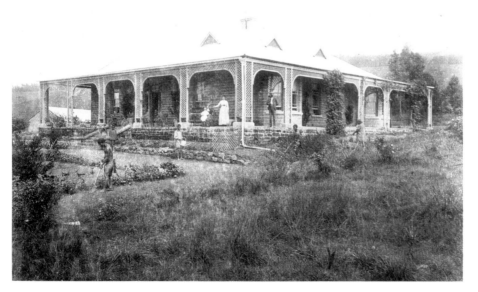

TOP: Woodville, Grahamstown (*circa* 1860). Elegant merchant's house with dome and verandahed bow exhibiting the so-called colonial time lag, for this is all rather Regency for 1860. (Albany Museum)

CENTRE: Government House, Pietermaritzburg (*circa* 1867). Colonial Gothic, informal and more like a rectory than the popular image of a proconsul's residence. (Ogilvie Collection, Pietermaritzburg)

BOTTOM: Holme Lacey (*circa* 1875). Stone Natal verandah house.

Nor did it, and though, in fact, a new vernacular did arise, it proved to be a trans-imperial genus rather than a purely indigenous species. Regency architecture and, with it, that uniquely English and astonishingly pervasive and protracted penchant for the Picturesque bequeathed the verandah house to the Empire. In Africa, India and Australia the *cottage ornee*, initially the product of a fashionable metropolitan whimsy, found in the veld, jungle or outback a location more truly rustic than a landscaped park, and the verandah – an architectural conceit borrowed from the empire, reworked and exported back again – a purpose more useful than as an architectural embellishment in Brighton or Cheltenham.

The verandah or stoep was, for generations, the most typical South African domestic locality – the very hub of colonial home life. It was here that the colonials sat – shaded in summer, warm in the bright winter sunshine – and discussed the topics of local import: how many 'lines' had been measured in last night's thunderstorm, the price of beef, the rumour that the Province intended replacing the old pontoon with a bridge, the prospects for the forthcoming by-election. It was here that over their *elevenses* – strong tea and cheese scones, or anchovy toast, perhaps – they idly exchanged the gossip of the moment: the minutiae of plans connected with an eagerly anticipated local wedding, the doings of the royal family, the picking over of Saturday night's dance at the club and the scandal concerning that new *gel* on the telephone exchange. And it was here too that, in creaking wicker chairs, red-ringed from the house boy's careless floor polishing, they unwrapped and ironed flat the newspapers, periodicals and catalogues to peruse in peace the news and wares of the world outside: the imminence of war in Europe, the new garden furniture from The Army and Navy, the victories and defeats on the Empire's sports fields and last summer's modes from Marshall & Snellgrove.

Though by no means as zealously preserved in South Africa today, the verandah houses of the colonial era were as significant a vernacular prototype as the Cape Dutch houses of the preceding ages. Both were simple structures given a panache with the addition of a single architectural conceit – the gable on one hand, the verandah on the other; both sat at ease in their landscape and both conformed sparingly to the domestic requirements of their inhabitants.

Naturally, the more affluent saw room for improvements. The prosperity engendered by the commodity booms – not only diamonds and gold (discovered in 1865 and 1886, respectively) but also sugar and ostrich feathers – gave rise toward the end of the nineteenth century to the robber-baron type of colonial house. 'Palaces' they were habitually called and palaces are exactly what they must have seemed to be – either by comparison with the simple houses built during the unprosperous decades following the 1820's, or merely by their outlandish appearance on the virgin veld. "There is something about a Johannesburg palace which reminds one of Romans under the later Republic like Lucullus," wrote Lionel Curtis as he gazed on Julius Jeppe's endlessly verandahed and embellished Friedheim.[5]

In fact, the really great South African wealth of the *fin de siècle* was reserved for London and the fabulous displays of the randlords' houses in Mayfair (see chapter 13). The 'palaces' referred to by Curtis were almost tawdry by comparison. In striving to impress, they acquired all manner of fancy dress – oriental domes, colonnades, turrets, battlements, applied timbering – every trick, in fact, that was available from the bag into which the late nineteenth-century architects delved. Until quite recently this was considered quite as prejudicial to their merits as the inevitable taint supplied by the *arriviste* money which built them; but nowadays, released from a half-century's diet of restraint, we can admire their verve and flamboyance alongside their more modest cousins: the simple red-bricked colonial versions of the Queen Anne Revival that appeared in Pietermaritzburg and Kimberley, enclosed by delicate trelliswork or cast-iron verandahs from the foundries of England and Scotland.

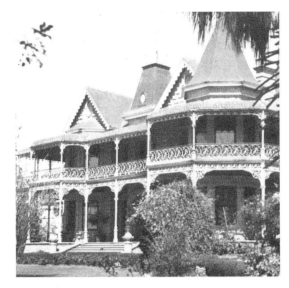

Neither style could have been claimed as a national one, and this is what Cecil Rhodes (for aesthetic as well as patriotic motives) required as he, at the turn of the century, sought to unify South Africa so that it ranked alongside Canada, Australia and New Zealand as one of the great Dominions of the British Empire, then at its zenith. Rhodes's chance meeting and subsequent collaboration with Herbert Baker, a young English architect who had trained at the very nursery of the Arts and Crafts movement, evolved in the heyday of unification, an Edwardian style that was at once both national and imperial. It sought to avoid the feminine frippery and ostentation (though not, of course, the expense) of the preceding generations and to revive the design and solid craftsmanship – significantly Cape Dutch rather than African tribal – of the country's past in an aesthetically and conveniently acceptable present.

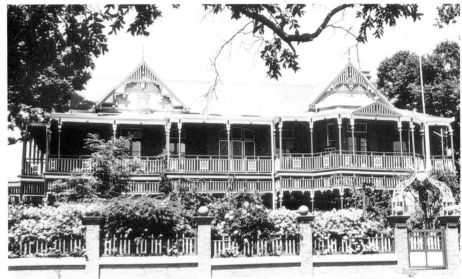

Baker's use of Cape Dutch conceits resulted in a revival in popularity and a consequent eleventh hour rescue of such original Cape Dutch houses as survived. It is ironic that on the eve of the Anglo-Boer War Cecil Rhodes was spending a small fortune restoring them and living in a house considered by his contemporaries to be in the Cape Dutch style, while the Krugers in Pretoria lived in a verandahed British colonial bungalow, complete with fusty interiors which would not have been out of place in the English Midlands.

Baker's career as architectural protégé, first of Rhodes at the Cape and later of Lord Milner as he sought to reconstruct the defeated Transvaal and Orange Free State after the Anglo-Boer War, had a seminal effect on twentieth-century imperial architecture. His Africa career extended north through Rhodesia (Zimbabwe) to Kenya and undoubtedly strongly influenced his friend and colleague, Edwin Luytens, with whom he collaborated in designing New Delhi – one of the great imperial cities of the modern world. It is his role as the *architect laureate* of early twentieth-century South Africa which accounts for the preponderance of his houses towards the end of this book.

Baker's reputation, currently being reinstated, was for many years much maligned, partly eclipsed by Lutyens himself, but more often for inferior,

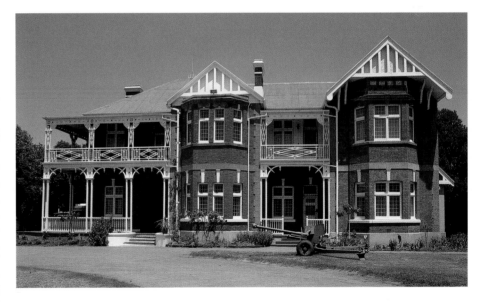

TOP: The Towers (*circa* 1900). Handsome cast-iron (*broekie lace*) verandahs provide a pleasing rhythm as they wrap around this elaborate Oudtshoorn 'feather palace'.

CENTRE: Dunluce (*circa* 1897). Elaborate barge-boarded, verandahed Kimberley diamond palace which received a direct hit during the siege of the Anglo-Boer War. (Kimberley Museum)

BOTTOM: The View, the Cullinans' Parktown house. Red brick and white trellis – the colonial cousin of the 'Queen Anne' Revival.

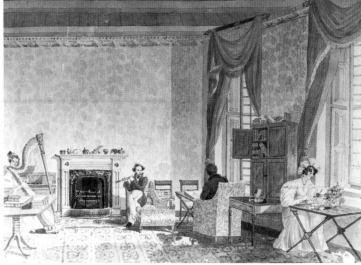

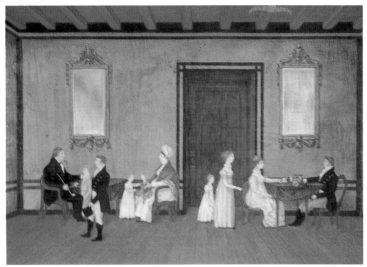

TOP LEFT. The Cape Dutch interior –
modest farmhouse *voorkamer* with
casement windows, tiled floor, *rietdak*
ceiling, yellowwood furniture and the
proverbial welcoming cup of coffee or
tea. (Africana Museum, Johannesburg)

TOP RIGHT. The Cape interior regencyfied.
Patterned carpet, wallpaper, swagged
curtains, upholstered sofa and chairs,
cornice frieze and fireplace – evidence
of the English penchant for comfort.
(Sir Charles D'Oyly, Cape Archives)

ABOVE LEFT. The Cape Dutch interior –
townhouse. Grander than the farm-
house (TOP LEFT), with painted dados
and cornice, bare floor and exposed
ceiling. Two fine gilt looking-glasses
and late eighteenth-century Cape
furniture. (Library of Parliament)

ABOVE RIGHT. The drawing-room at The
Presidensie, Bloemfontein, in the Steyns'
day. The anglophile character of the
presidential family may account for the
colonial opulence of this pre-Boer War
Free State interior when compared
with the Krugers' Pretoria villa. (The
Presidensie Museum, Bloemfontein)

derivative work in which he never had a hand and by people who judge his houses out of context in terms of the period and original owner. This is a significant point for students of architectural history. For it is as fatuous to condemn a Baker house as being made up of small rooms as it is to condemn a verandah house for getting no sun, or a Cape Dutch house for lacking sufficient accommodation. This book attempts to show, with some degree of veracity, the attitudes of the owners and architects which caused them to build the houses they did. It also attempts, where possible, to address the more ephemeral subject of interior decoration, the history of which, it is now generally acknowledged, is a necessary complement to that of domestic architecture.

Alas, we have almost no contemporary depictions of the interiors of the Dutch period, and those which survive from the early days of the British period show houses of the humble, rather than affluent Boer, farmer or town dweller. The inventories of estates lodged in archives provide an invaluable clue as to the contents, if not the actual arrangement, of the rooms, revealing them to have had no specified purpose – sitting-room, bedroom and so on – as we know them today. By the end of the eighteenth century they were enlivened with *trompe-l'oeil* architectural motifs – dados, cornices, pilasters, swags and the like – all executed with a varying degree of skill.

Obviously there were crazes in décor as there are now – French wallpaper seems to have been popular in the late eighteenth century and (less promising sounding in those rather gloomy rooms) chocolate brown taffeta for hangings.[6] But the silver and brass must have gleamed as in the 'period' rooms of twentieth-century imagination and a mass of porcelain, festoons (*ophaalgordyne*) and stuffs, whose patterns and effects we can but guess at, enlivened the somewhat austere whole.

This is how the English first saw them and they were unlikely to have been charmed. Not only was their way of life very different, but so too were their aesthetic sensibilities. By the beginning of the nineteenth century the refined styles of the brothers Adam had already filtered down to the more prosperous middle classes and the sophisticated revivals of the Regency period would be familiar enough within another twenty years. This alone would have made Cape Dutch architecture appear boorish and provincial, if not actually queer to their eyes.

But there was another factor which was to change South African houses radically as the decades of the nineteenth century wore on. For in that time the English, breasting a double wave of rising middle-class prosperity and a rapidly increasing technological know-how, advanced the level of domestic comfort and convenience at a hitherto unprecedented rate, much as the Americans would do a century later. In the early decades of the nineteenth century, the internal arrangements of most Cape Dutch houses still reflected those of late seventeenth-century Holland and Flanders. To the English, therefore, they not surprisingly appeared uncomfortable and inconvenient to a degree. No nation understood better the requirements of comfort than did the Victorian English, and nothing could have seemed quite so uncomfortable to them as the average Cape Dutch house.

It is too easy to say that two cultures – out of step – had clashed, for it was more than that. Then, as now, the new and stylish – much like the new and comfortable – had an irresistible attraction, and in no time at all the old beamed ceilings were plastered over and corniced and the many-paned windows replaced by wider, thinner frames. Fireplaces appeared and from now on became the focal point in the arrangement of the main rooms. The Dutch furniture, suddenly rendered so clumsy to contemporary eyes, was slowly banished to back bedrooms, servants' quarters and attics. The murals were painted out in fashionable colours or covered with stylish wallpapers. As manners changed with modes, so the interior arrangement of the rooms came to be designated as we know it today, with bathrooms – and sometimes even indoor lavatories – appearing in the houses of the rich.

The marvels of industrial Victorian England, combined with colonial sentiment, ensured that the houses of the South African colonies – and to a considerable extent even those of the two Boer Republics – were furnished with British products. The over-stuffed, over-cluttered parlour of middle-class Pietermaritzburg, a Karoo farmhouse or a Cape villa of the 1880's would not only have been instantly familiar to Sannie Kruger, wife of the Transvaal President, but could quite easily have contained some identical items. It was a similarity that no doubt extended around the Empire. Lionel Curtis, coming across a Boer farmhouse in the veld in 1900, described it in a letter to his mother as having 'a parlour as one has seen a hundred times in England.'[7]

Cecil Rhodes and Herbert Baker put an end to this. Beneath the florid wallpapers, under countless draped arches and behind rows of cast-iron verandahs, they perceived an almost forgotten world which in an idealized form suited their simpler, Arts and Crafts tastes. Vernacular craftsmanship was to be revived – re-taught in its ways if necessary, its products no longer despised as clumsy but admired as sturdy. Aesthetic predilections required that the walls be whitewashed to display a sudden flood of teak and stinkwood; Edwardian standards of comfort required the inclusion of chintz sofas and reading lamps, bathrooms and flower-rooms, nurseries and endless servants' quarters.

The wheel, they all said, had turned a full circle, and certainly in the happy afterglow following unification so it seemed to be. It hadn't, of course, *really*. But – then as now – time had passed, prejudices had faded and aesthetic sensibilities, just like political ones, had shifted perceptibly. And though the aesthetic past which they so freely embraced was shot through with the idiom of another tribe, still it was – for better or worse – perceived as an intrinsic and indelible part of the country's history to be absorbed, in the full flush of reconciliation, as part of the rebuilding of a modern nation.

BANTRY BAY, CAPE TOWN
1987, 1996

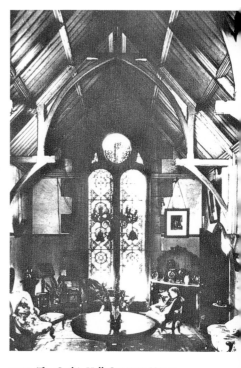

ABOVE. The Gothic Hall, Overport House, Durban. Colonial Natal Gothic at its best in what was then the finest house on the Berea. (Local History Museum, Durban)

OPPOSITE PAGE, BOTTOM. The drawing-room, The Villa Arcadia (*circa* 1914). Baker's beams, carved fanlight and cavernous fireplaces. The décor is the curious combination that he and Lady Phillips evolved – South African Arts and Crafts with a healthy dollop of the more fashionable 'Curzon Street Baroque'. (Africana Museum, Johannesburg)

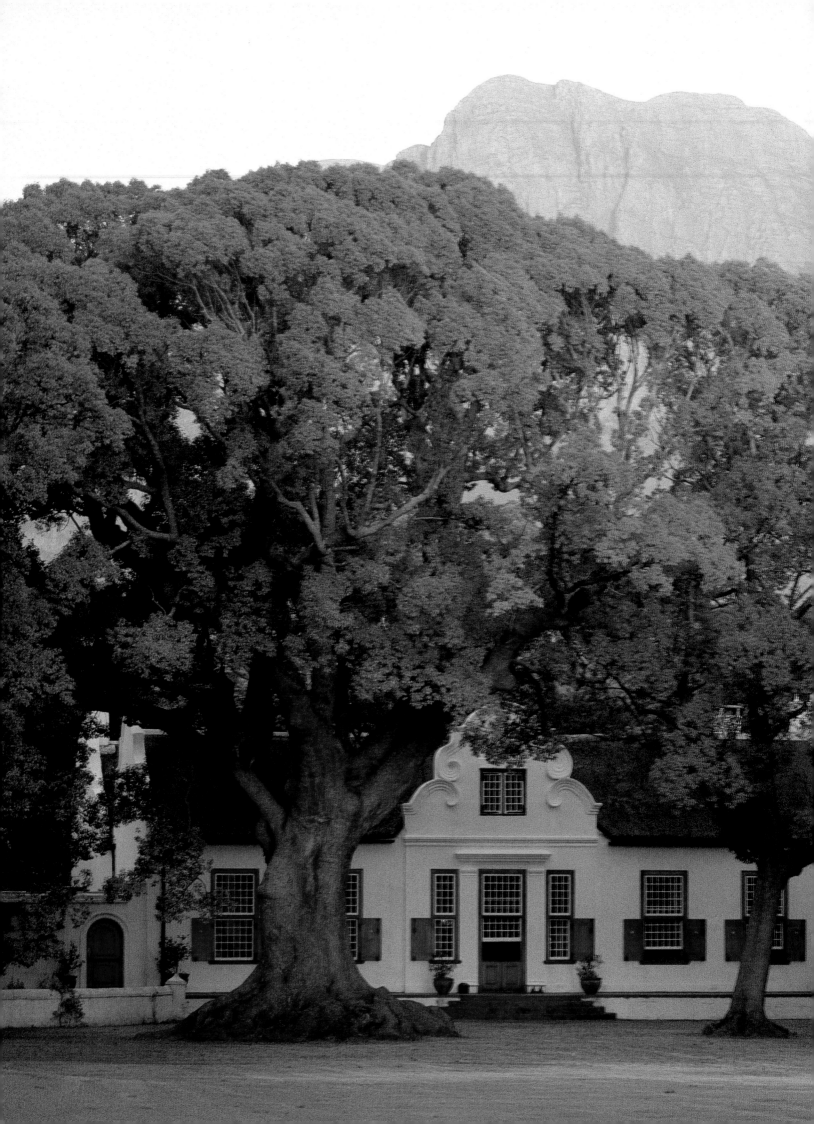

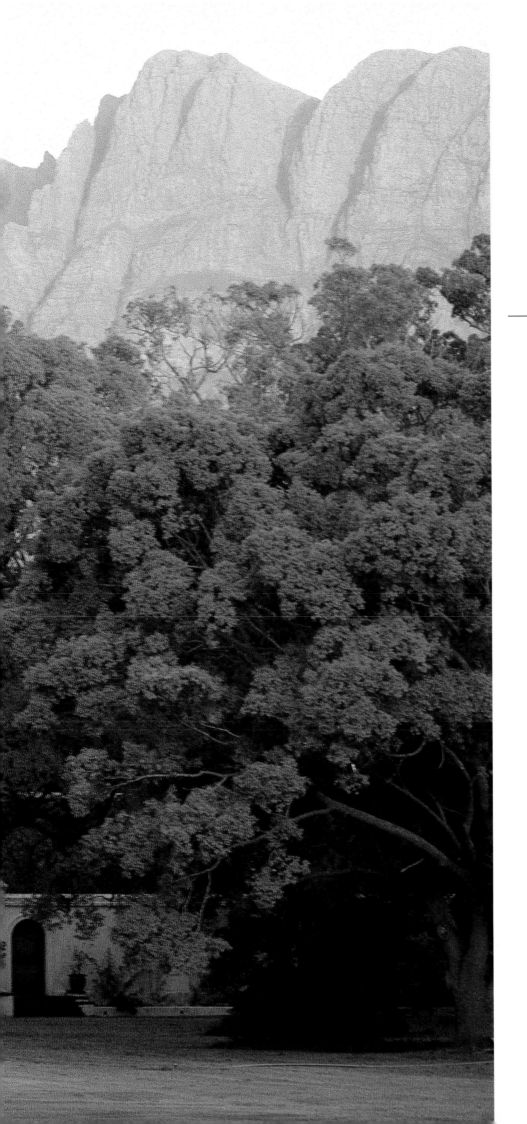

VERGELEGEN

HOTTENTOTS HOLLAND

On the very first day of the eighteenth century, four years after the rebuilding of Petworth and a year after the establishment of Williamsburg, Wouter Valckenier granted a 400-morgen tract of land to Willem Adriaan van der Stel, Governor of the Cape of Good Hope, a tiny, insignificant Dutch settlement on the other side of the world.[1] As a councillor in India and Admiral of the Return Fleet, Valckenier was senior in rank to the Governor of the Cape, and it was in his capacity as special commissioner to the Dutch East India Company – a sort of annual inspector who visited the settlements – that the grant was made.[2] The size of the land was almost seven times that normally granted to the average free burghers so that Valckenier's motives must necessarily be suspect. Moreover it was in direct contradiction to the recently and repeatedly espoused company policy which was strongly opposed to the heads of government holding farms at the Cape. Still, he can hardly have foreseen the consequences of his action which were to stir up one of the most ferocious storms in a tea cup in all South African history.

The land was in a fertile valley of great magnificence and beauty, bounded on the east, west and north by high mountains and sweeping down to the False Bay shore to the south. A favourite grazing ground of the Hottentots, the area was known to the early Dutch as the Hottentots Holland. It was a twenty-four hour journey from Cape Town and Van der Stel called it Vergelegen, which in literal translation means the 'place laid far away'.

The Governor immediately began to transform the virgin wilderness into a model colonial estate. Its manor house faced south-west. According to the descriptions of Valentyn and Bogaert it comprised a double-H plan, connected by a 'lovely and unusually pleasant gallery',[3] eighty feet long and sixteen feet wide (24 x 4,8 m). This would have made it half as long again as the average substantial Cape house of the day and twice as large, if one takes into account the offices which were in narrow, flat-roofed wings stretching outwards and slightly backwards from the ends of the main rear façade.

The two contemporary depictions[4] of it show the north-east façade (now the front, then the back) with three dormer gables of the distinctive Cape form, simply accommodated by the curved sweep of the fine Cape reed thatch. Cross-windows – frequent enough in the Netherlands at this time but uncommon at the Cape – and applied pilasters flanked a central door. The front or south-western façade was similar but more elaborate with two elliptical (possibly dormer) gables on either side of an elegant and more typically Dutch one. This looked out over the orangery, formally laid out in a double-walled octagonal garden. Between the inner and outer walls were two entrance courts, a dairy, a cattle shed, two sheep pens and, opposite the manor, a farmhouse for the overseer. Beyond the enclosure and on one side was a watermill (supplied from a reservoir) and the slave lodge, balanced on the other by a pigeon-house and a press-house for the grapes. Further off stood a tannery, a workshop for making wooden pipes and a wine cellar.

Cheerfully appropriating the services and some of the prize specimens of Jan Hertog,[5] the Company's master gardener at Cape Town, Van der Stel proceeded to lay out the grounds in the grand manner. At the back of the house was a plantation of camphor trees, planted to create a wide avenue leading up to the door. Five of these remain there to this day. Great in girth and age they are one of the glories of the garden. A great wood of oak trees was planted; a summerhouse (*lusthuis*)[6] was planned in the mountains. Immense vineyards covered sixty-one acres with nearly half a million vines – a quarter of the whole number in the settlement. There were orchards of chestnuts, walnuts, almonds, figs, pomegranates and even mulberries, the latter in an ill-fated attempt to start a silk industry. Van der Stel was not only a progressive farmer with a sound knowledge of animal husbandry; he was also a forester, botanist and horticulturist. His *African Gardener's and Agriculturalist's Calendar*[7] is full of useful tips and information. Even the grandest South African estates of the present day would be unlikely to provide the variety of flowers and vegetables he listed; Valentyn actually mentions the delicious asparagus he ate at Vergelegen. Beyond these lay the great cornfields yielding (according to Bogaert who is reliable) over eleven hundred *muids* per annum and beyond the mountains there were eighteen cattle and sheep stations.

Van der Stel lived in considerable style. The exiled King of Tambara provided an exotic note in the household, his wife acting as the housekeeper, if we are to place the strictest interpretation on Valentyn's account. They were waited upon by the Company slaves who staffed the Governor's quarters at the Castle.

The logistics of such a venture would be daunting at the best of times – far more so in such a primitive and backward settlement – so that it is almost beyond belief that the whole thing was achieved in less than six years.[8] But impressive though all this may sound today, it seemed like nothing so much as ostentatious magnificence to the ordinary burghers of the early eighteenth century. Doubtless there was an element of sour grapes. Enterprise and elegance beyond the commonplace are invariably greeted with disparagement in a colonial environment and Van der Stel is unlikely to have been spared this. Unfortunately his conduct in pursuit of pleasure and what in the end amounted to peculative gain laid him wide open to scandal and rebuke.

To start with, Hertog was not the only servant on the Company's payroll to be despatched to Vergelegen. Slaves, soldiers and sailors were all impressed into service. Private individuals were obliged to transport materials to and from the estate. The Governor was seen to absent himself from his duties at the Castle for weeks (something he took care to conceal from his official journal) and refused to conduct Company business while there.

He might have got away with all this if it had not been combined with a quite unbridled venality. It is true that until the nineteenth century most colonial governorships were unofficially regarded as a means of increasing personal fortune, but it was Van der

Stel's undoing that he failed to perceive that the Cape with its resident, articulate burghers offered less opportunity for such lucre than a tropical post with a large and powerless native population. The Governor's produce – of excellent quality, we may be sure – flooded the market. First into the Company's warehouse (no tithes were paid) and first aboard visiting ships, it soon satiated the strictly limited requirements of the settlements.[9] The burghers, who relied on the sale of their crops for their very existence, were outraged. Finally they banded together. A complaint was sent in secret to the Council in Batavia. Another, authorized by Henning Husing and Adam Tas, was smuggled to Holland. Van der Stel, appraised of the situation, drew up a counter certificate extolling his own integrity and many virtues and began insisting that it be signed by one and all.

By 1706 the Cape was in an uproar. There were house arrests, imprisonment without trial in the Castle dungeons, confiscations, insubordination and flight. There were demonstrations in front of the Landdrost's at Stellenbosch and a near riot on the Parade. At one stage poor Mrs van der Stel even went so far as to attempt suicide[10] declaring (as she flung herself into the fountain at the Castle) that her life was a misery owing to what she was obliged to see and hear daily.*

The Lords XVII acted promptly. Van der Stel was deprived of his rank and, together with his brother and several others in cahoots, ordered back to Holland. The grant of the land was held to be improper and it was confiscated to be divided and sold. The manor house, the most visible evidence of the many irregularities, was ordered demolished as 'setting an example of ostentation'.[11]

Overnight Van der Stel's world had collapsed. Right up until the last minute he procrastinated hoping that influential friends in Holland would secure a reprieve and that he might be allowed, as he rather wistfully wrote, to end his days at Vergelegen, 'that sweet and pleasant place', as a 'forgotten burgher'.[12] His pleas fell on deaf ears and in 1708 he and his brother left the Cape for good, only their father, old Governor Simon, remaining behind – with what thoughts (in Alice Trotter's romantic rhetoric) we do not know – to finish his days in the sunshine amongst the vineyards of Groot Constantia.

Inevitably decline set in. Seventy years later when Captain (later Admiral) Stavorinus visited the place he recorded that the garden, the buildings and the plantations 'all bore evident signs of the magnificence and wealth of the founder who had spent large sums of money on this spot; but everything is now much decayed, as the succeeding proprietors did not possess the same means as Mr van der Stel, to keep it in proper repair'.[13]

Alas, money is not all that is required to keep things in proper repair. Over a century after that, in 1916, when Sir Lionel and Lady Phillips inspected the property with a view to purchase, they found that the previous owner, who had made his fortune in the

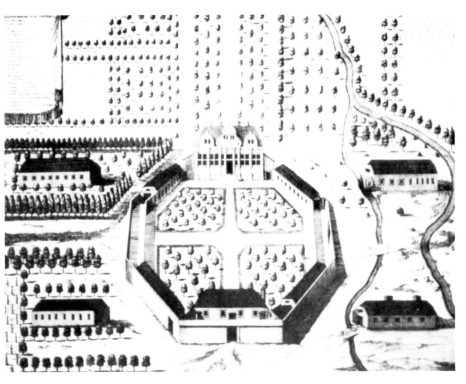

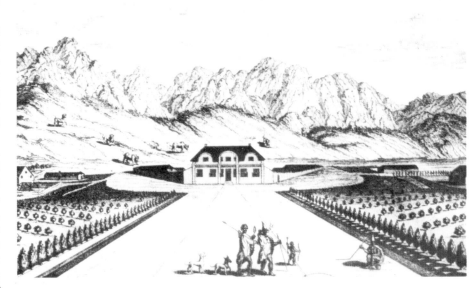

The well-known depictions in the accusation (TOP) and defence (ABOVE) of Van der Stel's model Dutch colonial manor *circa* 1705. Van der Stel's depiction showed the less impressive rear façade and includes a few wild beasts to highlight the undoubted extent of his enterprise in darkest Africa.

* The censorius Theal insinuates that Van der Stel was a libertine like Charles II!

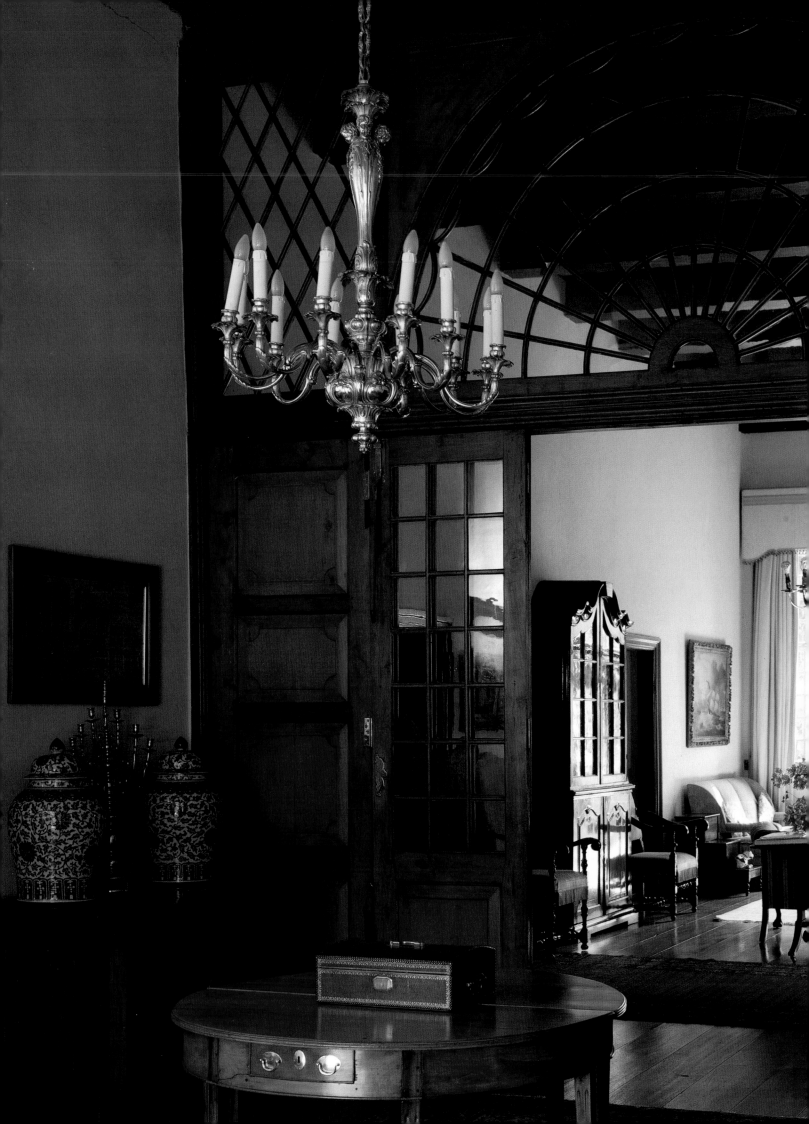

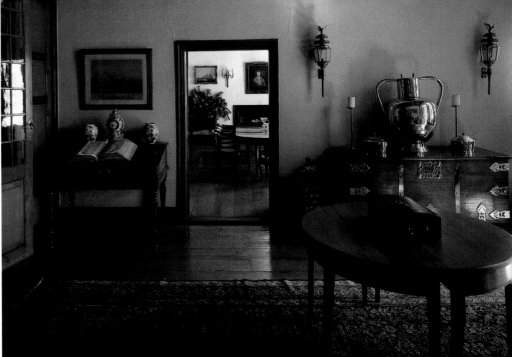

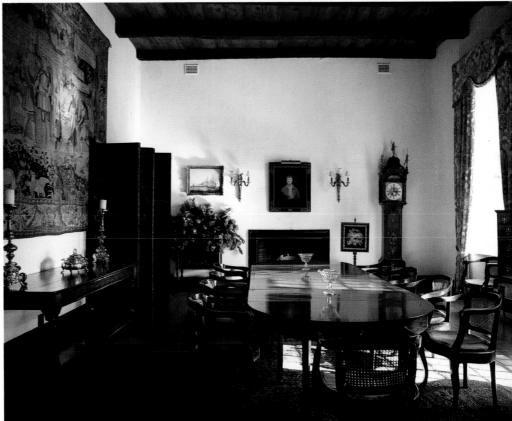

LEFT. The *voorkamer* showing the handsome screen which Lady Phillips rescued from an attic. Its Georgian upper section must date it from the British Occupation. The circular table comprises a pair of late eighteenth-century Cape stinkwood *demi-lunes*.

TOP. The *voorkamer,* looking towards the dining-room. The Cape bible table to the left of the door is topped with Delft; the Cape stinkwood chest and the brass milk can are both eighteenth century.

ABOVE. The dining-room. The tub chairs are stinkwood, and the portrait is by John Opie.

Australian and South African gold and diamond rushes, had begun a process of modernization which practically amounted to vandalism. The old teak sixty-pane windows had been replaced with deal and plate glass, the eighteenth-century screen removed, the old brick stairs replaced by a concrete flight and hideous iron gates 'appropriate enough to a modern villa in the suburbs of Birmingham or a factory at Salt River', as Dora Fairbridge noted tartly,[14] guarded the entrance.

Lady Phillips, a formidable Edwardian hostess and tireless patroness of the Arts, was unlikely to be deterred by any of this and in 1917 her husband instructed Sir Alfred Hennessy of the Colonial Orphan Chamber to purchase Vergelegen in her name.[15] Handsome, energetic and bossy to the point of tiresomeness, Florence Phillips (Florrie as a child, Lady Li Phi to Mrs Smuts and others in later life) appeared almost divinely chosen to the *cognoscenti* of her day as the practical redeemer of the efforts and vision of Willem Adriaan two hundred years previously.

To begin with they knew her to be a woman of considerable discernment. Although fundamentally Edwardian in her taste, she had been influenced towards the theories and philosophies of William Morris and Byrne Jones by her friend, Mrs Norman de l'Aigle Grosvenor who had also introduced her to Sir Hugh Lane, the connoisseur and art dealer.[16] At her instigation he had advised on the purchases for the Johannesburg Art Gallery, one of her pet projects, and from him she had learned much. Then too, Herbert Baker, Dr Purcell and Dora Fairbridge had inspired in her a passion for Cape Dutch architecture and its preservation. Her enthusiasm bordered on a mania; her drive in the face of seemingly dauntless odds was legend. Moreover, they knew very well that apart from furthering her husband's career, much of her life had been devoted to spending his money and bullying other mining magnets to do likewise in the general cause of cultural improvement in South Africa. The list of projects she initiated and often financed is remarkably long – her memory is one of the most scandalously unhallowed in this country. It was fitting, therefore, that the uncrowned Queen of Johannesburg (as she was known to an adoring press) should spend her retirement – and a great deal of her husband's remaining fortune, as it turned out – in landed glory at the Cape, lavishing the knowledge and discernment of a lifetime on the by now much needed restoration of its greatest and most historic manor.

The house that the Phillipses bought ('almost an uninhabitable ruin,' according to C P Walgate, their architect) was very likely part of the one in which Van der Stel had lived. In accordance with the Company's orders, the estate had been divided into four and sold off by auction on 31 October 1709.[17] The Company realized 24 400 guldens of which 20 000 was clear profit. The portion with the house on it was sold to Barend Gildenhuys. All evidence points to his having obviated the final calamity which the destruction of the manor would have occasioned by buying as much of the material it comprised while still standing (the sale of which was to be for Van der Stel's account) and

then destroying only the back third of the building which included the three gables.[18] The resulting gap was built up with the demolition rubble, as was discovered at the time of the Phillipses' restoration.

Gildenhuys had therefore been left with a good sized but suitably unostentatious house. Over the new front entrance (formerly the back) the Phillipses found a decorative Cape baroque gable with a rather rare double in-curve in the moulding, probably added at the time of the second rethatching. Traditionally a forty-year occurrence in Cape houses and by the sounds of things not completed at the time of Stavorinus's visit in the late 1770s, it may be dated *circa* 1785, circumstantial evidence crediting it and the side gables to Rudolf Loubser, the then owner. Beyond the back door the foundations of the old octagonal garden, mostly crumbled to ruin, were found and rebuilt; and the old wine cellar (used as a cow byre) was transformed to house Sir Lionel's priceless library from The Villa Arcadia, their Baker-designed Parktown mansion. Its T-shaped structure dated from the early 1800s and its neo-classical gable from about twenty years later. It must have been built at the time of Marthinus Theunissen, who had married Loubser's step-daughter and become owner of Vergelegen in 1798. Subsequently known as 'Die Held van Blaauwberg' for his bravery in the face of the Second British Occupation, he was a breeder of horses (even selling one to Lord Charles Somerset) and a good farmer.[19] Benefiting from the wine boom that resulted from the Napoleonic Wars, he increased the size of the estate. His son and grandson in turn farmed the land in peace and a certain prosperity – indeed, it was quite as well-known in the nineteenth century as 'Theunissen's Farm'.

Lady Phillips's first choice of architect was her protégé, J M Solomon, one of Baker's assistants and whose cause for the prestigious University of Cape Town's contract she had supposedly championed over his former employer. Full of enthusiasm for her latest project, she urged him on to produce the working drawings. The wretched man, breaking under the strain of his university commitments, had in the meantime appealed to Baker in New Delhi to send him one of his collaborators as assistant. C P Walgate came to South Africa but was helpless to provide the sort of assistance Solomon needed. In August 1920 Solomon shot himself. Insomnia, strain and overwork was the coroner's verdict; the Cape being what it is, it was darkly hinted in some quarters that Lady Phillips had Driven Him To It. Walgate knew nothing of Cape Dutch architecture and in order that he become well versed in it Lady Phillips motored him up and down the countryside to examine the houses and architectural details. He was a willing and talented collaborator; the schemes were undoubtedly hers.

The four main rooms of the existing house were opened up, the front windows copied and replaced. The splendid late eighteenth-century screen or *porte de viste* with its Adam motif was found in an attic and reinstalled, a gable – a copy of that on the Paarl Parsonage – added to the façade overlooking the octagonal garden. Lack of accommodation, always a problem for modern hostesses who live in these

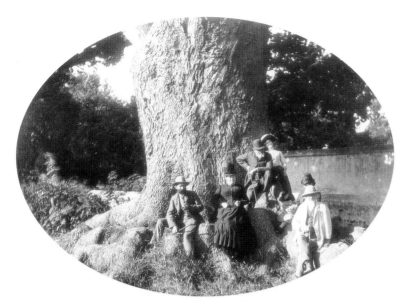

LEFT. The Theunissen family under the camphor trees, *circa* 1885.

BELOW. The front façade showing the Cape baroque gable with its rare double in-curve and the screen walls which rather successfully mask the Phillipses' 1920s additions. The splendid row of camphor trees may well have been planted at the time of Willem Adriaan van der Stel.

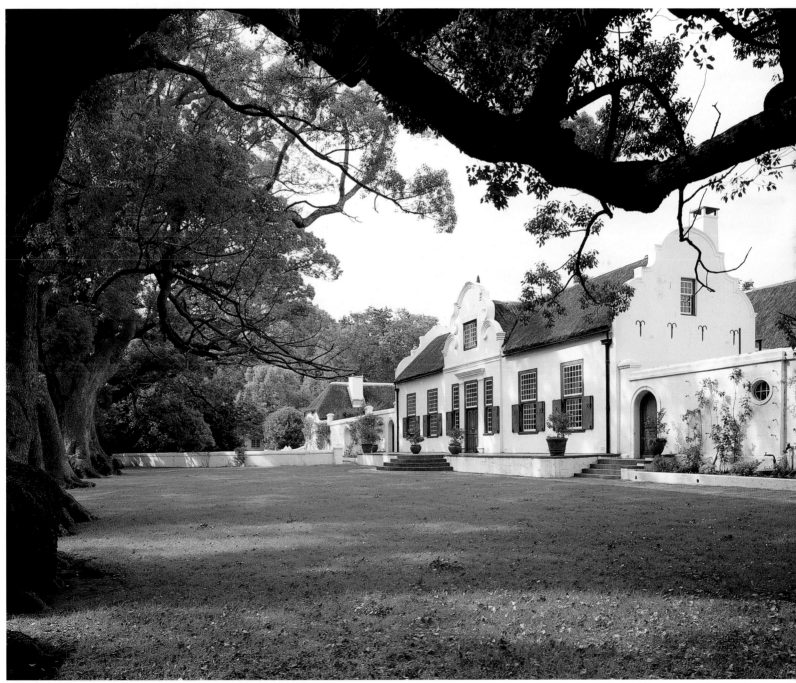

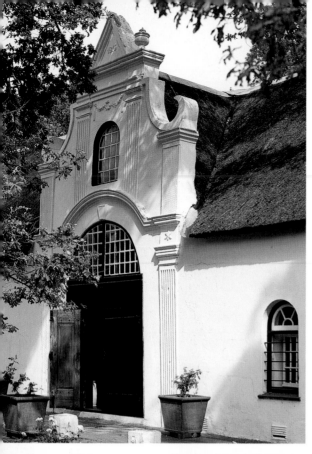

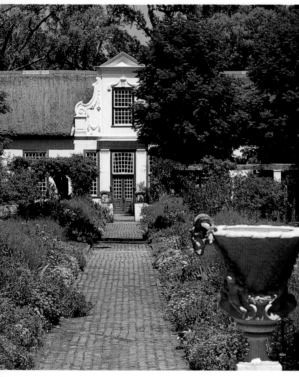

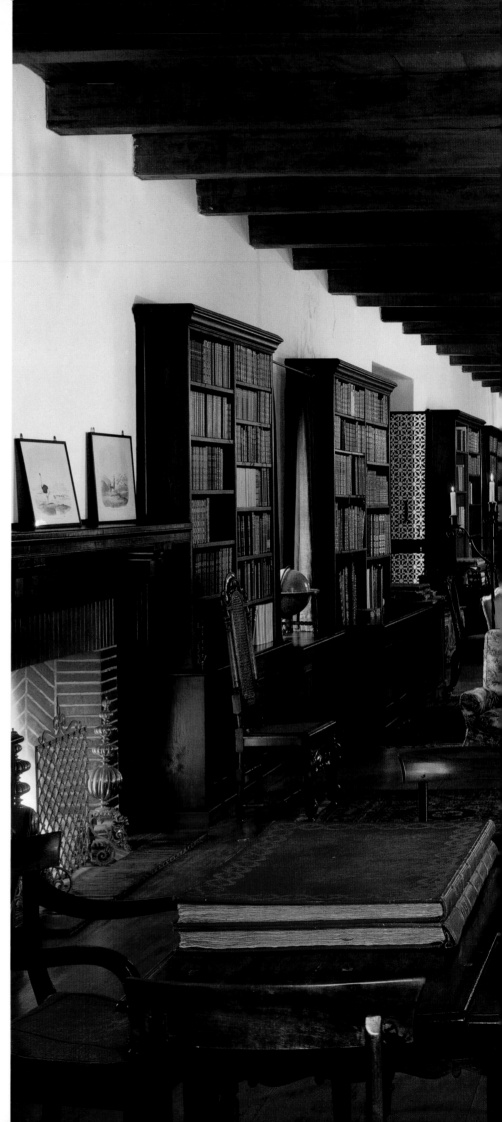

TOP. The neo-classical gable of the old wine cellar.

ABOVE. At the back of the house the Phillipses added a copy of the Paarl Parsonage gable in what was thought to be the gap left by the demolition of the rear third of Van der Stel's manor house. The twin borders bisecting the old octagonal garden were laid out by Hanson, the Phillipses' gardener.

RIGHT. The library, converted from the old wine cellar to house Sir Lionel's library from The Villa Arcadia. Its décor is a perfect example of that curious combination of South African Arts and Crafts and 'Curzon Street Baroque' that Herbert Baker and Lady Phillips evolved. The fine wrought-iron screen, centre left, is an example of George Ness's metalwork at its best.

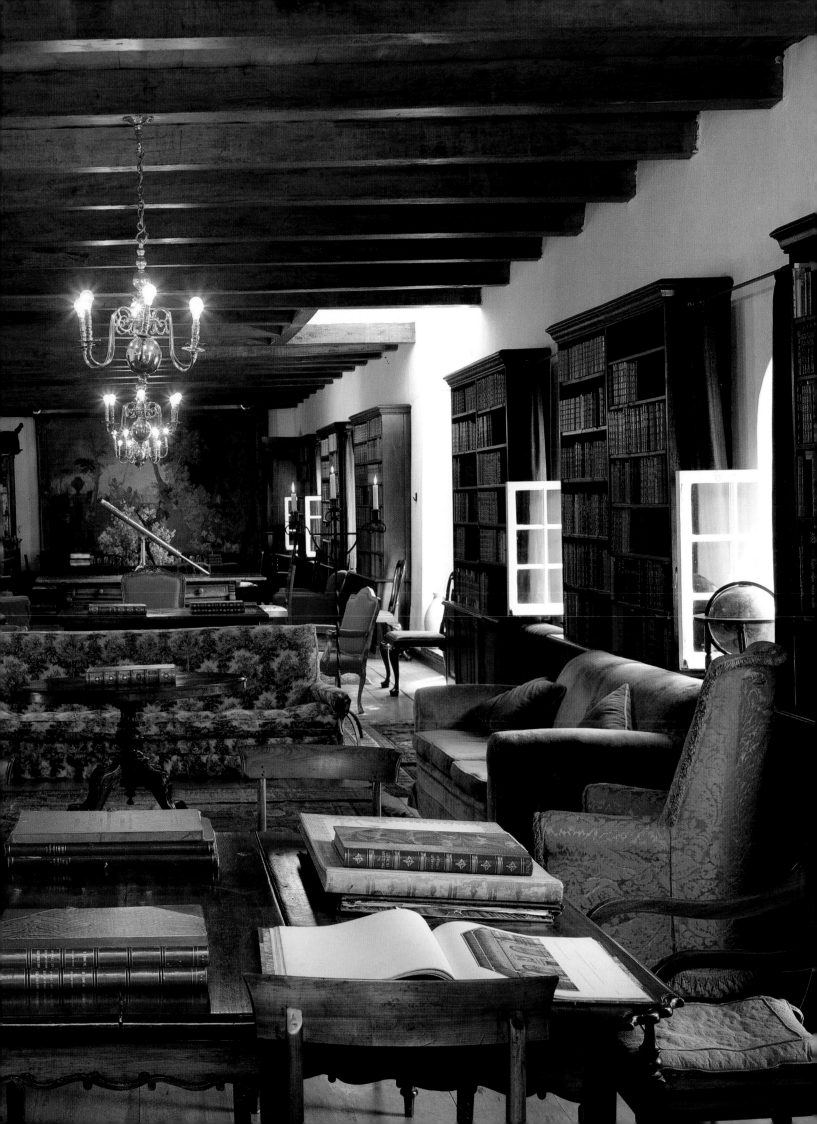

RIGHT. Sir Lionel (centre) and Lady Phillips (left) in old age with General Smuts and his wife as their lunch guests.

FAR RIGHT. The amazing Lady Phillips, the great South African hostess and patroness who restored Vergelegen in the 1920s. (Portrait by William Nicholson, Johannesburg Art Gallery)

BELOW. The morning-room. The furniture and decoration reflect the taste of both Lady Phillips and Cynthia Barlow.

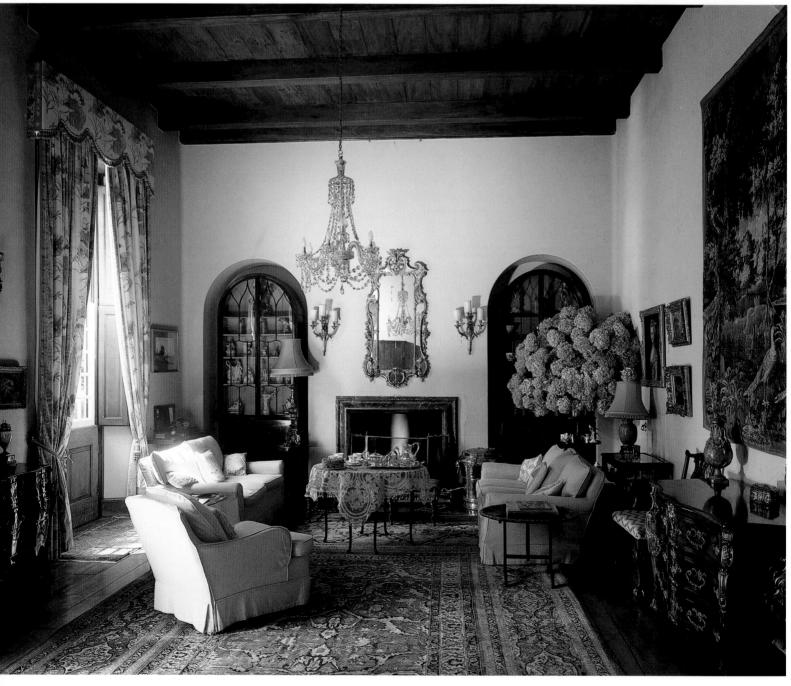

houses, was solved with the addition of two side wings subordinate to the main block and camouflaged by the two existing screen walls. Unthinkable as such a solution would be in these days of purist restoration, they have stood the test of time and are successful beyond all reasonable expectation. They house the bedroom and kitchen quarters. In addition to the wine cellar being turned into a library, another outbuilding was transformed into a guest cottage. An SOS was sent out to 'find Hanson', the head gardener of Tylney, the Phillipses Berkshire mansion. He was duly tracked down (with a war limp) working for Lord Warwick and in 1921 came out to Vergelegen.[20] In his hands the gardens rebloomed in Edwardian splendour.*

The rebuilding took five years. Filled with the treasures of Tylney and The Villa Arcadia and surrounded by the gardens Hanson had already created, Vergelegen emerged as the Cape's and, indeed, South Africa's greatest jewel. The architect and builders – roundly abused and chastised by Lady Phillips almost beyond endurance – were bidden to luncheon. Placing Walgate on her right she announced that now he had ceased to be her architect, she wished him to be her friend.

It was a gracious gesture. But her mercurial moods – her 'April temperament' as she called them – seemed only to increase. After her husband had died – in comparative poverty owing to the fortune she had spent on the house and farm – she lived out her remaining days at Vergelegen unloved and deserted by almost all her friends and servants. It was hardly surprising: the roaring blaze in front of which so many had been happy to warm themselves for years had collapsed into a heap of smouldering embers, only an occasional hiss or spat – disconcerting in its very unexpectedness – reminding the intrepid of the vitality and energies that once had been. She died in August 1940, the world she had known almost in eclipse. Like Sir Lionel she lay in state in the long dark library and it was here that her old friend General Smuts gave the memorial speech. Deservedly laudatory, it was a noble valediction.[21]

The beneficiaries of her estate had no wish to live at Vergelegen and gave instructions for its sale. There was a feeling that it should be purchased for the nation. Wartime exigencies prevented this. Unlike The Villa Arcadia (refused by the nation twenty years before) Vergelegen's fate was a happy one. The whole estate, including much of the furniture as well as the library, was bought by Mrs Cynthia Barlow at rock-bottom wartime prices.[22]

It was one of the real estate buys of the century.** The Barlows maintained and enhanced the place in a manner of which Van der Stel and Lady Phillips could only have approved. It remains in their son's possession today, the most romantic of South Africa's houses and a cynosure of all visitors to the Cape. Tom Barlow well recalls from his early childhood its most illustrious visitors, who arrived almost without warning in April 1947. Peter Townsend had told King George VI and Queen Elizabeth of the 'magically beautiful place' where he rode every morning towards the end of the royal tour. They asked to be taken to see it in private and were overcome by its loveliness. 'Never,' wrote Townsend of the visit, 'did I hear Their Majesties express such pleasure.'[23]

* Plants and shrubs were imported from all over the world. Beyond the old kitchen garden stands an oak grown from one of the last crop of acorns collected by Lady Phillips from Alfred the Great's oak at Blenheim. In 1947 the King and Queen gathered some of its acorns which now grow as oak trees in Windsor Great Park.

** Although the Barlows overlooked two 'Views of Venice' which recently turned up as Canalettos at Christie's and fetched a record R2 million.

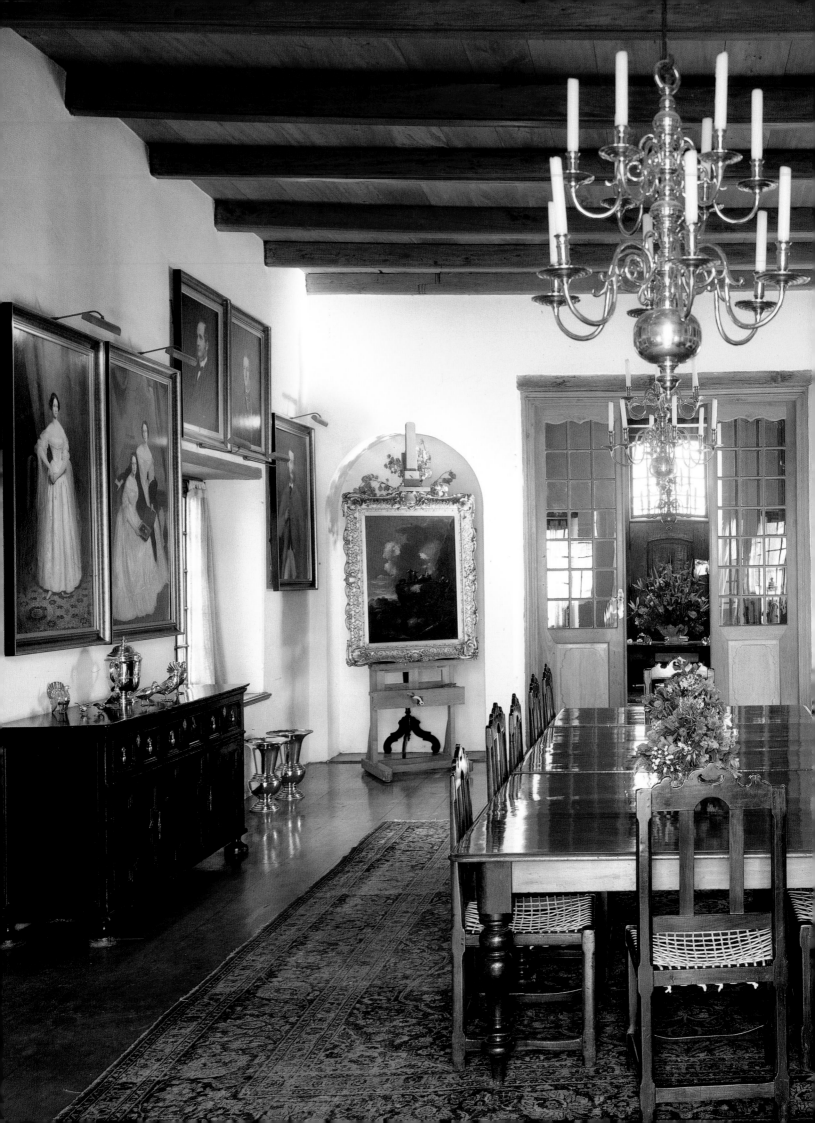

IDA'S VALLEY

NEAR STELLENBOSCH

Around about 1787 Samuel Cats began to build himself a fine new *hofsteeder* on Groot Idasvallei. Twelve years before, in 1775, he had purchased the property together with the adjacent farm, Nazaret, for 10 000 guldens[1] – a happy occasion for him, one likes to think, since sentiment seems to have played a part in the acquisition. Samuel was the grandson of the previous owner, Johannes Groenewald[2] and since his own parents had died young it may be reasonably supposed that as a child he had known the farm quite well – indeed may even have been brought up there under his grandfather's wing, for there is a bill among old Groenewald's inventory providing for the education of both Samuel and his sister, Johanna.[3]

Armed with this by no means general advantage in the Cape countryside in the mid-eighteenth century, Cats had prospered nicely. Five years after his initial purchase he bought Klein Idasvallei for 2 000 guldens[4] from his aunt's second husband, Pieter de Hoog, thereby adding 37 morgen to his adjacent estate. In 1777 he had married his first cousin – a shotgun affair, it is regrettable to note, for the first of eight children was born only four months after the wedding – but happily this did not affect his chances to be made a deacon of the church two years later. He became an officer in the army at thirty-one and in 1786, at the age of thirty-six, he was appointed *Heemraad*. The public-spirited are not always motivated by aims entirely altruistic and one has a sneaking suspicion that all this betterment – what the Americans would nowadays describe as upward social mobility – was as much responsible for his decision to build a brand new manor house as was his rapidly increasing family. There were, after all, already dwellings on both Nazaret and Klein Idasvallei as well as his grandfather's quite substantial *hofsteeder* on Groot Idasvallei.[5]

The original house on Ida's Valley, part of which in all probability remains as the *jonkershuis*, had been built a century earlier by François Villon, a pre-Huguenot French immigrant who, in 1683, had taken advantage of the attractive land offer made by the Commander of the Cape, Simon van der Stel.[6] Ida's Valley was thus one of the handful of farms which, at the end of the seventeenth century, comprised the first European settlement beyond the Cape Flats.

In October 1679 Van der Stel had taken over what was, in the words of his predecessor, an impoverished and moribund community. Enthusiastic and enterprising, he was determined to make the Cape, at the very least, self-sufficient in food – needless to say a cause close to the commercial hearts of the Lords XVII in Holland who had hitherto been obliged to import rice as a supplement from the East. In November, having dispensed with 'numerous unnecessary occupations' at the Castle, Van der Stel set off to inspect the Company's wheatlands in the Hottentots Holland.

During this tour, as he records in the margin of his logbook, he camped for the night on an island in the Eerste River which he named Stellenbosch. Struck by the surrounding valley's suitability for agriculture, he put it out on his return to Cape Town that anyone who so desired would be granted full ownership of land there. It was to be occupied tax free for a year and thereafter the standard tithe would be payable to the Company. As extra incentive – and one was necessary in order to tempt the burghers away from the immediate environs of Cape Town – the offer was for as much land as the owner could cultivate with the added attraction of being allowed to choose it for himself.[7]

The first colonist had moved into the valley by the end of 1679 (or so Theal says) and by the middle of the next decade the Stellenbosch settlement boasted a string of farms whose romantic names remain familiar today: Mostertsdrift, Welgelegen, Libertas, Voorgelegen. And Ida's Valley. Exactly for whom or what the farm was named is not known although many are the theories put forward on this score. For generations the story went that Ida was the mistress of the Commander, Mrs van der Stel having chosen a more or less perpetual grass-widowhood in Holland. Nothing exists to substantiate this theory, though persistent rumours elaborate, insisting that Ida was in fact a slave girl – as was the Commander's own mother[8] – and that all evidence of the liaison and, indeed, her very existence was subsequently expunged from church records. Others suggest that the picturesque site, beneath the winter waterfalls of the Banhoek mountains, brought to mind the Mount Ida of antiquity, though it is hard to believe that such classical nuances were common parlance among the often illiterate early settlers. Yet another more reasonable guess is that Villon, a Catholic, named the farm after St Ida, a saint popular in the district of France from which he came.

Needless to say life at the very edge of the wilderness was rough and ready. The inventory of Villon's widow, subsequently married to Wemmer Pasman whose brother farmed neighbouring Rustenberg,* describes a three-roomed house and kitchen of the humblest sort: a *voorhuys* which was evidently also used as a dining-room, with two rooms on either side designed for no specific purpose as we would know it today. In the one on the left, for example, there was a bed (not a four-poster, merely a *kadel*), a copper kettle, a plough share (new too), fourteen sickles and four canvas sacks. There was an amount of wheat and rye in the *solder* and in the *pershuys* or wine cellar there was a winepress and sixteen leaguers of wine. Apart from some stock, there were four male and two female slaves and a grandchild, born into slavery. The Pasmans had no ready cash.[9]

Two generations later, in the time of Samuel Cats's grandfather, Groenewald, things had improved considerably. An extra room had been added and the furniture now included a glazed armoire, a grandfather clock, several four-posters, two pictures and masses of porcelain – one of the great enlivening decorative features in the somewhat gaunt old Cape interiors. Some silver is also mentioned in the inventory and the *agterkamer* had an *ophaalgordyn* – the local version of a roman blind or eighteenth-century festoon. In addition to wine, the cellar now boasted a copper brandy kettle with its 'pipes and cooling vat'.

* See Rustenberg.

PREVIOUS PAGE. The *gaandereij*, looking towards the *voorkamer*. The table is surrounded by Cape stinkwood transitional Tulbagh chairs. The brass chandeliers are modern, made in original eighteenth-century moulds in Holland. The walls are hung with Erskine, Radcliffe and Colmore family portraits. The Landseer-like stags in silver are a Goodwood trophy.

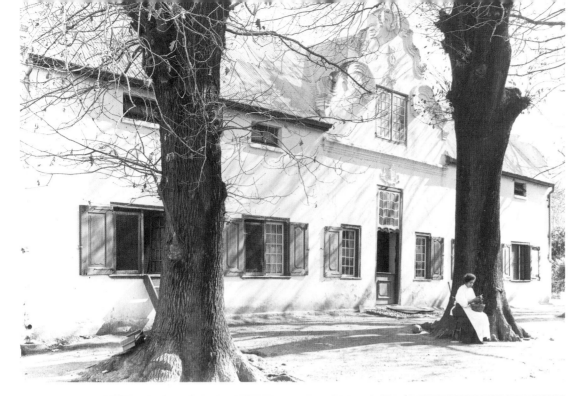

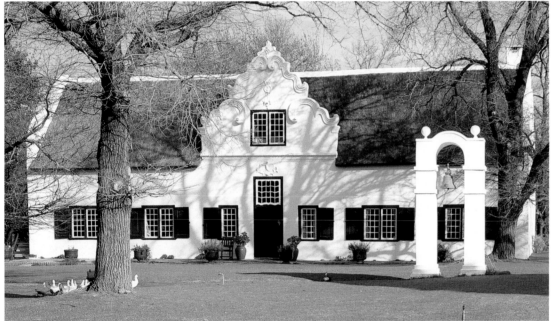

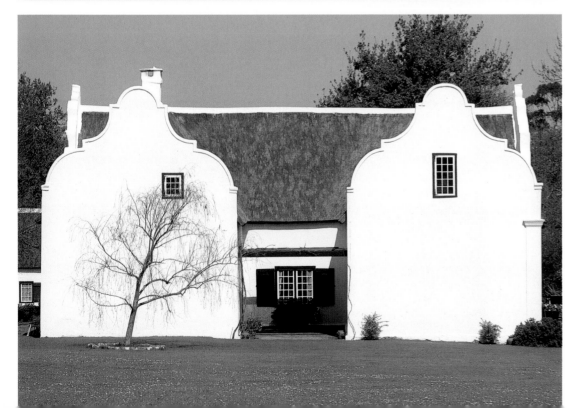

TOP. The famous turn-of-the-century Elliott of the back gable showing the swan in plasterwork above the wavy transom and glazing bars of the fanlight. (A Elliott, Cape Archives)

CENTRE. The rear façade (possibly once the front) today.

BOTTOM. The H-shaped ground plan of the house is easily detectable from this side view with the profiles of front and back gables projecting to the left and right. The *jonkershuis*, part of which may have been Villon's original dwelling, is seen to the left beyond the main house.

TOP. View from the front door.

ABOVE. Beatrice Malleson's Edwardian gardens are being replanted and extended by the present owner.

RIGHT. Front façade. The gable, dated 1789, shows the skills of the Malay slave plasterers at their most ebullient. Most of the Cape farmhouses had small casement windows such as these before the many-paned sashes became generally popular at the turn of the eighteenth and nineteenth centuries.

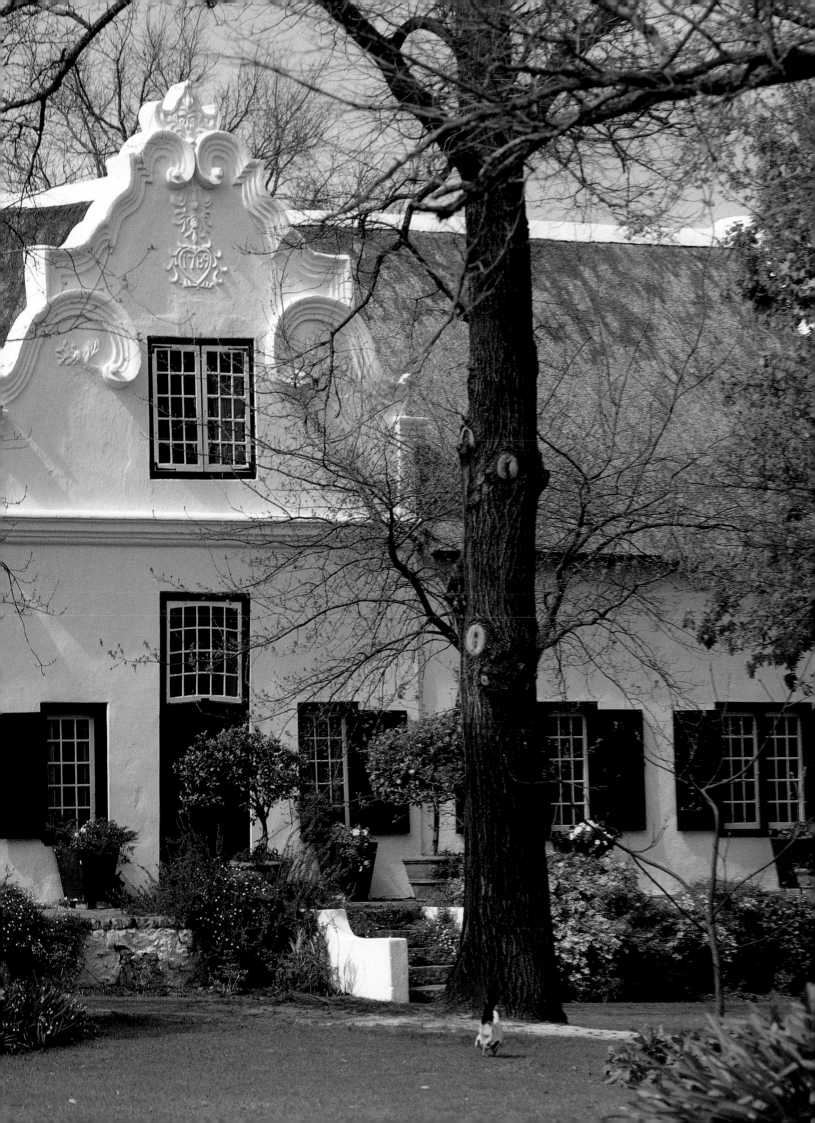

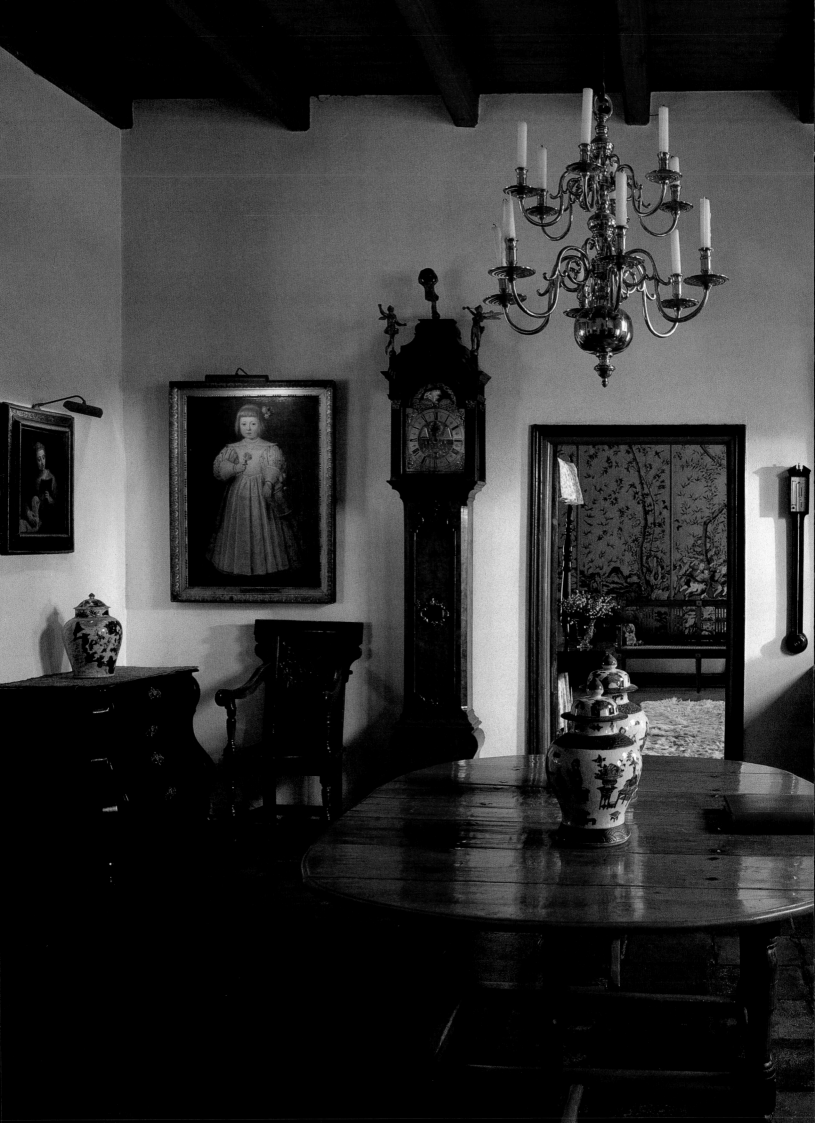

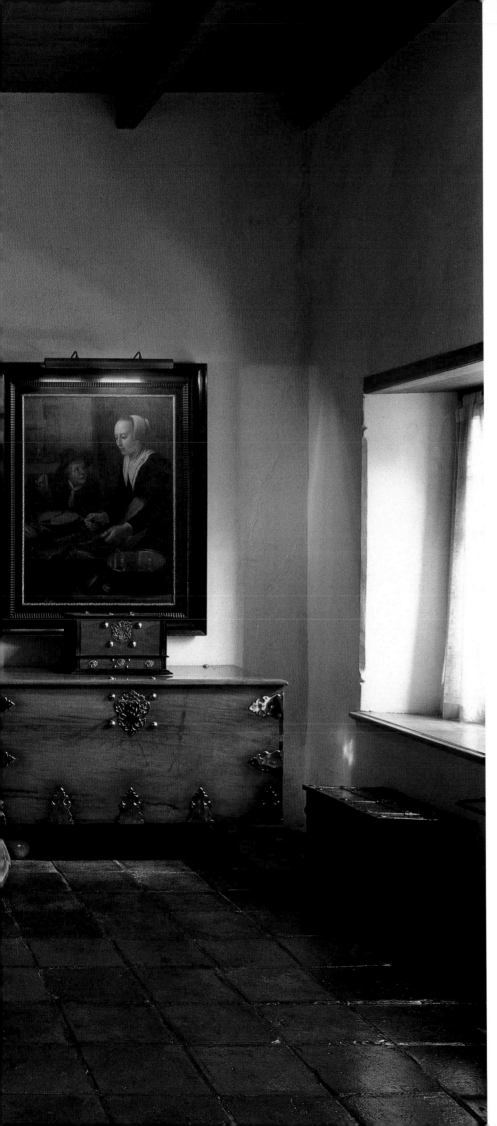

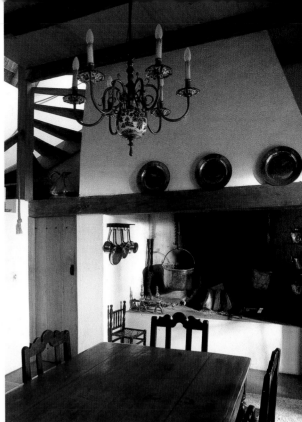

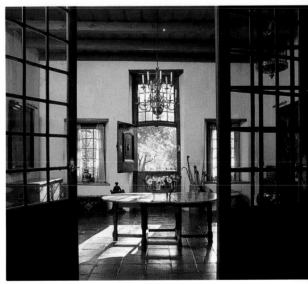

LEFT. *Voorkamer* with its Batavian tiles, looking towards the bedroom which was the Regency parlour. The yellowwood gate-leg table is Cape, the stinkwood and beefwood chest Batavian and the serpentine-fronted chest Dutch. The Elizabethan armchair belonged to Lady Randolph Churchill and the Chinese wallpaper in the bedroom beyond is eighteenth century.

TOP. The old Dutch kitchen with an array of copper and brass in the open range. The ladder stairs lead to the attic beneath the thatch. In winter this would have been the one warm room in a house without a fireplace.

ABOVE. *Voorkamer*, looking through the screen.

Victorian Ida's Valley, photographed by Elliott in the 1920s, showing the french windows, venetians, corrugated-iron roof and side wing. (A Elliott, Cape Archives)

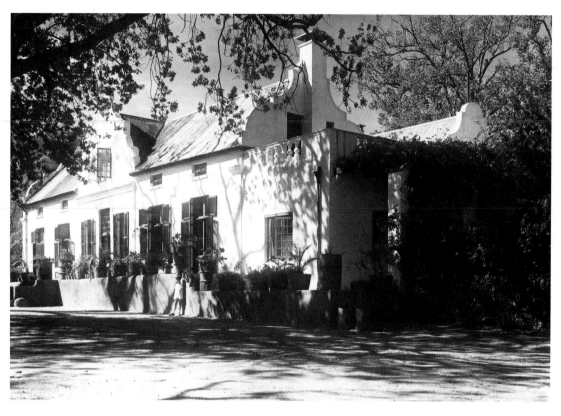

There was a well-equipped smithy and the *werf* contained two horse carts or wagons, an ox wagon and, on a less utilitarian level, two deck chairs.[10]

Rather than elaborate on the existing house (or so structural investigation leads us to surmise)[11] Cats decided to start from scratch and, unconstrained by considerations and compromises which the former option would almost inevitably have necessitated, built a gem of a new manor house. The ground plan followed the straightforward and particularly pleasing H-shape – one of the letter-of-the-alphabet designs in Cape domestic architecture which had evolved in the course of the eighteenth century – and the pleasingly regular though uneventful front and rear façades were given elaborate late baroque gables.

The wavy Cape gables of the 1780s, of which Ida's Valley's and Morgenster's are perhaps the finest examples, are the subject of a minor but persistent storm of controversy. For years they were described as Cape rococo,[12] a colonial time-lag apparently accounting for the fact that they are a good sixty years beyond that style's evolution from European baroque. But revisionist academic analysis has pointed out a lack of deliberate asymmetry and the equally pertinent fact that there is nothing remotely feminine about the vigorous scrolls.[13] This of course is true, but in this instance academic analysis – revisionist or otherwise – must surely bring with it its own limitations. Colonial architecture, especially in a settlement made up of so many nationalities such as the Cape, is nothing if not serendipitous: much like Topsy, one feels, it 'just growed'. The sources for the scrolls and other motifs are far more reasonably traced to the inspirations of the anonymous Malay slave plasterers who, with their own strong tradition for curvy plasterwork, must claim significant credit for making the Cape gable something entirely

unique.[14] Handsome carved doors with their wavy transoms repeated in the curved glazing bars of their fanlights added another distinguished decorative note to the façade. Within, the yellowwood beamed ceilings were left exposed and it is apparent that the entire floor surface was covered with an ox-blooded pavement of Batavian tiles.

The first description we have of the house dates from the 1820s when it was owned by Jacob Daniel de Villiers and we are fairly safe in assuming that this is substantially the house that Cats had built, and that Jacob's father, Johan Pieter, had purchased for 60 000 guldens in 1812 when Cats sold up and moved on.[15]

As far as can be deduced from the inventory, the house of the De Villiers' day comprised the *voorhuys* with a room on either side. The one to the right was the best room or parlour and though it is not described as such, the contents alone is evidence of a changing world in the Boland. There was a horsehair canapé and chairs, some mahogany, a gilt looking-glass and what appears to be a tip-top tea table. Behind the *voorhuys* was the *galdery* with two wall cupboards (*muurkaste*), a backroom (*agterkamer*), a kitchen and two pantries which may or may not have been *afdaks*.[16]

Cats's price is evidence of the increased value of Cape wine farms owing to the boom in the industry. J P de Villiers evidently benefitted from this and the neo-classical gable must have been his addition to the wine cellar.

J P died in 1822. His eldest son, Jacob Daniel, inherited the farm, buying into the estate for the huge sum of 150 000 guldens.[17] Needless to say he didn't have anything like this amount. He took over his father's mortgage to Cats and borrowed the rest.[18] One would have thought that the pages of sums that he did, alarming in their amounts as they were,[19]

would surely have sounded a note of caution. Apparently they did not. From the start the repayments were onerous and by 1826 he was insolvent.[20] His movables were sold off although the creditors wisely agreed not to rush the sale of the property until a good price might be realized.

In the event Ida's Valley was purchased in January 1834[21] by Jan Pieter or Petrus, Jacob's brother and one of his chief creditors.

The De Villiers family farmed Ida's Valley for the rest of the nineteenth century. Like many of the Cape Dutch manors, the main house was substantially altered during this time. By the time the Rodbard Mallesons acquired it from A B de Villiers in 1908,[22] the thatch roof had been replaced by corrugated iron, its pitch altered and the small casements of the front façade substituted by pretty french windows complete with louvred shutters.* Even so, accommodation was short and the new owners added a wing to the right of the house.

Beatrice Malleson was a great character. She was born a Miss Struben, the daughter of one of the early Rand pioneers. One of the finest horsewomen at the Cape, she regularly rode to hounds with the Government House hunt, at Milner's invitation.[23] She took a keen interest in the farming of the estate and is also credited with the laying out of the grounds very much in the Edwardian 'Italianate' manner with long gravel walks, pergolas of wisteria and banksia roses and sunken gardens.[24] A staunch member of the White Ribbon Temperance League (as was Lady de Villiers, her neighbour at Rustenberg) she ordered the vineyards, replanted after the phylloxera disaster in the 1880s, to be rooted out immediately and replaced with fruit trees.

It was the era of cold storage and the great export of Cape fruit to England. At picking-time the wives and children from the estate and extras brought up from the village would pick the fruit and sort it by eye in the old wine cellar, grade it in cardboard grading plates and then wrap it in branded tissue paper. The trays were then passed to Mrs Malleson herself, sergeant-major-like supervising the whole operation, her gimlet eye not missing a trick. Thus inspected, they would be packed in the correct sizes of wooden wool-lined boxes and driven to the Cape Town docks. The 'Ida Brand' – whose logotype was a young girl in a *kappie* – was for many years well known and popular on the fruit stalls at Covent Garden.[25]

On the Rodbard Mallesons' deaths, the Stellenbosch Municipality purchased most of the estate excepting the old homestead, wine cellar and farm buildings. Mary Malleson, who had married Jack Dendy, inherited these. The Dendys sold to Major and Mrs Philip Erskine and they, with Gabriel Fagan, have carried out extensive restorations removing all the Victorian additions and leaving the house as a perfect example of an H-shaped Cape Dutch manor. Its interiors have been enhanced with their families' fine collection of furniture and pictures and the gardens replanted and extended.

* These were removed in the recent restoration: happily they have been installed in the cottage at Morgenster.

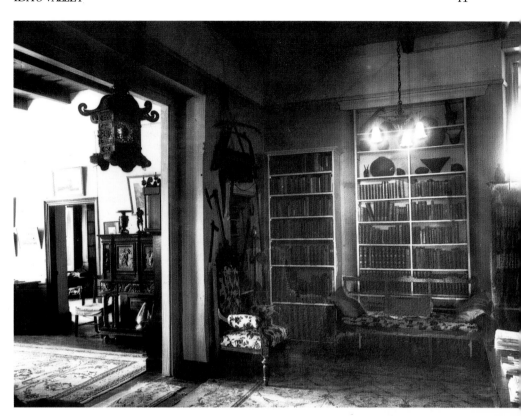

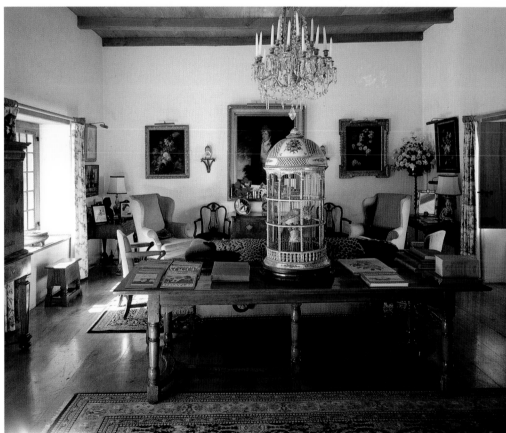

TOP. Interior just after the First World War. No illustration could better indicate the changing fortunes of Cape farmhouses. (A Elliott, Cape Archives)

ABOVE. Drawing-room. The family portrait is a Lawrence and hangs over a William and Mary chest. The birdcage is Delft. The door, right, leads to the courtyard. Needless to say, the arrangement of the original *kamer ter linkerhand* would have borne no resemblance whatsoever to this charming room.

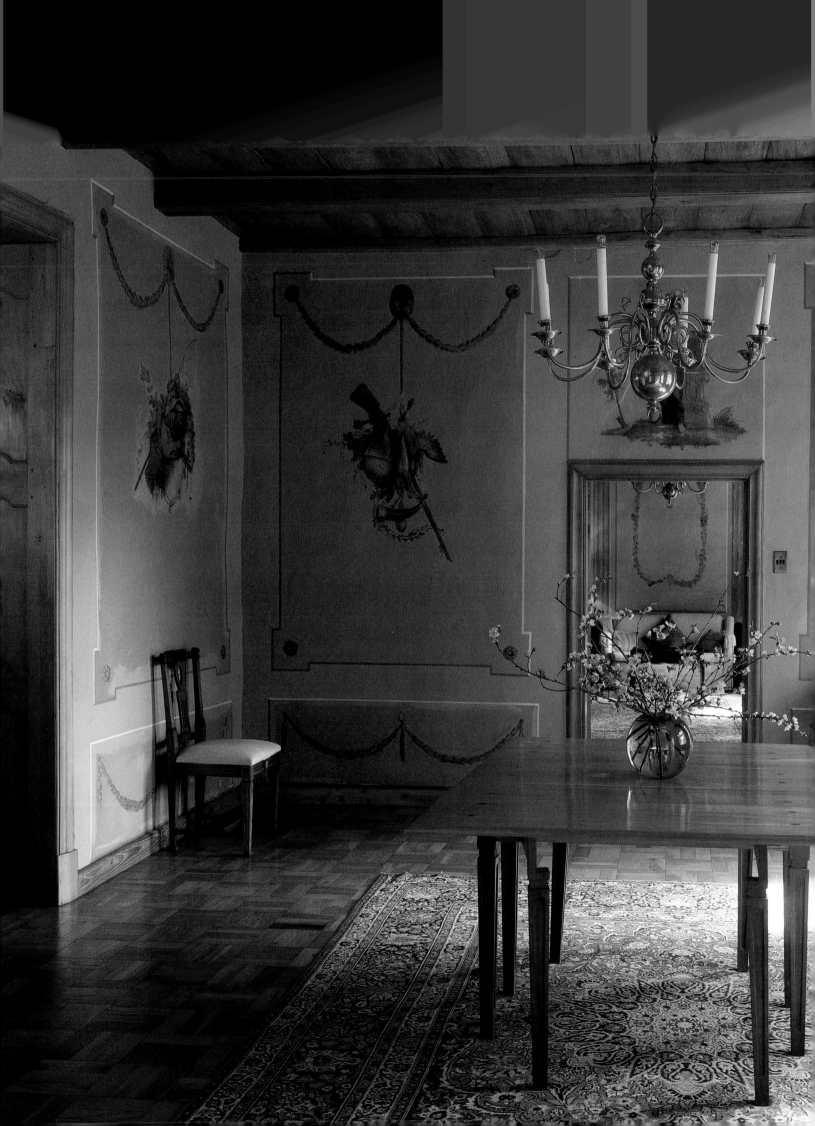

LIBERTAS

STELLENBOSCH

There is an old and well-loved story that Adam Tas, released from the dungeons of the Castle and the terrible tyranny of Willem Adriaan van der Stel (wicked as all hell), greeted the Cape sunlight after fourteen months of near solitary confinement with a pun: 'Libre est Tas' – Tas is free. It is a good story as it goes and has more than a ring of truth about it, for its author was not only blessed with a facile pen but was also something of a wag – what would nowadays probably be called a smart Alec. What certainly isn't true is that he then proceeded to transform the pun into the name of his farm. Libertas existed before Tas ever lived there. Indeed, in the best tradition of the more enterprising and quick-witted bachelor burghers of his day, he came to own it only by marrying in community of property the widow of the man who had amalgamated the 'grassy clover meadow ... and right pleasant estate'[1] as Willem Adriaan irritably described it.

In 1690 Hans Jurgen Grimpe purchased a small farm from a Mijnheer Ouderbeyerland who had been granted it in the previous year.[2] It was a boomerang-shaped piece of land on one side of a stream which snaked round two sides of the site of the present homestead. Opposite it and on the other side of the river was an oblong piece of land marked 'De Tuin'. Two years later Grimpe was granted his own in the vicinity[3] and although he may have built a dwelling on this additional evidence suggests otherwise. To begin with the land was low lying and would have flooded after heavy winter rains. Moreover, a much more suitable site for a house existed nearby on an adjoining piece of land which contained a large granite outcrop marked onbekwaam[4] (not cultivable) on the grant. It was useless for farming but ideal for a house built with primitive foundations and damp-coursing.

Grimpe seems to have set his heart on acquiring this. However, its owner, Andries Voormeister, evidently disliked him sufficiently to thwart his efforts and it took three years and the services of a friend – there are two transfers recorded on the same day[5] – before the property was his. On this he built a house of sorts, possibly the present wine cellar.[6]

Grimpe was to acquire a fourth piece of land before he died. The four grants made up the original Libertas which existed until 1822 when the widow of A F de Villiers procured an amended grant. She promptly cut up the property and, together with other land, made up and transferred two farms to each of her sons.[7]

Following her husband's death, the widow Grimpe married Adam Tas who presumably moved into the existing unpretentious house, where his wife's previous husband and source of his new prosperity had so recently breathed his last. Not an entirely happy state of affairs one might imagine and not one, anyway, likely to be tolerated by someone used to the comforts of Meerlust, the splendid (by Cape standards) house of his Uncle and Aunt Husing or by someone who, by all accounts, was excessively sociable and fond of entertaining. Having come to this 'unfamiliar affluence ... gotten in a twinkling'[8] as the Governor sourly put it, Tas may quite possibly have decided to build himself a new house, and indeed, a diary entry dated 4 July 1705 shows some building to be in progress.[9]

The first known description of a house on the farm Libertas, however, is contained in the inventory of the will of Wouter de Vos who bought the property after Tas's death in 1722 when it had been sold for the benefit of his children and stepchildren.[10] It describes a house that is basically T-shaped – 'voorhuys, groote kamer ter linkerhand, slaap kamertje ter regterhand ...' forming the downstroke of the T, the cross being formed by the 'combuys' and the 'bottelarij in de combuys' on the one side and, on the other, by an 'agterkamertje' reached, most unusually, by the passage which passes a 'bottelarij in de gang'. Off the 'agterkamertje', and evidently the reason for the passage, is a 'voorkamertje aan de regterhand in de gang'.

De Vos's inventory may be describing the present jonkershuis but there is just as much reason to believe that it is describing the back half of the present homestead.[11] The passage is still there, as is the 'voorkamertje aan de regterhand van de gang'. What is more, the present building has what was clearly a front door leading in from one of the side courtyards into the gaandereij. From De Vos's inventory, it would seem that this comprises the old voorhuys

PREVIOUS PAGE. *Voorkamer*. The assemblages depict the occupations and hobbies of the Hoffman family: to the left of the door is hunting and to the right is navigation – one of the sons was a ship's captain. The parquet replaced the old floor of Batavian bricks in the late 1940s, when the screen was also removed.

RIGHT. The front façade has undergone several alterations over the years. The gable is an old but not very happy copy of the one at the back; the central front door and surrounding half sashes were put in in the 1940s after the removal of the twin Georgian front doors.

FAR RIGHT. *Agterkamer*. Appropriately enough, the mural shows Bacchus with a wine cooler.

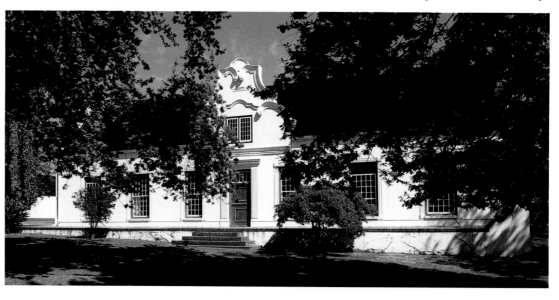

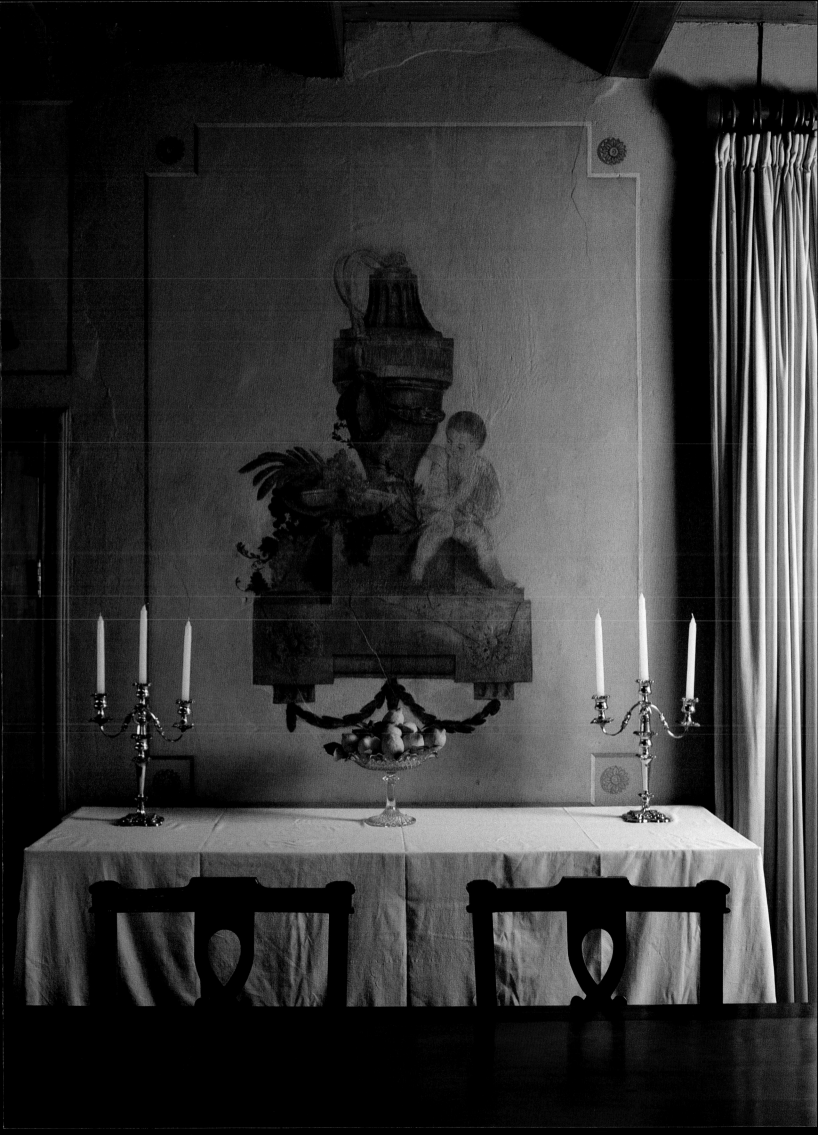

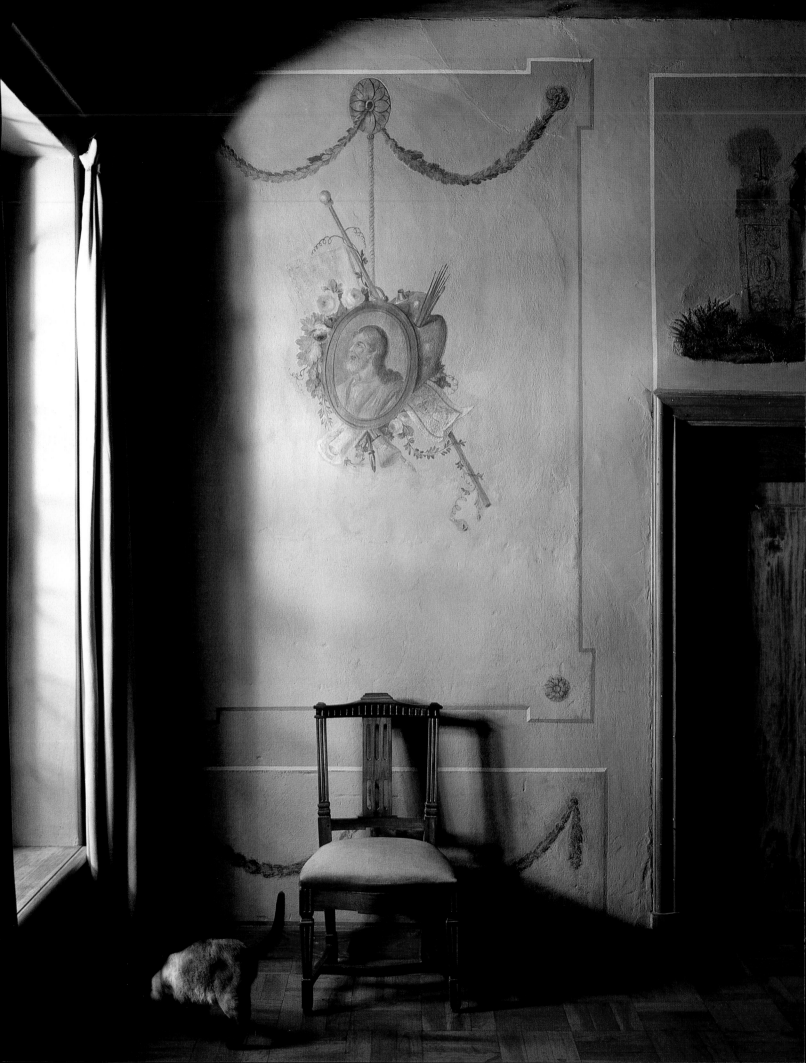

(hence the front door) and the '*groot kamer ter lin-kerhand*'. Further inspection reveals that De Vos's '*voorkamertje aan de regterhand van de gang*' – which mars the old perfect T – was a subsequent addition so that it is not all that improbable that the original T-shaped house was in fact the house that Adam Tas built. It is all lovely (if reasoned) guesswork and only structural investigation involving the removal of the plaster would confirm this. For reasons which will become obvious later this is out of the question.

After De Vos's death the estate changed hands four times. In 1768, the then owner, Jacobus Hermanus Malan (son of Daniel Malan of Morgenster) died. His inventory describes the house of Wouter de Vos's day unaltered.[12] Six months later his widow remarried. Her husband was Johan Bernard Hoffman, a German immigrant who had arrived at the Cape on board the *Vryheijt* in 1744. He rose to be a man of some substance, for he is described as a *korporaal*, and later as Landdrost of Stellenbosch (1747–1752), *Heemraad* and *Kaptein* of the Burgher Dragonders. By the time of his marriage to the widow he had already buried two wives who between them had borne him twelve children. Mrs Malan, who already had three of her own, produced a further six.

The problem of accommodating so large a family, even in a society that still did not consider separate bedrooms as necessary or even particularly desirable, must have been daunting. The T-shaped house required enlarging. Hoffman's solution, like that of many of his contemporaries, was to make the T an H, thereby gaining a handsome *gaandereij*, the *voorkamer* now at its far end with two new rooms on either side. Following this premise, the building must have taken place *circa* 1771; the date may be noted on the front gable which is a copy (or a rebuilt copy) of the one at the back. The main gables at Libertas are the typical Cape *holbol* type, full of wavy plasterwork like those at Morgenster and Ida's Valley. The back gable is undoubtedly the finer of the two though it is marred by the flue of a fireplace added at the rear of the *gaandereij* and inserted, complete with cupboard-like doors, in the position of the *muurkas* mentioned in Wouter de Vos's inventory.

Hoffman is also responsible for the other great feature of Libertas. In keeping with the vogue which we now know was almost universal in the Cape towards the end of the eighteenth century he had the interiors painted in *trompe-l'oeil* architectural motifs: dados, pilasters, entablatures and such like – even elaborate cornices cheerfully added below the exposed beams and boards. It is a typical decorative conceit of a colonial society enjoying a period of affluence: metropolitan grandeur affected and bearing little or no relation to the simplicity or positive crudeness of the buildings or way of life it was intended to adorn.

Herbert Baker and his adherents, who sought to idealize this very simplicity, would have been horrified at the thought of such feminine frippery ruining the aesthetic effect of all that 'teak and whitewash'. It is not that such schemes are without a certain naïve appeal but simply that, like those of the Victorian colonials a century later,* the results – invariably from the hands of the only moderately talented – have little more than a hollow bravura about them.

At Libertas, however, the architectural conceits are enlivened by wall paintings of tremendous charm. They are believed to be the work of Jan Adam Hartman who may well have been assisted by his son and were probably executed in the last decade of the eighteenth century. The panels in the *voorkamer* contain assemblages depicting the Hoffman family's occupations and pastimes – warfare (Hoffman, as we know, was *Kaptein* of the Burgher militia), navigation (one son was a ship's captain), hunting, fishing, music and the arts – the latter including what is believed to be a self-portrait of the artist. Over the door to the present sitting-room is the goddess of war, depicted in classical garb but with a contemporary, anachronistic hat over her spear. Allegorically, therefore, she asks for peace. Similar themes appear in the *agterkamer*. More hobbies and talents appear in the form of sculpture, farming, medicine – one son seems to have trained as a doctor. Appropriately enough, there are other panels depicting hospitality – cherubic Bacchuses frolicking around urns, and fruit and flowers

* See those at Hawthornden, for example.

FAR LEFT. *Voorkamer*. The assemblage depicting 'Art' contains what is believed to be a self-portrait of Hartman, the artist responsible for the murals shown here *à la* Leonardo, one might suppose.

ABOVE LEFT. The *voorkamer* from the *agterkamer* before the post-war alteration: the screen and Batavian brick floor are still to be seen. The house used as a fruit packing shed. (A Elliott, Cape Archives)

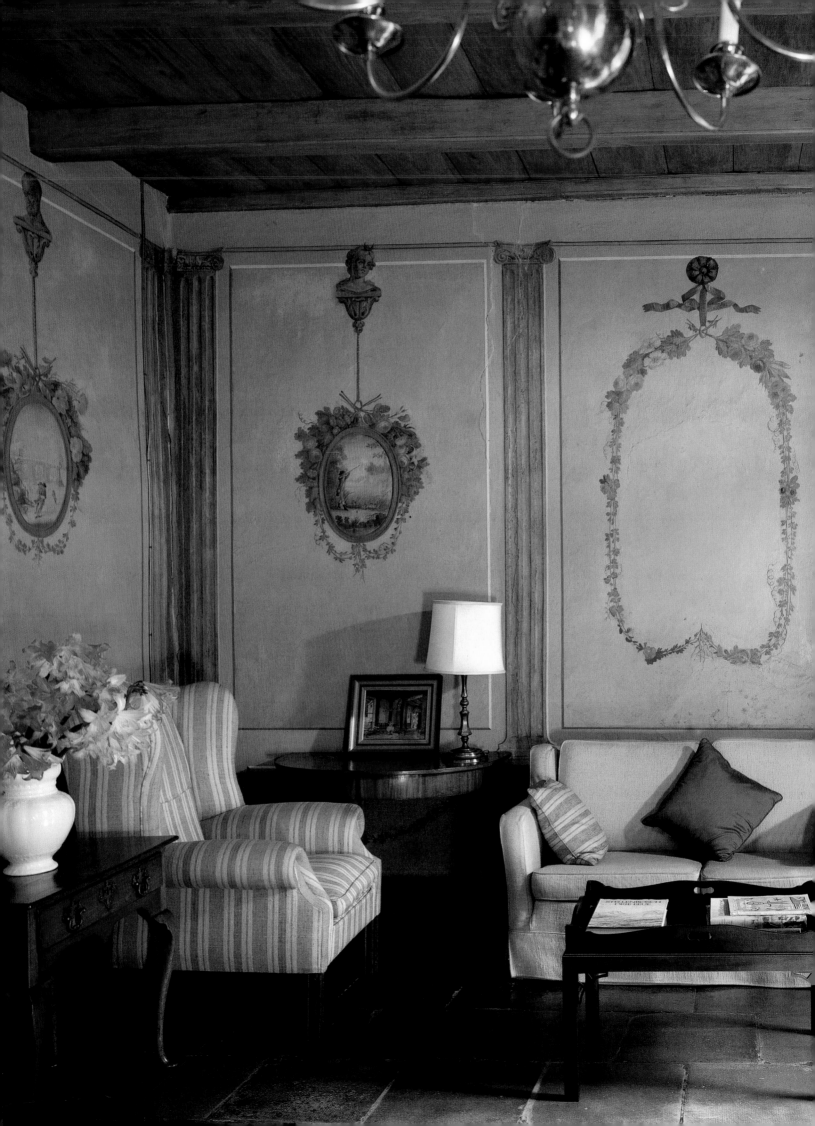

aplenty. There are also sundry classical virtues – Mother Love over the fireplace; Faith (in terms of religion); Caution (with a snake) over the doors to the kitchen and the steep loft ladder; Prudence (with the purse-strings) over the pantry door and even Polly parrot alongside as a warning to light-fingered slaves.

The new room to the right of the *voorkamer* is decorated with charming garlanded medallions between the pilasters representing the seasons as known to Europeans: winter, for instance, is depicted with ice skaters, a pastime which the Hoffman children can only have heard of. The other medallions depict hunting, fishing and mischief or flirtation – a sleeping lady being tickled awake by a saucy gentleman. The medallions are suspended on streamers from cornice height by a row of what appear to be Hoffman's children by his second and third wives together with his Malan step-children, all in the guise of classical busts. The trainee doctor wearing his winged hat is one of them. An extra child is depicted as a sort of cameo in one of the medallions and the remaining three (two from the first marriage) must have been included in actual portraits for these are listed in Hoffman's will[13] and there are blank medallions for two of them in the room.

Historical conjecture is fraught with dangers, but seldom can one imagine interiors of more period charm, with festoons (the *ophaalgordyne* whose tie hooks still survive) and lots of china offsetting all that chalky-pink and blue. Surely Mrs Hoffman chose pretty Indian chintzes and striped taffetas to go with her new murals, surely she was disposed to place posies of old roses and wild flowers on all those dark stinkwood surfaces, surely she would sit with her family at a tea table in the *voorkamer*, its doors and sashes thrown wide to the fresh air and African sunshine. Or was the reality much more sobering, was her house really awkwardly arranged and uncomfortable, the coffee undrinkable, the beds damp, the atmosphere thick with the smell of cheap candles. Was there, perish the awful thought, was there the constant smell of cabbage in the hall?

In 1940 Mr Andries Blake acquired the farm from Mr Constant Roux whose family had lived there for several generations. The actual homestead was in a somewhat dilapidated state but, remarkably, the murals had survived. It was used as a packing shed for vegetables until wartime restrictions could be overcome and restoration carried out. This included not only much needed structural repairs but, less happily, the replacement of the old pavement of Batavian bricks with parquet (very much in the vogue of the day) and the substitution of a pair of Georgian doors and a single copy of the old one in the *agterkamer*.[14] The brick floor as well as the old four-leaved screen between the *voorkamer* and *agterkamer* may still be seen in the old Elliott photographs of the house.

Further work and careful restoration of the murals was carried out in 1962 by Mr Blake's son and daughter-in-law with the assistance of architect Revel Fox and Mr Jonathan Wood. The family still occupies the house, and the farm – now with the suburbs of Stellenbosch at its gates – is today famous for its strawberries.

LEFT. At the end of the eighteenth century most of the grander Cape houses were given *trompe-l'oeil* architectural detailings executed with varying degrees of skill – those at Libertas are enlivened by wall paintings. In the sitting-room, or *kamer ter regterhand*, the pretty garlanded medallions depict the seasons (winter is on the extreme left) and hunting. They are suspended on streamers from portraits of the Hoffman children represented in classical guise. The pavement of Batavian tiles is original and the oil on the *demi-lune* to the left shows the pre-war interior of the house.

ABOVE. The lunette above the sitting-room door probably represents two Hoffman children or grandchildren who died in infancy. More than a touch of Fragonard to be detected here.

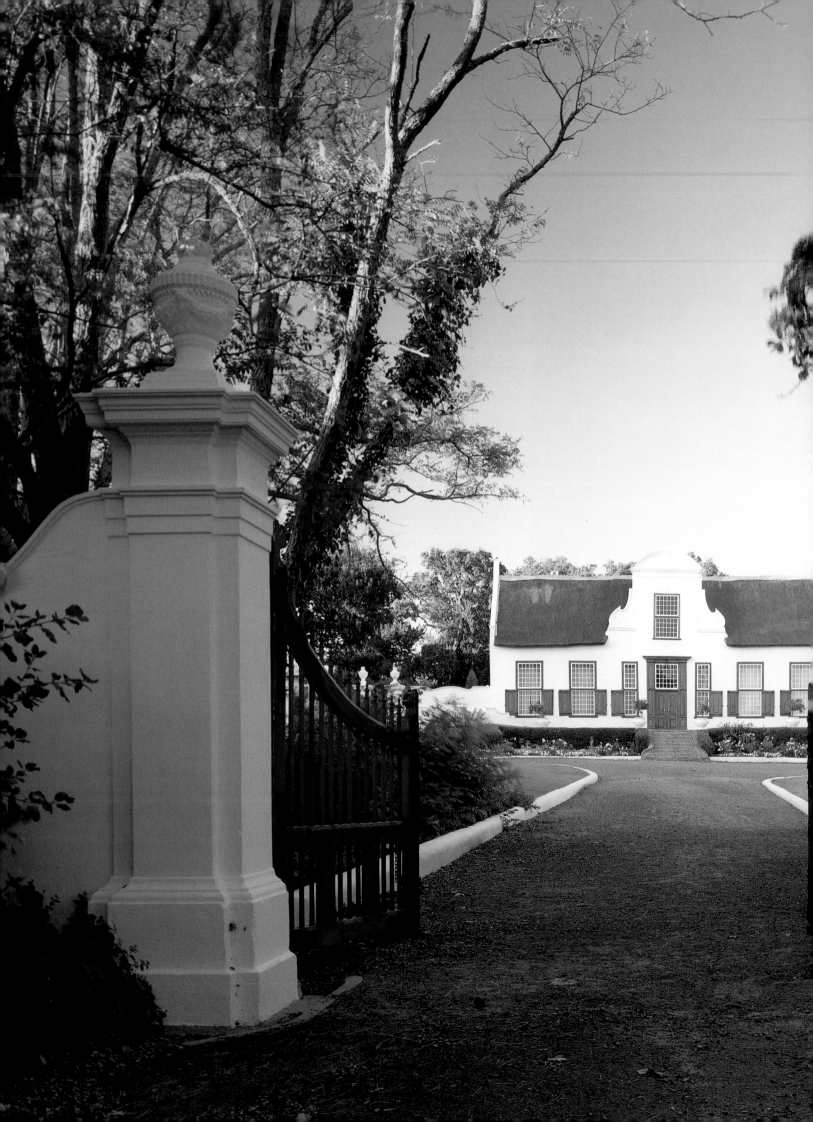

STELLENBERG

KENILWORTH, CAPE TOWN

ABOVE. Lady Anne Barnard's sketch of Louis Michel Thibault, the French architect responsible for some of the finest Cape architecture at the end of the eighteenth century. The embellishments at Stellenberg are believed to be his.

PREVIOUS PAGE. Front façade seen from the screen at the top of the avenue. The beautifully proportioned Vingbooms-type gable was a copy of the one at old Newlands, as was that at Groot Constantia. The piers and urns, repeated in the side courts and *werf*, and the low relief detailing on the gable are attributed to the Thibault-Anreith-Schutte trio. This is Cape eighteenth-century architecture at its finest.

RIGHT. Courtyard between the back wings of the U-shaped manor house. The Thibault urns again repeated. The barley-stick chimney, Gothic vents and venetians are all well-mannered nineteenth-century additions.

BELOW. Eighteenth-century garden seat with stucco ornamentation. It originally terminated a long alley.

At the end of the eighteenth century Stellenberg was as splendid a Cape manor house as you could wish to find and certainly one of the most important and imposing in the Cape Peninsula. It was the house of Mynheer Rhenius, the *Secunde* of the recently collapsed Dutch regime, and during the Interregnum which separated the First and Second British Occupations it was for a time the residence of De Mist, the Commissioner General of the Batavian Republic.

The manor stood below Wynberg Hill at the centre of five great avenues of oaks converging on the front door, like the spokes of an immense wheel.[1] In the best late seventeenth-century tradition (the Cape remaining innocent of the vogue for landscaping until the arrival of the British) its main approach was between gates on the Wynberg road and up the central axis – what is now Stellenberg Avenue – through the screen, with its piers, urns and wooden railings, straight to the wide front steps. The piers and urns were repeated, demarcating courts to the left and the right of the house, and the garden itself was formally divided with alleys, the vistas terminating in rustic benches charmingly decorated with stucco ornamentation. The front façade boasted an elegant segmental-topped gable with its pediment filled in low relief. Passing up the stairs and beneath this, the visitor entered the *voorkamer* through the double front door with its handsomely carved panelled pilaster surround. A four-leaved, half-glazed screen separated the paved *voorkamer* from the *gaandereij* and at the back of this half-glazed double doors led out to a courtyard (between the two back wings) enclosed by piers and railings matching those in front. Behind the courtyard the farm buildings enclosed the *werf* and this finally terminated the half-mile axis.

Almost all this remains, an accomplishment truly remarkable, for the surburban sprawl of Cape Town has long since engulfed the area.

The gables, the piers, urns and railings, the tall sash windows, and the neo-classical murals that lie buried beneath the layers of paint of the intervening years are all vestiges of late eighteenth-century Cape elegance and were almost certainly all added by Rhenius. By this time there had been a house on Stellenberg for at least fifty years and a dwelling of sorts since the close of the seventeenth century when the original land grant was made.

As in the case of many an important Cape house, the shadow of the Van der Stels falls heavily over the early days of the estate. In fact, the original grant was made by the Governor, Simon van der Stel, to Jacobus Vogel.[2] It comprised fifty-seven morgen 547 square roods lying '*onder der Wynberg*'. The title deed ensured the right of way along the wagon track and the use of a drift but otherwise contained the usual conditions of the time. A tenth of the harvest was payable to the Company; trees cut down were to be replaced by young oaks and the land had to be cultivated within three years at the risk of forfeit. Vogel signed it but clearly had no intention of complying with the conditions at all, for only five months later he had transferred the land to Frans van der Stel[3] – son of Simon and brother of Willem Adriaan – and since direct grants from the Governor to a member of his family were

prohibited by the Company, it may be safely assumed that Vogel had been acting as a stalking horse for it. The name Stellenberg (spelt 'Stellenburgh') actually appears as an insertion on Vogel's title deed and this is suspicious enough. Far more damning was the testimony given by Vogel some years later, after the scandal and subsequent dismissal of the brothers Van der Stel, in which he stated that, with the connivance of Governor Simon, he had performed a not dissimilar role in the transfer of Oude Wijnberg to the dreaded Frans who, at the end of the day, seems to have acquired that neighbouring property almost free.[4]

There is no evidence that Frans lived at Stellenberg – his main farm was Parel Vallei – but there was a dwelling on it, possibly built for the *knecht*. It is said that this burned down in 1710.[5] Frans van der Stel was thoroughly disliked. Like his brother he suffered not a little from *folie de grandeur* – the French referred to him as Don Francisco and even in Company records he appears as Jonker François.[6] Sixteen months before his departure from the Cape – disgraced and dishonoured – he had married Johanna Wessels. Poor little Juffrouw Wessels! The dreams she must have entertained of so advantageous a marriage ended in a rude awakening indeed. The couple seem to have separated in acrimony – Johanna lists herself in the register as widow even before her erstwhile husband's death and he in turn cut her out of his will, leaving their only daughter – his chief beneficiary – to the care of others.[7]

Johanna had remained behind at the Cape ostensibly to dispose of her husband's properties as best she might. She seems to have been somewhat tardy in this regard – to what end we can but speculate – and Stellenberg was finally sold in 1717,[8] a year before Frans's demise.

In some ways the new owner was every bit as interesting as the last. Not only was she also a woman but a freed slave at that. Christina van Canary had been one of Simon van der Stel's slaves, and was granted her freedom by her master in his declining years. Simon's mother was of course a slave, although it is unnecessary to ascribe to this gesture some deep-seated psychological motivation. Many a Cape will of the eighteenth century granted freedom to favourite slaves, while it was not uncommon for a burgher wishing to marry the slave woman with whom he slept to buy her freedom (or replace her in the slave lodge) in order to do so. At the time of acquisition Christina paid 1 300 guldens for the property so whatever her occupation – and given the society in which she lived, it was almost inevitably a form of prostitution – she must have been successful at it. Possessed of landed property, she became respectable and married another freed slave, Jan Hendriks, who was *Kaptein* of the Black Militia or *vrije swartens*. Their ownership of an important Cape farm was unusual but not unheard of – Jonkershoek, Nektar and Klein Gustrouw were all farmed by freed slaves at one time or another. The Hendrikses had one child who died young.

Christina predeceased her husband who, in 1730, sold the land – reduced by half through a deduction to Weltevriend – to Jacob Marik.[9] Though respectably

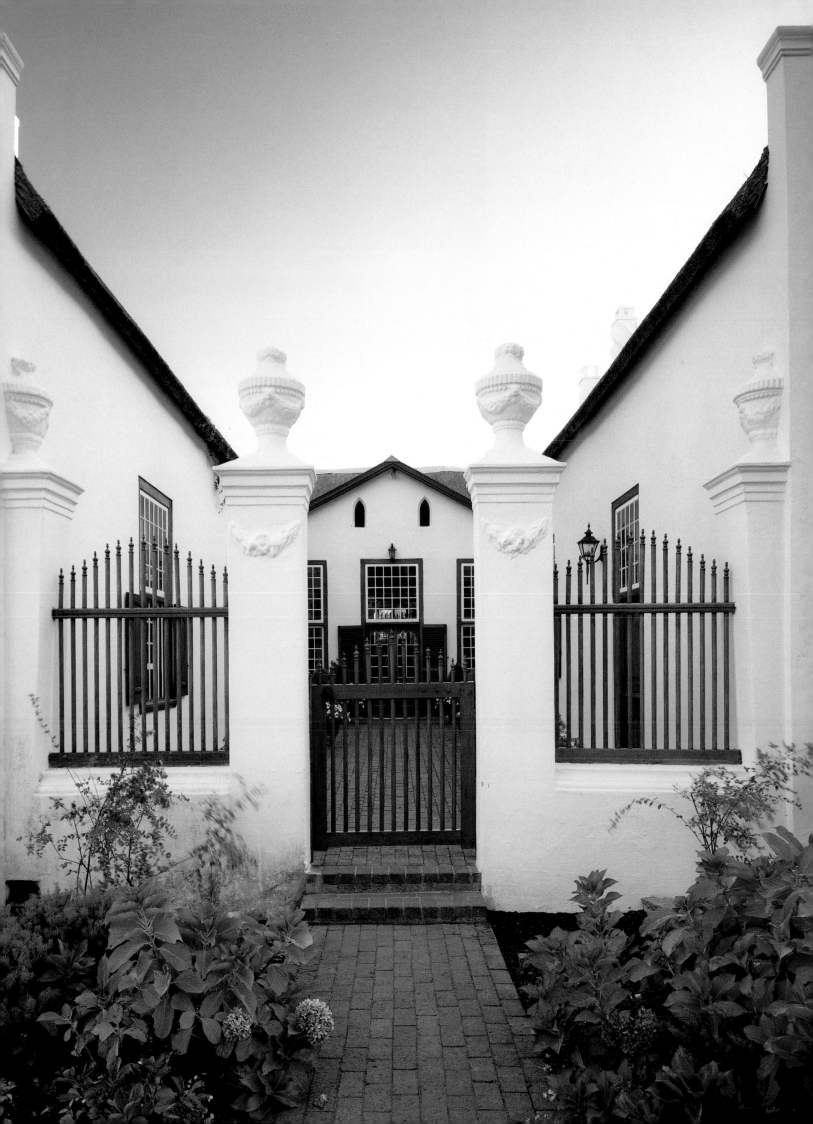

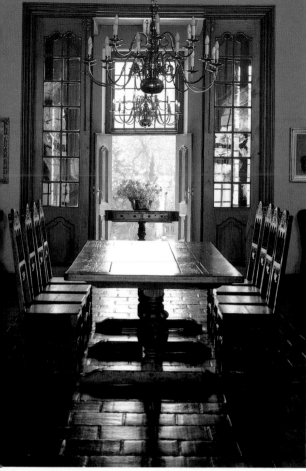

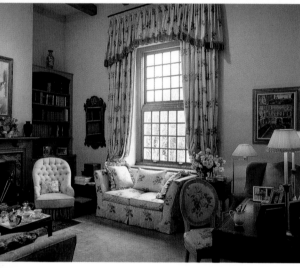

TOP. *Gaandereij* looking from the back courtyard through the original glazed *porte de viste* and out down the avenue. The oak refectory table is seventeenth century.

ABOVE. Library. In keeping with the current vogue, the Cape Dutch interior here decorated up in the Colefax manner.

RIGHT. *Voorkamer* showing the original Batavian tile pavement and the handsome *porte de viste* with its elongated bolts. The stinkwood and yellowwood cupboard on a stand is Cape, as are the two Cape Louis chairs, part of a set of forty-eight which once stood in the old Tuynhuis.

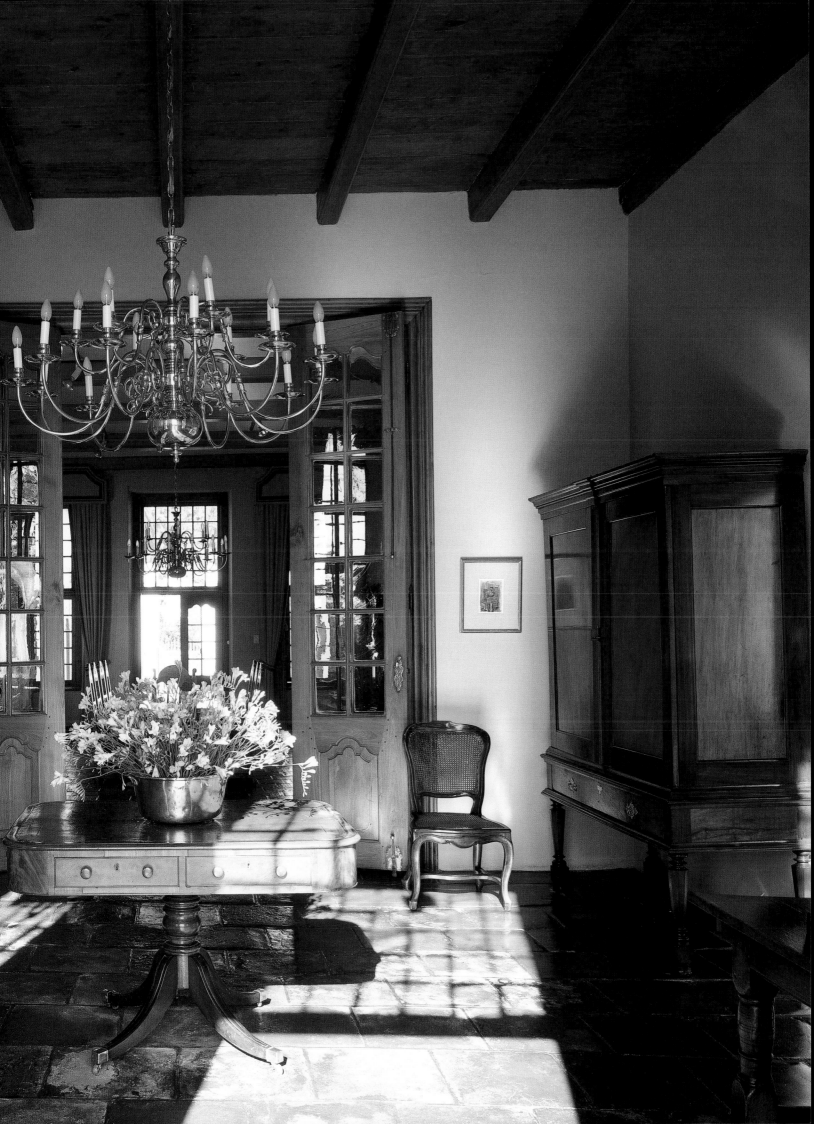

TOP. Mynheer Rhenius, the *Secunde* at the time of the collapse of the Dutch East India Company rule. (Cape Archives)

CENTRE. Miss de Mist (*en vogue turque*) around the time when she stayed at Stellenberg acting as her father's hostess. (Cape Archives)

BOTTOM. Jacob Abraham de Mist, Commissioner General at the Cape during the Interregnum. (Cape Archives)

RIGHT. Breakfast room. The double doors placed beneath the Dutch sash give easy access to the garden (now 'the white garden') outside, in which can be seen a Cape Regency bench. The marbling and the dado with the *trompe-l'oeil* chair rail and frieze devised from the design of the 1830s chintz are decorative touches borrowed from Cape interiors of the first three decades of the nineteenth century.

married, Marik enjoyed a scandalous relationship with another slave girl, Anna van Bengal whom he shared, it is regrettable to note, with his neighbours Hans Kasper Geringer and Christiaan Bok, joint owners of Veldhausen. Marik owned Stellenberg for two years before selling it to another Van der Stel connection, Harman van Mario, sometime overseer at Groot Constantia.[10]

Ten years later Van Mario died in possession of Stellenberg and his widow sold it to Jan de Wit.[11] Like many an early immigrant to the Cape, De Wit had buried his family name in a Dutch equivalent. He was in fact a Mr White from Stanton White in Norfolk, one of the first Englishmen to settle at the Cape.[12] John White or Jan de Wit had prospered nicely. He owned a large, well-furnished townhouse in Strand Street, just a little above Koopmans de Wet and on the opposite side of the thoroughfare. Following his death his son, Petrus, inherited five farms in addition to Stellenberg.

Petrus had started his career with the Dutch East India Company in Holland where he had been sent at the age of sixteen. He returned to the Cape in 1741 and, the groundwork for a fortune having been laid by the first generation, he proceeded to secure it in his. In 1761 he received permission from the Company to export aloe juice from the Cape and became the first person to do so. He shipped about ninety kilograms annually and for years encountered almost no competition. By 1779 he was a partner in Cruywagen & Company, one of the several big firms which, to the chagrin of the general populace, virtually monopolized trade with ships using the anchorage in Table Bay. Any bad feeling aroused by the Burgher Petition of 1779 against this was happily mitigated by conspicuous evidence of a strong sense of public duty and civic pride. There is a long list[13] of councils and commissions on which he sat and at his death it was said of him that he enjoyed the confidence of both the burghers and the authorities.

As one of the few rich families with English connections, the De Wits were famous for their hospitality towards the officers and distinguished passengers aboard the passing British fleets, receiving, rather like the Logans over a century later,* all sorts of notables whom in metropolitan circumstances they would be unlikely to encounter. It is unlikely, however, that such personages were entertained at Stellenberg. Jan de Wit's inventory[14] describes what in all probability is the basis of the present U-shaped house: a *voorhuys* with a room on either side, a *gaandereij*, a *gaandereij kamer*, a *botterije* (sic) and *combuys*. There is a *solder,* a *werf* with a *pakhuys* and a *stookhuys*. But the house itself is not at all elaborately furnished – positively drab, in fact, by comparison with the swish-sounding affair in Strand Street, and something of a dumping-ground it would seem for discarded furnishings. The red striped *ophaalgordyne* in the room to the right are actually listed as old and those in the room opposite were in a similar state. Both rooms do contain a four-poster and the De Wits would doubtless have visited Stellenberg, though Jan's renaming it 'Onrus' does not immediately call

* See Tweedside Lodge.

to mind the oak-shaded *villégiature* that one might otherwise be tempted to imagine them spending the summer in.

In Petrus's day things seem to have been jollied up a bit.[15] The room to the right received six Chinese chairs, those already in the one opposite got chintz cushions. The *gaandereij* was provided with a copper lantern and six etchings – some paintings had also been hung in the front left room – but much is still described as old and little sounds of good quality. There is no silver, for instance, compared to the pages and pages of it listed for Strand Street. The farm itself, however, reflects the improving fortunes of its owners. There are twenty-two slaves as opposed to ten in Jan's day and the cellar is full of vats and beerpipes. There are 275 sheep, twenty-four trek-oxen and five horses.

There is, alas, no more evidence to suggest that the Van Cahmans, who bought Stellenberg from Petrus's widow, lived on a more permanent basis on the estate. Some improvements may have been made – the interior glazed screen could well date from the 1780s for both Van Cahman and his twice-widowed wife were very rich indeed. The couple were childless and, her husband having predeceased her, Mrs van Cahman's will liquidated her assets (excepting her jewellery) and left substantial legacies to her favourite step-children, nieces and nephews.[16]

In 1795, Stellenberg (Petrus de Wit had restored its original name) was bought by Johan Isak Rhenius. He was a third generation South African, son of the first Landdrost of Swellendam and grandson of Johannes Tobias, the explorer. Rhenius had been appointed *Secunde* in 1786 and after the recall of Van de Graaff in 1791 had actually acted as Governor of the Cape for thirteen months. Neither appointment seems to have been based on any particular merit. The two Commissioners sent out by the Dutch East India Company in a last-minute attempt to stave off financial collapse were not much impressed by his abilities[17] and, swayed not at all by his frequent hospitality, bypassed him in favour of Sluysken.

Rhenius stayed on as *Secunde* until the British Occupation in 1795. He immediately offered his services to the new regime and in October his accommodating attitude was rewarded with the post of Receiver General and Treasurer; he was also reappointed to the post of *Commisaris Politiek*. Two months later he purchased Stellenberg. At the best of times both the posts were unpopular – the latter actually entailed attending church meetings to ensure that the clergy did not exceed their powers – but under an occupation force Rhenius's duties must really have rankled. It is not surprising that when the British left the Cape in 1803, Rhenius left too. Stellenberg was sold to Mynhard van Schoor and for three months it was the residence of General de Mist, Commissioner General of the Batavian Republic, and his daughter, Julia, who accompanied her father to the Cape and acted as his hostess.

The alterations at Stellenberg, which left the house substantially in the form we find today, were executed at the behest of either Rhenius or Van Schoor, circumstantial evidence coming down fairly heavily

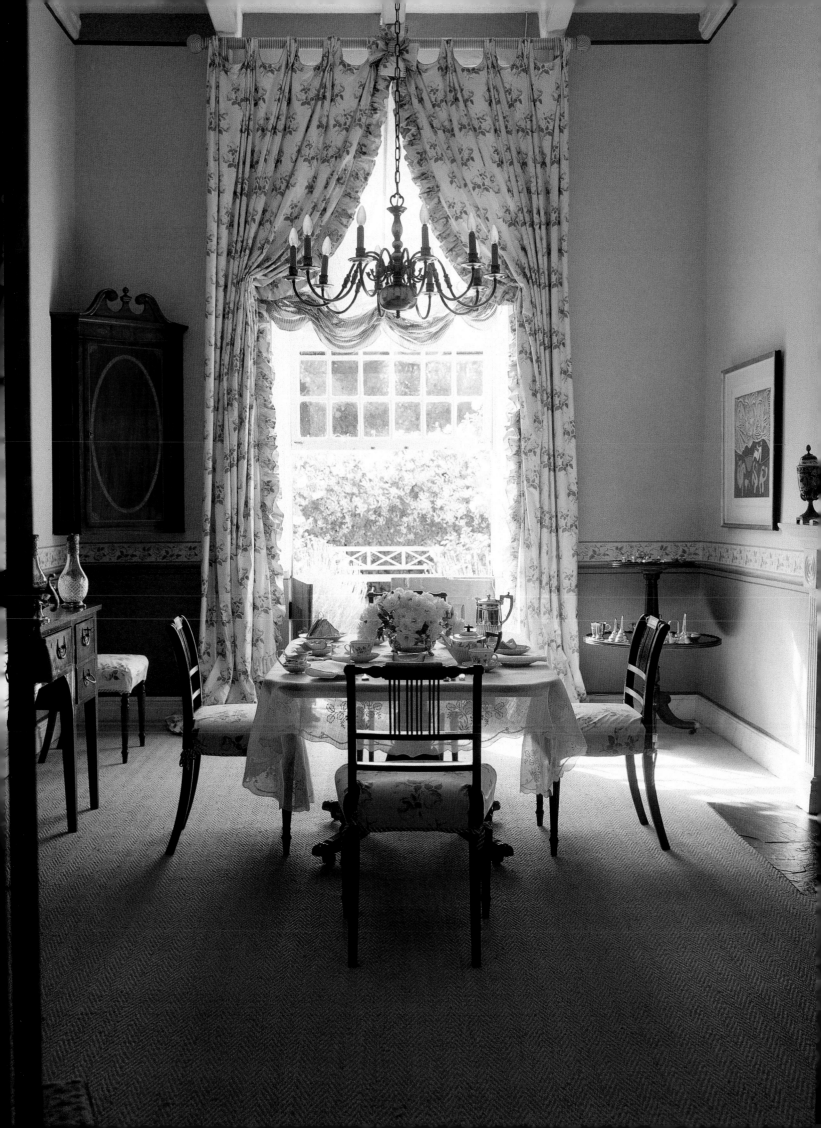

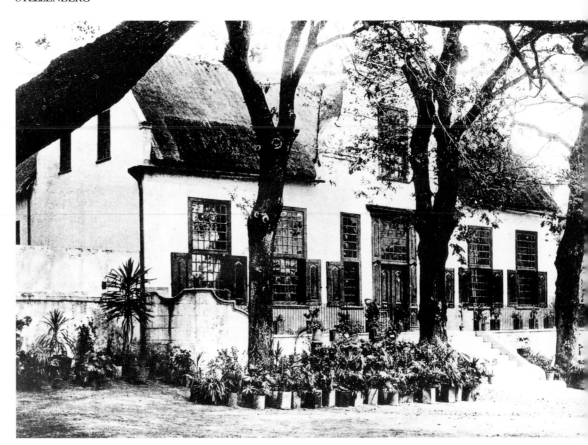

RIGHT. Victorian Stellenberg. Miraculously unscathed and with the woodwork apparently never painted. The pretty Regency iron railings create a balcony out of the stoep, the painted dado and the mass of pot plants in paraffin tins provide typical period details. 'An old Dutch dwelling' notes a brisk and unimpressed colonial script.

BELOW. The house from the *werf*. The U-plan is easily detectable. Lower Stellenberg, the house on the left, has the Cape Regency doors and windows typical of Wynberg village in the early days of the British Garrison camp there. The great oak tree is one of the last of those planted two hundred years ago that survive. Their demise here and elsewhere is one of the great losses to the Cape Peninsula in the present generation.

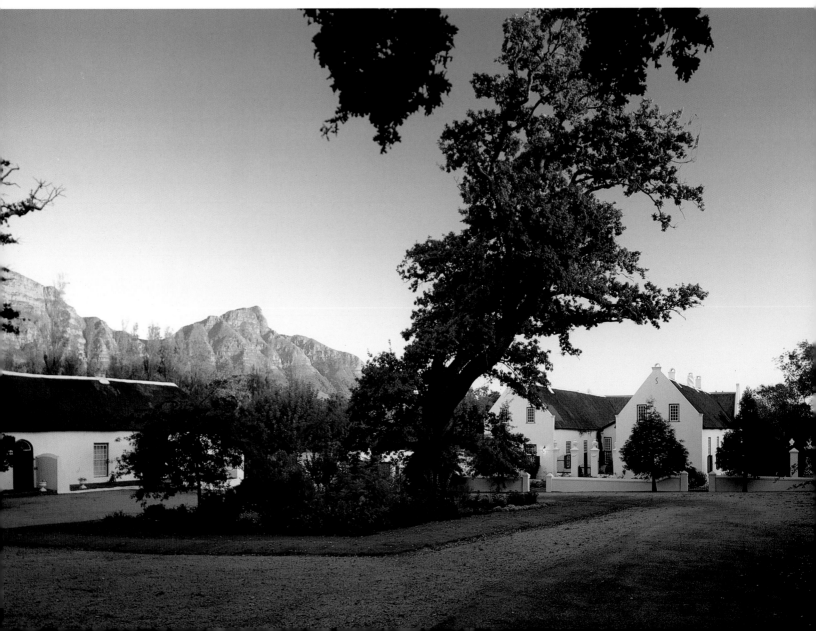

on the side of Rhenius. He was rich – probably very rich – after nine years as *Secunde*, for in the last days of the Company rule official corruption reached a perfectly disgraceful level.[18] The governorship which to his disappointment had eluded him had also deprived him of Newlands, the official summer residence and then the most elegant country seat in the environs of Cape Town. Its loss would have saddened all but the most puritanical of officials. To add salt to this wound he had actually been obliged to execute its sale on behalf of the government and already another rich Peninsula landowner, Hendrik Cloete, had sought to emulate it by copying its beautiful and very modern gable as the finishing touch to his elaborate improvements at Groot Constantia.[19] It seems perfectly reasonable to suppose that Rhenius decided to do exactly the same at Stellenberg.

The work at Groot Constantia is invariably attributed to the Thibault-Anreith-Schutte trio and in seeking Thibault's hand in the additions at Stellenberg (the urns are almost as good as his signature, the low relief in the pediment perhaps less easily ascribed to Anreith alone) it is worth noting that Mme Thibault was Mrs Rhenius's first cousin through the Cruywagen connection. This last, of course, would not clinch anything, for Mynhard van Schoor was Mme Thibault's brother and therefore the architect's 'very dear brother-in-law'[20] until the two had a nasty fall-out over the surveying and rebuilding of the old wagon road (now the Main Road) that passed below the house.

The Newlands gable seems to have pre-dated Thibault's work at the Cape and, given his strong classical training and inclination, would not immediately suggest his style. There is, however, no reason to suppose that Thibault was above copying its very pleasing design if it made his clients happy. For while the newly popular classicism was easily accommodated at the Cape in the double-storeyed townhouses where parapets could suddenly sprout pediments and urns, in the rural areas the single-storeyed manor houses with their central gables posed something of a problem. The Newlands gable belongs to the 1780s, a period of transition to classicism in Cape architecture. In seeking an alternative to the florid wavy curves of the Stellenbosch gables of this vintage* the unknown architect appears to have sought his inspiration in Dutch classicism of the seventeenth century where architects such as Vingbooms had developed a gable type with a high central section under a segmented or pedimented top, flanked by two lower sections with scrolled wings.[21] These in turn, let it be remembered, were derived from the early baroque churches in Italy – all in all a singular colonial stylistic development from the so-called rococo gables that preceded them! The Vingbooms-type gable appeared beyond the Peninsula at Schoongezicht, near Stellenbosch, and in a very rustic version over the coach-house at Kersefontein. That at Stellenberg is the most perfectly proportioned example.

The remaining history of Stellenberg is remarkable in that the house was little tampered with by the Victorians due to the efforts of the Feltham family who owned it for several generations. The Felthams were a well-known and well-liked family in the Peninsula – kind, courteous and generous – the sort of people, in short, who nothing common ever did or mean. They evidently lived very well at Stellenberg. Years later their young under-parlour maid,** by then a senior servant at the Deanery, from time to time was heard to comment (with a sniff) on comparable household arrangements: 'There's no gentry left today!'[22] Nineteenth-century photographs show the gable shaded by two oaks, the stoep with a pretty Regency iron railing, a painted dado (still to be seen in Gwelo Goodman's oil commissioned by Lady Phillips in the 1920s) and a mass of pot plants.

In 1931 the estate was bought by Professor C F M Saint, first Professor of Surgery at the new medical school at Groote Schuur, and some restoration was undertaken by him. In 1953 the house changed hands again. Its new young owners, Jeck and Renée Ovenstone, had used a legacy of £30 000 to buy it and announced their decision as the family party boarded the Union Castle liner, packed with South Africans bound for London and the Coronation summer of 1953. Old Andrew Ovenstone exploded and refused to allow them on board. 'Thirty thousand pounds for a Mud Hut!' The Cape with its strong philistine streak happily took up the cry. 'Thirty thousand pounds!' they exclaimed over their gins and tonics, their planters' peanuts and their brandies and sodas; 'Thirty thousand pounds!' they exclaimed over the baize-covered bridge tables, the Stuttafords tea tables and the Stewards' lunch tables at Kenilworth; 'Thirty thousand pounds!' they exclaimed as they foxtrotted around the ballroom at Kelvin Grove; 'Thirty thousand pounds for a Mud Hut – can you beat it?'

Needless to say, history has long since vindicated the purchase and both Jeck Ovenstone and his son Andrew have done much to preserve and enhance what remains one of the finest houses of the Cape.

* Such as Ida's Valley and Morgenster.

** Jesse Norton. Almost all the upper-middle class and local gentry at the Cape were attended by white staff in those days. This was to die out in the 1920s and '30s, though it is interesting to note that there was still a white member of staff at the Deanery up to the Second World War.

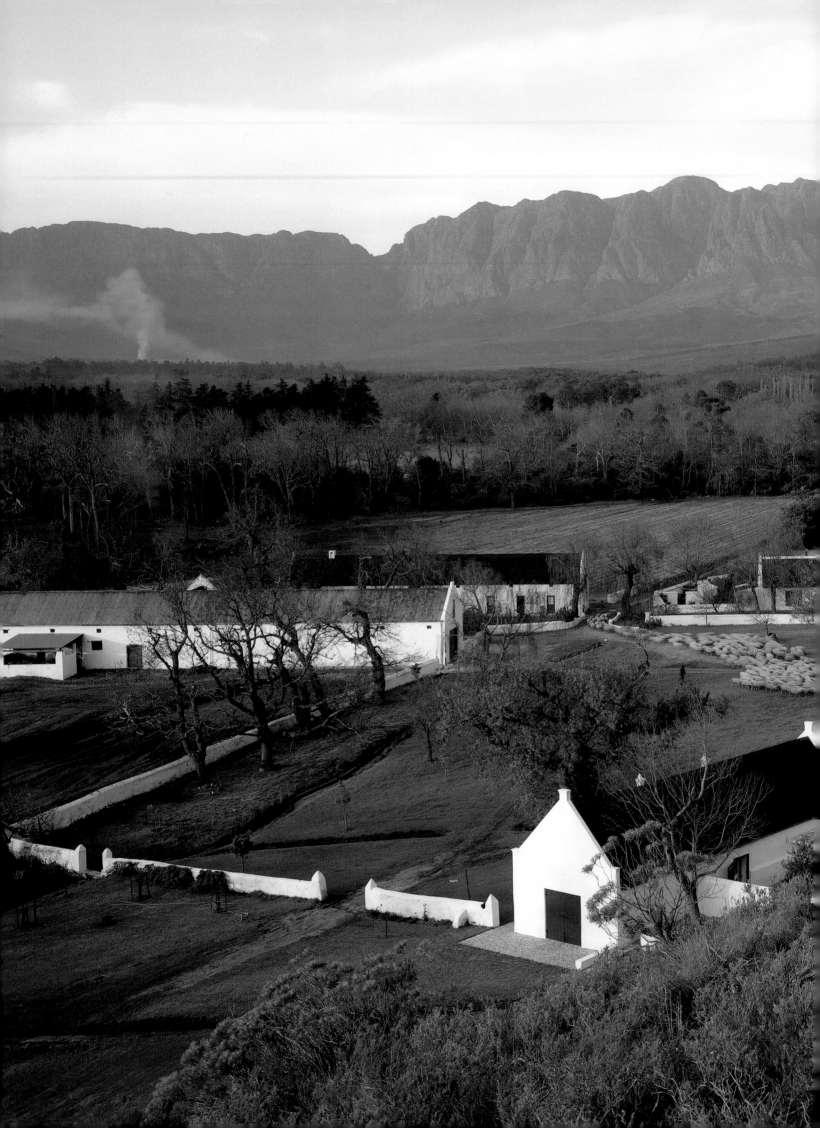

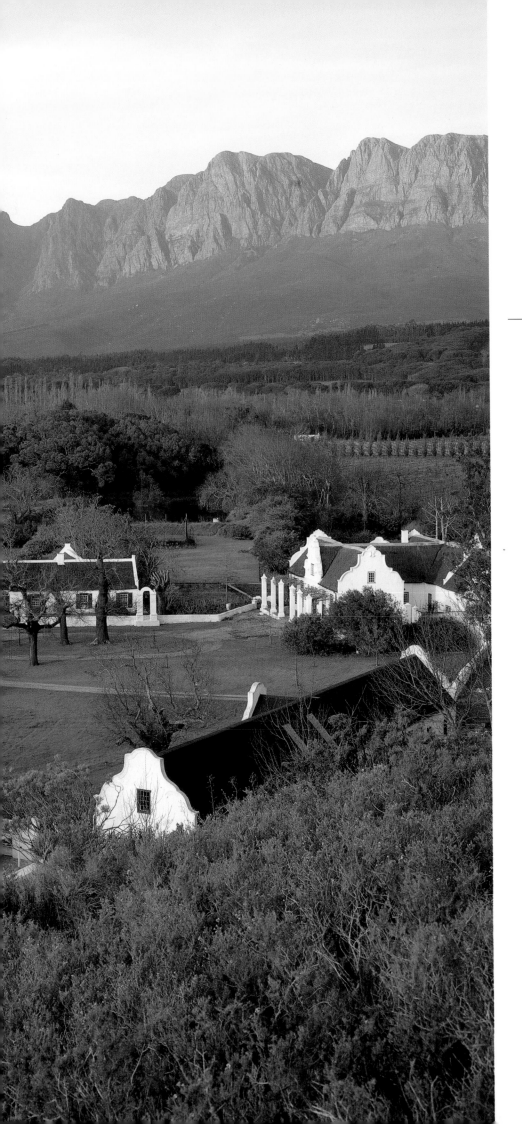

MORGENSTER

(MORNING STAR) SOMERSET WEST

PREVIOUS PAGE. The *werf* at Morgenster containing no less than seven different styles of gable. Much of the surrounding wall is original. The Hottentots Holland mountains rise behind.

ABOVE. Mrs Alexander van der Byl (*née* Morkel).

BELOW. Wine cellar with exterior loft steps.

The disgrace and banishment of the two brothers Van der Stel – Willem Adriaan, the Governor, and François (known as Frans) – had released that family's stranglehold on the best and largest area of the Hottentots Holland, generally regarded as the most fertile farming district of the Cape. On 31 October 1709, in accordance with the decision of the Directors of the Dutch East India Company, Vergelegen, Willem Adriaan's adored estate, was put up for auction in four lots.[1] The Cape was revelling in the first of many orgies of approbation directed at those seen to try harder and fall and, so rancorous was the prevailing mood, that it was widely insinuated that the lands were vast – 'stretching towards Natal' was how Kolbe put it – and there was much similar nonsense bandied about. In fact it totalled 613 morgen, a sizeable chunk but hardly the princely domain suggested.

Divided in four, there was therefore little danger of further accusations of ostentation which the Directors were so anxious to avoid. The second portion – 171 morgen and 765 square roods situated to the south of the Lourens River – was bought by Jacques Malan.[2] There was no farmhouse on it, but the land was good and it did at least contain fifteen of the sixty-one morgen of Van der Stel's vineyard.

Malan was one of a band of French Huguenot refugees who, following an already well-trodden route, had poured into the Free Netherlands following the Revocation of the Edict of Nantes in October 1685. Faced with this minor invasion, the Directors of the Dutch East India Company, whose efforts to persuade Dutch colonists to emigrate to the Cape had hitherto proved painfully unsuccessful owing to the healthy demand for labour in the prosperous motherland, had at once seen their chance. Putting their best foot forward, they had offered the refugees the same conditions dangled in front of their compatriots – free passage, farms, supplies and stocks at cost price and on credit and so on. An oath of allegiance was required but as a sweetener (and one not to be underestimated, considering the cause of the Huguenots' recent miseries and flight), a clergyman speaking the French language was to be engaged for them.[3]

Malan arrived in the Cape in 1688 and seems to have settled down and prospered nicely. He was the owner of La Motte in the Franschhoek valley by 1694 and five years later married Elizabeth le Long. They had three children. In 1711, over twenty years after his arrival at the Cape, he bought Morgenster for 3 300 gulden. Fourteen years later, in 1725, he made the farm over to his only surviving son, Daniel.[4] The young man had just come of age and had recently married Maria Verdeau, the widow of Pieter Jordaan. Pama, the authoritative genealogist of the old Cape families, describes her rather wildly as his aunt, but this is hardly fair. Maria's husband was the brother of Daniel's mother's first husband, all of which goes to prove very nicely the theory that the Huguenots at the Cape stuck close together for at least one generation. In fact, the Malans and the Jordaans had travelled in the same party and thus may easily have been friends in France. If not, their terrible seven-month voyage to the Cape in the *Berg China* would certainly have fostered a close acquaintance.

The widow bore Daniel Malan nine children before her death in the late 1740s. Daniel, who had by then risen to become a respected member of the community – *lid van die Kerkraad*, *Heemraad* of Stellenbosch, and so on – remarried in December 1750. His new wife, Emmarentia Steyn, who had also buried a spouse, proceeded to give him four more children – Jacobus, the first-born, and three girls. One suspects that Emmarentia had a strong influence over her ageing husband for it was her son who inherited according to Daniel's will of 1770[5] and possibly to the chagrin of the others, for it is interesting to note that the actual transfer of title deed was handled by a Court of Justice and the executors of the will.

It is possible that old Jacques Malan had built a house on 'De Morgenster'* after he sold La Motte in 1719. Certainly his son, who had thirteen children to bring up, did. The inventory of the deceased estate of Daniel Malan describes what appears to be a basically H-shaped house well furnished by the standards of the day.[6] There was a '*voorhuys*' flanked by two rooms, a '*galderey*' (the long room extending to the back of the house), a '*vuurkamer*' (sic), an '*agterkamer*', a kitchen full of copper, a pantry and a loft. There was also a '*klijne kamer*' – which seems to have been a sort of lean-to dormitory – and a schoolroom, possibly detached. Considering the size of the family, these two rather unusual additions to the typical eighteenth-century Cape farmhouse are not to be wondered at and the whole place was crammed with beds – two in the front right-hand room, three and a *kadel* in the one opposite, two in the *agterkamer*, two and two *kadels* and a crib in the *klijne kamer* and two and a *kadel* in the schoolroom. Daniel had built up a flourishing farm. At his death, in addition to a wine cellar holding lots of wine, the *werf* boasted a barn containing one hundred and seventy *muids* of wheat (and four more *kadels*!), a wagon-shed and a packing-shed adjoining it, a well-equipped carpentry shop, smithy, stable and threshing floor.

In August 1772, two years after his inheritance, Jacobus Malan married Catherina Morkel, eldest surviving child of Willem Morkel of Onverwagt. They had only three children and the inventory following his untimely death in 1778, aged twenty-six, shows that the *klijne kamer* had been demolished and lists the schoolroom as a stableroom.[7] The house sounds a little more agreeable to the modern mind with fewer beds and a few more *ophaalgordyne*.

What other building projects had been set in motion by Jacobus must be left to conjecture. Perhaps he had decided to build a new outhouse directly below the hill next to the manor, perhaps he had only decided to add a gable to what already existed; what is certain is that he died before it was completed. His widow saw the work through, commemorated her husband in a charming gesture by placing his monogram on it in plaster relief and a year later remarried. Bride at eighteen, widowed at twenty-four, her haste in marrying Rudolph Loubscher need not be considered unseemly. The Malans owed money, doubtless

* Since the days of the Van der Byls it has quite commonly been known by the anglicized version, 'Morning Star'.

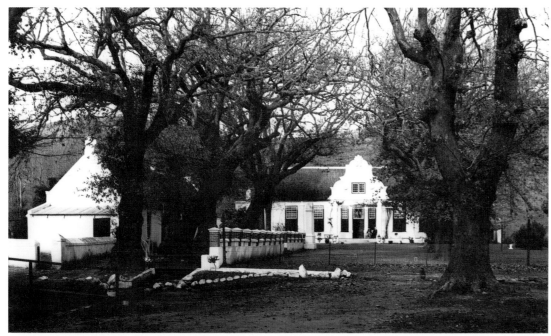

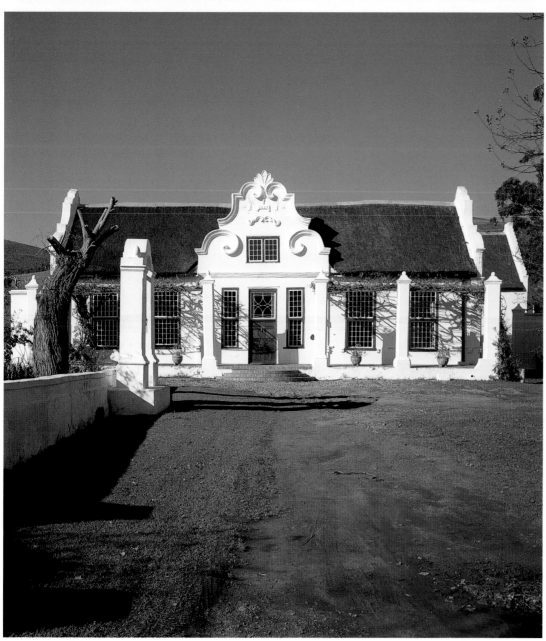

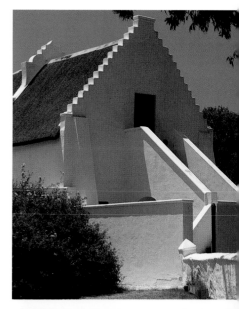

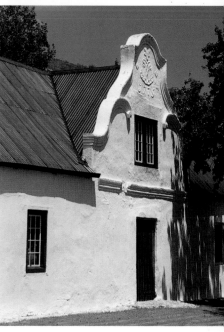

LEFT. Morgenster at the turn of the century. The stream's embankment wall has brick bollards and what is now the parking area was then the croquet lawn. (Cape Archives)

BELOW LEFT. The manor house with its elegantly florid *bolbol* front gable. Those at the side are more elaborate than most; that on the extreme right accommodates an early addition and is stepped. The slave bell and pergola are probably contemporary with the house; the front door and pretty fanlight are Regency embellishments.

BELOW. The stepped gable of the kitchen addition with its exterior staircase giving access to the loft.

BOTTOM. The rustic gable over the outhouse is dated 1779 and contains the monogram of the then recently deceased owner, Jacobus Malan.

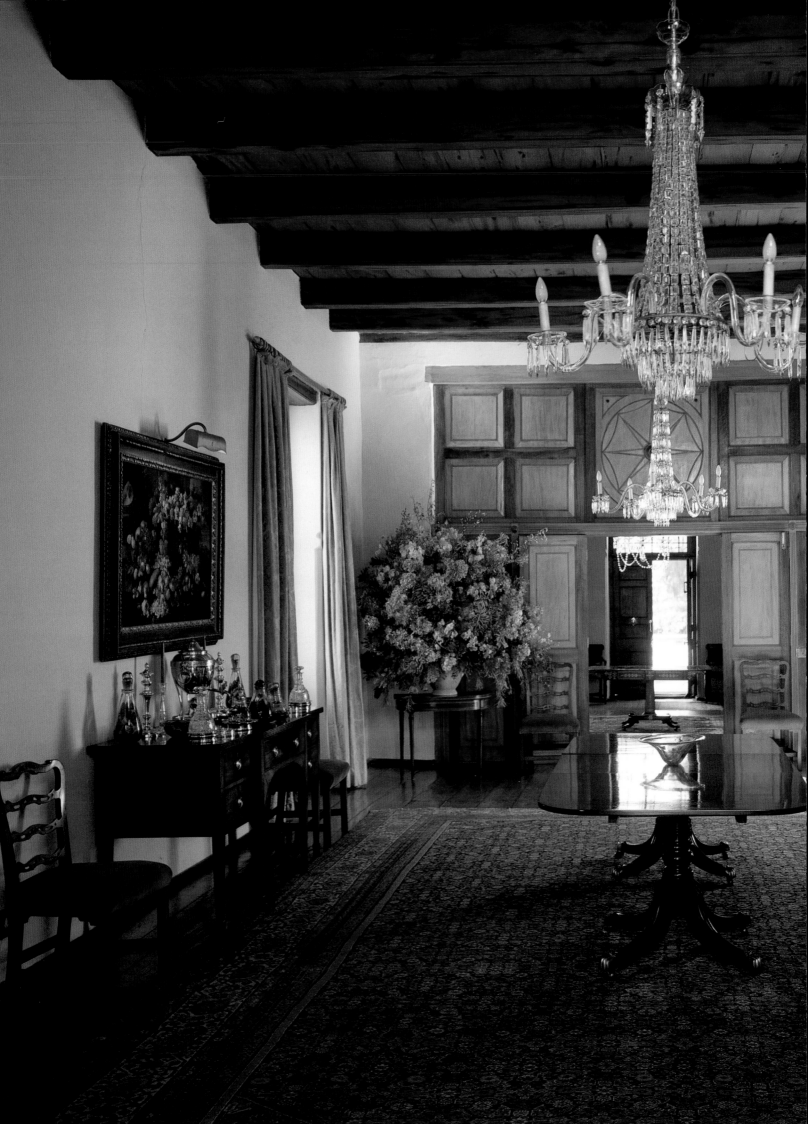

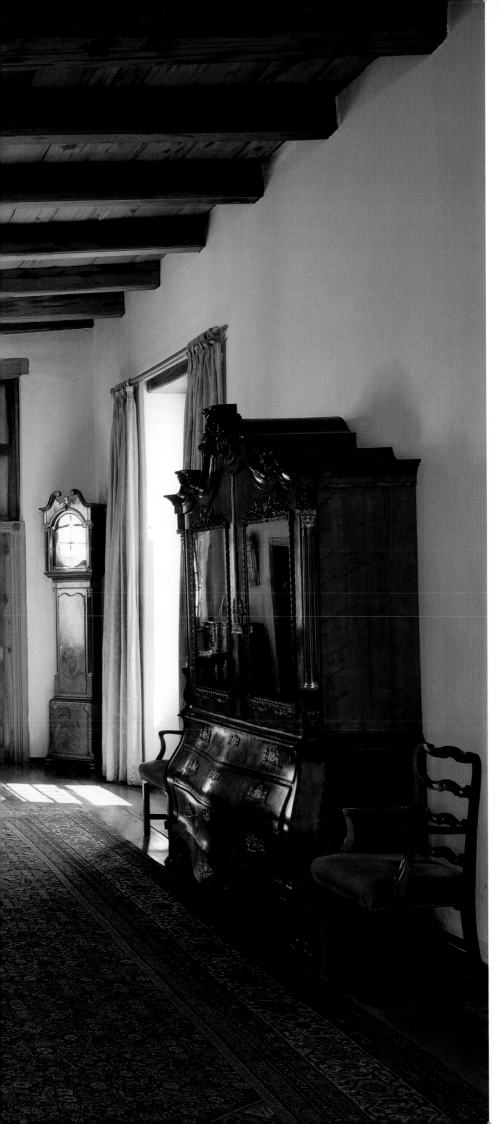

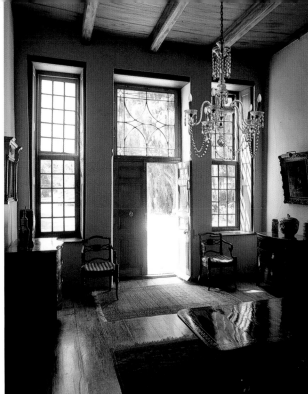

LEFT. The *gaandereij* looking towards the fine stinkwood and yellowwood screen whose design shows how Regency detailings were absorbed into the Cape vernacular. The armoire is Dutch and the chandeliers early nineteenth-century English.

TOP. *Voorkamer* with Regency furniture complementing the door and fanlight. At least two layers of murals lie beneath the paint.

ABOVE. The partially restored classical murals in the *voorkamer* showing the architectural entablatures painted *en grisaille*.

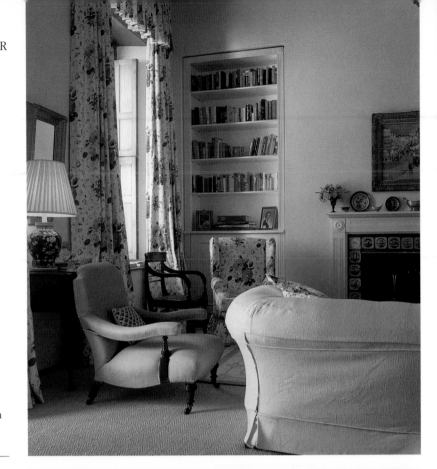

RIGHT. The library, formerly the kitchen.

BELOW. The back hall, which links the H-shaped manor house with the additions at the back. Their date is unknown, but they are already visible, in some state of decay, in Arthur Elliott's photographs at the turn of the century.

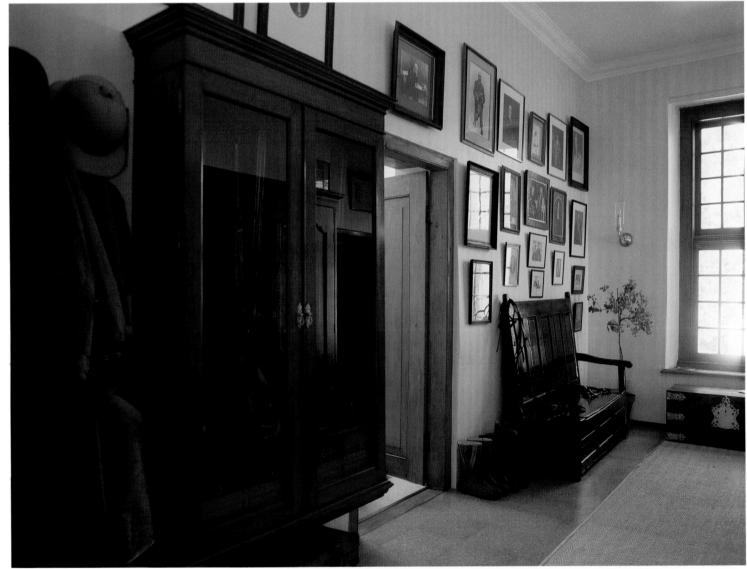

having had to pay in to old Daniel's estate and the widow with three young children could hardly have managed the farm on her own. Catherina was to outlive her second husband, but it was during their marriage that the house must have acquired its splendid gables for it would seem highly unlikely that the Loubschers would have demolished the large house they already possessed only to build another gabled one in its stead.

The manor at Morgenster was given six of the most beautiful gables to be found at the Cape. The *holbol* or concavo-convex style may here be seen at its most elegant, the convex mouldings of the edge continuing well onto the gable face and terminating in two tight scrolls. At the other end, the scrolls are separated at the cap by a scallop motif – similar to that at Ida's Valley* – and the face of the gable has further plaster decorations of small trees in pots, animals and a small *holbol* motif. The end gables are again most elegant – well proportioned and far more elaborate than most. One of those at the back peeps out from an extension, probably added within thirty years of the others and given a crow-stepped gable. It is reasonable conjecture that the Loubschers were likewise responsible for replacing the small casements of Daniel's day with the large sixty-pane sashes which still survive.

Loubscher died in 1795 and the following year his widow sold the farm to Albertus van der Poel.[8] Van der Poel may well have been trying his hand at a little land speculation for just three years later he sold the farm to Marthinus Neethling.[9] Eight years after that Neethling sold the house and seventy of the two hundred morgen he had purchased to Philip and Johanna Morkel.[10] Both husband and wife had sentimental attachments to the place. Philip was Catherina's younger brother and Johanna was the daughter of Hercules Adriaan, son of Daniel Malan – the 'burgher of Stellenbosch' who had acted as executor of the will which had given Morgenster to his half (and younger) brother, Jacobus, years before. Morgenster was therefore Johanna's father's childhood home and the farm of her grandfather and great-grandfather. It is reasonable to suppose that the pretty Regency fanlight and the handsome screen which separates the *voorkamer* and *gaandereij* were added by the new owners.

With the exception of eleven years, Morgenster had, therefore, been in Malan or Morkel hands for a century. It remained thus for another eighty, until 1885 when following the ravages of phylloxera it was bought from Daniel Morkel by his brother-in-law, Mr Alexander van der Byl.[11] He and his wife sold their successful stud at Caledon and lived happily at Morning Star for the rest of their days. After her husband's death Mrs van der Byl, whose beauty had long ago caused a minor sensation at Court, stayed on the estate in her widowhood – an elegant, white-haired old gentlewoman always dressed in black, her chatelaine clinking at her side. The house was filled with mahogany and there was a conservatory or palm house that has now completely vanished.[12] As the Van der Byls were childless, the farm went to their nephew, Major William Barnett of the Indian Army and after his death and that of his widow, to their daughter Zaidee, known to all as 'Babs'.[13] She continued to live in the cottage on the estate, but, short of funds and unable to cope, she let the farm run down and decay began to set in. Finally, in 1958, urged on by Syfrets, she was obliged to sell.

Morgenster's new owner, Mrs Leonard Hawkins, known to her friends as 'Dinkie', was neither short of funds nor unable to cope. She was the daughter of Sir Thomas Cullinan, whose Premier Mine had produced the famous diamond. As a dazzlingly beautiful young woman she had been a favoured dancing partner of the young Prince of Wales and Duke of Kent before the war. Her first husband, Mr Colin Bain Marais, had died while in London as Smuts's wartime Minister Extraordinary to the Allied Governments and she subsequently married Mr Leonard Hawkins and lived in England at Salhurst Park in Sussex. In the agreeable manner of many English of the day who had South African connections and who could afford to do so, they wintered every year in this country, travelling to and fro on the Union Castle Line.[14]

Mrs Hawkins was quick to perceive the possibilities in the decayed house and the surrounding outbuildings, some of which may have survived from Daniel Malan's day. She engaged the services of Bruce, Gibbons and Tomlin, a local firm of architects, and threw herself into the restoration with characteristic enthusiasm. After completing the very necessary structural alterations, the main rooms of the manor house were opened up, the back additions were tidied into bath and bedroom accommodation and the old kitchen was transformed into a study.[15] Fashions in restoration change like anything else, and it is interesting to compare that at Morgenster with that fifteen years later at Ida's Valley where a bunker was built to avoid retaining additions to the original structure, and where a similar transformation has retained the open range, loft stairs and copper pots so charming to contemporary eyes but which the previous generation would have been surprised to find in a library.

The work begun has been continued and enhanced by Mrs Hawkins's daughter, Mrs Shirley Bairnsfather Cloete, with the assistance of architect Revel Fox, and it is her son, Pieter, whose forebears produced the wines of Groot Constantia and Alphen, who now inherits this most beautiful of Cape manor houses.

* See Ida's Valley.

TOP. Mrs Leonard ('Dinkie') Hawkins, formerly Mrs Colin Bain Marais, *née* Cullinan.

ABOVE. Mrs Shirley Bairnsfather Cloete, *née* Bain Marais, by Robert Broadley.

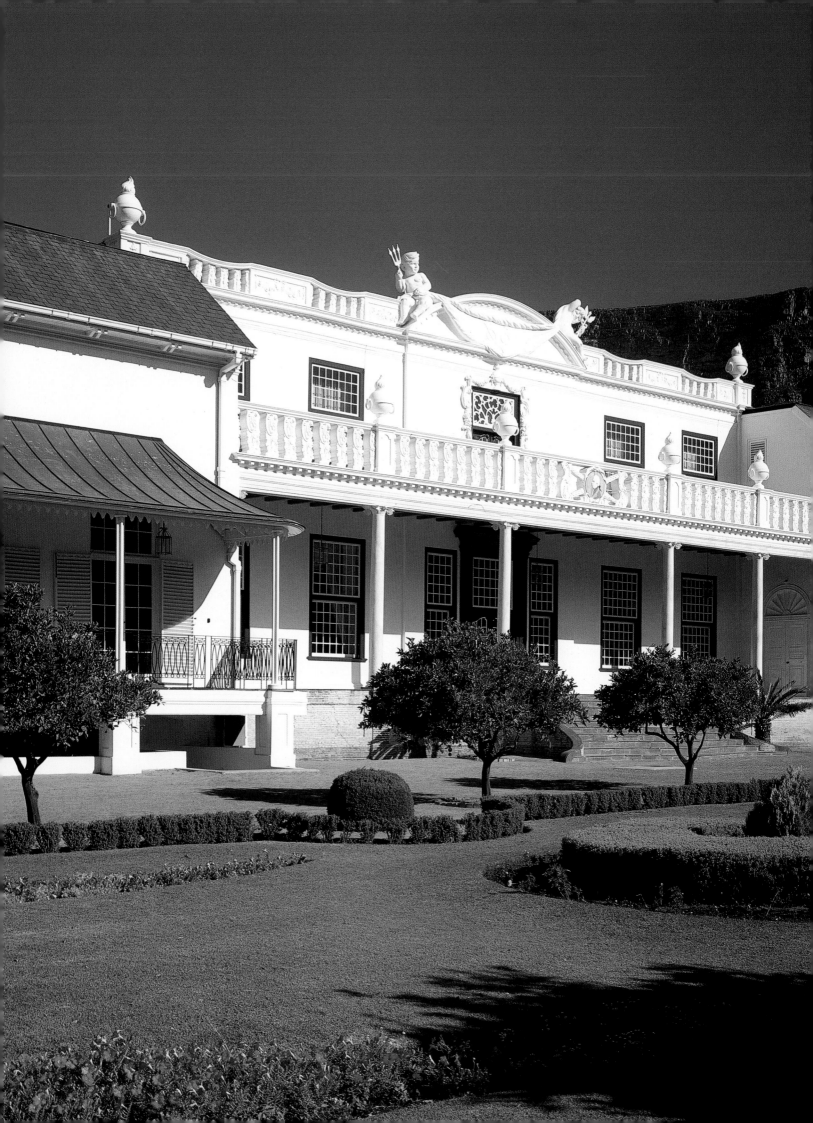

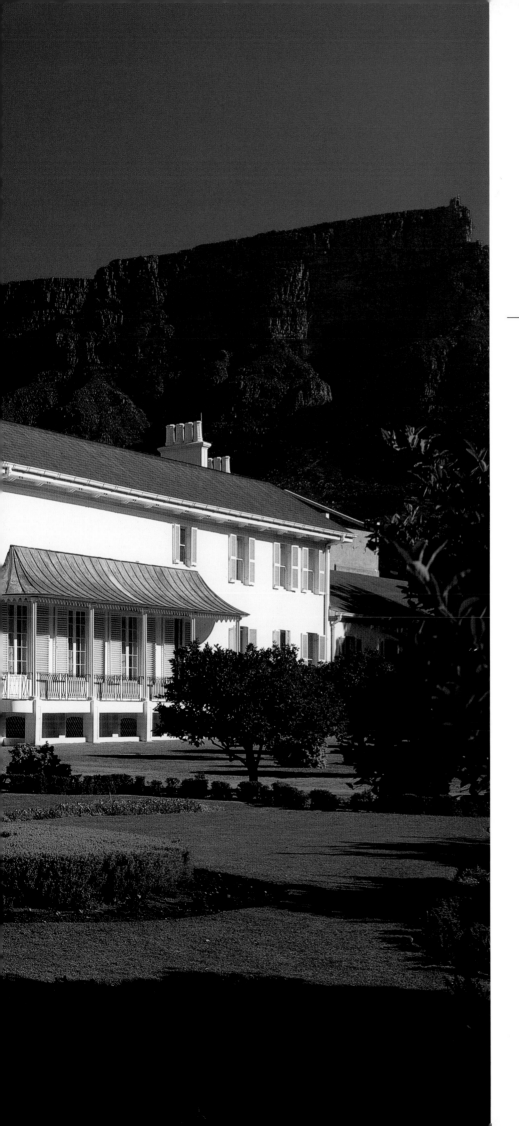

TUYNHUIS

SOMETIME GOVERNMENT HOUSE,
CAPE TOWN

All over the old imperial world still stand the edifices that once represented the seat of authority in the colonial territories. For generations, even centuries, the appellation 'Government House' was synonymous with power and prestige, apprehended with admiration and awe by the governing and respect and even fear by the governed. And if the stucco is now peeling and the coats of arms chipped away, and if the ballrooms are turned to canteen or conference room and the gardens grown rank and wild with nature, here and there still lingers evidence of imperial pomp long forgotten, of official entertainments no longer recollected, of glories that once were.

The history of a Government House is likewise unique, for its very purpose ensures the greatest opportunity possible for incident and consequence. Its advantages surpass even those of a house fortunate enough to have remained in the same family for generations since the never-ending cavalcade of proconsuls (and proconsuls' wives) who pass through its impressive portals do so with a rapidity and in a variety that no natural genealogical succession could ever hope to achieve. All leave their mark; some, it is true, more radically than others and if from the safe vantage point of historical hindsight we see them not always as improvements, we must acknowledge that in most cases the house has survived the richer for the experience.

Such a theory, currently so unpopular in South Africa, is hardly original. Fifty years ago, Vita Sackville-West, in a now celebrated passage, claimed that the best historic houses are those which grew in a leisurely way over the generations, sprouting a wing here and a tower there, like the oaks and elms that surround them. They grew inside, as she put it, in the same way as outside ... all in a mixture to make the purist shudder.[1] If only walls could speak, we cry, what tales they would tell! For the story of Tuynhuis is not simply the story of a house but really a social and historical chronicle of the nation.

In 1822 William Bird wrote of the already partly anglicized Government House at Cape Town: 'This abode might be thought to be handsome enough for a high and mighty mercantile body, but it is not on a scale becoming the representation of the British King on the outwork of his Eastern Empire.'[2] Bird's is perhaps the most pertinent of the criticisms (of which there have been no shortage) levelled at the residency: it highlights once and for all that two very different types of proconsuls born of two different cultures lived and sought to rule from its lofty halls. And this in turn explains why the Tuynhuis is in fact two very distinct houses set on the same foundations – the late eighteenth-century colonial palace of the Dutch governors which had grown out of the garden pavilion of a century before, and the nineteenth-century British Government House into which it was transformed. The recent restoration which sought to recreate the central block of the earlier house has only served to highlight further its dual personality.

The splendidly elaborate Tuynhuis of the 1790s had been erected at the behest of the Governor, Van de Graaff. As the town increased in size and sophistication the Governor's quarters, hitherto at the Castle,

appeared less and less attractive – 'melancholy as a cloister', was how Mentzel put it[3] and clearly an alternative, at least for summer, was desirable. Tulbagh had built himself a *maison de plaisance* among the oak trees at Newlands. Charming and delightful though it might have been, it was in one sense an awkward arrangement, for in the eighteenth century its distance from Cape Town 'suited very few people who had affairs to solicit with the Governor'.[4] And anyway, by the 1780s the notorious Newlands winters had already done their worst and the house was in a poor state of repair. Attention must therefore have turned to the Governor's guest house in the Gardens which combined administrative convenience with an agreeable location.

The original garden house – really a pavilion – was put up in the time of the first Governor, Simon van der Stel. It was intended for the Governor's recreation rather than abode, and to provide accommodation for distinguished visitors whom it was felt neither politic nor convenient to accommodate at the Castle. It faced north and was prettily sited halfway up the length of the Company Gardens, which were already being transformed into the elaborate formal affair of oak avenues and walks and enclosures of myrtle and box described by some eighteenth-century visitors as one of the glories of the Cape.*

The house was modest enough. Père Tachard, one of a party of astronomers who stayed there in 1685, described it as 'a small Pavilion which is uninhabited: the ground floor consists of a vestibule with doorways on the sides facing the Castle and the garden, flanked by two rooms (*salons*). Above them is a room (*cabinet*), open on all sides between two terraces paved with brick and surrounded by balustrades'. The astronomers were delighted: it almost seemed to have been expressly designed for their telescopes.[5] In time the two terraces must have been enclosed, for both Kolbe and Valentyn, who visited the Cape in the first decades of the eighteenth century, describe the house as having three rooms upstairs as well, topped by a flat roof.[6] The stables stood on what is now Stal Plein and the kitchen was detached from the main house with a private lavatory or privy (*heimelijk gemak*) for the Governor behind it.

There is now some considerable doubt as to whether this pavilion formed the core of the Stal Plein end of the present Tuynhuis.[7] It is certain, however, that a house stood on the present site in Tulbagh's time and evidence uncovered during restoration suggests that the old pavilion may have formed a back wing blocking off the courtyard of a U-shaped single-storey house, in the Cape Dutch idiom, which faced onto the gardens. It boasted a trilobe gable typical of the period.

Doubtless this was handsome enough, but the Dutch Tuynhuis was to reach its most magnificent a generation later during the governorship of Van de Graaff. Aloof from the common people, tactless and with luxurious tastes (according to one of history's

* Not all, let it be noted. Mentzel described it thus: 'Take the cabbage field at Leipsic and enclose it with laurel, myrtle and rosemary hedges, and you would have a replica of the garden at the Cape.' (Mentzel, part 1, p 120.)

verdicts) he was evidently delighted with his results, for when he was recalled to Holland, partly on account of his building extravagances, he took as a memento a sketch of the house by Josephus Jones.[8]

Jones's depiction of the garden front shows a really rather splendid little Dutch colonial palace with a central double-storeyed block flanked by two projecting single-storey wings – de luxe versions of *stoepkamers*. Above the stoep between them is a colonnade, and the whole is embellished with late baroque, almost rococo, detailings – the S-shaped balustradings, the curved glazing bars on the main door, and the swirly surrounds on the upper one and the central windows of the wings. All are mixed up, and not unsuccessfully, with bits of neo-classicism evidenced in the colonnade, flaming urns and pilasters.

Based on comparative rather than concrete evidence, it is not unreasonable to assume the work to have been Anreith's. Certainly the putti with their drape recall his pediment for the wine cellar at Groot Constantia and the door surrounds those at Rust en Vreugd. Anreith was, after all, in the Company's employ, having been appointed Master Sculptor in 1786 and the Tuynhuis of this period very much suggests his *oeuvre*. He had been apprenticed in Freiburg in the 1770s,[9] and produced work in the Cape that reflected all too clearly the high tide of late baroque in Southern Germany coupled, as might be expected, with an awareness of the early stirrings of French neo-classicism.

The austere interiors would have been made grand with painted neo-classical architectural motifs such as survive here and there in Cape houses of the period, and at least one room was papered, for this is how Lady Anne Barnard found it ten years later: 'a deep orange in colour, in compliment, I suppose, to their Prince. Indian flowers and Parrots covered it all over, which no quantity of candles would have brightened.'[10]

Lady Anne was by no means the archetypal sneering British proconsul's wife of twentieth-century literature, but it is quite unreasonable to expect Cape houses to have appeared anything but boorish, provincial and inelegant to cultivated English aristocrats. The Garden House in particular had suffered additionally as a result of the financial strictures attendant upon the Company's collapse: it was not only in need of repair, but positively dirty and its formal parterres choked with weeds.[11] Nevertheless, in 1797 Lord Macartney took up residence there in preference to the Castle which was left to the Barnards and General Dundas and their ensuing squabbles. A precedent was thereby established. Unconvinced of the permanency of Britain's tenure at the Cape, Macartney was reluctant to spend a penny on the building,[12] but his successor, the plump and pompous Sir George Yonge, whose marvellously *opéra bouffe* governorship lasted two years before his recall, suffered from no such inhibitions.

'Wonderfully fond of buildings,' as Lady Anne rather pointedly puts it, he was to be seen, bottoms-up, on the very first day of his occupation there chalking out the plans of his proposed improvements that

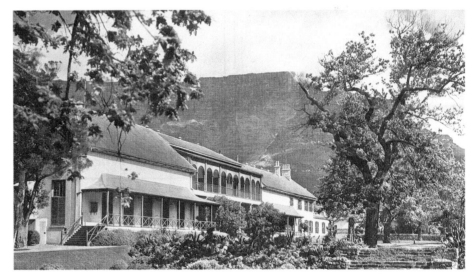

TOP. Tuynhuis *circa* 1790 in Dutch colonial baroque: the main central block flanked by two *stoepkamer* wings. The putti and plasterwork were probably Anreith's. (Cape Archives)

CENTRE. Government House *circa* 1830. Somerset's alterations seen in the verandahs, pitched roof and bow end to the ballroom. The Gothic apse (*circa* 1829) for the orchestra is just visible behind the trees. Notice the grounds redesigned in the gardenesque manner, complete with resident crane. (De Meillon, William Fehr Collection)

ABOVE. Government House *circa* 1935. Somerset's two wings are much extended, and the ballroom has a late Victorian criss-cross verandah. The trellised loggia above the colonnade is clearly visible. (*Cape Times*)

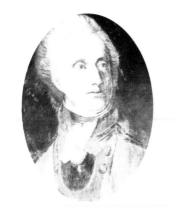

Lord Charles Somerset. (Cape Archives)

were to occupy much of his attention.[13] Fireplaces and chimneys – an almost unheard-of luxury in Cape Dutch houses – were installed in the rooms which were painted fashionable colours or hung with wall-papers chosen by Lady Yonge in London. The terrible old staircase – very likely the one under which Kolbe sheltered in the early 1700s fearing that a violent south-easter would blow the house down, and up which Lord Macartney had long-sufferingly hopped, gout and all, like a parrot to his perch (Lady Anne again) – was pulled down and a very grand new one, 'the fellow of my Lady Buckingham's in St James's Square', installed at a cost of £400.[14]

The work was done under the direction of Thibault at one stage and under Somerville at another; Schutte was one of the contractors. The kitchens were trebled in size to include a stewards' hall, butler's pantry, lar-ders of various descriptions, a scullery, a dairy and a bakehouse. There was a lavatory and a bathroom in the central hall upstairs and another lavatory in the dressing-room off HE's sitting-room downstairs. At the far end of the yard, opposite the laundry and cop-pers, were three privies for the numerous staff.[15]

But the changes at the Garden House were not con-fined to structural alterations alone. On New Year's day of the new century Sir George ('who likes parties above all things')[16] held a full dress levee; on 18 January a banquet in honour of the Queen's birthday ('the wines various and excellent; the royal toasts drunk under discharge of cannon')[17] and on the 20th a Grand Ball. The old *gaandereij* was decorated with orange trees, the dining-room transformed as a ball-room and supper served in the upper hall. Hence-forth the Garden House was the Government House – the faint reflection of the Metropolitan Court, though enormously modified, as one metropolitan visitor was quick to point out, by the different condi-tions of colonial society, principally owing to the lack of a county aristocracy.

The entrée, therefore, was untrammelled by the elaborate regulations of St James's. On special occa-sions, such as the Sovereign's birthday, the guest list would consist of the top-ranking naval and military officers and others holding official positions – mem-bers of both houses, the judiciary and so on. But in the course of the nineteenth century the custom evolved for all people 'who think they are of fair standing socially' to pay set visits to Government House, either at the levee or on certain At Home days, when their names were inscribed in the visitors' book and cards left in due course.[18] Considering the immense social prestige of Government House, this casual-sounding arrangement was not much subject to abuse until well into the twentieth century and even then signing The Book was almost certain to be rewarded by an invita-tion to a Garden Party.

The Governors were anxious and indeed, as the Sovereign's representatives, under instruction to be on cordial terms with all colonists, though often these attempts backfired. The Freres' efforts to ingratiate themselves with the Dutch sector were derided by the die-hards on both sides ('thought that the fortress could be carried with tea and cakes and evening crushes,' was the sneer) and several Governors and

their ladies occasioned unfavourable comment for gestures towards people of colour that nowadays would be considered a common courtesy.[19]

Despite plans and proposals, the façade which had aroused so little enthusiasm from Lady Anne and others remained unaltered during the Batavian Inter-regnum which saw the erection of Thibault's hand-some guardhouse and lion gates at opposite ends of Government Avenue, and the British Reoccupation that followed in 1806. Indeed, all improvements seem to have concentrated on making the interiors more agreeable and elegant. The diaries of Samuel Hudson are full of praise of the results.[20]

By the second decade of the century, therefore, not only were structural repairs again necessary (at one stage there were actually props inside the rooms to support the sagging ceilings)[21] but it was inevitable that the appointment of a governor of taste and enter-prise would augur a radical alteration.

Lord Charles Somerset was just such a governor. The scion of ducal Badminton and a prominent member of the Prince Regent's set, he was appalled by his first sight of Government House. It was by then a twenty-five year old colonial version of an unmodish (even to contemporary English eyes) Middle Euro-pean style, and appeared hideous and its accommo-dation inadequate.* His Lordship arrived, took one look down his skinny Plantagenet nose, and was aghast. 'That dog kennel!' he is supposed to have said.

Somerset duly began a series of alterations and im-provements which, by the time of his departure for England in 1826, had transformed the house entirely. Something of a dilettante, as was not unusual for one of his class and age, there is evidence that much was done according simply to his verbal instructions: a complaint listed in 1819 by Melville, the Commis-sioner of Works, notes that extensive repairs and alterations had been done 'without my knowledge and completed before I was called in to examine it'.[22] In the long run it was inevitable that some of Somer-set's efforts were no more structurally sound than Van de Graaff's had been, yet in their day they were every bit as elegant.

This is what he did. The two low wings – the old *stoepkamers* – were demolished and replaced, the one on the Table Bay side making an impressive ball-room (seventy-seven feet by thirty-four [23,1 m x 10,2 m], compared to the thirty-four feet by eighteen [10,2 m x 5,4 m] of the grubby old orange dining-room) and the companion wing housing his hand-somely proportioned suite of a study or audience room and dressing room. The ballroom was ap-proached via an anteroom (the breakfast room of Sir George Yonge's day) and entered through mahogany folding doors. At the far end was a circular apse mak-ing a nice typical Regency bow-end from the exterior and housing the orchestra.[23] The whole was lavishly decorated with gorgeous wallpaper and friezes – the Inventory of Government Stores lists a mouthwater-ing selection[24] – and given an elaborately moulded plaster ceiling, lead chandelier roses and cornices. New fireplaces were put into all the main rooms –

* Badminton had 106 rooms.

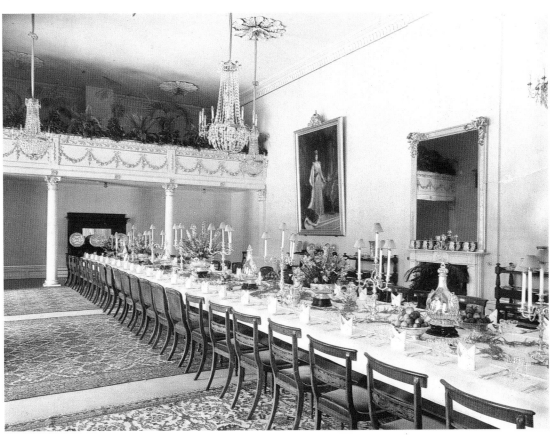

LEFT. The white and gold ballroom with the décor surviving from 1842. No photograph better illustrates the notion of Government House constituting the Court in miniature in the colonies. For almost 150 years this was the most elegant ballroom in the country. (Africana Museum, Johannesburg)

BELOW LEFT. The ballroom in the 1880s: gas lighting, patterned wallpaper and trophies from the Zulu wars.

BELOW RIGHT. The morning-room in the Freres' day: a little bit of greenery-yallery and two assegais for good measure.

BOTTOM LEFT. The Chinese drawing-room (?), circa 1832 (Lady Frances Cole). The Chinese wallpaper is presumably that ordered by Somerset. The oriental theme is continued in the porcelain and fans displayed on the chimney-piece.

BOTTOM RIGHT. The Chinese drawing-room circa 1925. The former morning-room extended by Princess Alice and redecorated with 'Chinese' silks and chintzes. The furniture is a mixture of eighteenth-century and Edwardian chinoiserie. (South African Library)

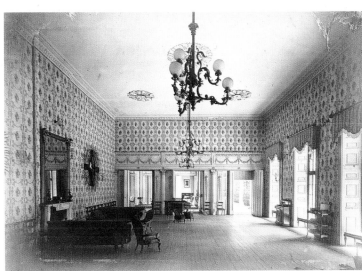

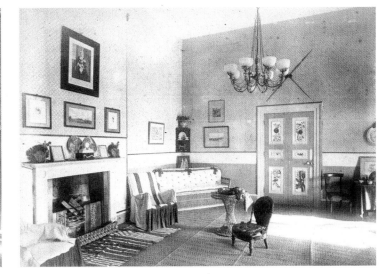

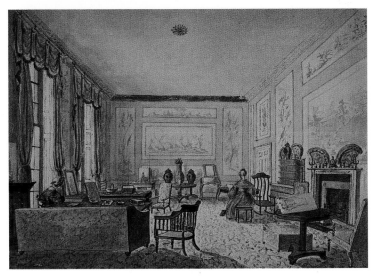

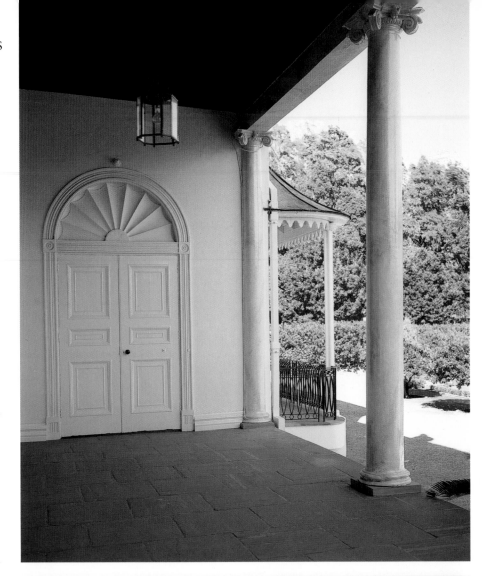

RIGHT. The stoep paved with Robben Island slate. The Adam motif and door surround may have been added before Somerset's time by Sir George Yonge. There was a similar plaster surround to the porch door of The Vineyard as built by the Barnards.

BELOW. Somerset built the side-wings to house the ballroom and, shown here, his suite of offices. This elegant verandah with its canopied zinc roof and iron railings is the last to survive of all those added by the Governor to his buildings at the Cape.

FAR RIGHT. Somerset's audience room with the mahogany furniture used by successive Governors. The fire surround is of Robben Island slate, the leather reading chair was Milner's. Until 1985, when it was completely transformed through redecoration, this handsome, masculine study with its coved ceiling was the last of his rooms at the Cape which Somerset might have visited without grief.

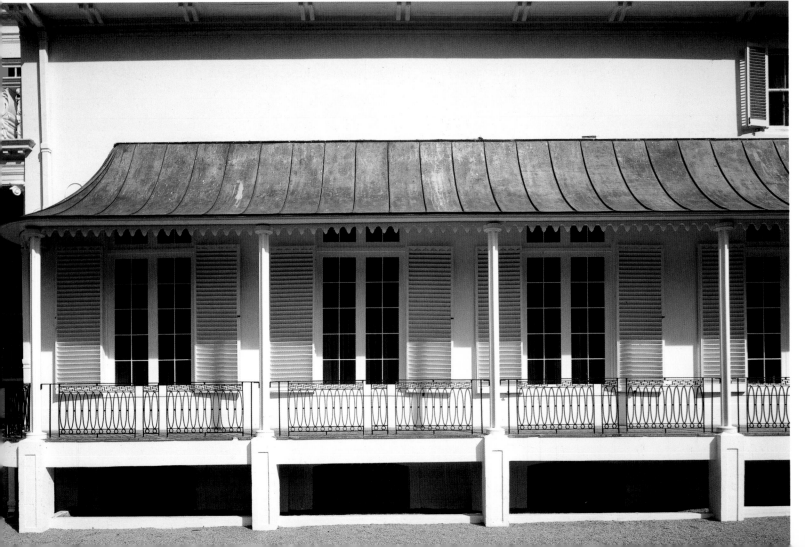

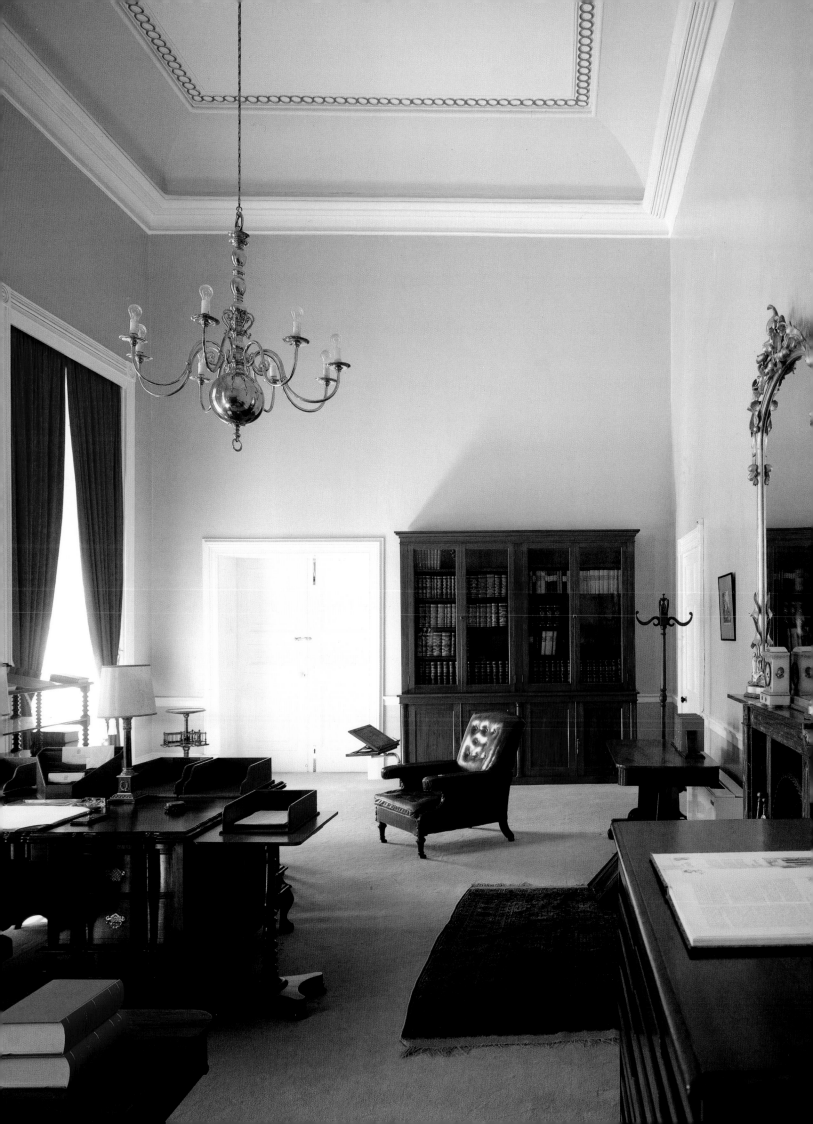

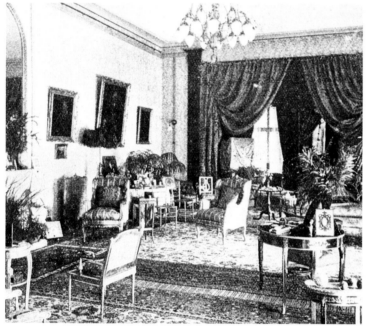

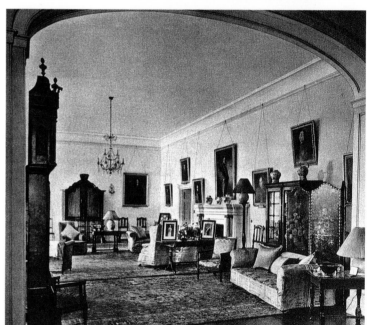

TOP LEFT. The drawing-room 1832. Sir Lowry Cole warms his bottom at the fire. The circular tea table survives to this day. (Library of Parliament)

TOP RIGHT. The drawing-room at the time of the Bartle Freres: like a curate in a fine rectory, a civil servant governor without private means was often hard put to furnish the residencies which housed him.

ABOVE LEFT. The drawing-room *circa* 1900. Lots of *fin de siècle* gilt, palms and the arch to the anteroom draped. (South African Library)

ABOVE RIGHT. The drawing-room between the wars. Silk damask covers, oils of departed Governors and framed photographs of royals. The odd piece of Cape furniture provides an ethnic, if incongruous, touch. (*Cape Times*)

FAR RIGHT. The drawing-room 1984. 'Period' furnishings by Mrs Diederichs.

RIGHT. Bedroom, possibly a nursery, in 1870. Victorian clutter and a generally feminine feel. (Cape Archives)

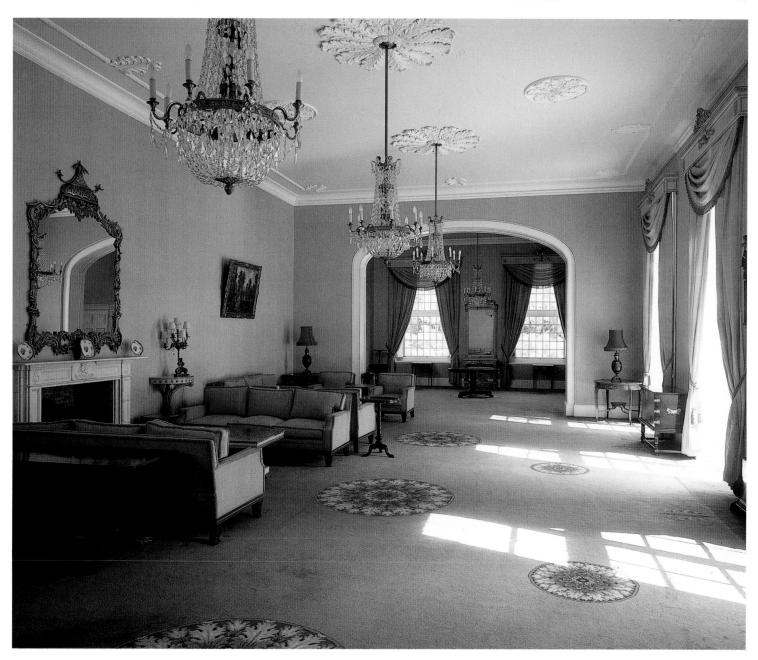

marble for the drawing-room and ballroom, Robben Island slate in others.[25]

Along the length of the two wings Somerset added the most elegant raised verandahs with delicate cast-iron railings, the slender teak uprights supporting tent-like zinc canopies finished with prettily scalloped barge-boarding. The central block was accordingly simplified, the colonnade being topped by a trellised loggia (redolent of Cheltenham), the whole being covered by a pitched painted shingle roof.* Most of the main rooms communicated with the verandahs by way of french casements protected against the afternoon sun by venetian shutter blinds. The two side doors were the exception and were given handsome sculptured radiating patterns in the position of the fanlights. Sir George's rather higgledy-piggledy servants' quarters and kitchens were more successfully rationalized; four new patent lavatories at the considerable cost of £230 were installed.[26]

All this metropolitan stylishness combined with a heady whiff of the faintly raffish air of Regency Brighton caused a minor sensation in the Colony and sketches of the 1830s and 1840s show Cape architecture regencyfied to a degree.

The Somersets lived in great style** and though it is not to be supposed that all this conspicuous affluence seemed in any way remarkable to them, it was gleefully seized upon by the Governor's many detractors as an example of his extravagance and autocratic ways. During His Excellency's leave in England, Sir Rufane Donkin, the acting Governor, was quick to point out that he managed to slash the quarterly maintenance for Government House to one fifth of that spent by the Somersets.[27] When the Governor left for England in 1826 to answer the charges laid before him, the alterations were barely completed. He never returned, but left behind him what was agreed by all but the most parsimonious to be the most handsome residence at the Cape. He left with regret. 'I have spent

* This was replaced with Welsh slate in the 1840s.
** 'Send post-haste to Paris for a cook', reads one of His Lordship's first letters home.

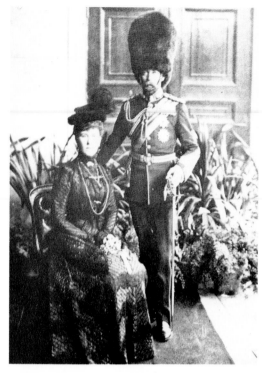

TOP. The Duke and Duchess of York (later King George V and Queen Mary) sit on the stoep. 1901. (Cape Archives)

CENTRE. The Athlones with the Prince of Wales in 1924. (South African Library)

ABOVE. The King investing Field Marshal Smuts with the Order of Merit in the ballroom. The future Queen is seated at left. (*Cape Times*/South African Library)

TOP RIGHT. Bedroom for Queen Elizabeth (the present Queen Mother). Baker's fittings survive from the earlier royal visit of King George and Queen Mary. An electric fan and Mrs Brand van Zyl's welcoming bowl of glads provide finishing touches. (South African Library)

RIGHT. Princess Elizabeth dances at her twenty-first birthday party in 1947. (*Cape Times*/South African Library)

The Stal Plein façade which has lost its pitched slate roof. Regency windows and venetians surround the entrance portico with its Egyptian revival columns.

some of the happiest days of my life here,' said His Excellency on his departure, 'my ties with the Colony will only be broken when I die.'[28]

During the rest of the century and the first half of that which followed Government House was altered here and there, its Regency elegance inevitably coarsened rather than improved by the Victorian additions. In 1842 the ballroom was altered. Improper foundations and incorrectly mixed plaster for the ceilings meant that further use of it for dancing would, according to the official report, 'be attendant with great danger'.[29] The bow and the projecting Gothic bay added to it in 1829[30] were removed, the room extended and an orchestra gallery installed. It was supported by a screen of columns and a gilt frieze of acanthus leaves and Grecian honeysuckle (by Bevil) which was repeated around the doorways at the opposite end.

The alterations had cost £1 936 and were reckoned a success from every point of view: 'Unique and chaste as well as brilliant,' was the contemporary verdict of Sam Sly's Journal. On regal and viceregal state occasions the thrones were placed on a dais beneath the gallery. It was here that, fan in hand and ablaze with diamonds, the beautiful Spanish Lady Smith received over eight hundred guests at her balls and receptions. It was here that for thirty years from 1855 the State Openings of Parliament were held, the members summoned from the Good Hope Lodge and the new House of Assembly. And it was here, nearly a century later, that the young Princess Elizabeth in a spangled ballgown danced on her twenty-first birthday. Towards the end of the nineteenth century the ballroom was again altered and a criss-cross verandah – crude and clumsy by comparison with its old-fashioned neighbour in the opposite wing – added outside.[31]

Other changes followed. Herbert Baker, who had become a protégé of Sir Alfred Milner, re-did several of the interiors for the visit of the Duke and Duchess of York in 1901, including the columned boudoir which Princess Alice so enjoyed.[32] She, who still had praise for the 'charming old place', created a Chinese drawing-room in the vogue so favoured by her sister-in-law, Queen Mary; the room stretched from the anteroom to the Governor's study. All these were casualties of the restoration of the early 1970s and further alterations were carried out in 1984 and again in 1985.

Since the photographs accompanying this chapter were taken, Tuynhuis – redundant as an official residence with the new constitution – has been given over to the State President's offices. The house is nowadays curiously unsatisfactory, for the lavish sums spent on it seem only to have reduced the atmosphere of history and romance with which it should so richly be invested, and efforts made to dispel the traces of imperial grandeur that hung – miasma-like, perhaps, for some – in its handsome rooms. Gone are the portraits of governors past, the mahogany writing tables and the silver-framed royals, the damask-covered sofas and the endless Axminster carpets. Difficult now to conjure up the discreetly heightened atmosphere of a royal or vice-royal court – to imagine the comings and goings, the sleek ADCs bearing red dispatch boxes from London, the dowdy lady-in-waiting reassuring a nervous Mrs du Plessis as she anticipates her first curtsy, the ceremonious flinging back of double doors, the stuffy heat of a reception on a Cape summer's night with the heady smell of candlewax and tuberoses and the acrid whiff of too newly cleaned orders and kid gloves. Difficult now to hear in the mind the once familiar sounds, to hear the clatter of the horses' hooves on the cobbles outside and the sentries snapping smartly to attention, the orchestra improvising the waltz from the latest West End hit and the sound of loud and confident patrician voices laughing in the drawing-rooms downstairs.

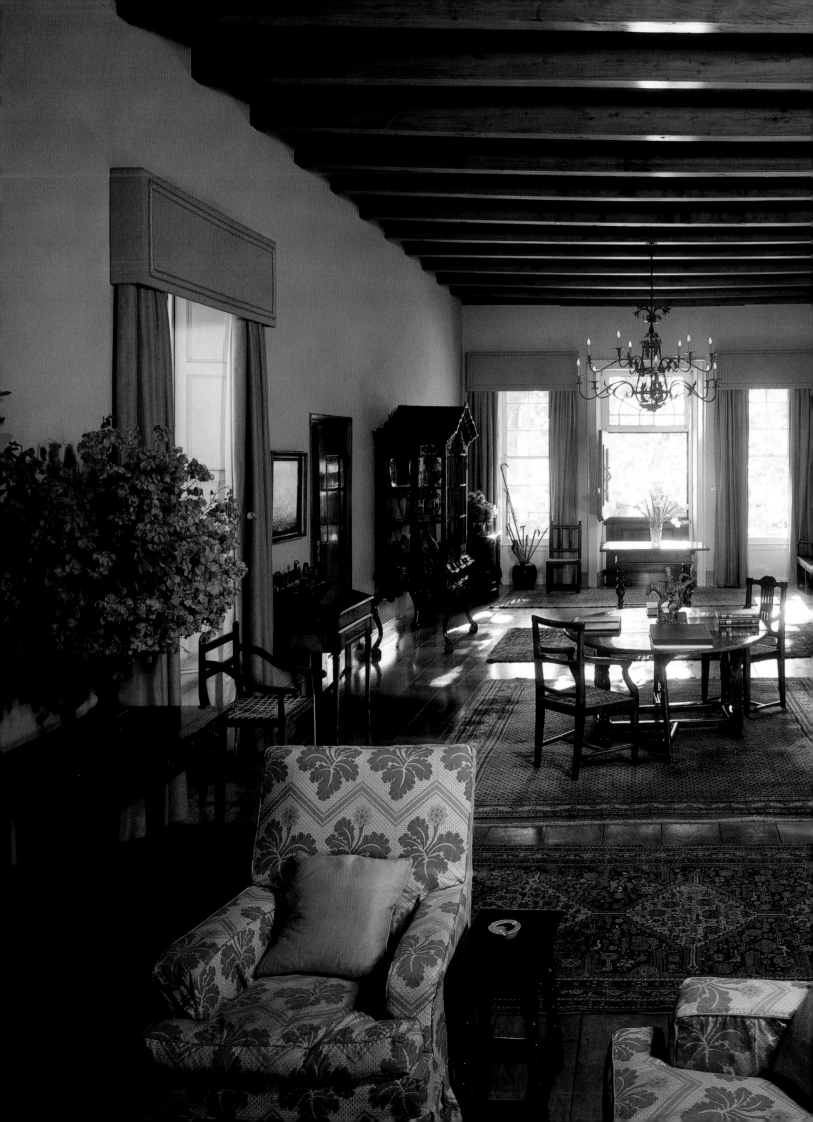

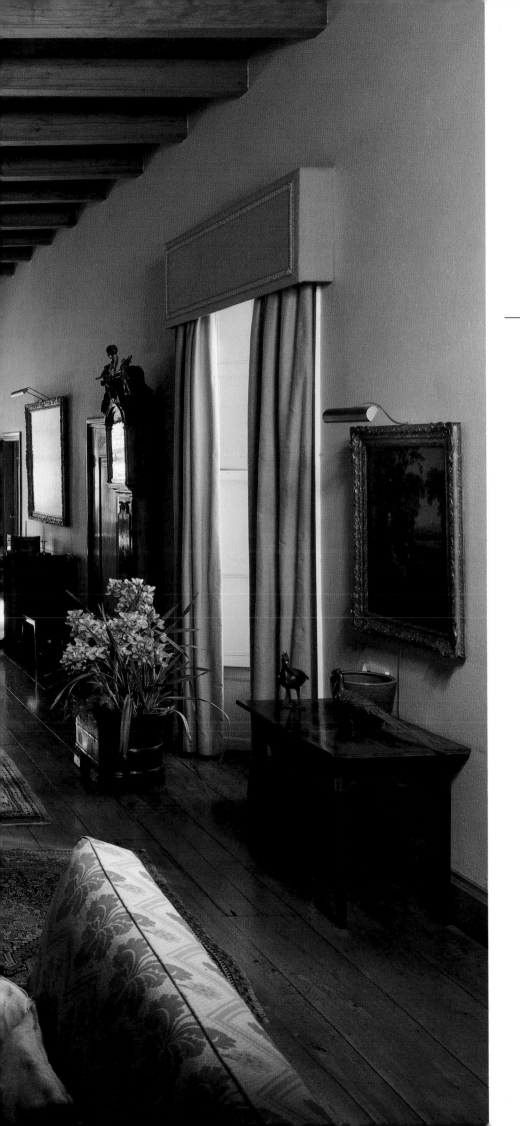

RUSTENBERG

IDA'S VALLEY

On the first day of 1683, the same year that François Villon of Claremont was granted Ida's Valley, Roelof Pasman, a German from Meurs, was granted the adjoining farm. It comprised 135 morgen 200 square roods lying beneath the Banhoek Mountains.[1] Pasman gave it the romantic name of Rustenberg; in old documents it is variously spelt as Rustenburg or Rustenburgh, which, given his origins, is doubtless the way he intended it to be.

Nearly two years later, on 12 November 1684, Pasman married Sophia Schalk van der Merwe, more cosily known to most as 'Fytje'.[2] Fytje bore Pasman five children before his death in 1695. The shortage of marriageable girls in the early days of the Cape settlement – far less an unattached woman left in full possession of a 130-morgen working farm – made Fytje something of a catch. Roelof Pasman had been a diligent farmer. By 1692 he had a flock of four hundred sheep, twenty oxen and with the assistance of only two slaves had planted the wilderness with five thousand vines.[3] Casting her fresh grief aside, Fytje Pasman became Fytje Robberts in January 1696. Her new husband Pieter Robberts had arrived at the Cape from Neustadt in Holstein in 1693 and was a sergeant employed by the Dutch East India Company.

The veil of obscurity that surrounds so many of the earlier generations of free burghers – buried and forgotten as though they had never been – is mercifully lifted a little in the case of Pieter Robberts and reveals, one is sad to say, a not entirely attractive character.

To be perfectly fair, we cannot hold it against him for snapping up a rich widow: such alliances were the foundation of many of the old Cape families and fortunes. Nor could we interpret his action in getting the re-grant of Rustenberg in his name as evidence of ulterior and acquisitive motives, were it not for subsequent events. The re-grants were made as a matter of official policy and since the Robberts's were married under Roman-Dutch law and therefore in community of property, it would probably automatically have been made in the husband's name. Rustenberg, now measuring ninety-two morgen 175 square roods, was re-granted to Robberts in February 1699 in full freehold,[4] the reduction quite typical of the re-grants that followed a decade after the originals of the 1680s.

It is Mr Robberts's subsequent career which leads us to suspect that he was on the make. He was appointed *Heemraad* in 1701 and acted as Landdrost of Stellenbosch from 1703 to 1705. This was one of Willem Adriaan van der Stel's appointments and made in the Governor's rather than in the public's best interest. Adam Tas who, with some justification, disliked all Van der Stel's cronies, referred to Robberts slightingly as 'den Oud Noordsen Landdrost'* and never had a good word to say of his capabilities. Robberts was apparently a real Van der Stel yes-man, forever trotting off to Vergelegen in his horse chaise, sometimes in the company of Starrenberg, the new Landdrost, 'diligently practising the informer's craft', as Tas put it, 'for which he stands to reap his reward in due course'.[5]

Evidently Robberts reaped his reward all right. The Van der Stels' banishment and the consequent opprobrium attached to their supporters following Tas's release must have led to no small amount of ostracism in the tiny community. Robberts suffered a stroke which left him at fifty-two semi-paralysed and with an obstruction in his speech.[6] Moreover any dynastic dreams that he might have entertained came to nothing. He predeceased his wife, who seems to have decided on a firm course of action to redress the wrongs suffered by her first husband's memory and by his children. Under Roman-Dutch law the farm was hers once more. She gave Rustenberg – farm and house[7] – as an outright gift ('als een vrywillige gift') to her grandson, Pieter Loubser, and formally disinherited her son Jan Robberts, her only child by her second marriage. Pieter Loubser was the son of Sibella Pasman and she and her sister, Catherina, gave testimony to the foregoing which is contained in a separate document attached to the deed of transfer dated 8 February 1742.

The year before the transfer, Pieter had married Johanna Eksteen, daughter of the influential and rich Hendrik Oostwald Eksteen who owned several farms as well as fisheries at Saldanha Bay. The property he inherited was very different from the one that had seemed so attractive to Robberts forty years before. The amazing Fytje, tough as old boots by Tas's account,[8] had not only farmed Rustenberg in her second widowhood, but had increased its productivity considerably. By 1720 there were six hundred sheep, two hundred oxen, thirty horses and twelve thousand vines.[9] There were also twenty-four slaves.[10]

Obviously the Pasmans, Robbertses and Loubsers had lived in a house of sorts on Rustenberg. The diagram on Robberts's re-grant contains a sketch of the humblest imaginable dwelling described as a '*hofstede*' in the will of Roelof Pasman and on Sibella's transfer. No room by room account of it is given. The prosperous young Loubsers may have been responsible for building a house on the site of the present manor for, if nothing else, the pretty circular front steps made of Batavian bricks survive from this period. Perhaps the rest of the house was theirs too. The first description we have of it is in the inventory of the insolvent estate of Gerrit de Wet, its owner from 1825–1845. It describes an H-shaped house which is what remains, plus additions, to this day.

What seems to have happened is this. In 1810 Loubser's nephew, Jacob Eksteen, decided to subdivide his farm.[11] The larger portion of sixty-one morgen was sold to his son-in-law, Arend Brink, who had been working it since 1808 and possibly even earlier[12] and who now named the property thus created, Schoongezicht. Rustenberg, reduced to thirty-one morgen, was sold to Johannes van der Bijl.[13] He died in 1819 and when his widow remarried in 1825 she sold it to Gerrit de Wet.[14]

Either Van der Bijl or De Wet, or both, made alterations or substantially rebuilt the house already there. Any major construction remained true to the vernacular form but the front façade was given the plainest of gables and the unusually wide side wings finished with half-hipped ends. In keeping with the

PREVIOUS PAGE. The folding screen which once divided the *voorkamer* from the *agterkamer* has long since disappeared, leaving a great hall or gallery that is today filled with Cape and English furniture.

TOP. Outbuilding which matches the adjoining wine cellar, now transformed by the Barlows to house their library, guest wing and squash court. (A Elliott, Cape Archives)

CENTRE. The rear façade. Typically the stoep contains drying towels, a pram, wicker chairs and Lady Barry's major-domo. (A Elliott, Cape Archives)

BELOW. It is reasonably supposed that, like many Cape Dutch houses, Rustenberg was given a going-over during the first decades of the nineteenth century, and this is how the main block survives – the gable simplified entirely, the windows given the wider Regency panes and the double front door (now replaced) a Georgian fanlight.

changing fashion, the old casement windows were replaced with sashes containing thin glazing bars typical of Cape Regency architecture; the double front door (now replaced) given a Georgian fanlight; and iron railings added along the front stoep creating a balcony.

The De Wets lived in a style typical of the moderately well-off Cape farmer of their day and – unlike the generation which immediately preceded it – easily identifiable to the modern mind. The front hall (the old *voorkamer*) contained two sofas with rattan seats, the room to the right was their drawing-room with its horsehair sofa and chairs, pianoforte, three large gilt looking-glasses and chintz curtains. The room to the left was the best guest bedroom – the four-poster hung with white curtains and the dressing table similarly dressed. The hall behind the old folding screen (the old *gaandereij*) was their dining-room which seated twelve. Mr and Mrs de Wet had a chintzy bedroom with washstand and commode, and next to it was Mr de Wet's dressing-room which contained his

writing-desk, his gunrack and a clothes horse. There were three children's bedrooms and the *brandsolder* was partitioned, making a hall and four additional rooms.[15]

De Wet was a keen farmer and acquired two further properties so that by 1831 the total land at Rustenberg measured thirty-one morgen freehold and 729 morgen quitrent ground. On it grew 300 000 vines, 2 500 fruit trees and a poplar forest. There were seven morgen under cereals.[16] In addition to the main house there was a stepped-gabled wine cellar 150 feet (45 m) long which had probably been built by Van der Bijl. There was a second, equally long outbuilding used as a wagon house, a stable for forty horses, a barn with a threshing floor, two slave quarters (known as 'servants' apartments' after 1834), five fowl houses and a brick pig-sty.

Their indoor staff consisted of a Malagasy cook and five housemaids. There was a resident tailor and a coachman and the estate had two carpenters, a mason and over twenty other labourers besides.[17] They were

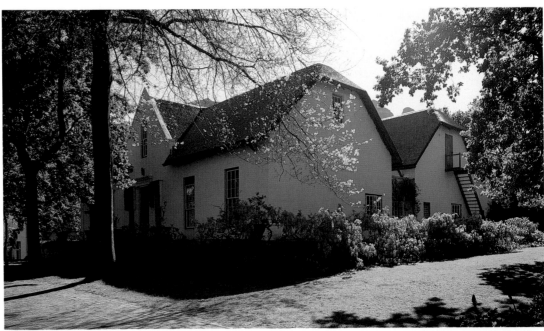

RIGHT, ABOVE. The great half-hipped gables (like those at Kersefontein which was rebuilt at much the same time) were possibly part of the early nineteenth-century alterations, a theory supported by the extreme narrowness of the courtyard between them.

RIGHT, BELOW. Rustenberg is now surrounded by the celebrated gardens laid out by the present owner, Mrs Pam Barlow.

FAR RIGHT. Entrance showing the semi-circular steps of *klompie* bricks (imported as ballast in the ships of the Dutch East India Company) which are interplanted with *Erigeron* daisies – one of Gertrude Jekyll's gardening conceits introduced to the Cape by Herbert Baker.

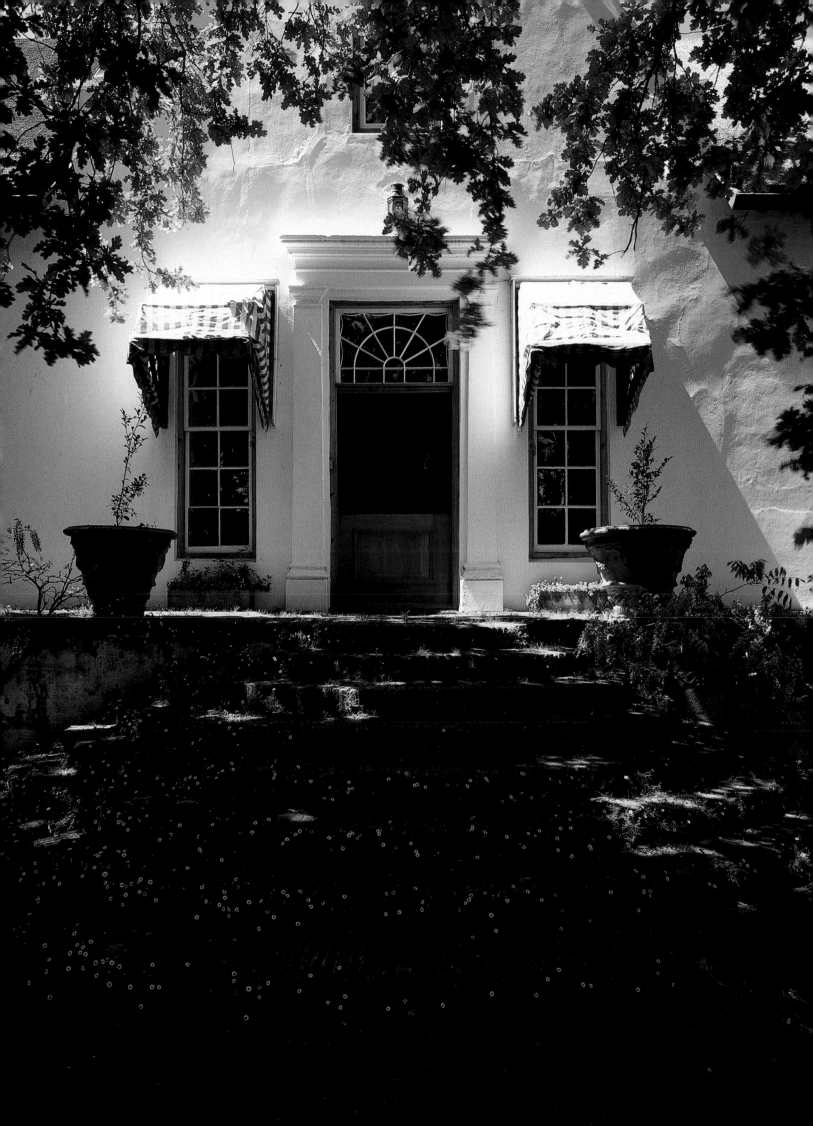

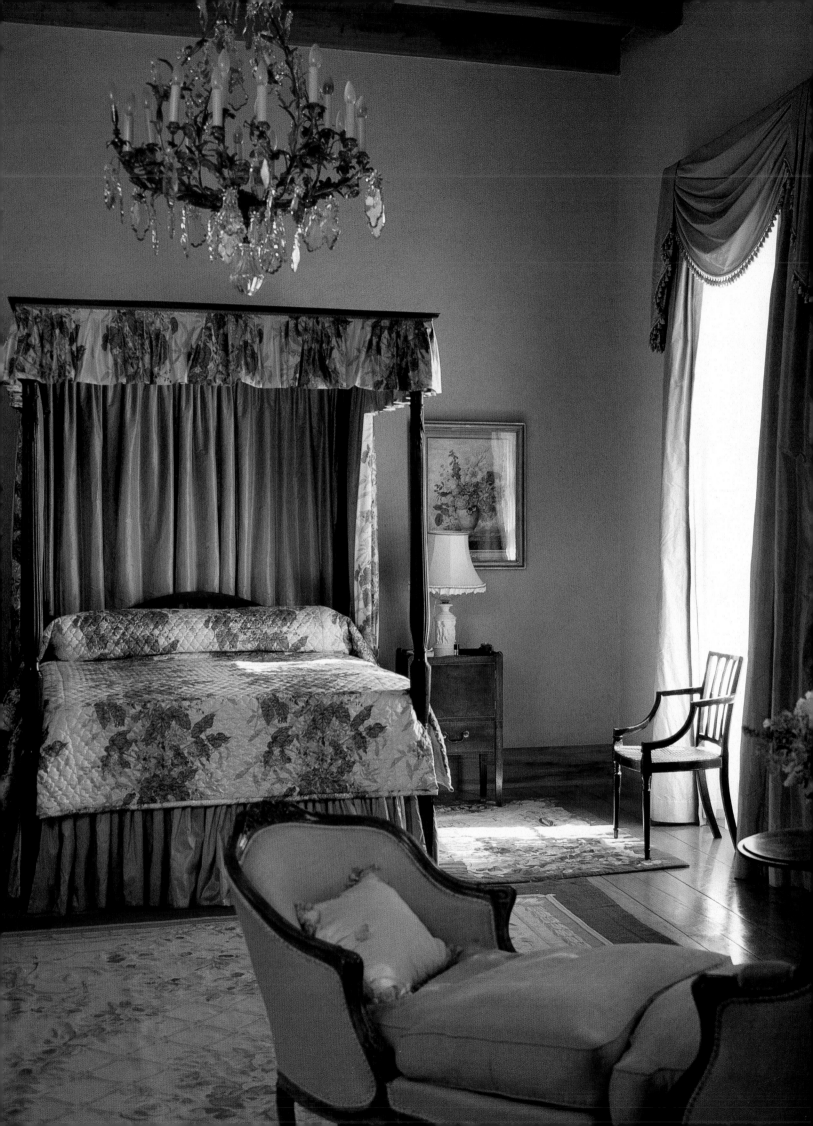

all slaves and represented no small amount of wealth to the De Wets. As was the case for many other slave-owners, their slaves were mortgaged as security against borrowed capital.

The Abolition of Slavery in 1834 came, therefore, as a crushing financial blow. Against all reasonable expectations, the compensation paid out by the Imperial Government turned out to be paltry and its distribution inexpeditious.[18] There was a panic caused by the sudden redemption demands and the farm was mortgaged along with the other De Wet properties for a total amount of £3 900.[19] Even this was not sufficient to weather the slump that hit the Cape. By 1843 De Wet was declared bankrupt, his farms and, indeed, his wordly goods all liquidated, the cold charity of Victorian officialdom all too evident in the intelligence inscribed in sloping copperplate in the insolvency file that the bedstead and bedding be allowed to the insolvent.

Rustenberg was bought from the insolvent estate by Phillip Haupt, and his family farmed it in prosperity until the next calamity hit the Cape wine farms in the mid 1880s. The dreaded phylloxera, a blight that had wiped out the European vineyards, attacked the 200 000 vines on Rustenberg. 'Haupt's place' – the finest in the land, according to J X Merriman, and with a first mortgage of £4 000 – was sold for £2 400.[20] Merriman, the Minister for Agriculture, was an enthusiastic advocate of the buying and replanting of the ravaged wine estates of the Cape. In 1891 he encouraged his sister Charlotte, wife of Sir Jacob Barry, to purchase Rustenberg. He himself bought Schoongezicht the following year and slowly the process of replacing the vineyards with American stock and planting great orchards of fruit trees was begun.

The diaries and letters of the two families paint an agreeable picture of a sunlit colonial world – gently Edwardian in its ways and manners – in the Simonsberg valley.[21] Lady Barry's nephews inherited Rustenberg on her death and sold the farm to the Hon Charles Percy de Villiers, later second Baron de Villiers of Wynberg.

The opportunity for reuniting the two estates was thus lost, the Merrimans not having the necessary capital, but in the event it was achieved a generation later by Mr Peter Barlow, the brother of Punch Barlow who had bought Vergelegen. Peter Barlow purchased Rustenberg in 1941 and Schoongezicht at the end of the war. It is nice to think of these two popular and hugely successful brothers fascinating and delighting such historians of Cape farms as may be writing more than a century hence.

With the assistance of the architects Walgate and Elsworth who had done the work at Vergelegen for Lady Phillips twenty-five years before, the Barlows restored and extended the house and turned the adjacent wine cellar into a library, guest bedrooms and even a squash court. The vineyards, hacked out by the teetotal Lady de Villiers, were replanted and wine produced once more; the Jersey herd was bred up to the highest standard.[22] Rustenberg has in addition been greatly enhanced by the now internationally notable gardens – both formal and wild – laid out by Mrs Pam Barlow, who continues to farm the estate.

LEFT. Bedroom: the four-poster, the *duchesse-brisée* and the gilt pier glass are all nineteenth century.

BELOW. Gold medals for Rustenberg at the Imperial Fruit Show in London in 1939.

BOTTOM. Mr Peter Barlow.

SIDBURY PARK

UPPER ALBANY

PREVIOUS PAGE. The Regency villa with its sneezewood verandah may just be discerned through the oaks planted by Daniell a hundred and fifty years ago and which now obscure the façade.

TOP. Sir Rufane Donkin, Acting Governor, Cape of Good Hope. (Cape Archives)

ABOVE. Lieutenant Richard Daniell, RN. (F T Ions, Albany Museum)

Of all the problems which the British inherited when they took control of the Cape none was to prove as troublesome or as costly as the Eastern Frontier, at which extremity two expanding populations – Xhosa and white settler – clashed head-on in hostility. In 1812, having driven the Xhosas back across the Keiskamma, the officer commanding the British frontier forces, Colonel Graham, had advocated the settlement of five hundred Highlanders along the frontier which, together with the assistance of a small, regular force, would act as a sort of human barrier. This idea had been enthusiastically taken up by the Governor, Lord Charles Somerset, keen anyway to increase the population of the Cape and keener still that the new arrivals should be British. Fortunately his views complemented nicely those of Lord Bathurst, Secretary of State for Colonies in London, who was grudgingly coming round to the view that assisted immigration – hitherto generally regarded as a terrible waste of money and resources – was a means of deflecting to British possessions the flood that left England annually for the United States, while at the same time providing some amelioration to the unemployment and poverty so widespread in the wake of the Napoleonic Wars.[1]

The whole scheme might have taken years to gel in the way that these things usually do, had not events forced the ruling Tories' hand. In 1819, faced with major radical discontent – shut-downs, strikes and riots – and baying Whig opposition, they decided to act. On the very last day of the parliamentary session, the Chancellor of the Exchequer proposed a vote of £50 000 'to assist persons disposed to settle in HM's Colony of the Cape of Good Hope'. The bill was passed and Bathurst and Somerset were able to go ahead and implement their projects accordingly.

The announcement met with immediate response. Applications were, however, by no means confined to the indigent and unemployed and the Colonial Office received many requests from persons of both middle and upper class background – second, third and fourth sons who had no reasonable expectation of land or fortune and who faced, in consequence, an almost certain loss in their social status. Lieutenant Richard Daniell belonged to this class of gentleman settler.

A younger son, he had been born in Devonshire in 1790 and had joined the Royal Navy in 1806. The siege of New Orleans seems to have been the high point of his naval career; at the end of the Napoleonic Wars he had, like many others, taken retirement on half-pay offered by an Admiralty anxious to reduce its wartime ranks.[2] Possessed of this income, some capital and no further expectations, Daniell decided to try his luck in the colonies. He did his homework thoroughly. Enquiries and even a call on Lord Bathurst at Downing Street (an opportunity, it must be said, not remotely within the realms of possibility for the average settler) elicited the intelligence that persons and their parties proceeding to the Cape at their own expense would be entitled to a land grant made in proportion to their means. Daniell made up a private party consisting of his brother James and his family, another family, the Handfields, and four artisans, as well as labourers and

maidservants – 'persons of various occupations and servants' as he referred to them.[3]

Armed with their personal possessions and 'implements necessary to start agriculture in South Africa' the party sailed from Portsmouth in the *Duke of Marlborough* in March 1820. Long ocean voyages, then as now, are often conducive to romances and on board Daniell fell in love with the young Miss Handfield. Upon arrival at Cape Town in July 1820 the couple took out the necessary licence and were married by the Acting Colonial Chaplain.[4]

The Daniells having waited upon the Acting Governor, Sir Rufane Donkin, at Government House, the party proceeded to Algoa Bay and thence to their location – the farm Zoetmelkfontein, situated south of newly settled Grahamstown near Rautenbach's Drift on the Bushmans River. It had been granted to Gerrit Scheepers in the days of the Dutch rule and, like almost all the farms in the area, had been abandoned after successive Xhosa attacks and had reverted to the Crown.

The expedition had thus far cost Daniell £1 000, so that his dismay in finding that his lands measured a miserable 700 acres is not to be wondered at. He lost no time in sending Donkin a request for an additional 500 acres to which, he felt, his rank and means entitled him. Donkin visited the party in May 1821 and, highly impressed by the progress already made, agreed 'in the presence of gentlemen', to a greatly extended grant of 3 000 morgen. Daniell was delighted and immediately began improvements. By 1824, despite various setbacks, there were 130 acres under cultivation as well as extensive fencing and 'every sign of great persevering and industry'.

Far less salutary, however, was the situation on the domestic front. The two brothers had built their houses cheek by jowl and Daniell had actually begun married life with his in-laws under his roof. Adult families are seldom suited to residing and working in close proximity and in no time the most dreadful squabbles arose. The final straw came when James shot dead one of Richard's 'superior breed' of pigs which had chanced to stray in his direction. Nor was this all that the Lieutenant had to contend with, for it now transpired that the additional grant from Donkin had never been formally made. On top of this, the situation was aggravated by the wagon service between Port Elizabeth and Grahamstown, which made a regular outspan nearby and grazed its cattle – sometimes as many as two hundred – on his lands.

In November 1824, seething with anger and frustration, Daniell addressed a strongly worded and ably constructed memorandum to Somerset. He pointed out that he had accepted Donkin's word as his honour and cleverly quoted a personal letter from Lord Bathurst which stated that the Governor had full power to grant land to settlers. He mentioned his efforts and achievements, the 'warfare' with his brother as well as the wagoners' wretched oxen and went on to request confirmation of the extended grant in order to separate the party and 'as a fair compensation for the exertions and sacrifices I have made'. Failing this, he stated quite categorically, the party would return to England.

It was on the strength of this letter that, on 7 January 1826, Daniell received his grant, signed by Somerset, of 2 914 morgen 100 square roods.[5] In honour of his birthplace he named it Sidbury Park.

In his memorial Daniell had mentioned as evidence of his industry the house he had built at a cost of 500 Rix dollars and this is very likely part of the present Sidbury Park, for it is quite sizeably marked in its present position on the original grant.[6] Built by the artisans in his party and Hottentot labourers,[7] the house was made of stone – small boulders, really, for some are fully six foot in length – held together with a mortar made from mud and rough-plastered.[8] The chimney-stacks alone were constructed of unbaked bricks. The floors on both storeys were made of yellowwood, felled on the estate, as was the entire roof, its planks caulked and tarred (the naval background of the owner-builder here in evidence) and nailed to the nine-by-three-inch-thick beams (22,5 cm x 7,5 cm). A canvas was secured over this against all weathers. It was replaced in the early 1830s when zinc became available.[9] The original sheets survive to this day and are only now beginning to show signs of wear.

The front façade was given a simple verandah, its turned posts being made of sneezewood, as were all the lintels exposed to the weather. The two *stoepkamers* were later additions, probably added in the 1850s for they appear in the watercolour (*circa* 1860) painted by Miss Berrington, a daughter of the house, but very unlikely we may be sure, to have used that term for them.

Inside, the ceilings were made from a plaster of lime, sand and horsehair (for binding), applied to a criss-cross of lathes nailed to the beam supports of the floor above. Sheep's wool filled the space in between, providing insulation and sound-proofing. The joinery – all typically Regency in design and charm – was mostly executed in yellowwood, ironically considered a most inferior timber by the settlers. It was originally painted, the last layer uncovered in the recent stripping revealing a pretty duck-egg blue which would probably have combined with a custard colour wall paint or striped paper. Pine, the much preferred wood, was used for the chimney piece in the drawing-room or 'parlour', the surround to the front door and the panels in the others. The sash windows were made locally, lead being melted down to make the weights. By the 1840s there were, in addition to the house, stores, an eighty foot (24 m) shearing house (with a boarded floor), a wood press, coach house, servants' apartments and a large sheep-shed.

The result of this improvisation and resourcefulness was a simple Regency villa looking, at a quick glance, for all the world like so many others dotted all over England. Its commanding position, however, on a rise facing south and overlooking the rolling grasslands of the Zuurveld, then not denuded of its copses of indigenous trees and still teeming with its herds of quaggas, zebra and buck, gave it – to contemporary colonial eyes at least – a positively aristocratic air. 'It was,' concluded one particular observer, and there were many who echoed his sentiments, 'one of the best rural mansions in the Eastern District'.[10]

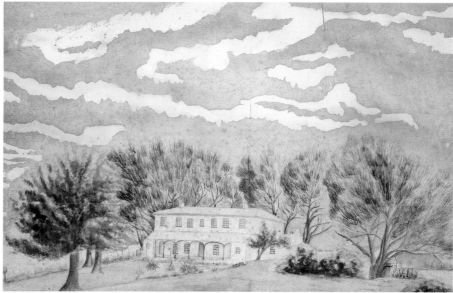

TOP. Sheep may safely graze . . . Before the trees obscured the house entirely, the siting of Sidbury on a rise overlooking the rolling grasslands of Upper Albany contrived to give it an 'aristocratic air' – to contemporary colonial eyes at least.

ABOVE. Sidbury, *circa* 1860. A watercolour by one of the Miss Berringtons shows the house built thirty years previously. Both ends of the verandah have already been enclosed to create two *stoepkamers*.

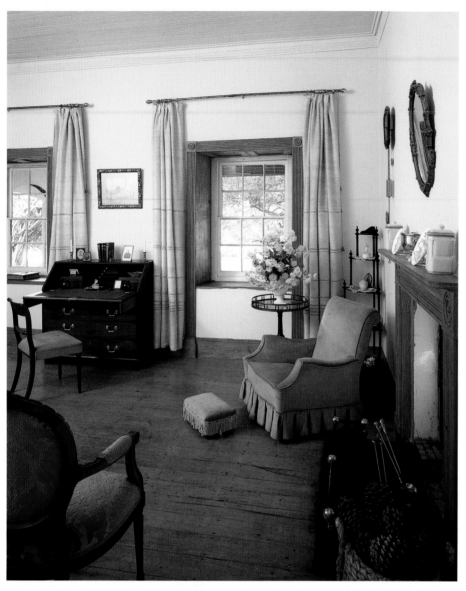

ABOVE. Drawing-room showing the attractive window architraves.

RIGHT. Characteristic Regency architraves and fire surrounds in the dining-room, the latter executed in yellowwood which was considered a most inferior timber by the settlers and almost always painted. A recent stripping revealed the original colour to have been duck-egg blue. In the Daniells' day the table seated twelve, and it was here that the outgoing Governor Sir Henry Pottinger briefed Sir Harry Smith on the frontier situation when the latter assumed command on 16 December 1847 at the time of the Seventh Frontier War.

It was an illusion that the settlers of Daniell's class must have cherished. And just to start with, before the harsh light of common Eastern Province day – the successive Xhosa invasions, the drought and disease – had dispelled the high hopes and expectations of the misty dawn, settler life was not all makeshift and commonplace. The Daniells employed a governess and maids in addition to seventy Fingoes and Hottentots.[11] The coach house at Sidbury contained a curricle and phaeton.[12] A gardener, Henry Nosworthy, reputedly trained at Kew, was brought out and settled at Green Vale – a place better watered and situated some distance from the main house. Here he laid out orchards and vegetable gardens on a series of gentle terraces that ran down to the river winding its way beneath a krantz.

Daniell's finishing touch to this little bit of picturesque nineteenth-century manorialism was a village – complete with tenantry* – surveyed and set out on a portion of Bushy Park, the adjoining farm which his brother had been granted in 1826 and which Richard had acquired in 1831.[14] 'The already populous and rapidly increasing neighbourhood of Sidbury', as the *Graham's Town Journal* of 1838 enthusiastically described it, in no time boasted a vicar – a failed missionary, in fact, poor Reverend Francis Owen, recently fled from Natal where he had actually witnessed the slaying of Retief's party at Dingern's (sic) kraal[15] – a regular agricultural show and an inn, complete with genial innkeeper famed for his strawberries and cream.

In short, those historians wishing to project an aura of Jane Austen's novels on Sidbury life in the 1820s and '30s may do so cautiously, though the present writer would more happily settle for that of George Eliot's. One need only consider the gentle rebuttal by Mrs Rice Smith, a neighbour at Welcome Wood, in response to a little bit of metropolitan condescension from her sister-in-law in the form of a parcel of cotton dresses with the inference that these were suitable to her new location and situation. 'Never since I have been in Africa do I remember sitting down to dinner in a cotton frock,' was her politely pointed reply.[16]

Somerset's eulogy on the Zuurveld, contained in his original despatch to Bathurst and taken up in all immigration propaganda, contained a terrible half-truth. He had described the countryside as 'the most beautiful and fertile part of the settlement', and declared himself at a loss as how to describe it, unless by saying that it 'resembles a succession of parks from the Bushman's River to the Great Fish River in which, upon the most verdant carpet, Nature has planted in endless variety'. That was fair enough, but His Lordship, partly out of ignorance and partly out of wishful thinking, proceeded to add that the soil was marvellous and suitable for both cultivation and pasturage.[17]

In fact it was nothing of the kind. After several crop failures,[18] Daniell was among the first to perceive that the salvation of Albany lay in wool. Along with two other half-pay English officers – Thomas White of

* The erfs at Sidbury Village were deductions off Bushy Park. Daniell seems to have leased them initially and then sold them off in the 1840s.[13] In the event the new owners were obliged to pay in small amounts to the insolvent estate.

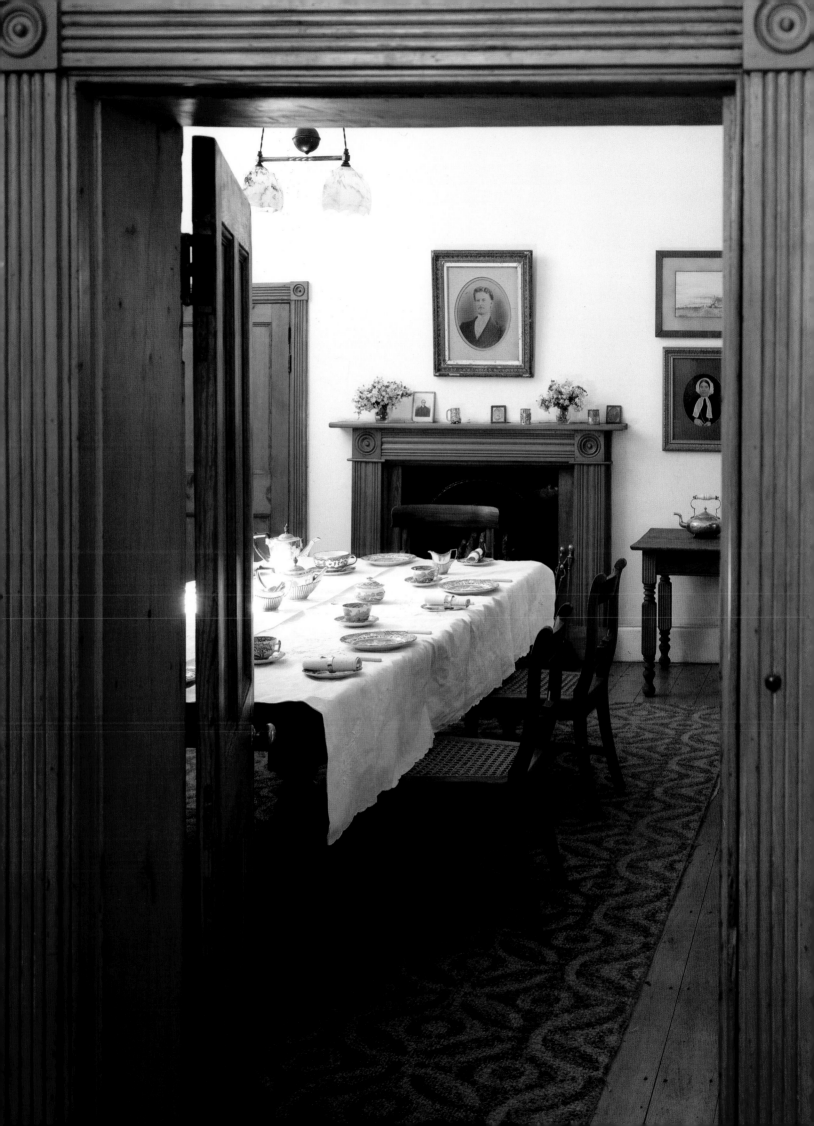

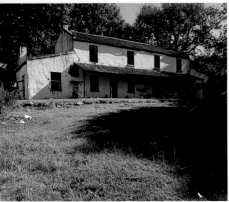

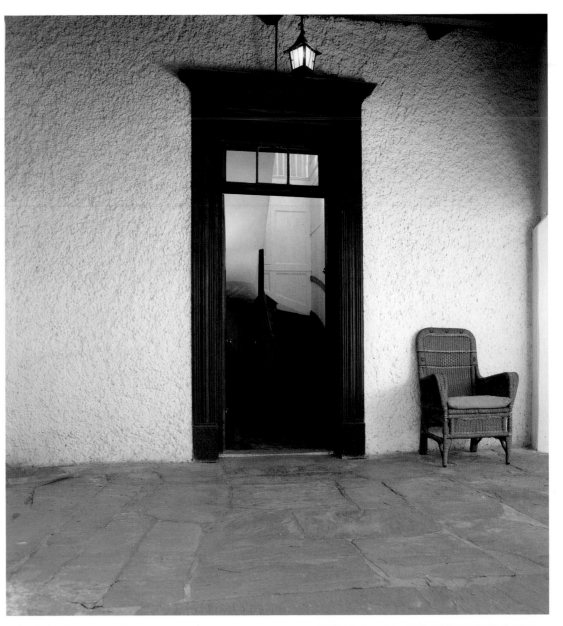

TOP. Upper landing and passage showing typical joinery and the wide yellowwood floorboards.

ABOVE. The gardener's cottage which stands above the terraces of the old kitchen garden three miles away. Simple settler architecture, this charming dwelling was restored fifteen years ago, but has subsequently fallen into complete ruin once more.

ABOVE RIGHT. The front door surround is pine left in its natural state. The simple staircase and trunk cupboards on the landing may be seen inside.

BELOW RIGHT. Sidbury church. Originally of unplastered stone and erected in a crude Greek Revival style (as was St John's at Bathurst), it was also designed as a fortress and used thus in the 1846 – 1847 frontier war.

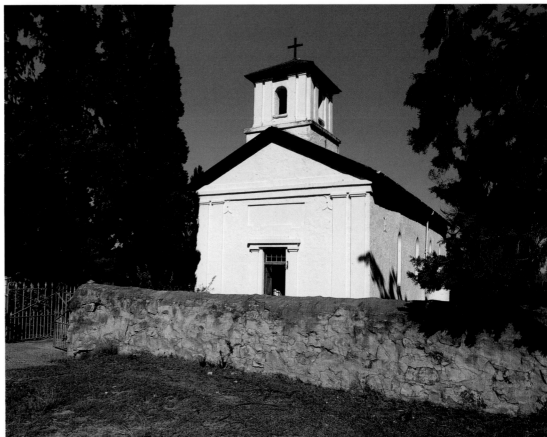

Table Hill Farm and Charles Griffiths, with whom he entered into a partnership, he acquired in Port Elizabeth some merino sheep destined for Australia. Although the partnership with Griffiths ended in 1827 and to Daniell's detriment, he took up sheep farming again and with such success that by 1832 he was clipping a hundred pounds of fine wool. He improved his flock with imported stock and is justly accredited with being one of the founders of the South African wool industry.[19]

The Daniells weathered the Frontier War of 1834–1835 better than most. Situated south of Grahamstown, they were appraised of the impending attack. The family refugeed to Port Elizabeth and Daniell with his Hottentot servants drove his whole flock, now numbering 4 000 choice merino-type sheep, the fifty miles (eighty kilometres) south to Algoa Bay.[20]

In the event the house was not destroyed and, determined not to be downhearted by the calamity that had befallen the rest of the district, Daniell proceeded with his plans. The village went ahead and, with it, plans for the church. At the meeting convened at Sidbury Park in 1837, Daniell was elected chairman of the Building Committee. Funds began to pour in. The Lieutenant-Governor set the ball rolling with a 'handsome donation'; the Bishop of London subscribed (much local gratification being occasioned by this); Sir Benjamin D'Urban sent £20. Tenders were called for in August 1838, and with full ecclesiastical ceremony and before all the Anglican clergy of the Eastern Province (this latter much to Daniell's satisfaction) the foundation stone was laid by the Lieutenant-Governor on 31 October 1838.[21] The stone (now plastered) church was sturdily built in a simple Greek Revival style and designed not only as a house of worship but also as a fortress and place of general refuge in time of attack, its square turret or belfry serving as an observation post. It was used thus in the Frontier War of 1846–1847.

Ann Daniell, who witnessed the foundation laying ceremony, never lived to see the building completed. She died on 19 February 1839 and hers is the oldest tombstone in the churchyard. Within three months, to the consternation of the whole district, the widower had remarried. In accordance with that most recurring of rural colonial scandals, Daniell had chosen his children's governess as his new bride. Not surprisingly, the second Mrs Daniell was not considered quite the thing – a few too many airs and graces seem to have been the problem, as Mrs Rice Smith took little time in informing her sister-in-law. 'What will you say when I tell you that the present Mrs Daniell is seldom seen without her gold watch at her side, a handsome dress and a satin or some other fancy apron. What think you of that for an African sheep farmer's wife?'[22]

What, indeed! But evidently Harriet Daniell had no intention of worrying about the opinion of stuffy neighbours, for it was presumably at her insistence that Richard added the new ballroom – a rather elaborate name for a medium-size room (it was thirty-three and a half feet by twenty-four and a half feet and was adjoined by a small anteroom) on the second storey of a new wing built at right angles to the house.[23] In fact, it was not solely intended for the entertainment of his wife and the officers from the garrison: it had a ladder-like staircase, loopholes (rather than windows) and was built over the kitchen cellars and a well. The yard behind the house was enclosed by a sturdy twelve-foot wall incorporating it with the cow byre and stables. Thus at last did the realities of frontier life come to Sidbury Park.

These fortifications were sufficient to protect the house and inhabitants but, alas, not the livestock. The excessive losses in the Seventh and Eighth Frontier Wars, added to the financial burden caused by the then Cape law of inheritance which necessitated his children being paid out their shares of their deceased mother's estate as they came of age, resulted in Daniell surrendering his estate and removing to Cape Town.[24] The technically insolvent estate sold off the remaining erfs in the village and Daniell's two sons, Charles Crawford and William Henry Daniell, bought in the farm, now 4 041 morgen 100 square roods with the deduction from Bushy Park, for £2 200.[25] They owned it until 1856 when, upon the untimely death of Charles Crawford (killed in a wagon accident), it was sold to William Wright for £2 000 of which a third was paid in cash.[26] Wright himself died three years later and the property was again put up for sale.

The story goes that at the auction an unknown face in the crowd proved the highest bidder. His identity challenged, he replied: 'My name is Cash,' and before the gaping throng walked over to his horse and produced, from his saddle bag, the buying price in gold sovereigns. It amounted to £1 800,[27] illustrating all too clearly the sad decline in the value of Eastern Province farms.

The new owner's real name was Thomas Berrington. With his wife and infant son he had arrived in Algoa Bay with Mahoney's party in April 1820. They had originally settled in the Cuambs area, but by 1826 Berrington had moved to Port Francis (now Port Alfred) where he ran the inn (now the Victoria Hotel) – 'floored throughout and tastefully fitted up', said its sale notice[28] – and a successful ship's chandlers. He is listed as a director of the Albany and the Grahamstown, Bathurst & Kowie shipping companies.[29]

In contrast to Daniell, his origins, though quite respectable, were humble – the old 'yeomen stock' story again, and having made the capital he hitherto had lacked, he had decided to become a gentleman farmer. Here, then, was a more typical colonial success story, for from unexceptional beginnings he had succeeded in acquiring one of the most prestigious estates in the Eastern Province. One hundred and twenty-five years and six generations later his descendants still farm Sidbury.

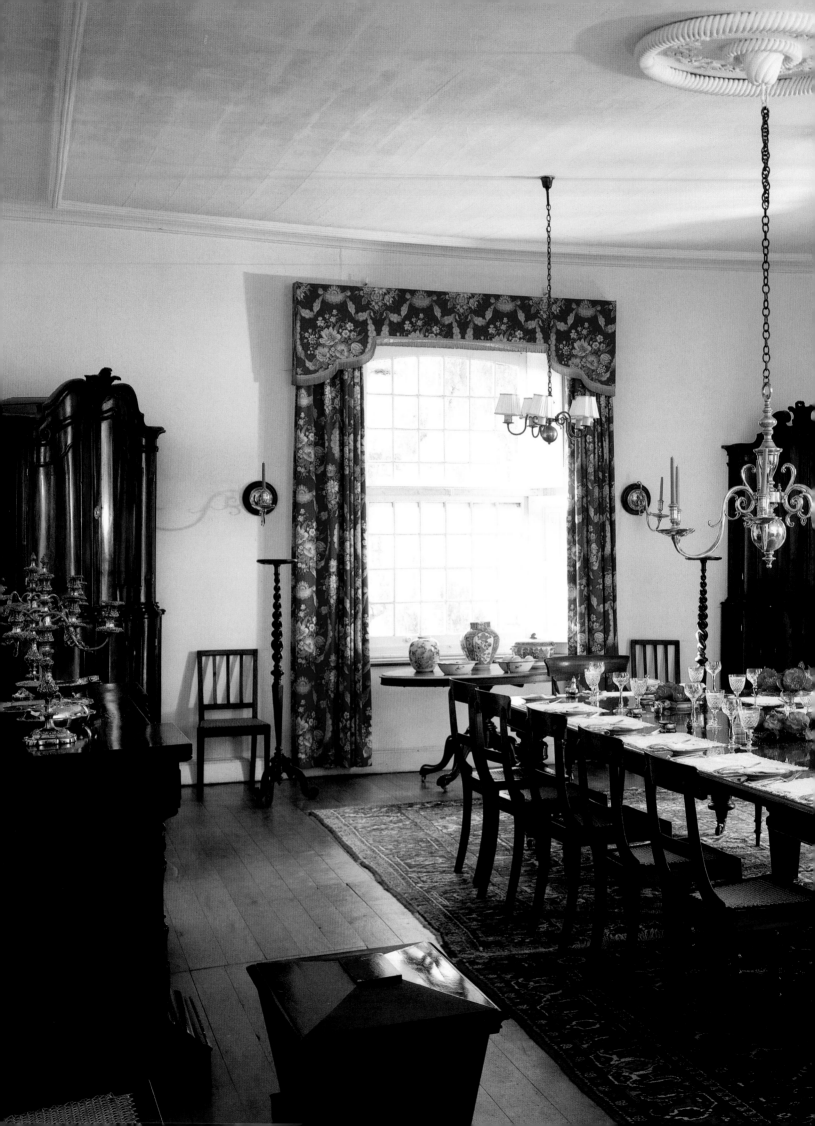

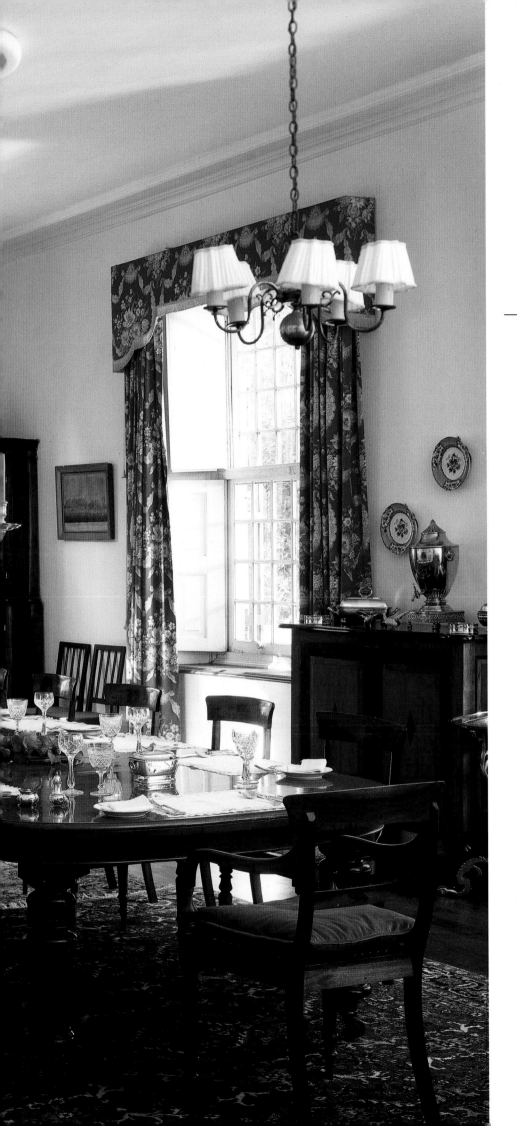

KERSEFONTEIN

BERG RIVER, SANDVELD

PREVIOUS PAGE. Dining-room. It is amusing to compare this generously and well proportioned room built around 1830 – note the skirtings, receded cornice and central rosette – with the banqueting hall at Government House (see page 73) which was almost certainly something of a prototype for it. The dining-room chairs are Cape Regency, the table, wine cooler and sideboard are William IV or early Victorian. The side chairs were *kerkstoele* in the Lutheran Church, Strand Street, which was built by the first Martin Melck; the Nanking porcelain is the remains of the family's original dinner service. The Melck stinkwood and ebony corner cupboards with their silver escutcheons by Johannes Lotter are undoubtedly two of the most exciting pieces of eighteenth-century Cape furniture.

BELOW. Library fireplace. A very early Cape Regency fire surround, possibly put in by the Kirstens. It would have represented the acme of contemporary comfort (and chic) in the Sandveld of the 1800s.

It is generally maintained that isolation confers a romantic air on all but the most utilitarian of dwellings. It is difficult to explain rationally just why this should be (and certainly one can think of many examples to disprove the general rule) but perhaps the notion arose because remoteness often ensures the preservation of styles long since dismissed as unfashionable in more populous areas. Then again and rather less tangibly, it must be conceded that the sense of delight in coming across a substantial house filled with treasures in an area wild and remote is sharpened by the unexpected nature of the find. Certainly, Kersefontein has a remote feel about it. It is not an architectural gem – having been added to from generation to generation – nor is it picturesque in the conventional sense of the word. Yet it is one of the most romantic of the Cape manors (and by moonlight, when the whole Sandveld seems luminous, almost unbearably beautiful) more, perhaps, for the latter of the two theories suggested above. For how much more entrancing to find this splendid grouping of outbuildings and a house filled with the furniture of seven generations in the middle of the inhospitable sandy wastes and winter vleis of the West Coast.

The story of Kersefontein is very much the story of the Melck family. The first Martin Melck purchased Kersefontein (or Karsefontein or even Karsje Fontein as it was sometimes written)* in 1770[2] from the widow of Johannes Cruywagen who had been granted the original freehold in 1744.[3] Included in the sale was the farm St Helenafontein and the total cost was 30 000 guldens, divided as to 10 000 for the farms and 20 000 for the movables – this latter including livestock, farm equipment and, presumably, the nineteen slaves who are listed by name.[4]

The original deed described the farm as a '*zeker Veepost*' ('certain grazing post') and it was precisely for this that Martin Melck intended to use it. He already possessed eight other farms, which comprised some of the finest agricultural property in the Cape – a remarkable settler success story by any reckoning for one who had arrived in the Colony as a soldier only twenty-four years previously. He had been born in Memel in East Prussia and after finishing his apprenticeship was admitted to the Masons' Guild in Riga in 1744. It was an unpropitious time for aspirant builders – the German states were devastated in the wake of the Thirty Years War – and the young man joined the steady stream of his contemporaries who poured across into Holland – so peaceful and prosperous – in search of betterment. Like many others, he joined the Dutch East India Company as a soldier and was despatched to the Cape, arriving with Major Meinhertzhagen's party in Table Bay in 1746.[5]

As was the practice of the time, the young Melck was hired out as a *knecht* or assistant both to the Gibbelaars at Elsenburg and at the Simonsberg mine.[6] He also set about putting into good use the knowledge he had acquired at Riga – not for nothing

*During the nineteenth century and right up to the last generation, it was familiarly referred to and invariably known as Berg River Farm. It appears thus in letters, documents, photographs and in the then Mrs Melck's contribution to Hildagonda Duckitt, the Cape's Mrs Beeton.[1]

did his testimonial from the Guild describe him as 'industrious'[7] – and in 1749 his name appears in the minutes of the Landdrost and *Heemraden* as a purveyor and cartage contractor of building materials.[8] Business must have prospered nicely for in 1750, the year when he was released from the Company's service, he acquired two farms (Aan't Pad and Watergang), purchased for 4 000 guldens of which he actually paid 2 000 in cash.[9]

Two years later he married his former employer's widow, Anna Gibbelaar, and, since under Roman-Dutch law marriages were almost always in community of property, also acquired Elsenburg and Mulder's Vlei. Thereafter there was no looking back. He became the leading wine farmer of the Cape and between 1760 and 1780 was twelve times awarded the lucrative wine and brandy contract, in one year cleaning up to the tune of 100 000 guldens due to the arrival of the French fleet.[10] By 1776, six years after he had purchased Kersefontein, he owned ten farms, two further leasehold properties, 203 slaves, 170 horses, 1 312 head of cattle, 4 161 sheep, 106 pigs and 200 000 vines – the entire estate being valued at an astonishing 240 000 guldens.[11]

Happily the unattractive traits which so often accompany newly acquired fortunes were absent, and what an agreeable chap he sounds. He remained touchingly devoted to his wife – repeatedly acknowledging her as the source of his prosperity and even seeing to the running of the household in order that she might 'enjoy undisturbed leisure'.[12] He also remained a fervent Prussian – his loyalty to Frederick which intrigued Stavorinus is still to be evidenced in the splendid royal coat of arms inlaid in wood at Elsenburg – and a devout Lutheran. He donated a warehouse in Cape Town for the worship of his co-religionists (this of course was in the days when the Lords XVII permitted no religion other than the Dutch Reformed Church, though the more liberal governors, such as Tulbagh, turned a blind eye to the goings-on at Strand Street)[13] and the adjoining plots were made available for the parsonage and a house for the beadle. They survive there today for all the world to see, a fleeting reminder of the charm of late eighteenth-century Cape Town. In the best ecumenical spirit he donated 2 000 guldens for paving the floor of the Dutch Reformed Church in Stellenbosch (it was finally used for the silver plates, chalices and font)[14] – in retrospect, not at all the 'generous impulse', as Dominee Appeldoorn described it, for it was his beloved wife's church and four of their infant children were buried there. He was distinguished by his good treatment of his slaves (which were legion) and was made *Heemraden*, an appointment apparently not based solely on his wealth for his peers acknowledged him to be notably intelligent and articulate and he impressed visitors with his progressive views – only see the favourable impression he made on Stavorinus by comparison with the 'happy unoffending children of nature' as the traveller described the Albertyns at De Klapmuts close by.

Needless to say this Martin Melck did not live permanently at Kersefontein though he and his son may have visited it from time to time. Isolated as it appears

now, it must have been positively in the wilds then – indeed, the previous owner habitually conducted sorties against marauding Hottentots from the farm – and the place would hardly have held overwhelming attractions for the builder of the splendid new manor house at Elsenburg. Except perhaps its solitude. A close study of inventories suggests that he might have retired there after his wife's death, for he built two new barns (for the barley and wheat crops he had introduced), a stable and a millhouse,[15] and, in addition to more elaborate furnishings, may have added on to the existing gableless, T-shaped farmhouse. This is clearly to be seen in Colonel Gordon's sketch (*circa* 1790), evidently having already been altered from earlier, more modest proportions. It faced west down the Berg River, just above the drift, the old wagon track continuing its way up what is now the lower lawn.

When Melck remarried after the death of his first wife he took out an antenuptial contract[16] – a most unusual step in those days. It was a precaution. No one knew better than he the advantages to be reaped by marrying a rich widow in community of property but clearly should he die, any Melck widow was an ideal catch for less scrupulous fortune-seeking adventurers. Alas, his long-awaited son and heir which Anna Gibbelaar had produced in her forty-third year after ten years of marriage, was not so farsighted.

He had been christened Marthinus in deference to an earlier infant son, Martin, who had died. Youth and riches in liberal quantities often lead to excesses and Marthinus was evidently a rather wild young man. Hendrik Cloete, a marvellous source of Cape gossip for this era, describes him as dissolute even in his married estate. This latter he entered only after several changes of heart, for his engagement to Miss Kriel of The Paarl was broken off twice before their wedding in 1786.[17] They must have made quite a pair. Pretty and fun-loving, she is forever branded as flighty in family lore,[18] and small wonder. Barely a year after the birth of their first child, fortunately a son, the second Martin Melck died. There was an immediate dispute over the will. The Orphan Chamber (the equivalent of today's Masters Office) maintained that it was irregular; the Court of Justice upheld it and the matter was referred to the High Court in Batavia. Naturally all this delayed the settlement and in the interests of producing ready cash the executors arranged to realize some of the assets. Kersefontein and St Helenafontein were sold.[19]

The purchaser of these farms, Jan Frederick Kirsten, was one of the executors of the estate and well-known to the family – his father was another successful German settler and a crony of old Martin Melck, the two having both been elders in the Lutheran Church together. Young Mr Kirsten now saw his chance. He seduced the pretty young widow – their first child was born six months after the marriage – thereby not only successfully retrieving his capital outlay, but also acquiring the other Melck properties – farms, townhouse, warehouses, the lot.

He really does seem to have been a very smooth operator. When the British first occupied the Cape in 1795, he wrote a long and toadying memorandum to

TOP. Colonel Gordon's watercolour (*circa* 1790) showing the *Veepost* and the gable-less, T-shaped farmhouse already enlarged beyond its original stoep.

CENTRE. Poorteman's sketch (*circa* 1840). The house already enlarged with the two gables, one half-hipped, the other straight, projecting backwards and the barley-stick chimney between them. Berg River Farm, as it was then known, was already famous as a stud. The slave quarters are to the left.

ABOVE. Kersefontein *circa* 1924. The present Martin Melck with his parents and governess (?). Behind them the three half-hipped side gables.

RIGHT. Arthur Elliott's depiction of the coach-house gable in the 1930s with the seventh Martin Melck and his sister Moira. (A Elliott, Cape Archives)

BELOW. Entrance gates to Kersefontein, surrounded by the Sandveld's spring flowers.

BOTTOM. The view down the *werf* lined with gum and pepper trees has hardly changed since Poorteman sketched it *circa* 1840.

FAR RIGHT. Coach-house. The very rustic segmental-topped gable (derived from those at Newlands and Stellenberg) may well have been added by the first Martin Melck when he was making his improvements at Kersefontein. The cobbled ramp is still original though the entrance has been widened for modern vehicles.

the new Government full of useful tips and ingratiating sentiments.[20] He was also a great urger of the development of the land around Saldanha Bay – something clearly in the best interests of the owner of large tracts in the vicinity. It is possible that his eagerness to support the new regime left him awkwardly placed after their sudden withdrawal in 1803, for it was in the remote solitude of Kersefontein that Lichtenstein found the couple in October 1803[21] – well away from their irate fellow-burghers.

Their sojourn there can only have been a temporary removal. 'I have no intention of burying myself in the sand!' Mrs Kirsten is said to have exclaimed[22] and, indeed, the couple had always lived in the greatest style. Mrs Kirsten was reputedly one of the few ladies in the Colony who did not rise for the Governor and her smart equipage and entertainments were much commented upon. Slowly the Melck fortune was squandered. As Kirsten's schemes and speculations came to nothing the farms were sold off – both Elsenburg and St Helenafontein went in 1801[23] – and by the time the third Martin Melck attained his majority only Kersefontein remained.* In that year (1808) it came up for auction and by borrowing money the young man purchased the farm.[24] Henceforth it was to be the main seat of the Melcks.

Four years later Martin Melck married Miss Anna van Reenen. Like her husband she had spent her youth in a substantial house (her family had lived at Welgelegen in Mowbray and her cousins lived at Papenboom) and she must have viewed with some dismay the prospect of settling in the inelegant dwelling which, while adequate to the requirements of the *Veepost*, was hardly suitable as a permanent home. It was in this generation and not, as has been previously believed, in the days of the fourth Martin Melck, that the house was altered to what is substantially its present form. Poorteman's sketch (*circa* 1840) shows the transformation to have already taken place, the two half-hipped gables projecting northwards and a deliciously long barley-stick chimney rising between them. The young Melcks were mortgaged to the hilt and though there might have been a few initial improvements – the fireplace in the library is arguably earlier than that in the dining-room – it would seem more likely that major alterations took place around 1830 by which time the farm was flourishing. There is, moreover, a quantity of furniture – a pair of card tables, a sofa table, chairs and so on – in the front two rooms belonging to that most delightful of periods which is neither Regency nor Victorian – William IV or the Adelaide Style as it is sometimes called – and this supports nicely the dating of the building programme.

And major alterations they certainly were. The old west-facing house was swallowed up in the new structure, the rooms all making pleasant bedrooms. Two wings were added parallel to the tail of the old T, one containing the present library, the other the dining-room. A long passage bisected the house and a drawing-room – very much for best – was built opposite

* In fact reduced by twenty morgen to about forty. Doornfontein had been sold off in 1801.

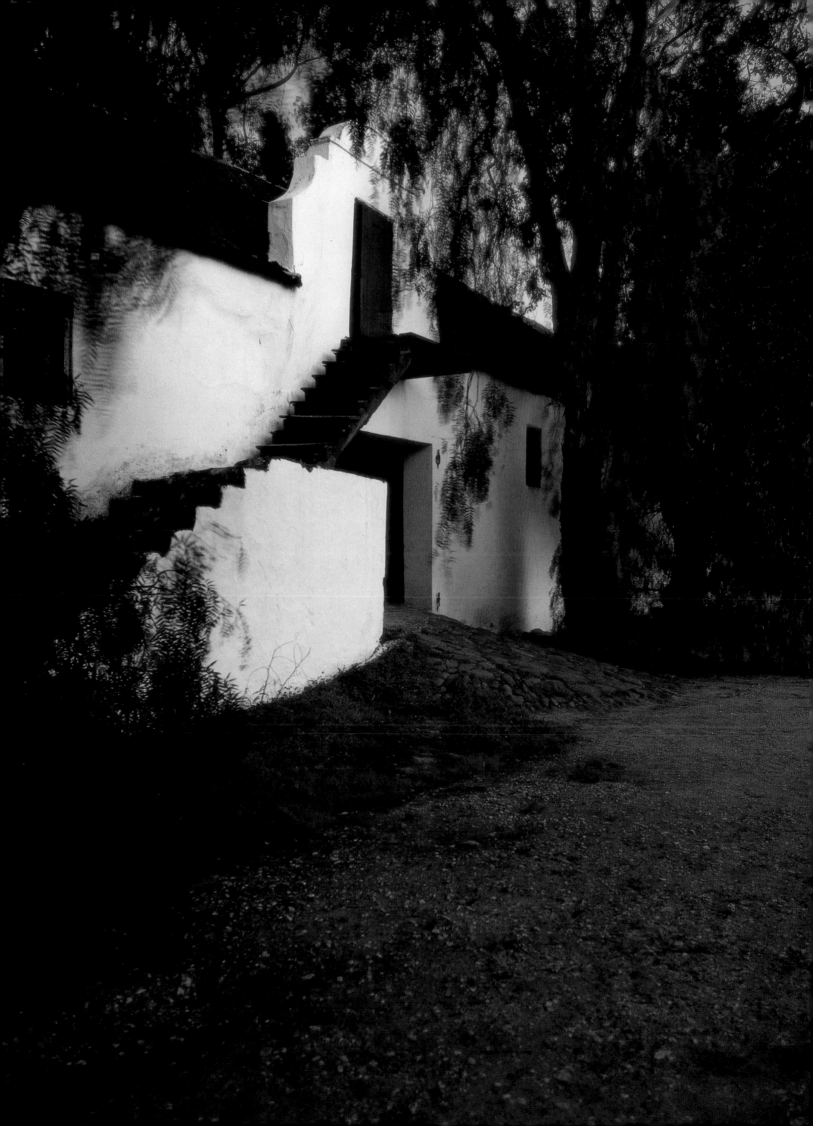

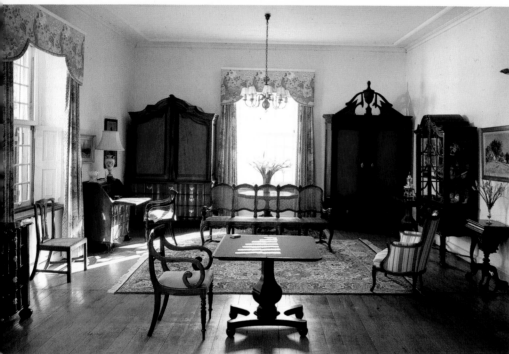

TOP. Gunroom. The equestrian photograph of Mr Melck to the left of the desk was part of a series for wartime propaganda.

ABOVE. Drawing-room. Generations of family furniture. Particularly interesting is the dowry armoire of Anna van Reenen, the third Mrs Melck (*circa* 1812), with its silver escutcheons by Twentyman and which may have been designed by Thibault. The stinkwood *rusbank* is Cape eighteenth-century, the pair of William IV card tables are designed *en suite* with the sofa tables (not shown) and these, together with a tip-top tea table, must have constituted the original furnishings for this room. At least one surviving member of the family recalls the drawing-room with heavy lace curtains, glass chandeliers (probably the originals), a lion skin and a companionable, all shrouded in the green gloom of the almost perpetually closed shutters.

RIGHT. Attic. The traditional Dutch construction still very much in evidence, with the mud *brandsolder* designed as protection against fire. This attic yielded many Cape Dutch treasures to the present family and still contains the discarded paraphernalia of generations of Melcks – the Regency pram, the hip bath, leather hatboxes, Victorian button-back chairs and even a gramophone. The skull beneath the window is that of the last hippopotamus in the Berg River, shot by the then Martin Melck in 1867 after it had drowned his valet! For a hundred years its ghastly visage gazed down on the dining-room table. The attic also provides a home for the unique *Eptesicus melckorum* bats discovered by Roberts in 1919 and whose nocturnal sorties provide a Gothic touch to the long passage below.

ABOVE. Martin Quartius Melck.

RIGHT. Bedroom. The handsome Melck four-poster is Cape.

the dining-room, thereby creating, with the front door, a new south façade.

The actual construction of the house was, of course, very much in the Cape Dutch tradition – random stone foundations, mud brick walls, a mud *brandsolder* and thatch roof. The half-hipped roof-ends (the curvy gables are all twentieth-century embellishments), the eyebrow gable over the front door and the curved tops to the sash windows are all typical of the early nineteenth-century vernacular style still found on the West Coast. Within, however, no attempt has been made to reproduce the traditional *voorkamer/agterkamer* plan or even to make the house an H-shape which was so often the solution to the problem of inadequate accommodation. Only a passage runs down the length of the house and the sizeable dining-room and drawing-room are obviously designed for their respective intended purposes. The ceilings are boarded and corniced and particularly attractive rosettes supplied for hanging chandeliers in the front rooms. Two fireplaces – an amenity notably absent in Cape Dutch houses – are provided in the main living-rooms and must have represented the acme of modern comfort in the Sandveld winters of the 1830s.

Inevitably the reasons for these changes were as much social as stylistic. The British had repossessed the Cape in 1806 and it was not long before many of the leading Dutch families gravitated towards the new and patently more sophisticated governing class. Then as now the new and fashionable held an irresistible fascination and the recently old made to seem inelegant and provincial. As a leading Cape family, the Melcks would have been invited to Government House on important occasions. Like his grandfather, the third Martin Melck was likeable and popular – the Earl of Caledon for instance, was a particular friend,

and gave him a splendid new Joseph Manton[25] – and with their connections the couple would have returned regularly to Cape Town.

Moreover, it was the third Martin Melck who developed the famous stud at Kersefontein and this alone would have ensured an increasingly anglicized circle. His stepfather had imported one of the first thoroughbreds to the Cape and stabled it at Berg River and the third and fourth Martin Melcks were to continue this practice, purchases often being made on the strength of oil paintings sent out from England. Great stables were built, some of which survive. The area proved disease-free[26] (and is advertised as such in Kirsten's sale notice of 1808), the terrain ideal and the stud flourished. Lord Charles Somerset stabled some of his horses there and was a regular visitor. Such, in fact, was His Lordship's enthusiasm that one of his favourite rides was the sandy eighty miles to Kersefontein and back, which amazingly he managed in a day, grooms going ahead with five changes of horses along the way.[27]

In the letters and memoirs written by children of the house a picture emerges of the changing face of the established and still influential Cape squirarchy in the second half of the nineteenth and the early twentieth centuries[28] and until recently there were elderly relations who recalled the time when only English or *Hoer Duits* was spoken in the household and 'kitchen Dutch' punished by the offender's being sent down from table. The fourth Martin Melck, who married a Miss Myburgh (and thus re-established a link with Elsenburg), was returned as a member for the Upper Western Circle in the new Cape Legislative Assembly, necessitating four-month annual stays in Cape Town. His children were educated there – his sons at Bishops, his daughters at various ladies' academies. Through marriage they were connected with most of

the other important landed families – the Duckitts at Darling, the Cloetes at Alphen, the Myburghs at Elsenburg, the Van der Bijls at The Grange (Groote Schuur) and even Mrs Koopmans de Wet – and this involved an endless round of extended country visits. Every year between April and June shooting parties would arrive, and the mounted shoots often included the Governor and members of his suite, or officers from the Garrison or the Fleet at Simon's Town.

In addition to the stud, winter wheat, sheep, beef and dairy cattle were farmed. They still are. Unlike so many other Cape estates, Kersefontein was never entailed, though by custom the older generation would retire at a suitable juncture and thereafter receive rent for the farm until their death. On the estate lived the family (and a governess if there were children) and about twenty labourers' families descended from the original Hottentot and imported slaves. There were also the head groom – for years a Scot named George who had arrived with one of the imported mares and stayed on[29] – a *mak familie*, the head of which for three generations was the farm foreman, and a family of *bywoners*. There was also a school teacher and his wife who taught at the farm school established by the fourth Mr and Mrs Melck for the children of the poor whites of the district. It was a social structure and in some ways a way of life that was to vanish completely after the Second World War.

Not many South African houses or estates are fortunate in having survived in the same family for generations. As a postscript, therefore, it is worth recording now the process of modernization that has continued in the twentieth century, almost imperceptibly with every new convenience so readily embraced that it was soon impossible to recall life without it. In time a pontoon, operated by the estate, replaced the drift across the Berg River until that too was replaced by a bridge built by the Provincial Authorities in 1932.[30] The first car (probably the first in the Sandveld) was purchased in 1910, the first telephone connected in 1919 – a ten-mile private line was erected to the Hopefield exchange by the present owner's father to obviate the irritations of a party line. The house was wired for electric light in the early 1920s, at first supplied by a battery and finally by ESCOM in 1974.

Yet the sense of isolation remains. On a rise beyond the long row of outbuildings, beyond the cowsheds and stables and the drinking troughs, is a graveyard. Within its four whitewashed walls and protected by a crested cast-iron gateway lie the graves of successive Melcks – Gothic plaster tombs side by side with polished marble tablets – and further on are buried the families who for as many generations have worked the farm. The weather has all but obliterated the High Dutch creeds and Anglican texts, and of the staff graves nothing tangible survives but the reasonable expectancy of homemade wreaths and wooden crosses and living memory's brief span. It is not a place of beauty, but after the winter rains, when under the great blue sky the moths and butterflies flit among the daisies and *bessiebossies*, the flax and the *vygies*, it has a roaring solitude that is, for all who have known it, unmistakeably African.

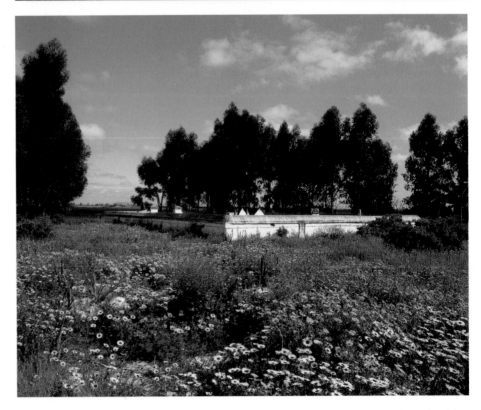

TOP. The Berg River which flows at the bottom of the garden. The old drift was sited fifty yards on, the old pontoon a quarter of a mile away.

ABOVE. Graveyard, spring. Here lie the successive generations of Melcks, surrounded by the graves of the families who have worked the farm.

BARVILLE PARK

LOWER ALBANY

PREVIOUS PAGE. Fortress-like, Barville Park stands above the Eastern Province bush, the barn to the left intended for the last stand in a final shoot-out, the loopholed stone walls encircling the cattle kraal to the right.

TOP. Mr Stephen Dell.

ABOVE. Mrs Dell.

RIGHT, TOP. The simple cottage, built for the manse, which is believed to have also housed the schoolroom and the chapel.

FAR RIGHT, TOP. The enfilading firing embrasure in the wall above the cattle kraal.

RIGHT. The main house with its straight end gables, very much like a farmhouse in the north of England, but surrounded by loopholed stone walls. The barn is placed in the position recommended for a sentry box in Alexander's Report, with the loading platform permitting raking fire across the gate. The remains of the old rose garden can be seen in the foreground.

Barville Park stands astride a hill, bleakly exposed to the elements and overlooking great expanses of the Eastern Province bush. The house itself is an unpretentious double-storeyed dwelling, so much like a farmhouse in Cumbria or Northumberland that, as Lewcock puts it, one is left in no doubt as to the origins of its builder, if not its owner.[1] Yet the similarity ends there. For the farmyard and outbuildings are surrounded by a sturdy, loopholed stone wall so that from a distance the complex resembles nothing so much as a fortress and, wonderful though the views are, it is immediately obvious that strategic, rather than aesthetic considerations dictated the siting of the house.

Fifteen years separate the building of Barville Park and the simple Regency villas which the more affluent of the 1820 Settlers built in attractive or well-watered positions.* This reversal of the conventional progression in domestic architecture from fortress to residence is easily explainable. The original settlers had paid little heed to the veterans of 1819 who had argued the necessity for defence measures in building and, fifteen years after their arrival in Africa, their confidence seemed to have been well justified. By 1834 a measure of prosperity, engendered by flourishing trans-frontier trading with Kaffirland rather than the infant wool trade,[2] was evident right across the Albany District where newly painted and thatched farmhouses and villas (bow-fronted Hilton is the elegant swan-song of this era) stood in 'fancied security' surrounded by maturing gardens and well-stocked farms.

Then suddenly and without warning, this picturesque and almost fashionably *rustik* little settler world was all but destroyed. On Christmas eve 1834 twelve thousand Xhosas swept across the border and in one short week laid waste, as William Shaw, the Wesleyan missionary put it, the entire labours of fifteen years.[3] Grahamstown itself was barely saved and when, after peace was concluded in September 1835, the settlers returned from their refuge in the towns, it was to a scene of terrible desolation. The Xhosas had sacked and burnt 456 farmhouses and driven back into Kaffirland 114 930 cattle and an even greater number of sheep and goats.

Clearly if the repeat of such a catastrophe was to be avoided stringent measures – either of defence or deterrence – would now have to be taken and in the Cape as well as Whitehall (who were expected to foot much of the whopping great bill for settler claims) there were voices raised for the need for more defensive frontier architecture. Prominent amongst these was the Governor's aide-de-camp, Captain J A Alexander, who wrote a report which Sir Benjamin D'Urban caused to have printed in the *Graham's Town Journal*. It duly appeared on 13 August 1835 accompanied by a strongly worded recommendation from His Excellency to take the advice seriously – an admonition quite unnecessary, it may be supposed, after the horrors of the preceding five months.

Alexander's report[4] is a fascinating piece of Africana. It cites, by way of example, a wonderful range of easily emulatable fortified architecture: the farmhouses of the French in Canada, Cossack look-out houses in the Caucasus, farm buildings of the Spanish Plain, Persian mills, Indian frontier posts are all included. At the same time zinc roofs, kaffirboom shingles, sod walls, entry boxes at kraal gates, loopholed walls with towers for flanking fire, homemade grenades ('tied to make it resemble a shuttlecock') and hedges of aloes and prickly pears are all recommended to enable 'the enterprising farmers of the frontier to labour in peace, sleep in security and with assistance of the regular force, defend their properties against all inroads.'

One such enterprising farmer was Stephen Dell who was a boy of eight when his family arrived on the Eastern Frontier with Thornhill's party in 1820. The Dells had settled in the Bathurst area and in December 1842 Stephen had acquired Barville Park for £1 200.[5] The vendor, George Wood, a settler turned land speculator, had got a good price for he had, in fact, purchased Barville Park from a William Campbell only two years before for a mere £750.[6]

All over the English-speaking world the origins of many immigrant families have been embroidered by subsequent, more prosperous generations, but William's father, General Charles Campbell, had a genuine claim to be a gentleman settler. He was the fourth son of the seventeenth laird of Barbreck House, comfortably off (for he financed his own settler party as well as his family's elaborate removal) and with a not undistinguished military career.[7] The modern reader, well versed in tales of Europe's poor and oppressed making good in the New World or the colonies may well wonder at the possible attractions that so remote a colony may have had for such an individual. Obviously the possibility of acquiring landed estates and the consequent assurance of a social status hitherto enjoyed had attractions to a well-born fourth son,[8] but needless to say a few cursory probings reveal another motivation. Forty-odd years previously Campbell had divorced his first wife, Harriet Fraser, for incestuous adultery with her uncle, and the then required Act of Parliament awarded him £3 000 in damages.[9] This in itself was sufficient to cause a minor scandal but within two months of the first Mrs Campbell's second unsuccessful appeal against the divorce, Campbell almost completely wiped out his credibility as the injured party by marrying[10] a woman by whom he already had two children. After her death, he had married his third wife in Newfoundland[11] where he had been appointed GOC Colonial Forces, and it was she who accompanied her husband to the Cape. A girl of undistinguished parentage ('agreeable and lively, but not very genteel or correct', was the Austen-like pronouncement of Mrs Philips, her nearest neighbour in Lower Albany**)[12] she was unlikely, even without the lingering scandal attached to her husband's name, to have been favourably received back in Argyllshire.

Campbell had planned his removal on a grand scale. Wishing to avail himself of Bathurst's offer of a land grant to all who would, at their own expense,

* See Sidbury Park.
** A marvellous example of imported snobbery: both ladies resided in wattle and daub houses!

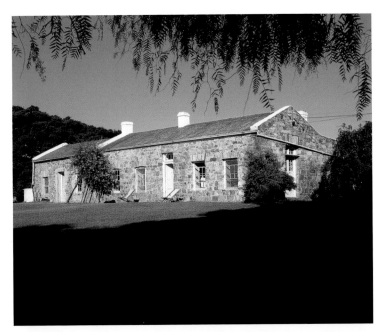

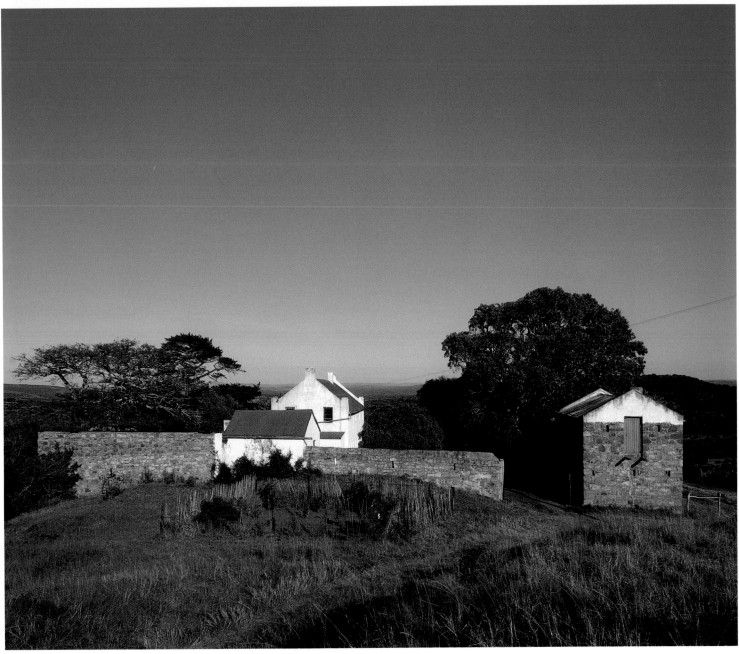

BELOW. The old kitchen with its open range. The table was made from teak beams of an early bridge over the Fish River which was washed away in 1874. The ladder-like staircase rises on the extreme right.

RIGHT. Hall-cum-sitting-room. Yellowwood ceilings and floors and Regency fire surround. The stinkwood chairs are Eastern Cape (*circa* 1835), the sofa about 1840, the military chest is late eighteenth-century English. The small parlour 'for best' was situated through the door beyond. The window shown replaced the original sash.

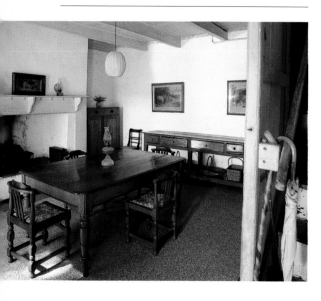

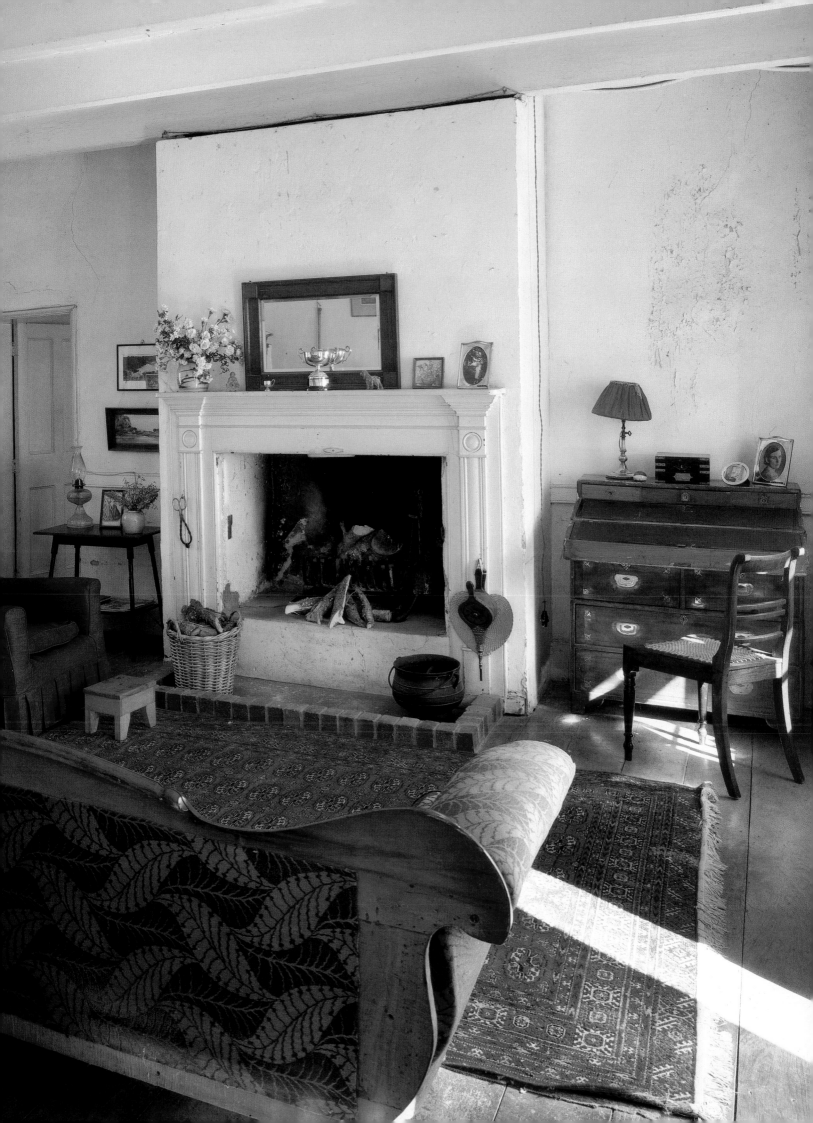

Upstairs passage and the rooms created by yellowwood partitions amongst the stout construction beams. The floor is also yellowwood.

take out a number of settlers and servants – one hundred acres for every male above seventeen years actually settled on the land granted were the terms – the General's original intention was to finance a large party wildly anticipated at the Cape as numbering between 100 and 400 persons. In the end only 47 came, but Campbell's connections and capital were sufficient to ensure preferential treatment from Sir Rufane Donkin, the acting governor, who had visions of raising 'a sort of aristocracy or gentry in Albany'. In consequence, Donkin had no qualms in relocating the somewhat humbler Salem party and directing to its lands the advance Campbell party. This included the General's bailiff, Cypress Messor, who was to erect provisional buildings and commence cultivation. The projected land grant to Campbell included both Barville Park and the adjoining farm Elmhurst, originally named Reed Fountain.

A report back from Messor shows only too clearly the colonial squirarchy Campbell envisaged for himself: 'It [the countryside] is like a gentleman's garden, decorated with clumps of all sorts of flowering shrubs as if it had been regularly planted ...'. There were plans to found a village, though the General would be 'a good distance from other inhabitants ... and will have a very pleasant place close to a wood, where I can with little trouble cut avenues for him and his family to walk in the shade all day and will have a river running nearly all round his house.'[13]

These visions of county life transplanted to the colonial bushveld never, alas, materialized. Shortly after his arrival at Barville Park – as the place had been named apparently in deference to the family house in Scotland – Campbell was thrown from his horse and died. His widow struggled to farm the estate for several years – the original perpetual quitrent grant

for 2 381 morgen dated 1826 is in her name.[14] She lived in a U-shaped wattle and daub house which stood near the bridle path between Bathurst and the Theopolis Mission and which Mrs Philips, in a more charitable vein, described as 'a very sweet place [with] a pretty, neat little cottage on it, tastily fitted up'. But the planned mansion and village were never built and the immense quantity of building, farming and household effects which Campbell had brought out with him – the six-panelled doors, the five pairs of half-light chamber window sashes, the Brussels carpet, Pembroke table, pianoforte, cane lounging chairs, table to seat twelve, fifty-eight bottles of port wine, clothes, linen, jewellery and toilet articles including four pounds of violet hair powder – all this and much more was knocked down for a fraction of its value at an auction.[15]

Any such hints of Regency frivolity were, not surprisingly, entirely lacking from frontier life of the 1840s as it was perceived by the Dells. Indeed, the family had already experienced its realities at their grimmest when, in 1835, they had fled for their lives to Grahamstown before the Xhosa hordes. Stephen began building Barville Park in 1843 or 1844, assisted by his younger brother, Sam, and one Geach, who was either a friend or tenant. The place was completed by 1845 until which time the Dells lived in two successive wattle and daub houses, the first of which may have been Mrs Campbell's.

The farmhouse is simple indeed. It is constructed out of locally quarried Bathurst limestone ('In culler ... very much like the Bath Stone onley thear is very hard semes in it', according to Goldswain),[16] a seam of which extends along the coast with outcrops here and there including one, fortuitously, at Barville. The entrance is straight into a hall which would have been used as a living-room, with a parlour to the right (for best) and a kitchen with a large open range to the left. The two living-rooms and at least one bedroom had fireplaces with pretty surrounds and an enclosed, ladder-like staircase shoots straight out of the kitchen to the second storey of four bedrooms carved out among the stout beams of the roof with yellowwood partitions. The roof would probably have been of roofing felt (asphalted) which was available in the Eastern Province at this time. The present corrugated iron must date from after the 1850s.

Dell had paid full heed to D'Urban's instructions, for while the house itself is not fortified, it is surrounded at some distance by a wall, originally eight foot (2,4 m) high, as proposed by Alexander in line with the new 'Wellington Barrack' which contained loopholes and at least two enfilading firing embrasures designed to defend both the cattle kraal and the house. At the entrance, in the position recommended in the article for a sentry box, is a stone barn, loopholed on both floors and containing a loading platform on the upper floor permitting raking fire down the walls and across the gate – very much as Alexander suggested when describing the fortified Spanish farmhouse. Adjoining the farmyard and slightly below it is the cattle kraal, a juxtaposition which appropriately enough recalls that of the bailey to the motte in a Norman castle. Its walls are slightly higher and again loopholed to provide a line of fire down the slope of the hill.

These elaborate precautions were not unjustified. Dell was evidently a good farmer and soon prospered. He contracted on a large scale for the supply of provisions to the military authorities – Private 'Buck' Adams of the 7th Dragoons describes him rather wildly as the greatest contractor for horse forage in the colony – and by the outbreak of the Seventh Frontier War ('The War of the Axe') he already had immense stock in hand. According to Adams, Colonel Somerset had advised Dell to sell his stock (for an apparently reasonable offer) and abandon his farm to safety.[17] Notwithstanding his position as Commandant of the Lower Albany Burghers, Dell was on excellent terms with his natives and had been told by them that in the event of a war Barville Park would not be attacked. He therefore ignored the advice and held out for a better offer. In the event his trust was misplaced.

In early May 1846, the Xhosas attacked the fort where fourteen families had fled for safety,[18] the Xhosa servants' wives and children hiding (according to oral tradition) in a clay pit near the house.[19] Colonel Somerset and his men arrived in the nick of time to save the settlers – they were in 'a great state of anxiety' as may well be imagined, and exhausted with fatigue from watching.[20] All their cattle had been driven off: 'We had only a few oxen left, and not a milch cow' was Dell's sad report to the *Graham's Town Journal*.[21]

Still, it might have been worse and although Buck Adams implies the actual destruction of the house, neither Dell nor Barville Park are listed in the splendidly headed report 'Dwelling houses and stacks fired and consumed by the kaffirs in Lower Albany,' which subsequently appeared in the *Graham's Town Journal*.[22] It would not be the first instance of inaccuracy in Adams' narrative which was, after all, written forty years after the event.

Dell descendants still farm Barville and the house has survived with little alteration as the boom provided by ostrich feathers saw the building of a large, separate, well-designed ostrich-feather palace early in this century. 'The Fort', as the farmhouse is still named, now houses the estate manager.

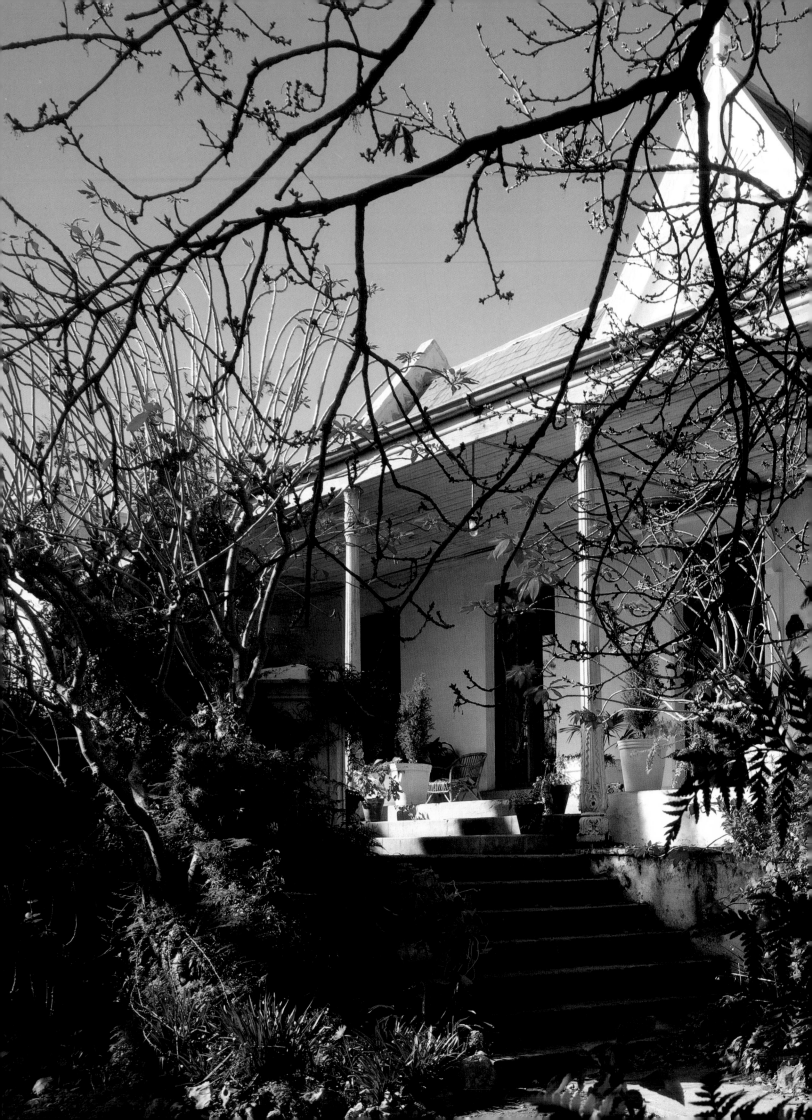

ZORGVLIET

GARDENS, TABLE VALLEY

In the early nineteenth century, the Platteklip stream, descending the great gorge that cuts into the rock-face of Table Mountain, coursed its way out into Table Valley past the municipal wash-houses and on down the steep descent through the city and into the bay. In the days before motor traffic the sound of its cascading waters must have been an agreeably familiar one to Capetonians; even today, when it is channelled underground, the roar of its winter torrent is sometimes discernible to the residents of upper Sir George Grey Street. By the time the stream had reached the top of the Government Avenue it had passed no less than six watermills which ground the wheat of the locality – all in all creating a picturesque little industrial neighbourhood on the outskirts of the residential area.

One of these mills belonged to Michel van Breda.[1] He had always styled himself as Michel van Breda (Arend's son) to distinguish him from his uncle, also Michel van Breda, who was Pieter's son and who was a near neighbour at Oranjezicht. Michel (Arend's son) lived at Zorgvliet, and one way and another the whole vicinity was thick with Van Bredas – Alexander (another uncle) lived at Rheezicht and Pieter van Breda (an uncle again) – at Nooitgedacht, now St Cyprian's School.

In their heyday the Van Breda residences were well-known landmarks in Table Valley, the others all rather grander in their way than Zorgvliet. You will find the house mentioned with little fanfare by Fransen and Cook who anyway devote their attentions to its Cape Dutch origins and design. Curious though these may be, Zorgvliet in fact remained a Cape Dutch farmhouse for less than forty years and its interest must surely lie in its two subsequent transformations, both good examples of the quite typical alterations that many Cape houses underwent in the nineteenth century.

The original freehold grant – one of the oldest in the Cape – was made to Matthys Coeymans in 1669.[2] It was for just over two morgen. Thereafter there are umpteen recorded transfers, annexures and deductions until what had hitherto been described as 'land in Table Valley' was acquired by the rich and enterprising Hendrik Oostwald Eksteen in 1774.[3] Eksteen seems to have cultivated the land more intensively than had previously been the case – it was later described as a 'garden (*tuin*) in Table Valley' – and may well have named it Zorgvliet after another Eksteen farm on the Liesbeek River at Rondebosch. The house was evidently built by the next owner – J J Swanevelder,[4] who purchased the land from Eksteen in 1782. There was quite obviously a rapid turnover in real estate in Table Valley, for only two years later Swanevelder sold his new house to Jacobus Tesselaar,[5] who had himself just sold three morgen nearby, destined to become part of Rheezicht. Tesselaar lived at Zorgvliet for seven years, acquiring an additional '*stukkie tuinland*' ('piece of garden') in 1787,[6] before selling to Frederick Hurling in 1791.

The house that Hurling purchased was a medium-sized Cape Dutch farmhouse boasting a *holbol* gable common to its period. It exhibited various features rather typical in the Cape Peninsula, most notably its

U-plan and a narrow *voorkamer*; this prevented the inclusion of half-windows which otherwise would have surrounded the central door on the front façade. There were the usual rooms to the left and right – the latter having a particularly pretty frieze of roses which was a decorative touch to be found at Alphen and elsewhere – and no more than two further rooms in either wing. The size of the property was small, but contained in its title deeds were water rights to the Platteklip stream. Hurling had just sold Clapperton's Mill at Mowbray, and since the transfers of the two properties contain consecutive dates, it is reasonable to conjecture that it was he who built the Zorgvliet mill.[7]

We do know for certain that he donated a corner of his property for the erection of the municipal pump that was built on Prince Street as part of the new Cape Town water system of 1812. Always associated with Zorgvliet, the 'Hurling *swaaipomp*' as it has since been known, is worthy of slight digression. At the time of which we are writing, every household of reasonable standing employed a slave whose sole occupation was the fetching and carrying of water from the municipal reservoirs on the Parade. The queuing, dawdling, squabbling and general time-wasting that ensued was part and parcel of daily life at the Cape and, one feels quite certain, the subject of endless, vociferous complaints from aggrieved Cape madams. In order to relieve this congestion, a scheme was put in hand to build several additional pumps with adjacent reservoirs supplied by the mountain streams in and around Cape Town. The design of the pumps, of which the Hurling *swaaipomp* is the sole surviving example, is easily attributable to Thibault – indeed it echoes the quite amazing conical affair which he had designed for the Parade some years previously – and the carved teak lion's mouth out of which the water spouts is almost certainly the work of Anreith.[8]

The Hurlings were responsible for the first transformation of Zorgvliet. By the turn of the century, changing modes and manners amongst the Cape's population increasingly necessitated the extension of the typical Cape Dutch farmhouse, with its few rooms designed for no specific purpose, into a dwelling containing living-rooms and bedrooms much as we know them today. In keeping with the current vogue, the Hurlings regencyfied the farmhouse, adding a wing which formed a substantial *stoepkamer* – the dining-room and kitchen, complete with long barley-stick chimney – to the right of the front façade, which was further smartened up with a pergola and a Georgian fanlight over the front door.[9]

Inside, a long corridor which connected with the front hall (the old *voorkamer*) through a folding screen separated the front rooms from the new bedrooms at the back. The screen, doors and architraves all conformed to a typical Regency design as did the new windows – or at any rate those at the back, for these still survive. The beamed ceilings were plastered and given reeded cornices, and central rosettes were affixed in the main rooms.

Thibault's survey, done at the behest of Sir George Yonge[10] and once more in 1815,[11] shows an entrance

PREVIOUS PAGE. The Victorian villa. French casements protected not by shutters but by a generous verandah supported by cast-iron columns. The balcony above has lost its 'broekie lace', but the barge-boarding and finial still decorate the clipped gable of the old Dutch house.

avenue leading up from Prince Street to the wide front steps, and another behind the house which started between the two outbuildings and then stretched to the bottom of the Oranjezicht garden. The *werf* was enclosed by a wall with gates on the fourth side which could be entered by way of a bridge across the Platteklip stream.

The Hurlings lived at Zorgvliet for only three years after the erection of the *swaaipomp* and then in 1815 sold the house to Michel van Breda,[12] brother of one of their daughters-in-law. Surrounded by their kinsmen – all respected members of the community – the Van Bredas raised their family at Zorgvliet and ran the mill. When Michel died in 1840 his widow continued to live there. The household comprised her fourth and favourite son, Christen Lourens Herman, three others – Hendrik, Kenne and Pieter – a widowed daughter-in-law and the elderly Elisabeth van Breda – evidently the proverbial indigent aunt. There was a German cook, Ernst Kleinsmit, two live-in maids – Betje and Filida – and three outdoor manservants – Homba, George and Klaas – all listed as heathens.[13] Mrs van Breda kept on the mill and her daughter Aletta married their miller – Hendrik Truter. Truter evidently succeeded in getting round his mother-in-law in some way – and to her great annoyance – for in the early 1850s the mill is suddenly listed in his name and a strongly worded codicil in Mrs van Breda's will dated 1854 stipulates that no benefits whatsoever shall accrue to him and bequeaths her legacy to Aletta in a trust to be administered by the Colonial Orphan Chamber.[14]

Old Mrs van Breda had the good fortune to die at Zorgvliet in the bedroom she had known for nearly forty-five years.[15] By 1860 the city's expansion was already encroaching up Table Valley and one by one the farms were being cut up for development. It was the first stage of the sad but inevitable process that was to continue for the next hundred years with the disappearance of the big estates of Newlands and Rondebosch up until the Second World War and those of Constantia in the 1960s. The land at Zorgvliet was clearly the old lady's most valuable bequest to her children and it was immediately subdivided and sold off as small residential plots.[16]

The house itself was sold to a nephew of hers – a Mr JWJ Herman – a prosperous Cape colonial of German descent who had farmed in the Swellendam district and subsequently moved to Cape Town. He became chairman of the Board of Commissioners which comprised the civic body that predated the present Corporation.[17] Herman died in December 1863 and the house was let to a Mr Salomon, partner of the Cape Town branch of Mosenthals.[18] It was Salomon, possibly carrying out Herman's intentions in keeping with such alterations as he might have actually put in hand, who renamed the house Coblentz Villa.

Unfortunately, we cannot be quite sure that it was Herman who ordered these alterations for, as will become apparent, they may have been carried out earlier by the Van Bredas or even the subsequent owners. Irritating though such uncertainty may be, it is not entirely crucial to our appreciation of what was done or why.

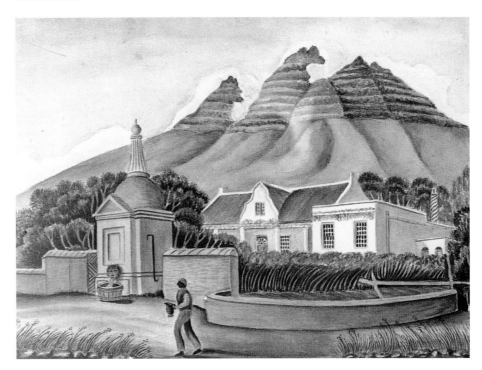

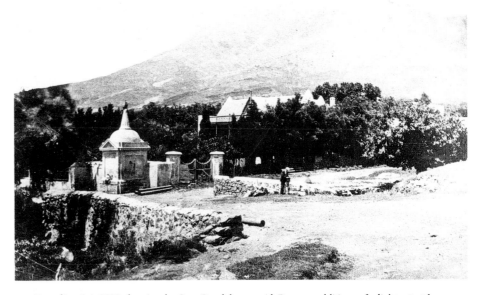

TOP. Zorgvliet *circa* 1820, showing the Cape Dutch house with Regency additions – fanlights, *stoepkamer* wing and barley-stick chimney. The Hurling *swaaipomp* shown in the foreground still stands there today and, then as now, the south-easter howls down Table Valley. (William Fehr Collection)

ABOVE. Photograph *circa* 1890 showing the cast-iron balcony over the verandah. (Cape Archives)

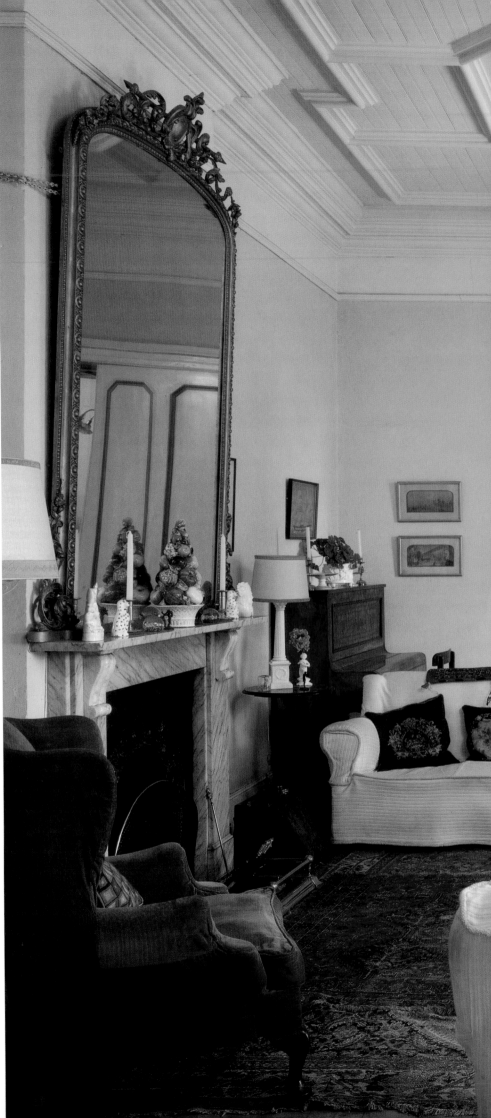

BELOW. Bedroom. The bed is Cape nineteenth-century, as is the *jongmanskas*.

RIGHT. The white and gold drawing-room was part of the mid-nineteenth-century going-over of the already regencyfied Cape Dutch house. The elaborate cast-iron grate and marble surround are original, as is the looking-glass, much like the one through which Alice passes in Tenniel's illustration. The whole is executed very much in the grand manner, and the ladies and gentlemen who gossip idly in the 1832 sketch of the drawing-room at Government House (see page 76) would have been very much at home in this agreeable room.

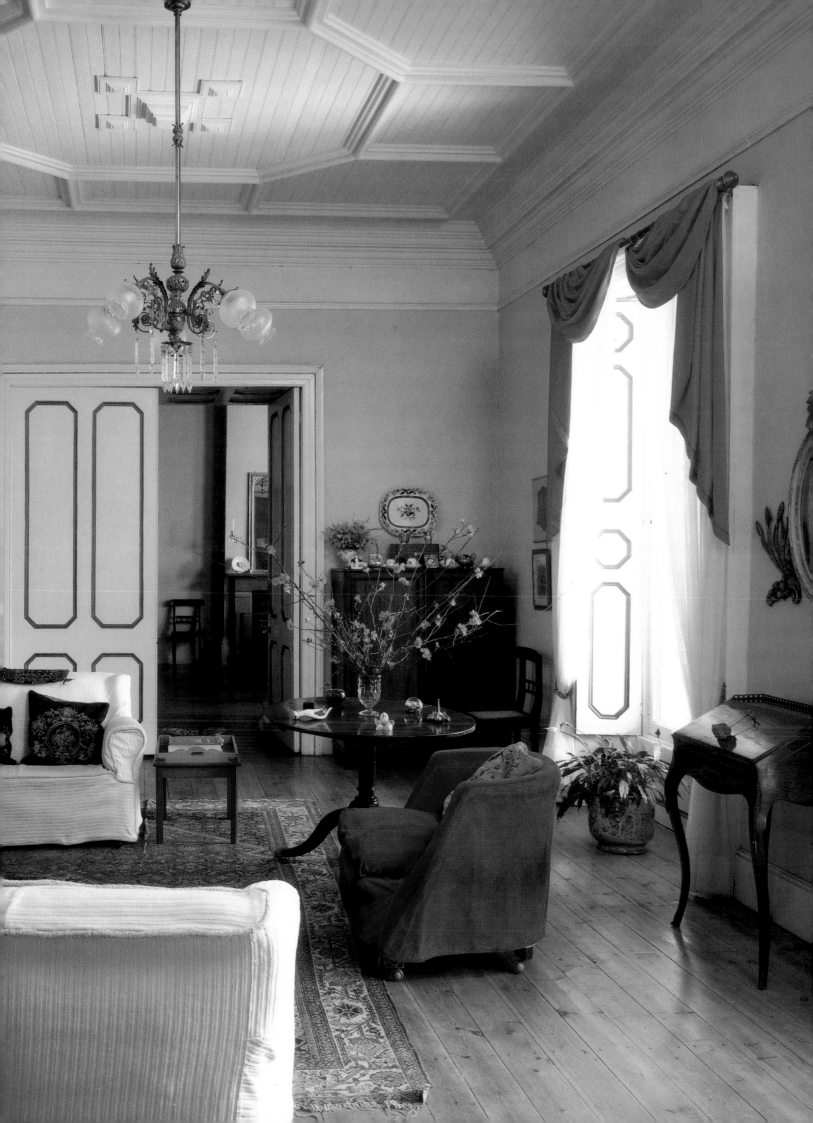

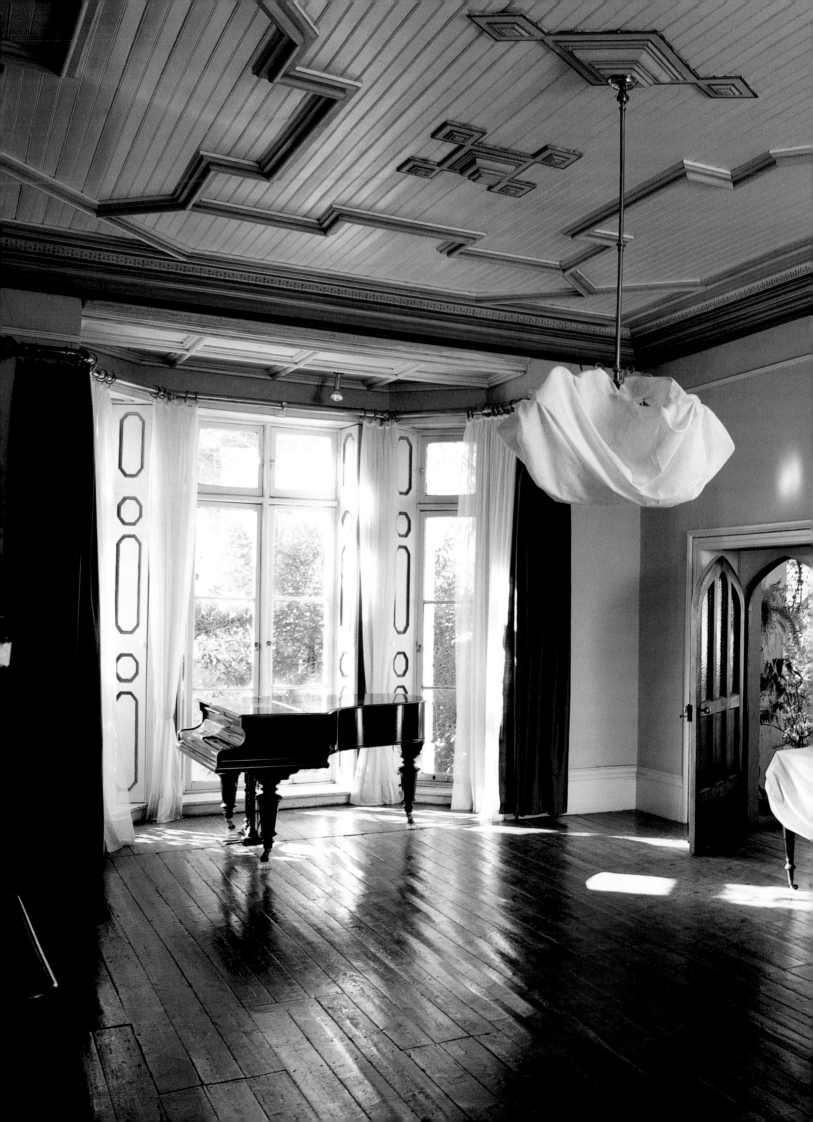

LEFT. The main dining-room-cum-ballroom (here seen under wraps) is contained in the old Regency *stoepkamer* wing. Note the elaborately boarded ceiling, the serpentine curtain rail and the Gothic 'vestry door' onto the verandah. The wall colour and cornice stencilling are original.

ABOVE. The pretty frieze of roses uncovered in the drawing-room dates from the house's Cape Dutch period. It is a decorating conceit to be found in the main rooms of other houses of the day. The door with its original crystal handles and mirrored crystal plate dates from the Victorian redecoration.

During the first half of the nineteenth century the English taste for Gothic (often spelt 'Gothick' to distinguish it from the more earnest 'ethical' mid-nineteenth-century genus of the style), having been made respectable by Horace Walpole several decades previously, enjoyed an ever-increasing social success. This culminated in the completion of the works at Windsor in 1830 and the decision to rebuild the Houses of Parliament in the Gothic style. It was by then no longer the preserve of a noble or rich *cognoscenti*, but being happily taken up by an increasingly prosperous middle class.

Recherché fashions are not always best served by popular success and all too often the dressing-up of Georgian bodies in Plantagenet clothes[19] led to unhappy and slightly absurd results. But the new is ever intriguing and the truth of the matter is that to enthusiastic middle-class English eyes in the 1830s, 1840s and 1850s (and to middle-class colonial eyes for a good two decades beyond that), the chaste Regency villas of the preceding generation appeared altogether too plain and simple. Very often the answer to this aesthetic quandary was to go for something a little more picturesque. And that something was almost always Gothic.

Not surprisingly, this new metropolitan taste was soon being exported to the colonies. In South Africa its popularity was nothing if not fitful. Had Somerset remained as Governor of the Cape and given Newlands a Gothic rather than a Regency rework, doubtless it might have established a more persuasive vogue. And had the decades between his departure and the discovery of diamonds not been so economically depressed, doubtless more opportunities for the erecting of buildings in this style would have presented themselves. As it was, there were one or two domestic buildings that were purely Gothic (Selwyn Castle, near Grahamstown is one) and, in time, countless ecclesiastical examples appeared across the land. For the rest, it was confined to detail and embellishment – twirls and twiddles applied to existing and often vernacular architecture. A Gothic apse was added to the orchestra of the ballroom at Government House in 1829; Newlands House and Bishops got Gothic gate-lodges;* Henry Nourse's house at the Kowie was castellated. Naturally, there was little about most of these efforts that could be described as academic. A pepper-pot chimney or pointed entrance porch here, a moulding or bit of scalloped barge boarding there – such colonial whimsy is not without charm and today provides a feeling of period rather like the echo of a lively and once popular melody.[20]

The gothicking of Zorgvliet was slightly more elaborate than that of most of its colonial counterparts. The plastered Regency ceiling of the drawing-room, the Dutch beams and the *brandsolder* above it were removed and a new raised and elaborately boarded ceiling put in its place. The old flat-topped dining-room roof was likewise raised and a matching ceiling installed. The whole house was covered by a

new roof of Welsh slates, and the old gable was clipped and adorned with decorative barge boarding. A large bay was added to the dining-room and french casements, complete with handsome, hexagonally patterned internal shutters, connected all the front rooms with the new verandah, whose early cast-iron uprights replaced the old pergola and supported a balcony complete with cast-iron balustrading.[21] This last addition may well have been an afterthought. It was reached by way of the old external loft staircase at the back of the house and a door through the remains of the front gable. With views that stretched across the garden to Signal Hill and Table Bay it must have been a delightful spot on a hot Cape summer's evening. The front door and the door that leads from the dining-room to the verandah were given Gothic points and this was repeated in the Gothic arch in the hallway.

One is tempted to dismiss Mrs van Breda as the instigator of all this new work, unless she was a very merry widow indeed. The alterations cannot predate her husband's demise in 1840 and were clearly executed in the grand manner, the dining-room most certainly intended to double as a ballroom. The few surviving buildings at the Cape containing interiors with a similar feel – the South African Library, the Roeland Street Gaol and the Somerset Hospital – all belong to the 1860s and the handsome cast-iron firegrates must anyway date from after the Great Exhibition. All this would point undisputedly to Mr Herman as the person responsible for the alterations – he was, by all indications, more prosperous than Mrs van Breda – were it not for the fact that the diagram accompanying the property's transfer (*circa* 1861)[22] shows the plan of the house in its present form.

There is one other theory concerning the alterations at Zorgvliet that may be mentioned as a postscript – one that persisted even in the house's saddest days as a sort of boarding-house in the twentieth century. The story is that the alterations were put in hand in order to accommodate Sir George Grey at some stage during his governorship at the Cape. There seems to be no evidence to support this. We have recorded the Van Breda's family occupancy right throughout the 1850s and all that can be provided as circumstantial evidence is that the month after Mrs van Breda's death Sir George arrived back in London, whence he had been recalled, only to discover that there had been a change in government at Westminster and that he was reappointed to the Cape. He returned immediately. The transfer of Zorgvliet to Herman is only dated July 1861 by which time Grey, anguished by his estrangement from his wife, had already requested transfer to New Zealand. No evidence has thus far been found of his having stayed at Zorgvliet nor of any reason why he should not have returned to Government House.

Herman's estate sold the house to the widow Hertzog and thereafter it enjoyed varying fortunes until it was acquired by Mr and Mrs Michael Duckham in 1969. Mrs Duckham, better known professionally as Désirée Picton-Seymour, is an authority on South African Victoriana and she has used her knowledge and expertise in restoring the house.

* Both of which have been spoilt by unsympathetic renovations and additions.

The hall from the long central passage, showing the Gothic front door and arch. The reeded cornice survives from the Regency alterations.

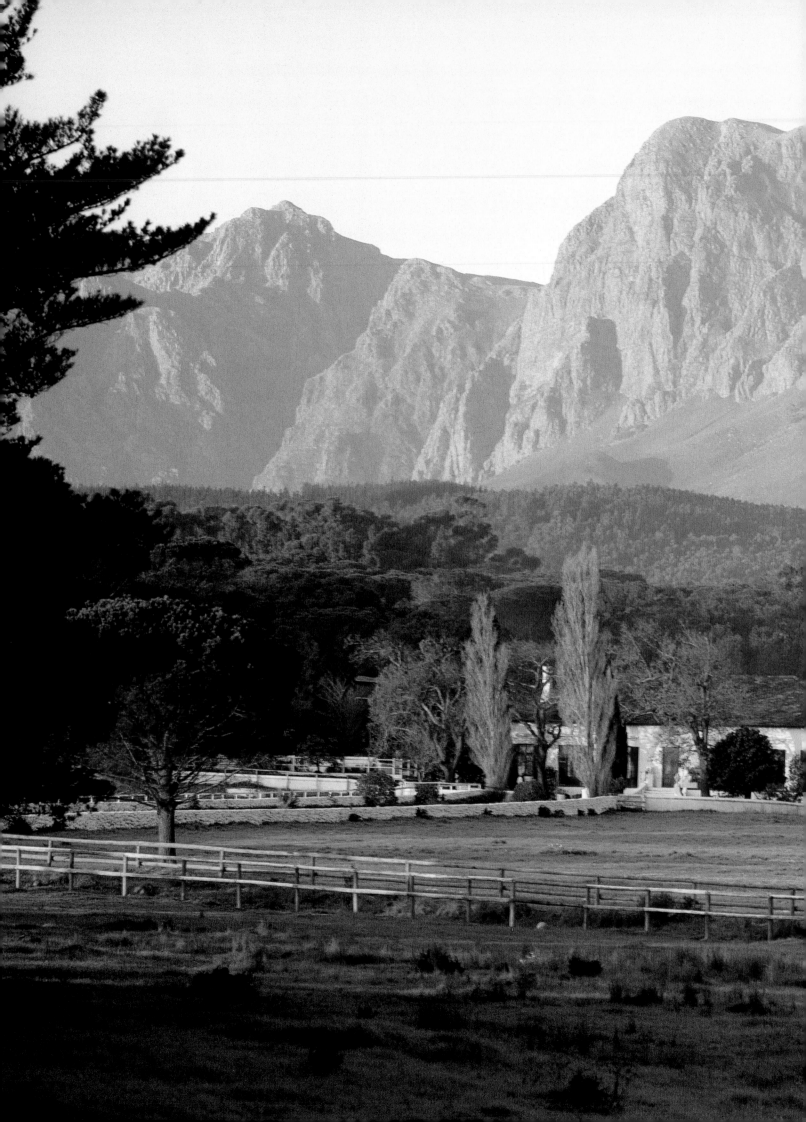

BROADLANDS

SIR LOWRY'S PASS

PREVIOUS PAGE. Broadlands – the house in its setting at the foot of Sir Lowry's Pass.

TOP. Sir Robert Stanford. (Cape Archives)

ABOVE. James Rawbone by Edward Roworth.

In the eighteenth century travellers journeying from Cape Town to the South Western Districts crossed the sandy wastes of the Cape Flats to reach the foot of the Hottentots Holland mountains. This natural barrier was negotiated by way of a pass – in reality little more than a track – through the Hottentots Holland Kloof. Until the construction of Sir Lowry's Pass in 1829, it was a prospect to be contemplated with apprehension. The gradients were frighteningly steep, the rocky surfaces dangerously slippery and a false move would send the wagon, oxen and often travellers hurtling to the bottom of the precipice.

The last farm that the wagon track passed before the ascent was De Fortuin or Fortuinje.[1] It twisted right between the homestead – an unpretentious dwelling of four rooms – and the wagon-maker's shed, the owner wisely perceiving a means for extra income provided by its proximity to the treacherous pass.[2] There was an equally simple house on the neighbouring Gustrouw and it is these two properties that have, with complicated annexures and deductions over the years, combined to make up the present farm of Broadlands.[3]

Nothing remains of the old Fortuinje homestead and mere conjecture leads one to suppose that the present house might have been built on the same site. The only evidence we have of the date of the latter's construction is provided by its owner during the Second World War who recalls being told that it was built by the Morkels in 1870.[4] The Morkels acquired Fortuinje in 1855.[5] They were descended from a German settler and the family was well known in the district. The circumstances surrounding the purchase were remarkable and tied up with the great *cause célèbre* of the Cape of the 1850s.

The intelligence of 1849 that the Imperial Government intended to use the Cape as a penal settlement for convicts had been greeted with dismay and indignation by the colonists. The Cape threw itself into a frenzy of protest. There were meetings, radical speeches, petitions to the Queen and acts of violence in Plein Street. Past ethnic differences were for once forgotten as one and all united to preserve the Colony from the threatened 'degradation'. The anchoring in Simon's Bay of the first batch brought matters to a head. An Anti-Convict Association, with a country-wide network, was formed vowing to suspend all business with the Government – including the victualling department – until the *Neptune* departed. It was immediately evident that if martial law were to be avoided supplies would have to be found.

Like many others of his breed and background, Colonel Robert Stanford of the 89th and 27th Regiments of Foot had retired on half-pay to the Cape where 'some of the best Society from India resorted for the benefit of their health'.[6] Cheap land, the low cost of living and a salubrious climate were also undoubted attractions. When Stanford purchased Fortuinje and Gustrouw from David Dow in 1848 for £1 100[7] he already had a townhouse in Stal Plein and a farm at Klein River in the Caledon District. Like Lieutenant Daniell at Sidbury,* he had visions of

* See Sidbury Park.

establishing on part of it (probably a portion of Gustrouw) a village to be called Ballana Stanford complete with four hundred allotments and commonage. Another section, near Gordon's Bay and therefore sheltered from the relentless south-easter, was to be developed as a seaside resort.[8]

The Stanfords were asleep at Fortuinje when, on 10 October 1849 – 'even at the dead of night'[9] – they were visited by the Attorney General and the Collector of Customs. Despite having cautiously identified himself with the Anti-Convict agitation, Stanford agreed to supply the Government with food to avoid open rebellion or, worse, civil war.

For five months Stanford and Mr Morkel, his near neighbour at De Bos, ran the gauntlet with their wagons to supply the Government. He became immensely unpopular and at the hands of his fellow colonists suffered social ostracism on a quite alarming scale. No one would have anything to do with him. His property was 'mercilessly pillaged', his haystacks were burnt, his family was openly insulted. His servants deserted; his crops rotted for want of reapers. Banks declined to do business with him; his children were expelled from their schools. One child actually died owing to the refusal of doctors to come and attend to it.[10]

Nor did the situation improve following the *Neptune*'s departure. Stanford went to England to seek compensation for his losses. He was rewarded for his troubles with £5 000 and a knighthood. This availed him nothing for worse was to follow. While he was abroad his agent, in cahoots with an unscrupulous stock dealer, had purchased for cash on his behalf a large herd of cattle suffering from a fatal lung disease. Stanford had a stroke. Second mortgages were taken out on his properties and in due course these were assigned to his creditors. The new baronet returned to England in an attempt to raise money to stave off ruin and whilst he was there the assignees, in suspicious circumstances, sold off his properties.

The Fortuinje and Gustrouw estates together with land at Kogel Bay realized £3 000, although they were valued at £5 000.[11] Klein Valley, which actually belonged to Lady Stanford, was similarly flogged off. Appeals to the Cape Courts and even the Privy Council fell on deaf ears and in the end the family was reduced to genteel beggary.[12]

Willem Morkel, who paid £1 000[13] for Fortuinje and Gustrouw, was an experienced farmer and had known a good thing when he saw one. The sale notice advertised the farm as 'perhaps without exception, the best place for general farming purposes within an equal distance from Cape Town, there being an abundant supply of water, a large extent of garden and plough land, the latter producing splendid crops of wheat, barley, oats, etc, and the pasture good and healthy for cattle, horses, sheep and well adapted for an extensive vineyard'.[14] Stanford's village never materialized.

The farm was not intended for Willem Morkel himself. He was the owner of Morgenster, the main Morkel family farm which in due course his eldest son, Daniel, would inherit. The new property was destined for his third son, Hendrik Johannes, whose

siblings, Roelof and Pieter, farmed Rome and Cloetes-burg (later Oatlands) respectively. Hendrik Johannes must have moved to Fortuinje/Gustrouw after his marriage to Anna van Breda in 1866. He is listed there on a voters' roll for the district for 1873,[15] although transfer took place only on his father's death in 1876 when he bought into the estate for £1 300.[16]

The young Morkels renamed their farm Broad-lands. The house there, probably built by David Malan in the late 1770s,[17] had not been Stanford's principal country residence – Klein River is described as their 'country seat' and by all accounts was their favourite estate – and by 1870 had been untenanted for at least fifteen years and was probably in a poor state of repair. Its style was certainly unfashionable and the newly-weds decided to start again from scratch.

They built a long single-storeyed house with a ground plan very similar to that of Zorgvliet. Its nine or ten large rooms – 'lofty and airy' as they would have been described – were all arranged on either side of the 100 foot (30 m) long central passage and all con-nected with the garden through large french case-ments fitted with external louvred or venetian shutters against the African sun. Much favoured by Victorians settled in sunny climes, these french win-dows had been added to both Government House, Cape Town and Ida's Valley near Stellenbosch and survived until the restorations carried out on both these buildings in the 1970s.

The front façade was given a raised stoep or veran-dah, uncovered since the building faces south, and originally stacked with pot plants and wreathed in moonflowers.[18] Beneath a pitched roof – planked and Welsh slated – the frontage's long expanse of white-washed stucco, regularly broken with oiled teak and shadowed by the oak trees, is perfectly pleasing in its simplicity. Broadlands survives as a good example of the style that is sometimes referred to as 'British Occupation'. Houses like it were built in Green Point and Sea Point from the 1840s onwards and in Victo-rian villages of the Karoo, such as Richmond, in the decades beyond. Though common enough in their day, they may not truly be claimed as a development of the Cape vernacular: Broadlands is, in fact, a typical, if sizeable, mid-nineteenth-century colonial bungalow.

The Hendrik Morkels farmed Broadlands for nearly twenty years. In 1885, with phylloxera causing havoc amongst the established Cape wine farmers, there was a shuffle up of ownership of the Morkel properties. Morgenster was bought by Daniel Mor-kel's prosperous brother-in-law, Major Alexander van der Byl who had bred horses at Nachtwacht near Caledon.[19] He also purchased Broadlands from Hen-drik, possibly with the intention of establishing his stud there. In the event, he kept the farm for only three years and sold it to James Rawbone for £1 820 in January 1888.[20]

James Rawbone was a young Englishman who had been trained at the French forestry school at Nancy. He was brought out to the Cape as forestry officer at Knysna and had married Rosalie Bain, daughter of Thomas Bain and granddaughter of Andrew Geddes Bain, the pioneer road and pass builders at the Cape.

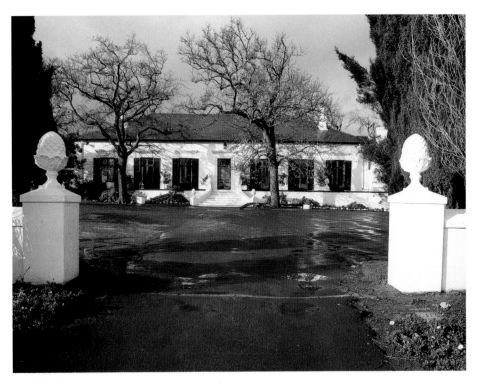

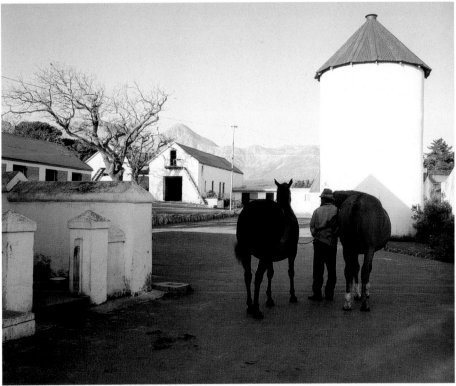

TOP. The British colonial bungalow *circa* 1870 with its double french casements and full venetians, the 'cupboard' front door and simple mouldings. The new roof replaced the old Welsh slate.

ABOVE. Victorian stables, silo and farm buildings.

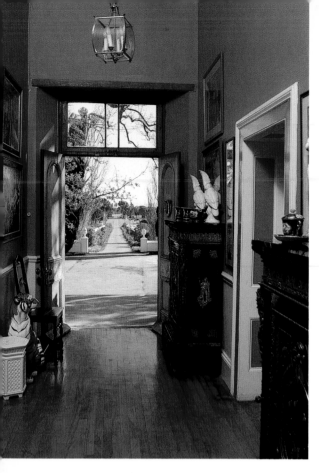

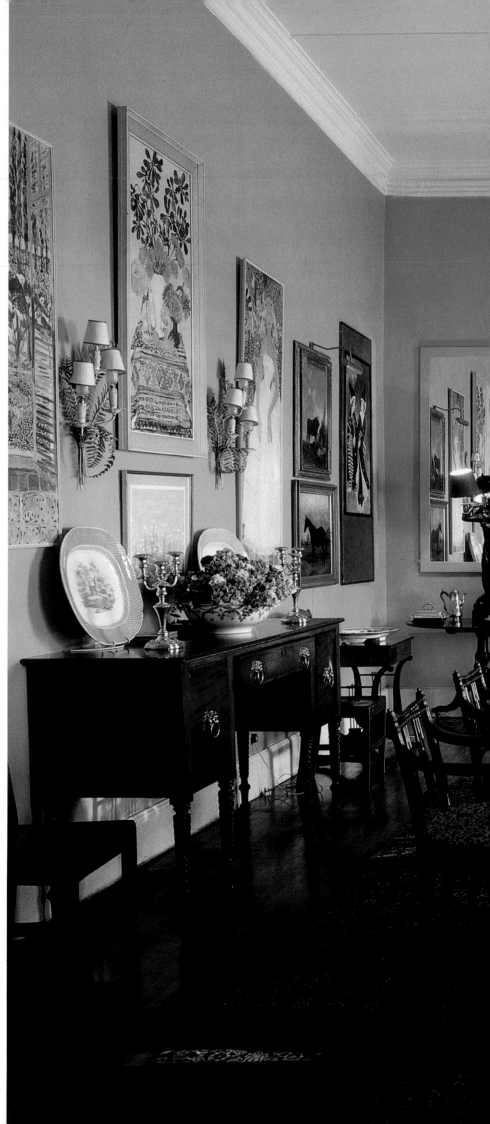

ABOVE. View from the front door down the drive. Gordon's Bay and Strand are in the distance.

RIGHT. The dining-room. The yellowwood table is late nineteenth-century.

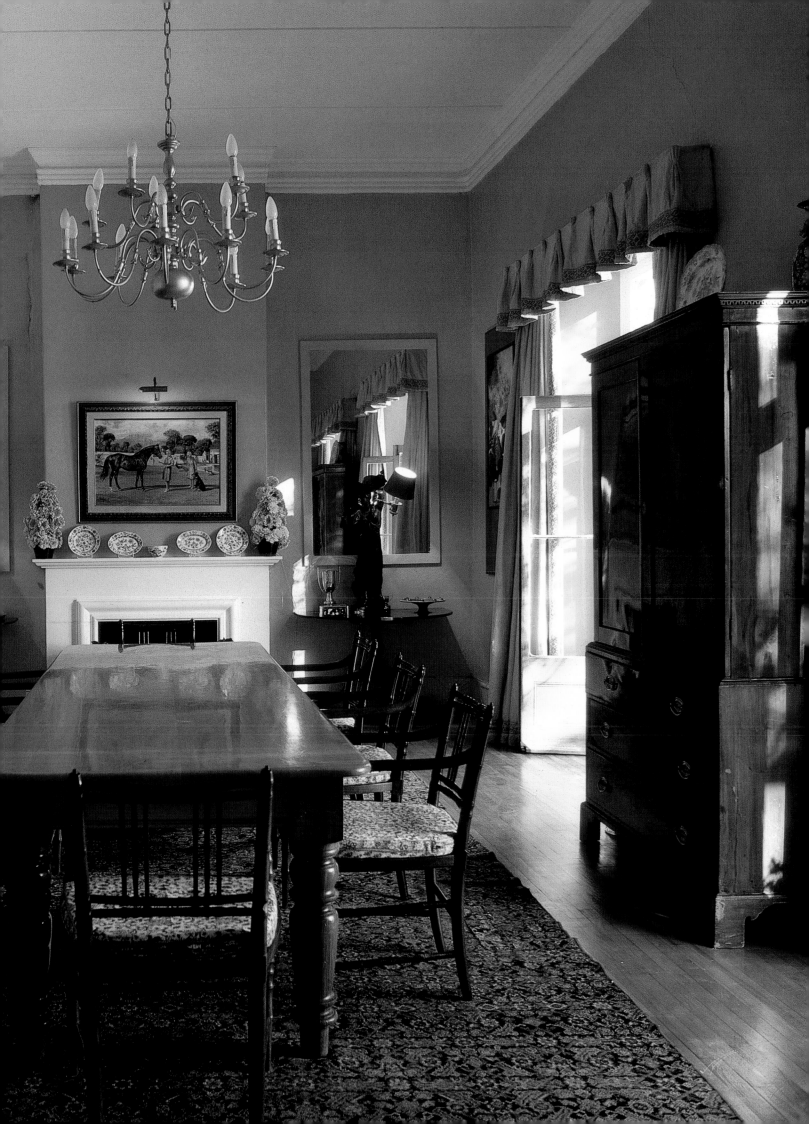

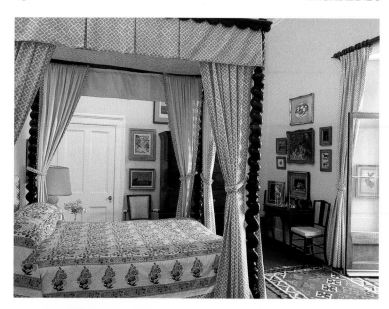

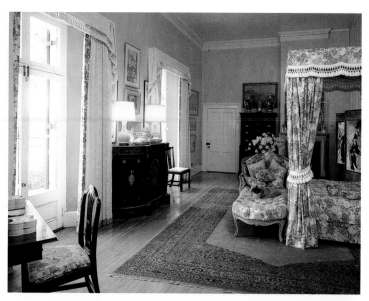

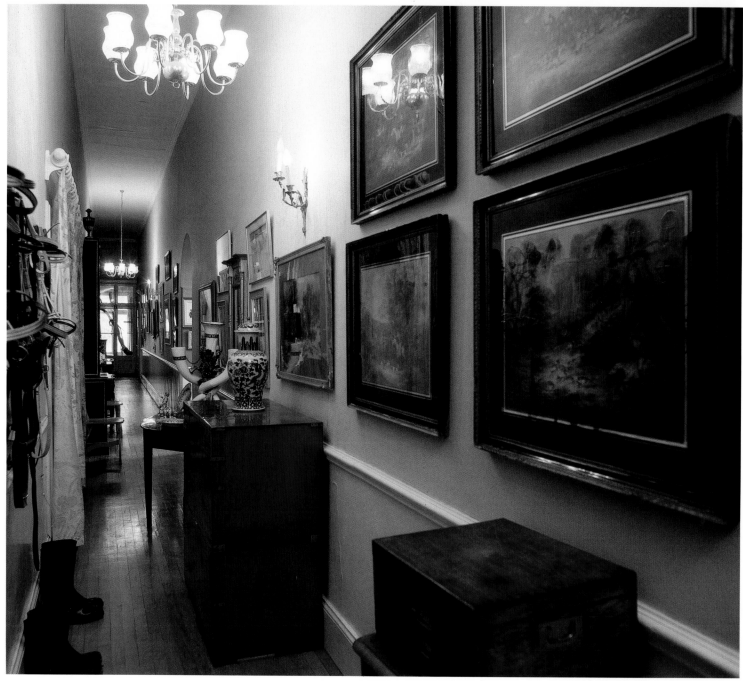

James Rawbone bred up a splendid pedigree Ayrshire herd for which Broadlands became famous and which for years was cared for by a Scots cowman. From 1911 – 1923 Rawbone was president of the Stud Book Association; he was a noted and enthusiastic breeder of racehorses, a keen racegoer and chairman of the South African Turf Club. He was JP for the district and the member for Stellenbosch on the Provincial Council.[21]

The couple were popular and Mrs Rawbone loved entertaining. At weekends the house would be filled with the officers from the Garrison at the Castle and the Fleet at Simon's Town, a supply of personable guests for years carefully cultivated by Cape hostesses. There was a tennis court to the left of the house and under her supervision and that of Pieter Eksteen, the gardener, the gardens were made charming. The Broadlands' Cecile Brunner roses – then a rarity – were much treasured additions to the more fashionable Cape bridal bouquets at the turn of the century.

Inside, the day-to-day running of the house was left to Mabel de Smidt, an indigent cousin taken in with kindly intentions who lived with the family as a sort of glorified housekeeper without actually being relegated to the status of domestic service. Such a person was a common addition to larger Cape households up to the Second World War. Under her supervision came the Dramat family, Mozambiquans, who comprised the main staff. There was Adam, the coachman (transformed before the First World War into the chauffeur); Martha, the enormous cook dressed in her Mother Hubbards; Dickie, a sort of tweeny; and two parlour maids – their pitch-black shiny faces beaming out from under the starched white caps. It was an unusual collection of domestics for the Cape, the more so because Dickie was deformed and Martha cheerfully acknowledged to be a '*bietjie gek*'.* But they were exceptionally well trained, the food delicious, and anyway they were only one of the Broadlands oddities, for Mrs Rawbone went in for unusual pets, and tame meerkats, two wallabies and even a white monkey wandered in and out amongst the Victorian clutter of the rooms.[22]**

* Kitchen-Dutch for not quite like other people, 'dotty'.

** History repeats itself and today visitors to Broadlands are once more confronted by a positive menagerie of pet animals and birds kept by the present owner.

The heir to all this would have been their only son, George Rawbone. In 1913, however, he married Miss Hannah Viljoen of Oak Valley at Elgin. Her father, Antonie (later Sir Antonie) Viljoen, was a former member of the Afrikaner Bond and had returned to the Transvaal as one of the Boer surgeons during the Anglo-Boer War. He had been captured, imprisoned and later confined to bounds at Oak Valley when, in a curious quirk of fate, permission for his daughter to attend school at Wynberg Girls' High had actually been signed by her future father-in-law in his capacity as JP.

Parental predispositions notwithstanding, and despite the recent fall-out at Congress between Botha and Hertzog, the wedding took place at Broadlands in the best spirit of Unification. The house was banked with Broadlands sweet peas and wild ericas sent over from Oak Valley in a scotch cart. Mrs Rawbone put on a handsomely embroidered frock ('amethyst ninon', said 'Lady Peggy' of the *Cape Argus*) and a brave face. Sir Thomas Smartt, leader of the Unionist Party, proposed the toast of the bridal couple; J X Merriman, the old Cape Liberal, that of the parents. Despite recent events at Congress, such marriages, he said amid applause, should yet make a nation.[23] George Rawbone joined his father-in-law at Oak Valley which became one of the great fruit estates of the Cape, and on the death of James Rawbone, Broadlands was sold.

The farm changed hands several times until finally, in 1962, it received perhaps its most remarkable – and certainly most glamorous – chatelaine, Enid, Countess of Kenmare. Australian-born and a great beauty of her era, she had already buried three husbands by the time she married the Earl of Kenmare. Her third husband, Lord Furness who owned the famous National Stud in England, had introduced her to Africa by taking her on safari in a Rolls Royce specially fitted with zinc-lined trunks for ice and champagne. She fell in love with the continent and later purchased a property near Karen in Kenya, close to the Baroness Blixen (Isak Dinesen) whose former husband had been Furness's white hunter.[24]

This she later sold up and came south to the Cape, where the lower altitudes and better racing suited her altogether better. It is her daughter Patricia, the Hon Mrs O'Neill, who today runs the Broadlands stud which she established.

FAR LEFT, TOP. Bedroom. Lofty and airy like all the rooms, with their high, tongue-and-groove boarded ceilings and french casements opening out onto the garden. The four-poster is English nineteenth-century.

LEFT, TOP. Bedroom. Part of Napoleon's dinner service stands on the nineteenth-century boule side cabinet.

LEFT. The long passage extending down the centre of the house – a typical feature to be found in many nineteenth-century houses throughout South Africa.

TOP. The wedding of George Rawbone and Hannah Viljoen at Broadlands, November 1913.

ABOVE. Enid, Countess of Kenmare.

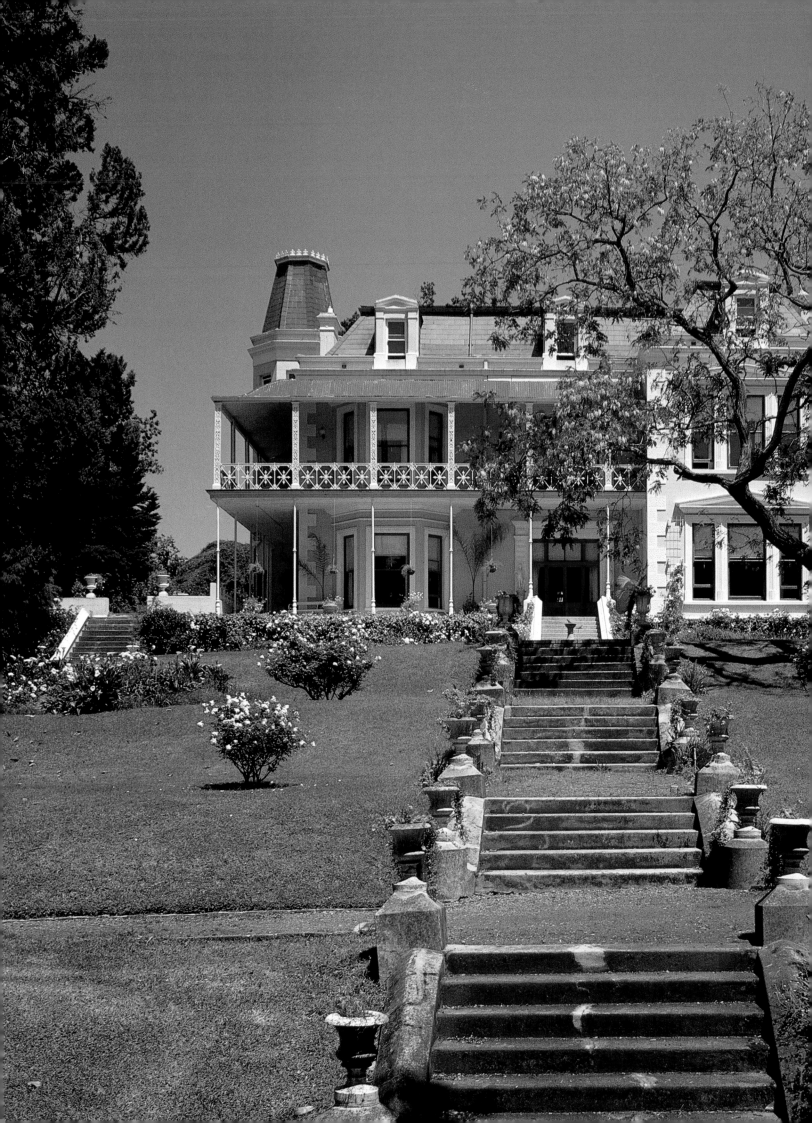

HAWTHORNDEN

WYNBERG, CAPE TOWN

In 1871 Captain John Spence married Miss Anna Cloete. She was the daughter of Dirk Cloete of Alphen,[1] one of the grander Cape families, and since there were already two Mrs Spences dead and buried one assumes that the groom's newly acquired prosperity merely added to such charms as he undoubtedly possessed. Certainly lineage does not seem to have been among them.

He had been born in the Orkney Islands in 1826 and at an early age joined the mercantile marine. By the late 1840s he commanded a schooner engaged in trade up and down the Skeleton Coast. He is listed in 1850 in the rather unpromising-sounding post as head of the Guano Island and five years later joined De Pass & Company who were pioneers of trade to and from Damaraland.[2] Spence personally obtained a concession of a tract of land from the Damara chief, and the firm – now De Pass, Spence & Granger – went on to become one of the largest operators of coastal shipping at the Cape.

Ten years after his marriage and increasingly prosperous, Spence acquired a nice new estate, adjoining Springfield and just over Wynberg Hill from his in-laws. The property boasted what had once been a Cape Dutch manor house – now rather rambling with additions and very *démodé* as a style of residence in the Cape in the 1880s. The place had been known as Oude Wynberg for almost two hundred years.

The nefarious tactics employed by the Van der Stels to acquire land for themselves contrary to the instructions of the Lords XVII in Holland, are once again all too evident in the early recorded history of the estate's ownerships. Governor Simon made the original grant ('a certain piece of land named De Oude Wynberg') to Herman Weeckens in December 1683.[3] A year later Weeckens transferred the land back to Simon[4] who sold it to his son, Adriaanus[5] (not to be confused with Willem Adriaan), a month after that. In 1701 the ground with its *opstal* and crops was sold by public auction to Albert Coopman,[6] secretary of the Orphan Chamber, who sold it on the very same day to Frans van der Stel.[7] Coopman had paid 925 guldens and Frans paid him 1200, the rather thin excuse for this quick bit of profit-making being inserted in the transfer as including 'further buildings and crops'. Whence these had suddenly materialized one can only wonder, but it is nice to think that someone benefited from playing ball with the Van der Stels' chicanery. The wretched Weeckens died leaving nothing but debts for posterity and having to depend on the Christian charity of his creditors for a decent burial.

Oude Wynberg remained in Frans's possession (possibly jointly with his brother) until after his death – disgraced and forgotten in Haarlem – when it was sold to Coenraad Feijt,[8] the silversmith. Feijt and his wife, Petronella, lived there in the humblest of dwellings – two rooms or three at the outside – meagrely furnished with their pathetic effects.[9]

The Feijts owned Oude Wynberg until 1720 whereafter it changed hands six times. In the 1770s, despite what looks like an administrative snarl-up in the Deeds Office, the estate – still the 176 morgen and 225 roods originally granted – passed into the hands of Sebastien Valentyn Scheller.[10] Scheller is reasonably credited with the building of the rather fine Cape Dutch house that survived as the core of the one the Spences bought a hundred years later.

It followed the U-plan rather typical of the Cape Peninsula – a *gaanderij* with two parallel wings on either side (*kamer aan die linkerhand, middelkamer aan die linkerhand, agterkamer aan die linkerhand; kamer aan die regterhand, kombuis, bottelary, solder*). There was a room for the *knecht* with another one next to it, an attic for the slaves, a summerhouse ('*lusthuis*') – one wonders where? – a stable and an outdoor privy.[11] The house boasted an attractive gable with the rare double in-curve found at Vergelegen, with which it is contemporary, and faced directly onto a row of oaks and the wagon track – what is now Herschel Walk. It is still there in Webb Smith's watercolour (*circa* 1840), which shows the oaks reaching maturity and various additions making a range of rooms along the road. Herschel Walk is easily recognizable to the modern reader, its notorious bend plainly to be seen in the middle distance. But Oude Wynberg has long since disappeared and today an imposing Victorian mansion stands in its stead.

This is what happened. Scheller went insolvent and the property was sold to a Mr Cruywagen.[12] Cruywagen sold it the following year to Hendrik Brand[13] and it is at this stage that the Oude Wynberg estate, which had survived intact since 1683, began to be split up. Brand made the first deduction; the next owner, J H Dolfus,[14] an officer in the Württemberg Regiment, divided the remainder into two: 84 morgen were retained at Oude Wynberg, the remaining 79 became Springfield – now the convent.[15]

In 1820 the house was acquired by Captain Hare,[16] military aide-de-camp to Lord Charles Somerset. Thereafter it changed hands three times until it was acquired by the Chief Justice, Sir John Henry de Villiers, later first Baron de Villiers of Wynberg. De Villiers built himself Wynberg House on a sizeable portion of the property and sold the remainder, which contained the house, to the Spences in 1881.[17]

By all reasonable expectations the house that Spence built and named Hawthornden should have been a disaster. To begin with it was to be set on the foundations of the old house,[18] sufficient cause to prejudice the design of almost any building from the start. No architect was commissioned: he employed a master builder, a Frenchman named Tier,[19] who seems to have done only some other minor work in Wynberg at this time.[20] Tier simply acted as his own architect – though doubtless in consultation with the architectural handbooks which were then available – and, with no more than a few alterations suggested by Mr and Mrs Spence,[21] he was allowed to 'get on with it'.

As it happened, Tier got on with it exceedingly well. The clients' wish for opulence was translated into that cheerfully eclectic style that had enjoyed tremendous popularity in his native country during the Second Empire. Best left loosely as 'in the Renaissance manner' (the term appears in almost all contemporary descriptions of Hawthornden), its most distinctive

feature was the mansard roof which provided not only an authentic, decorative and useful touch, but also the desired element of grandiose domesticity, subjected without difficulty to the rather classical buildings below. The exterior of Hawthornden is, in fact, surprisingly uncomplicated, any hint of pomposity being offset by its siting on a steep gradient and by a delicate double-storeyed cast-iron verandah which meets the projecting bay of the dining-room and encloses the drawing-room on two sides.

In South Africa, 'Second Empire Renaissance' – so popular in the United States – appeared too early to enjoy the fillip that the gold and diamond booms might have given it. By that stage 'Queen Anne' provided a more fashionable alternative – and one more attractive, one suspects, to colonial sentiment – which is why to local eyes Hawthornden now seems more redolent of New Orleans than typically colonial. In fact Melbourne, Adelaide and Simla all boasted buildings in this style.

Entering through the glass *porte-cochère* that connects the old front door and the scrolled gateway and railings on Herschel Walk, the visitor would have had the billiard-room and library to either side and ahead of him the wide inner hall (the remains of the old *gaanderij*) with the drawing-room to the right and opposite that the dining-room, the teak staircase (constructed *in situ*) and access to the breakfast room and extensive kitchen and servants' quarters beyond. The inner hall gave straight onto the verandah. Beyond the servants' wing, the stables of Captain Hare's day were extensively modernized and included a coach-house and coachman's cottage. On the first floor in the main house there were the usual bedrooms, dressing-rooms, nurseries, bathrooms and maids' rooms. The whole of the floor beneath the mansard roof was left as a 'recreation room'. There were thirty rooms in all.

The house was fitted with the very latest modern appliances – electric bells, ventilators, patent fire-gates, kitchener with hot and cold water and so on. The main reception rooms were richly decorated in what was fondly imagined by the *Wynberg Times* of the day to be 'the Louis XIV style': the floors laid with parquet, the ceilings ornamentally designed and stencilled and the walls given architectural motifs richly picked out in gold. These motifs were the work of the wonderfully named Mr J Christ, a decorator from Prague,[22] whose Middle-European taste adds yet another ingredient to the improbable whole. The ceiling in the billiard-room is a similarly inventive creation, with billiard balls and cues and the Spences' initials all forming part of the decorative scheme.

The final result was undoubtedly impressive, the more so when seen surrounded by elaborate and extensive Victorian gardens. These were designed with 'skill and admirable taste' by the head gardener, Robert Allan, formerly in the employ of Sir Harry Scudmore of Holme Lacey in Herefordshire.[23] Allan cleared away much of the woodland in which Emma Rutherfoord had roamed and read *Carlington Castle* in sentimental solitude in Hare's day,[24] and laid out a garden in typical mid-Victorian manner – gravel paths

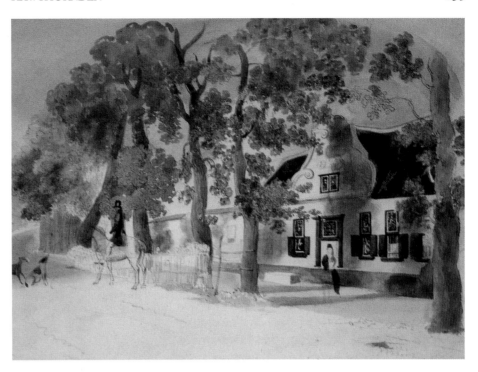

TOP. Captain Hare's house (*circa* 1845) by C Webb Smith. The Cape Dutch house with a Vergelegen-type gable and already expanded with a range of rooms along Herschel Walk. The present Hawthornden seems to have been built on the same foundations. (Library of Parliament)

ABOVE. Hawthornden *circa* 1890, still surrounded by vineyards, and Spence's conservatory as yet unaltered by Sir JB.

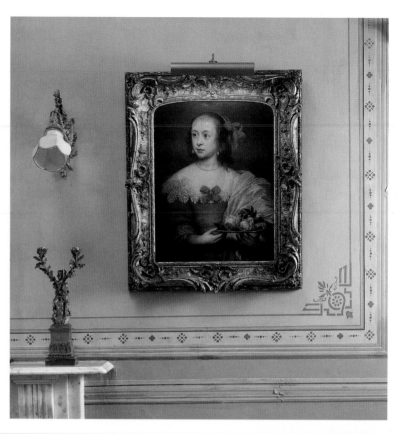

RIGHT. The School of Van Dyck portrait of Princess Mary came from Robinson's Park Lane mansion.

BELOW. Drawing-room. The stencilling executed by the marvellously named J Christ provides a background for the opulent 'Diamond Jubilee' furnishings – aubasson, nineteenth-century 'Hotel Louis' (the *fauteuils* are from Meillier and Co, London), too-new Sheraton, gilt overmantle and expensive pictures. Needless to say, the actual contemporary furnishing of this room was positively tawdry and provincial by comparison: in keeping with the attitude of most of the South African mining magnates, art and affluence were strictly reserved for London.

FAR RIGHT. Count de Werve's portrait (School of Rubens) hangs above a nineteenth-century walnut writing desk flanked by two ebonized 'Renaissance' chairs. The stencilling may be clearly seen.

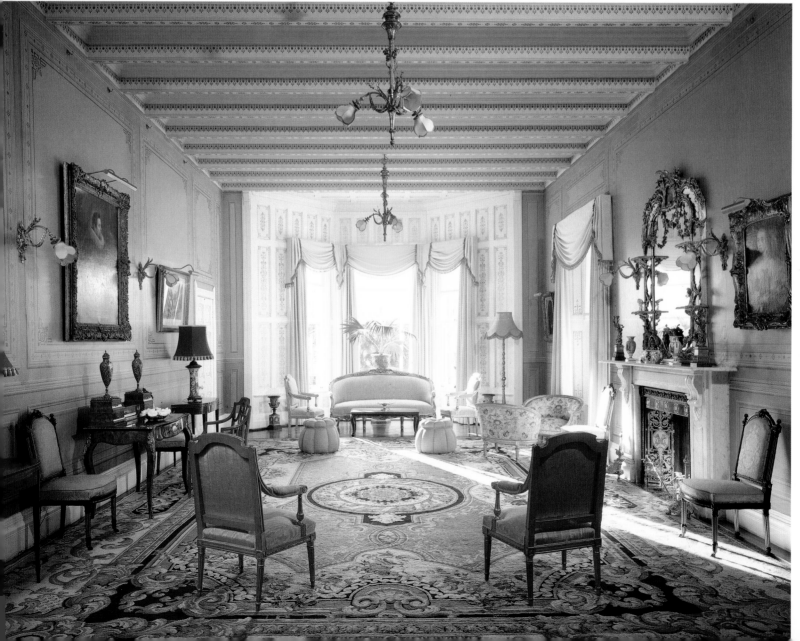

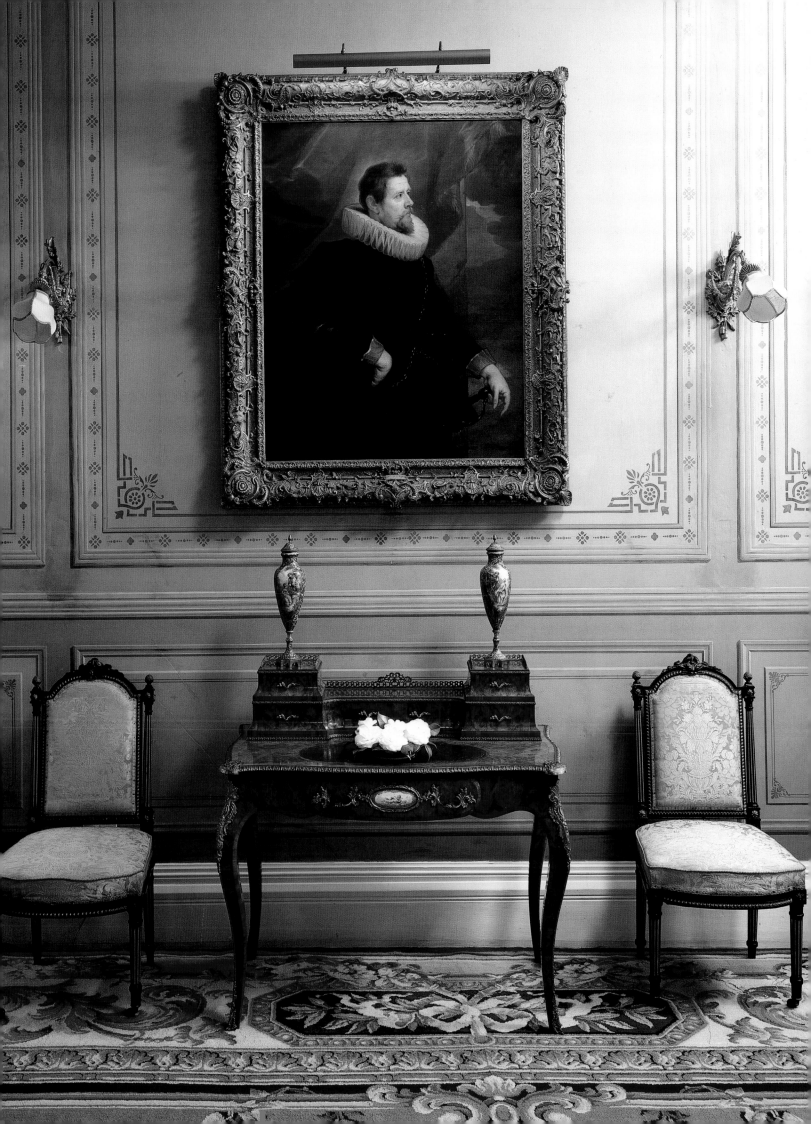

and series of staircases lined with urns descending the steep terraces in front of the house to the levelled lawns in the valley below. The lawns were interspersed with formal beds regularly bedded out by the under-gardeners. A large conservatory stood outside the drawing-room, and was entered by way of the bay in the base of the tower.

The house was completed by October 1882. Tier gave a dinner for his hundred workmen and Captain Spence gave another in the great hall for about ninety mechanics and the other labourers involved. The table was by all accounts sumptuously furnished and the evening ended on a convivial note with the Captain and his guests exchanging toasts of mutual admiration, general satisfaction being expressed at the completion of a building worthy of the owner, the contractor, the workmen, and indeed, of the Colony itself.[25]

It is a great pity that we know no more about Spence, for Hawthornden is very much his creation and structurally, at least, survives much as he built it. Alas, he enjoyed it for no more than six years. He went gloriously insolvent through diamond prospecting and was forced to sell. The house was bought by Sir Frederick Philipson-Stow, one of Cecil Rhodes's advisers, and three years later he sold it to Mr (later Sir) Joseph Benjamin Robinson.

No similar veil of obscurity shrouds Sir JB. Although his alterations to the house were not radical – he added a giant conservatory with a ballroom beneath it,[26] redecorated the library and billiard-room, and extended the servants' wing – it is his personality that still dominates the house where his descendants continue to live today. His portrait by Roworth, fittingly one-and-a-half times life size, hangs in the hall. He commissioned his likeness in the guise in which he saw himself – that of a colonial baronet, frock-coated and pith-helmeted, upright and with a generally patrician demeanour.

Roworth painted a second portrait of Robinson as he himself saw him in old age, the official portrait having been painted retrospectively, so to speak. It is a particularly fine example of the artist's skill and a more telling likeness, some would say, of the sitter whose Scrooge-like countenance – hard, mean and unrepentant – fixes the viewer with a beady gaze. Needless to say, Sir JB never liked this portrait and in his day it was never hung.* The two portraits represent the two conflicting images of the old Randlord – the former that of his supporters and which he himself caused to have enshrined in a wonderfully fanciful biography, and the latter that of his detractors, who were legion. Perhaps the reality was neither and there should have been a third – Robinson portrayed as the genuine pioneer.

He was born in Cradock in 1840, the son, so he claimed, of 1820 Settlers, though some eminent historians have expressed doubt about this. He is vague, except on various specific points, about his childhood. He claimed, for example, a vivid early memory of his brothers defending their farmhouse against a

* Although now hung, the portrait has exhibited an alarming propensity to crash to the floor, on one occasion narrowly missing one of the family who had been sitting below it.

Xhosa attack and one is tempted to credit this, if for no other reason than that it could explain his unnecessarily harsh attitude towards people of colour in his later life.[27]

After a patchy education he became a wool merchant in the Orange Free State and fought with the Boers against the Basuto in 1865.[28] Alas, one is forced to discount, against the evidence of more accurate historians,[29] his romantic version nicely embroidered of being first on the diamond diggings and first on the Witwatersrand. But he certainly was an early pioneer at Kimberley, enjoying rich claims initially, raising and commanding the Kimberley Light Horse and becoming mayor in 1880. The following year he took his seat in the Cape House of Assembly, and there was the moving force behind the Diamond Trade Act which sought to stamp out Illicit Diamond Buying with positively draconian measures.

In the end, his diamond business did not prosper in the face of competition and amalgamations, and it is now generally accepted that on the eve of the Witwatersrand discovery he was facing bankruptcy. A tip-off from an old friend sent him post-haste to the southern Transvaal where, in partnership with Alfred Beit, he started prospecting in 1886. Within that year they purchased Langlaagte from the widow Oosthuizen, and it was here that the main reef was discovered that began the industrialization, and prosperity, of the Rand.

In 1887 the Robinson Gold Mining Company was registered and in January 1888 the Langlaagte Estate & Gold Mining Company was formed with a capital of £450 000. By the end of 1899 the company had distributed dividends amounting to 304 per cent! In 1889 Robinson registered the Randfontein Estates Gold Mining Company.[30] Too strong a character to suffer a partnership long, he quarrelled with Beit and sold out his share in the company that bore his name to the newly formed Wernher Beit & Company for a quarter of a million pounds. It was a great mistake, for the West Rand never produced the riches that the East Rand did.

Robinson's pride and great vanity (what Emden calls his 'despotic egotism') ill-suffered any defeat; well might we believe his boast that by the age of sixteen he had beaten up every boy for miles around Cradock. In consequence he bore terrible grudges against any who bettered him: against Wernher and Beit who profited by his mistake; against Rhodes, where his attitude amounted to positive hatred for reasons that no one could pinpoint except his success and aura of greatness; against the Chamber of Mines and, indeed, against the whole new mining magnate establishment who viewed his activities askance. These resulted in wasteful efforts to get even which succeeded only in adding to his unpopularity – trying to break the De Beers monopoly and adopting a pro-Boer line through his newspapers, a contrariness that got him nowhere and sits rather oddly with his removal to London in 1894.

Robinson had acquired Hawthornden – 'my estate near Cape Town' as he habitually referred to it – in 1891 and had put his alterations in hand. But estates near Cape Town, like mansions in Parktown, were

FAR LEFT. The rose bedroom. Brass beds and a fine nineteenth-century Japanese lacquered screen. Millais' *The Mistletoe Cutter* hangs over the fireplace.

ABOVE. Sir JB had a curiously sentimental streak and collected the works of Millais, even owning *Cherry Ripe* at one stage. All the bedrooms at Hawthornden, and even the nurseries, have one over the fireplace. This one is *Day Dream*.

RIGHT. Roworth's splendid portrait of Sir JB in old age hangs in the library.

BELOW. Lady Robinson's portrait by Hal Hurst is suitably reflected between Mrs Whittington (by Lawrence) and Reynolds' Duke of Rutland, both of which were purchased by Sir JB for Dudley House.

FAR RIGHT. The billiard-room. Murals and wood graining and an elaborately designed ceiling incorporating billiard cues and balls and the Spences' initials. On the table next to the fireplace is the Governor General's Cup won at Turffontein before the war.

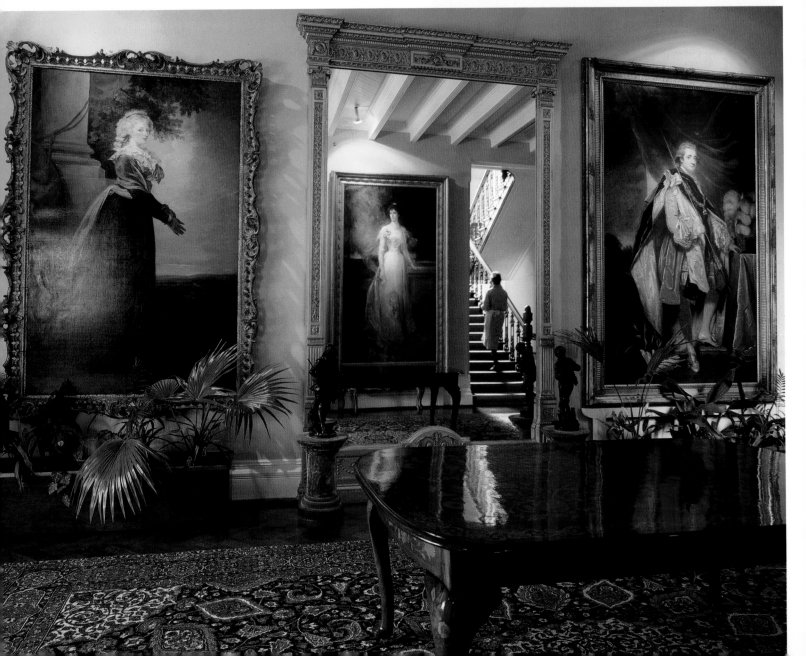

not the last word in social prestige. Park Lane was. It lay like the Holy Grail at the end of the long and dusty road that had led many a speculator from Kimberley to the Rand – and it symbolized the very pinnacle of financial success.

In 1894 the Robinsons acquired the lease on Dudley House in Park Lane. They were not the only South African magnates residing in this salubrious thoroughfare. Beit lived at No 26, the Ecksteins at No 18; Barney Barnato moved in next door to the Rothschilds. And there were others similarly lured by the very natural love of fashionable society who lived in the immediate vicinity. The Phillipses were in Grosvenor Square; the Wernhers had taken Bath House in Piccadilly.[31] The arrival of all these colonials was greeted with a certain amount of scorn: their elaborate entertainments, their fantastically bejew-elled wives ('I see diamonds are trumps to-night,' was a typical sneer) and their frantic social efforts caused them to be collectively and slightingly refer-red to as 'the Kaffir Circus'. And nowhere is all their so-cial climbing and carry-on better portrayed than in the soubrette's main number from a then current West End hit, *The Girl at Kays*:

> *It's very nice to be*
> *A dame of high degree*
> *With blood and reputation beautifully blue.*
> *But folks with cash can get*
> *Into the smartest set*
> *And that's what I shall proceed to do.*
> *When driving through the park*
> *Perhaps you may remark*
> *A silver-mounted perfumed petrol motor trap.*
> *You'll see me on the box*
> *In furs of silver fox*
> *With just a few big diamonds in my cap.*
> *I'll marry Hoggenheimer* of Park Lane*
> *The money he is winning*
> *I'll set it gaily spinning*
> *And ev'ry one that sees me will explain*
> *That I'm Mrs Hoggenheimer of Park Lane.*

> *My Thursdays ev'ry week*
> *Will be extremely chic*
> *As all the papers will remark in social pars:*
> *When Kubelik comes in*
> *To play the violin*
> *With recitations by dramatic stars!*
> *I'll build a hospital*
> *And give a fancy ball*
> *And all the House of Peers to dinner I'll invite.*
> *And when some noble Lords*
> *Are on my husband's boards*
> *He won't be long in getting made a knight*
> *They'll honour Hoggenheimer of Park Lane,*
> *And I shall be presented*
> *In style unprecedented.*
> *There never has been seen so grand a train*
> *As that of Lady Hoggenheimer of Park Lane.*

The library with its original William Morrissy wallpaper and gold frieze, 'Jacobean' ceilings and 'Renaissance' woodwork. Lord Leighton's *Frigidarium* hangs next to the window; the tea silver bears the Italian royal crest and belonged to the present count's father as Italian Minister Plenipotentiary to South Africa before the war.

* It should be noted that this was the rather erroneous source of the name of the cartoon character – anti-capitalistic and anti-semitic – created by *Die Vaderland* in the 1930s.

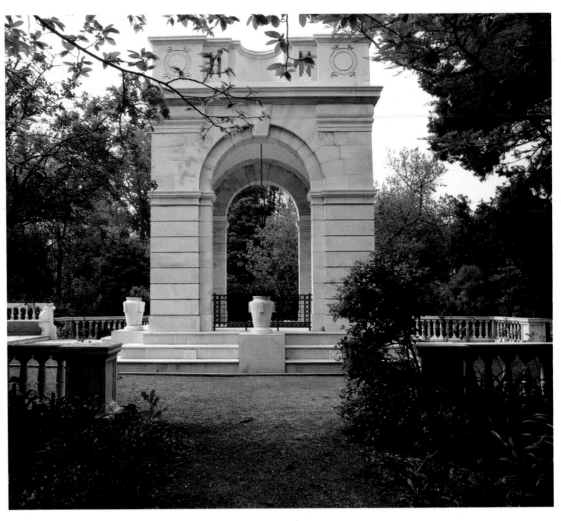

But our aspiring pride
Will not be satisfied
Unless we make a bid for something bigger yet!
I feel that I should seem
A sort of fairy dream
In ermine robes and little coronet!
I'll get my husband sent
Right into Parliament,
With friends enough to set his party in a whirl.
And if the voting's near
He may be made a peer,
A baron, viscount, or a belted earl!
He'll be Lord Hoggenheimer of Park Lane,
And prove he is descended
From Norman baron splendid
And I'll have royal blood in ev'ry vein
When I am Countess Hoggenheimer of Park Lane.

Still, London society, then as now, was not noticeably fastidious concerning the source of new money from abroad, providing it was splashed about in sufficient quantities, and many such as the Beits and Phillipses enjoyed great and, in the end, quite genuine popularity. The Robinsons enjoyed entertaining lavishly: and Dudley House was splendid by any standards, sumptuously furnished and hung with magnificent pictures.

Robinson received a baronetcy in 1908 for having advocated self-government in the Transvaal, but the peerage which he desired, and evidently actively

sought through Lloyd George in the early 1920s, eluded him. It says much for his indifference to criticism that he thought that he would get away with this. The publication of the recommendation led to a storm of protest: there was an extraordinary debate in the House of Lords where it was heavily hinted that money was involved.[32] A string of his old enemies already there ensconced whipped up a case against him.

Lord Harris (Chairman of Rhodes's Gold Fields) reminded the House of the sensational court case instigated after S B Joel had purchased Robinson's Randfontein Estate Company, where discoveries of gross irregularities on Robinson's part had led to a verdict of 'fraudulent trusteeship' and consequent fantastic damages of half a million pounds. Lord Buxton (second Governor General of the Union) pointed out that Robinson had made no contribution to the war effort ('the touchstone of public and Imperial services'), that Smuts was opposed to the granting of this honour and even went so far as to undertake that no one in South Africa, black or white, considered that his services warranted it. Lord Selborne (former High Commissioner) indicated that during his term Robinson had been 'unhelpful' and, worse, 'pro-Boer', and went on to denounce him utterly.

The following day Robinson issued an open letter to Lloyd George, asking for 'permission to decline the proposal'.[33] It was a dignified statement somewhat marred by an unofficial one repeated by him here

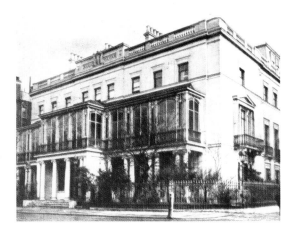

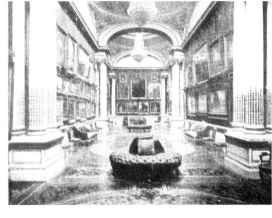

ABOVE. Langlaagte Restante, Robinson's first house on the Rand.

FARLEFT. Dudley House, no 100 Park Lane – Robinson's London house.

LEFT. The art gallery, Dudley House: full *belle époque* opulence. One of the nineteenth-century Hotel Louis canapés now stands in the drawing-room at Hawthornden.

and there to the effect that the lost title had not cost him a single penny.[34] Robinson decided to quit London altogether. Dudley House had been shut up in 1914; now its pictures and furniture were sold, many only to be bought in again by Sir JB who changed his mind at the last minute about their disposal.[35] Some of the contents now furnish Hawthornden and provide a faint echo of the Diamond Jubilee splendours that once were.

Sir JB proved as contentious in death as he had during his lifetime and people were not wanting who said that Robinson's last laugh came from the grave. To the general amazement and indignation, his fortune (popularly estimated at ten million pounds) was left substantially to his favourite daughter Ida, married to the recently ennobled Italian Minister Plenipotentiary to South Africa, Count Labia, his less favoured children being cut off almost without a penny. No charitable bequests were made. The will was greeted with much adverse press in London and South Africa which, in all fairness, the Countess refuted at length and in no uncertain terms in a letter she caused to have published in the *Cape Times*.[36] It filled a whole column, contending (accurately) that the editors had always adopted a malignant attitude

towards her father – 'one of the ablest, most sensitive men who ever lived – in fact the biggest man South Africa has ever produced'. She went on to say that Sir JB had felt that his charitable obligations to the state were more than amply discharged by the taxes he was forced to pay during his lifetime and ended by pointing out for general edification that on the very morrow of the funeral one of the disappointed beneficiaries – her sister-in-law* – was to be seen 'flaunting' herself at the most social of Cape venues, the Kenilworth Race Course (on that most social of Cape occasions, the Metropolitan Handicap), arrayed in a glorious pink frock!

After her husband's death the Countess lived on at Hawthornden with her sister. They and their parents lie buried in the splendid marble mausoleum erected in the grounds. Her younger son, Count Natale Labia, and his family now live in the house. It was recently restored by Mike Munnik of Munnik, Visser, Black, Fish and Partners. Through the Count's generosity it is bequeathed to the Provincial Authorities, destined to become a museum of Victoriana.

* Eileen St Leger, mother of Wilfred, the popular present (third) baronet.

TWEEDSIDE LODGE

MATJIESFONTEIN, KAROO

Saturday 23 November 1889 – like almost every other morning – broke bright and sparklingly clear over the Karoo. But the day was destined to be quite unlike any other and by mid-morning the relentless heat shimmered over a truly remarkable colonial scene. There, in the middle of the expanses of arid, dun-coloured desolation on the railway line between Montagu Road (as Touws River was then called) and Laingsburg, where three years previously there had been nothing but a wretched siding and a couple of wood-and-iron shacks, stood a spanking new village. Gaily bedecked in bunting on this particular morning, it boasted the Masonic Lodge Hotel ('a first class little establishment', according to the *Cape Argus*), stables, a store, a row of villas and a mill driven by steam and wind. The station was massed with flowers, the pots arranged in serried ranks in the manner once so beloved by station-masters.

At one end of the village, rather like the manor house, stood Tweedside Lodge, the Union Jack fluttering proudly from its flagstaff. It was surrounded by a new, carefully laid-out garden with a fountain, a tennis lawn, a well-stocked kitchen garden and a new orchard of plums, oranges, naartjies, guavas, cherries, apples, pears, peaches, quinces and figs. There was a trellised vinery, and a suspension bridge with a chinoiserie balustrade spanned the dry river bed. A newly planted avenue of bluegums backed by a pomegranate hedge led off across the veld.[1]

Matjesfontein* was presenting her most smiling face to a throng of dignitaries and fashionable guests who had left Cape Town on the 8.15 the previous evening, another contingent having arrived from Kimberley on the down train the night before. They had all had a hearty breakfast in the old goods-shed – elaborately transformed with plants and a great deal of upholstery into a *salon à manger* (the *Cape Argus* again) – and now disposed themselves to enjoy the variety of entertainments laid on by their host: cricket, bisley, billiards, lawn tennis and pigeon shooting. The band of the Worcester Rifles ground its way through its musical selection and added greatly, it was said all round, to the pleasure aroused by the day's proceedings.

The occasion for all this jollification was the inauguration of the new Matjesfontein Waterworks, designed to supply the railways as well as the village. The ceremony was performed by Lady Sprigg, the Governor's wife, who at an appropriate juncture was invited to step forward and turn a tap. Presently, as the Cape dailies duly reported, there spurted forth in a new fountain the bright drops of the new supply, fresh from the spring at Bulshouven, two and a quarter miles away. The company shouted 'Bravo!', the band struck up 'God Save the Queen' and there were loud cheers for Lady Sprigg and for the blushing hero of the hour, Mr James Logan – otherwise known as the Laird of Matjesfontein – who at great personal expense had established the source of water and sold the rights to the Colonial Railways.

James Logan was not quite universally held to be a

blushing hero. While the more charitably inclined would point to a nice modesty – 'It is not that I have done so much for the Karoo, it is that others have done so little'[2] – the best that many would allow was that he was charismatic. Olive Schreiner, who lived at Matjesfontein because of her asthma, described him as 'a man of remarkable personal force and even great violence'.[3] Doubtless there was a certain amount of sour grapes but his business success, his friendship with the likes of Sivewright, another tough and successful immigrant Scot, caused him to be looked at askance by the Cape Liberal establishment and the Afrikaner Bond alike. It was generally felt that in financial matters he and his cronies sailed close to the wind and, using political influence to personal advantage, were guilty of what Rose Innes was later to term 'hanky-panky'.[4]

Still, he was a doer or what the Americans would nowadays term an achiever: Rhodes on one occasion referred to him as the other great creator in South Africa.[5] Matjesfontein was his brain-child and no one, not even the censorious Sauers and Merrimans of that era, could deny him that. The desert had bloomed for him spectacularly and with a rapidity only matched by his rise to fortune. For if ever there was a rags to riches immigrant story it must surely belong to James Logan. This well-worn cliché is the only way to describe the career of a man of no particular consequence who, with £5 in his pocket, started work as a porter at Cape Town station in 1877 and who, twenty-five years later and a millionaire, attended the coronation of Edward VII at Westminster Abbey.[6]

The third son in the family, he was born at Reston in Berwickshire in 1857. His father worked for the North British Railways Company and, after leaving school at an early age, James followed in his footsteps. He seems to have done quite well, but at seventeen a natural enough wanderlust to see more of the world than Reston and its environs had to offer led him to sea as an apprentice on a sailing ship.[7] Two years later the Australian-bound *Rockhampton* put into Simon's Bay. It was severely waterlogged – not shipwrecked, alas, as romantics would have it, happily embroidering that Logan swam ashore and went on to make his fortune. In fact Logan discharged himself and with £5 in his pocket walked to Cape Town and got himself a job as a porter at the Adderley Street station. Within a week his NBR experience saw him promoted to a clerical position at Salt River Junction and a meteoric rise landed him, within a year, as station-master of the new Cape Town station at the age of twenty.

Shortly thereafter he was offered the post of superintendent of the railway line between Hex River and Prince Albert Road. The offer was made on condition that he married, which he did, taking as his bride a Miss Emma Haylett whose parents owned butcheries and several lodging houses in Cape Town.[8]

In addition to being on the railway line, Touws River was situated on the main road north to the Diamond Fields and in no time at all Logan perceived that there were ways at hand for making the sort of money railway employees could only ever dream of. In those days, when dining cars were still a foreign novelty, trains would stop at predetermined stations

PREVIOUS PAGE. The house with its striped verandah roof, rustications, pepper-pot chimneys and cast-iron crestings and finials, seen from the Karoo succulent garden laid out by James Logan junior.

ABOVE. James Logan.

* It was spelt thus until the 1950s and always pronounced 'Matchesfontain' by U-speaking South Africans.

LEFT. The cellars beneath the house.

BELOW. Arthur Elliott's photograph of Tweedside before the trees obscured the surrounding Karoo. Logan's 'Wind and Steam Flour Mill' is at right, and the picket fence has not yet been replaced by the elaborate cast-iron affair. This is 'Matjesfontein' as Olive Schreiner must have known it. (A Elliott, Cape Archives)

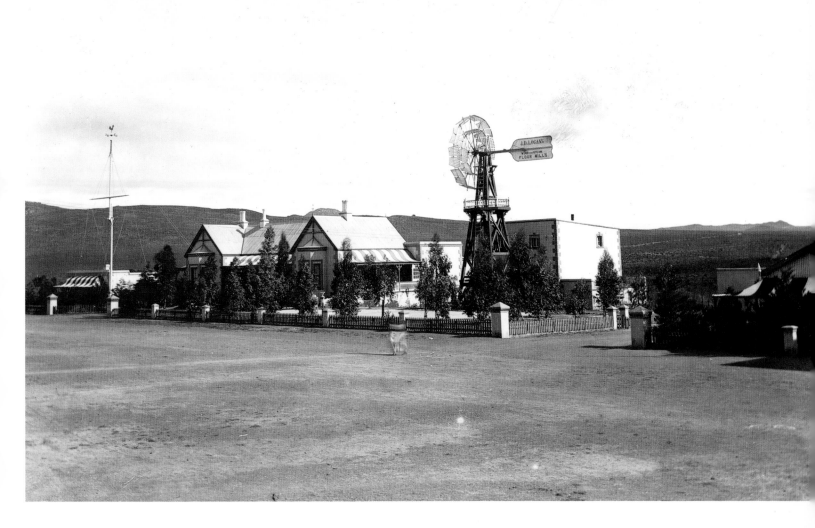

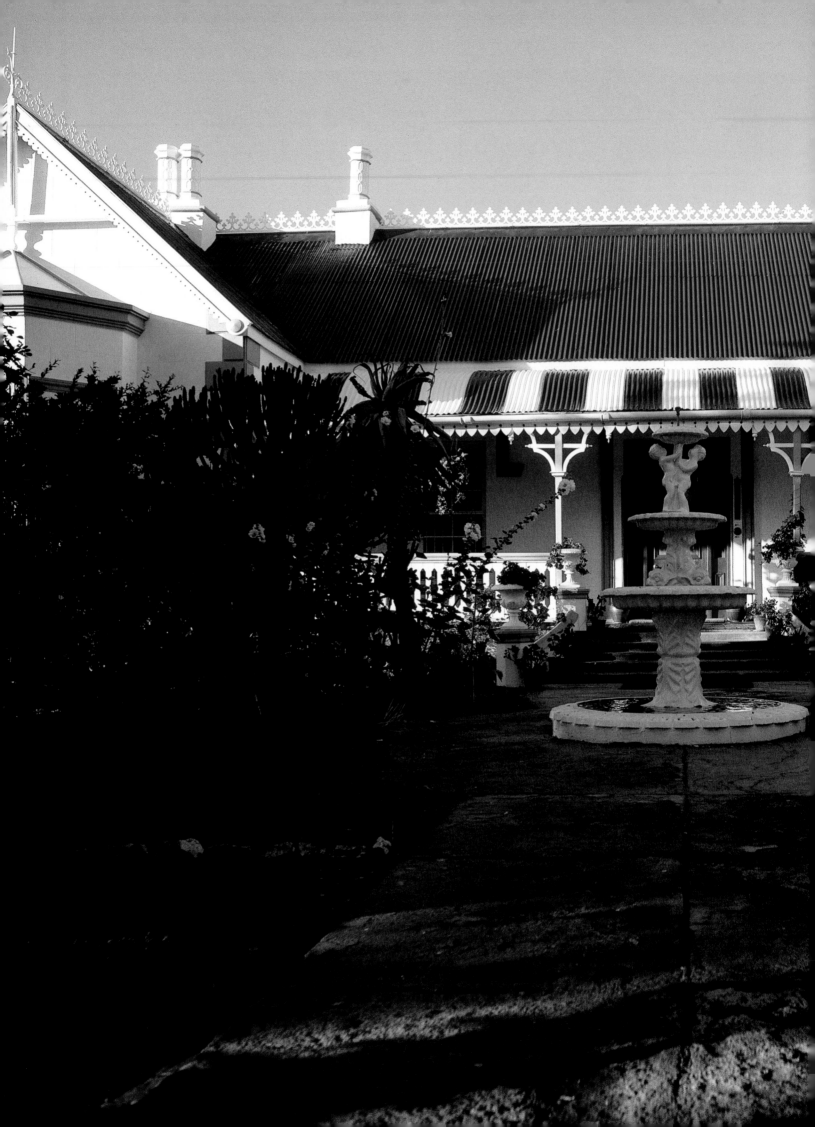

LEFT. The Victorian Karoo village house seen from the front gate.

BELOW. Front verandah with its dags and balustradings and showing the rustications picked out in 'Tweedside blue'.

TOP. The billiard-room. When Tweedside Lodge was used as staff headquarters during the Anglo-Boer War, this became the Operations Room.

ABOVE. The drawing-room. Needlework, pampas grass, gas lamps and photographs in silver frames – including one of the Louis Bothas in full court dress.

RIGHT. The dining-room with its original marble chimney-piece, its tongue-and-groove boarded ceiling and its light fittings. The portrait is of James Logan. Distinguished travellers would not dine at the station restaurant but would be conducted to this table, laden with Victorian silver, for gargantuan meals in the heat of the Karoo. Here, in the middle of nowhere, have sat Lord Randolph Churchill, Cecil Rhodes, the Sultan of Zanzibar, Lord Milner and other unlikely luminaries.

along the way and the passengers would disembark and take their meals in the refreshment room. Logan acquired the concession for the refreshment room at Touws River and also took on the lease of the railway-owned Frere Hotel. So successful was he that within twelve months he had resigned from the Colonial Railways to devote himself to his own affairs.[9]

And with success. Assisted by his wife he did so well out of the hotel and refreshment room that he began buying up land in the Karoo. It soon became evident that the couple's move from Cape Town had been a good one for another important reason. Logan had always been troubled by a chest ailment and for the first time in his life this was cleared up in the dry semi-desert air.[10]

Then in 1884 the refreshment contract at a stop thirty-four miles up the line came up for auction. The place was called Matjesfontein after the local reed used for making baskets or *mandjies*, and it then comprised a siding and a small wood-and-iron doss-house which also served as a refreshment room. The previous owner had bankrupted himself but Logan was sure he could succeed. Moreover, like others before him, he was intoxicated (the term was his) by the soft veld and silent desolation of the Karoo and, encouraged by its benefits to his health, determined to move his whole family there. He bought the lot for £400,[11] acquired the refreshment contract from the Colonial Railways and the following year began to build his new house.

Though slightly grander than most, Tweedside Lodge is typical of the many Victorian villas and farm-houses built throughout the Cape, Natal, the Orange Free State and the Transvaal from the 1860s up to the Anglo-Boer War. Indeed, until the Second World War this genre was generally regarded as 'the typical South African house', an expression, alas, no longer valid. In most cases these houses have since been destroyed or unsympathetically modernized so that today they are as much endangered as an architectural type as Cape Dutch buildings were at the turn of the century.

Their aesthetic antecedents stretch all the way back to the eighteenth-century *cottage ornée*, the verandah, like the gable on a Cape Dutch house, being its most distinctive feature. Though undoubtedly attractive, the verandah was no mere architectural embellishment, for it provided the ideal solution for nineteenth-century Europeans settling in a hot climate – protecting their interiors and furnishings from the strong African sunlight and creating a perfect outdoor living room – shaded in summer and sunny in winter. Massed with ferns and potted plants and furnished with wicker chairs, it fulfilled in the colonies much the same function as the conservatory did in England, for in the African climate glass was not only unnecessary, but also undesirable, violent hailstorms being a not infrequent summer hazard.

Though not a true verandah house, Tweedside Lodge had a verandah on each elevation, that on the front or south-facing façade with its dags and fretwork intended to provide shade from the heat of the Karoo summer; that on the back or north façade with its Chinese Chippendale balustrading being a sun-trap

in winter. Internally, there is a mass of rooms linked by two passages: an entrance passage dividing the two main front rooms (which have two further rooms with projecting bays beyond them) and a long central passage at right angles to this. All in all there are thirteen rooms and twelve cellars at Tweedside, including a drawing-room, dining-room, morning-room or boudoir, numerous bedrooms and a billiard-room – that most definitive of Victorian colonial status symbols. The kitchens are situated below the house – the slope of the ground accommodating all the servants' quarters in a type of basement with a rabbit warren of cellars for supplies built in the dry Karoo sand. The combination of the coal stoves and the heat must have produced the most frightful working conditions for the Scots cook and housekeeper[12] who prepared the endless succession of many-coursed meals there.

When it came to the actual construction, Logan turned up his nose at local craftsmen and materials, ruthlessly importing both from various parts of the United Kingdom. His boast – and it was one widely held and applauded in his day – was that this ensured that the standard of craftsmanship of his house was equal to the very best of Victorian England.[13] Certainly it is solid, but one cannot but feel that some of the contemporary enthusiastic accounts of it – 'would grace Belgravia'[14] and so on – owed more to the surprise of finding such a residence in that unpromising location than to any accurate comparison. 'Large and comfortable', was Lord Randolph Churchill's description[15] and as a source it would seem more plausible.

While it seems probable that Liston, the master builder who erected various hotels for Logan, would have been responsible for some of the later buildings at Matjesfontein,[16] there is no evidence that the design of Tweedside Lodge is his. At best he may have furnished plans, but like many a house built in the sticks one detects in its design a lack of supervision by an experienced contractor. Certainly there is an irritating lack of symmetry about the front façade that can hardly have been intended. Still, with its pretty fretwork, cast-iron crestings and finials, pepper-pot chimneys, striped verandahs and elaborate rustications picked out in 'Tweedside blue', the whole has a certain flamboyance and appeal that only the most aesthetically severe would deny. The interiors were handsome enough, Oregon pine being used for the floors and intricate ceiling, and marble fireplaces

providing heat against the cold of the Karoo winters. Papered walls, grained woodwork and a splendid array of overstuffed upholstery, and needlework, mahogany and knick-knacks provided the Victorian idea of comfort to which Lord Randolph had alluded, the whole being shrouded in a perpetual gloom ensured by the verandah and heavy lace curtains. Tweedside Lodge was not unique in this respect and until thirty years ago the Karoo was the great repository of Victoriana in South Africa.

Inspired by the benefits to his health and bolstered by the good supply of water, Logan proceeded in the next decade to develop Matjesfontein as a resort.[17] It must have had a curious type of appeal:

'The event of the day,' wrote Olive Schreiner, one of the earliest visitors, 'is when twice in the twenty-four hours the railway train sweeps by; in the morning the Cape train on its way up to the Diamond fields and Gold fields stops about nine o'clock and the people get out to have breakfast here, and they leave our mails; again about six in the evening, the train from the Diamond fields passes and stops for half an hour. It is curious and to me very attractive, this mixture of civilization and the most wild untamed freedom; the barren mountains and the wild Karoo and the railway train ... If only my asthma keeps away, this is the ideal place I have so long been waiting for.'[18]

The resort was soon remarkably up to date and modern, boasting water-borne sewage and serviced by acetylene gas and electricity.[19] Tweedside Lodge was thus one of the first houses in South Africa to be electrically lit. The whole village was designed as a piece, the new station included, the final uniformity being provided by the lavish use of cast-iron decoration – some of the best and most expensive that Macfarlane's foundry had to offer.[20] The long wall down the village street which incorporated Tweedside reinforces the impression of oneness. It seems that this dates from the time of the building of the new and much grander Hotel Milner: there is a picture of Reston Villa, another house in the street, by Daniel Krynauw dated 1895 showing it surrounded by a picket fence. Presumably Tweedside Lodge had previously had something similar and all the gate scrollwork, fencing, verandahs, lamp-posts and such-like were ordered and installed together.

Church Parade, Matjiesfontein, during the Anglo-Boer War. Tweedside Lodge has been transformed into Flagstaff House.

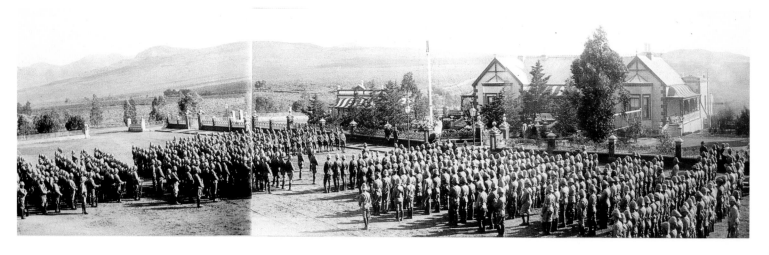

LEFT. Back of house showing the verandah or gallery and the kitchen situated in the basement.

ABOVE. Back verandah or gallery. With its wooden floor and chinoiserie railing, this is a sun-trap in the Karoo winter.

The hotel with its swimming pool – then an almost unheard-of novelty – was begun after the new station (with its separate waiting-rooms for ladies and gentlemen) and the mineral water factory, and was rushed to be completed at the outbreak of the Anglo-Boer War. During the war a vast remount camp with ten thousand troops and twenty thousand horses was established on the outskirts of the village. Even today the area is still littered with rusty bullybeef tins. Logan, who raised and commanded a corps of Mounted Rifles in the latter part of the war, lavishly entertained the troops and presented the hotel to the Imperial Authorities as a sanatorium for convalescent officers.[21] The castellated turret was armed as a look-out post. As at Brenthurst forty years later, it was a rich man's contribution to the war effort and the maintenance was fully underwritten by him. Tweedside Lodge itself became a sort of staff headquarters housing generals such as Haig and Ironside; the billiard-room was used as the Operations Room.

The house had become a great centre of hospitality, not only for the Logans' friends and acquaintances (the Tweedside shoot, then as now, being a coveted invitation in the Cape shooting season) but also for well-known visitors. In no time the Logans' catering reputation ensured that the principal up and down trains stopped at Matjesfontein for meals. Distinguished travellers would be met and conducted across the asphalt and dust to Tweedside Lodge where the gargantuan meals expected by Victorians would be ready for them in the dining-room. Even at breakfast great cold joints would be laid out on the sideboard in addition to the porridge, kippers, eggs and kedgeree provided.[22] It is because of this that the dining-room at Tweedside – a house in the middle of nowhere – can boast to having seated as unlikely a host of luminaries as you could wish to list: Rhodes, Merriman, the Spriggs, the Lochs, Milner, Olive Schreiner, the Sultan of Zanzibar, Lord Randolph Churchill and General Haig among them.

Following the Boer War there is a story of gradual decline as the twentieth century advanced, diminishing the village's attractions and indeed the very reasons for its existence. Medical advances dealt with tuberculosis and asthma; dining cars were added to every train and the spas of the nineteenth century fell out of favour as the seaside became increasingly popular for holidays. The national road bypassed the village at the end of the Second World War and finally only the milk-train ever stopped there. Logan himself seems to have slightly lost interest. He had continued to make his fortune in other more lucrative ventures, and weathered many a storm, including the celebrated Logan Crisis over a marvellously lucrative and shady railways refreshment contract which toppled Rhodes's first ministry.[23] He also acquired a shooting box in Scotland to which he travelled annually.

In the 1960s the village, regarded as an expensive white elephant by Logan's grandchildren, only just escaped demolition. It was purchased and restored as a resort by Mr David Rawdon. Preserving something of the atmosphere of the Victorian Karoo, he may justly claim part responsibility for reviving popular interest in Victorian architecture in South Africa.

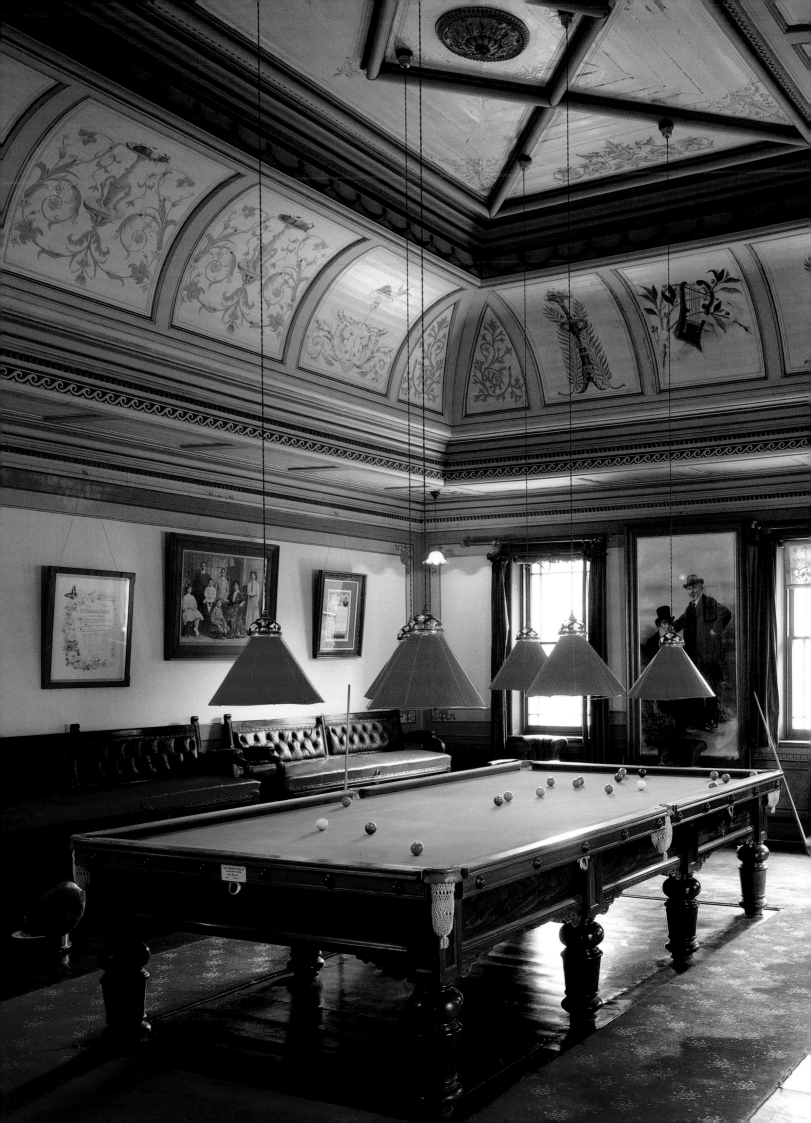

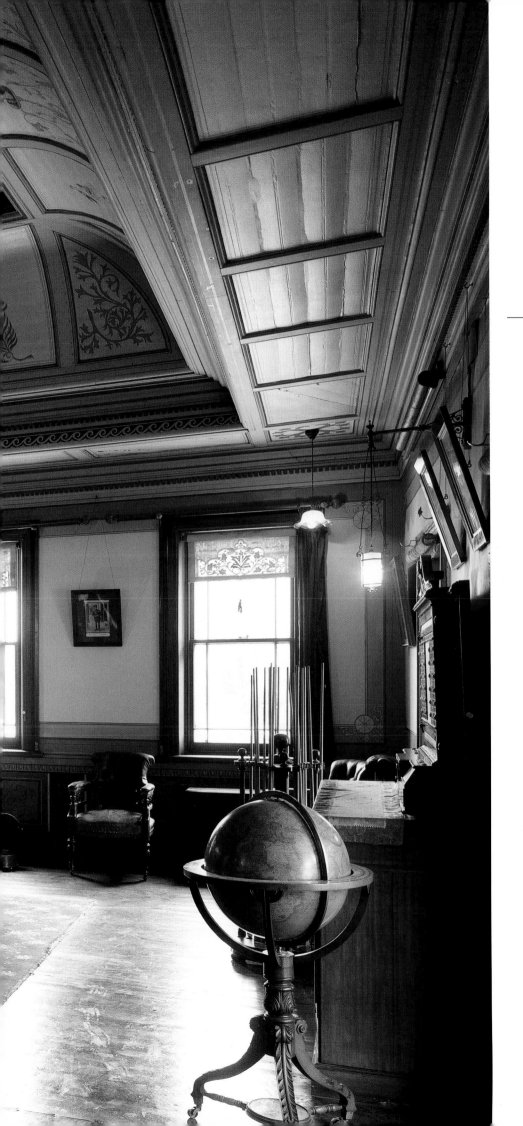

ZWARTKOPPIES HALL

HATHERLEY, NEAR PRETORIA

In the course of this book the reader will become acquainted with colonials of differing European backgrounds – the Dutch Van der Stel, the Prussian Melck, the French Malan, the English Chaplin and the Scots Logan – all of whom made their fortunes in South Africa. Samuel Marks, who built Zwartkoppies Hall in the mid-1880s, belongs to yet another but equally significant category of colonials who may justly claim to be builders of the modern nation. Himself too popular and generous to be classified with the Robinson robber-baron type of magnate, he fits neither into the colonial beau ideal mould of Reynolds and Andersson.* 'The worst thing about religion, politics and love,' he once said, 'is that they pay no dividends.'[1] Not a maxim of which Dr Arnold would have approved, to be sure, but then Samuel Marks's character had not been formed in cheerful cretonned nurseries and on the playing fields of a public school.

He had been born in a *shtetl* – in the Pale of Settlement – in Neustadt-Sugind, Lithuania. His father was an itinerant tailor and he was brought up in the orthodox Jewish traditions. As a young man faced with a future of discrimination in tsarist Russia he had emigrated to England and in Sheffield relatives had set him up in a small knife-finishing workshop. In 1868 he went out to the Cape where the local Jewish community provided him with sufficient credit to become a *smous* – a once familiar character that disappeared from the South African countryside this century – and with a horse and cart he peddled old clothes, cheap jewellery and such-like in the rural districts.[2]

The first reports of the Griqualand diamond discoveries sent him and his cousin, Isaac Lewis, up to the new fields with a wagonload of diggers' requirements. Their success enabled them to open a wooden store in Kimberley and before long they were engaged in the gem business and working claims themselves. Like many other hopefuls, they were to suffer in the inexorable amalgamation trend which culminated in the De Beers monopoly, but with an astuteness that was to characterize their later business developments they diversified their interests, amongst other things buying up coal-bearing land along the Vaal River in the hope of supplying the diggings with fuel. In any event, the experience would prove to have been rewarding: like Robinson and Phillips, the cousins had won their spurs in the dust and hurly-burly of Kimberley. As it was, their pockets were far from empty and with the short-lived Barberton gold rush where their Sheba mine yielded a fantastic twenty-three and a half ounces per ton,[3] the firm of Lewis & Marks had emerged as a major business enterprise.

Sammy Marks was a force to be reckoned with. He had had little formal education, but he was very clever, very intelligent and had a 'wonderful business prescience'; he was known as a man of his word and Emden is lenient on the subject of his less orthodox business methods.[4] He was a phenomenal worker: 'If you want to do a thing proper,' he would say, 'you must do it yourself.'[5] Though he did not suffer fools

* See Lynton Hall and Dolobran respectively.

gladly, and could be an implacable foe (as the brothers Farrar discovered), it is also clear that he was a man of considerable charm. In his hall stood a bust of Cecil Rhodes and a portrait of Paul Kruger. He admired both men – not in the manner of the Vicar of Bray one likes to think, but rather because nothing in his background or indeed his philosophy, as has already been noted, inclined him to be partisan to either cause.

Although happy that his family should enjoy the privileges which his new fortune made possible – a Harrow education and expectations for his son; Shetland ponies and governesses for his daughter; London gowns and Sheffield silver for his wife – he always remained modest. He despised the acquired snobberies of his newly-rich contemporaries and was quick to detect the humbug in their vaingloriousness. The story goes that after Rhodes's death, when Abe Bailey was seen to be assuming not a little of the departed statesman's aura, Marks happened to bump into him one day.

'I understand,' Marks fired off, 'that you are Elisha and the mantle of Elijah has fallen on you.'

Bailey foolishly permitted himself to smirk.

'Well,' said Sammy with devastating bluntness, 'let me tell you that secondhand clothes never fit; I know because I dealt in that (one likes to think he used the marvellous Yiddish word *schmattes*) for years.'[6]

In October 1881, four years before the Barberton gold rush, Marks visited Pretoria. There he met the colourful, Budapest-born A H Nellmapius, already friendly with Kruger, who had approached the Government for a comprehensive manufacturing concession. Nellmapius was at that stage weathering one of his frequent bouts of insolvency[7] but he did own a farm called Hatherley, due east of Pretoria, which was proposed as the site for the first factory – a distillery. Lewis & Marks purchased Hatherley and agreed to finance the distillery if the concession was granted. Following the Transvaal War of 1881, Marks went to Pretoria to register the *Eerste Fabrieken in de Zuid Afrikaansche Republiek Beperk*.[8] His intention was to stay there a few weeks; as events turned out, he remained a resident of the Transvaal for the rest of his days.

The Hatherley estate was adjoined by a farm named Zwartkoppies and it was here, after a peripatetic life, that Marks was to put down roots. In November 1883 he wrote to Barnet Lewis asking him to see to a sum of £1 500 from his bank account 'as I have thoroughly made up my mind to buy Swart Kopje (spelt thus) for myself with it.'[9] After some haggling, it was his for £1 400 in December of that year.[10] The following year Marks returned to England and in December married Bertha Guttman, daughter of middle-class parents, respectable and respected in the Sheffield Jewish community.[11] Early in the new year Sammy brought his bride to the Transvaal and to what one assumes were the rolling grasslands of the Middleveld, for although the previous owner, a Mr Rufus Cockroft, had renamed the farm Christiensen Hall[12] there is no evidence to suggest that the 'Hall' part was anything more than an unrealized pipe-dream. As pipe-dreams were not a pastime in which Sammy Marks

PREVIOUS PAGE. The billiard-room on the first floor, with its coved ceiling and almost Pompeiian frescoes painted by an Italian artist. The table is surrounded by leather chairs, raised banquettes and spittoons. The huge blown-up photograph is of Sammy Marks and his father, an itinerant Lithuanian tailor. The billiard-room was one of the great Victorian colonial status symbols.

ABOVE. Sammy Marks. (Jagger Library, UCT)

LEFT. The robust Transvaal Gothic gates. One wonders whether these did not survive from the proposed Christiensen Hall.

BELOW. The Hall *circa* 1891 as redesigned by De Zwaan and Van Dyk. Typical of a colonial house which has grown with a family's fortunes and therefore is not overly distinguished: a verandah house (in front) with a double-storeyed section and trellised sleeping porch behind, and the pompous Transvaal republican *porte-cochère* (repeated on the opposite side) added for good measure. Some of the verandah trelliswork is missing but the looped barge-boarding, spikes and air vents all survive.

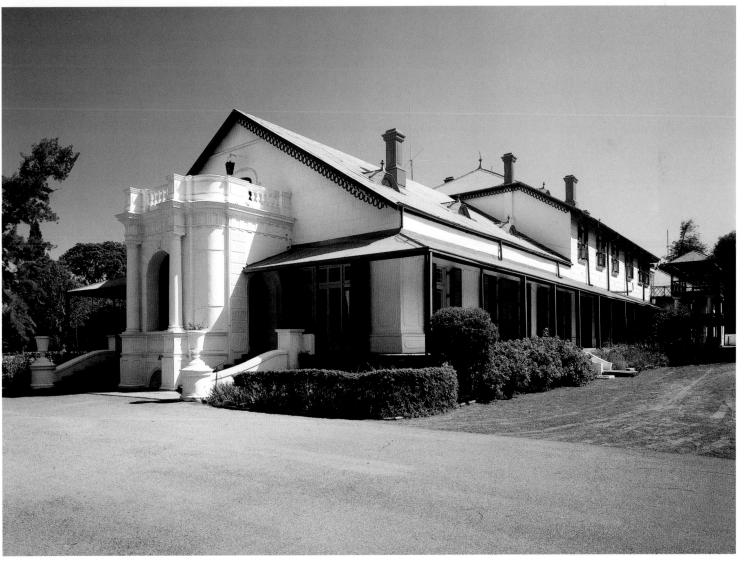

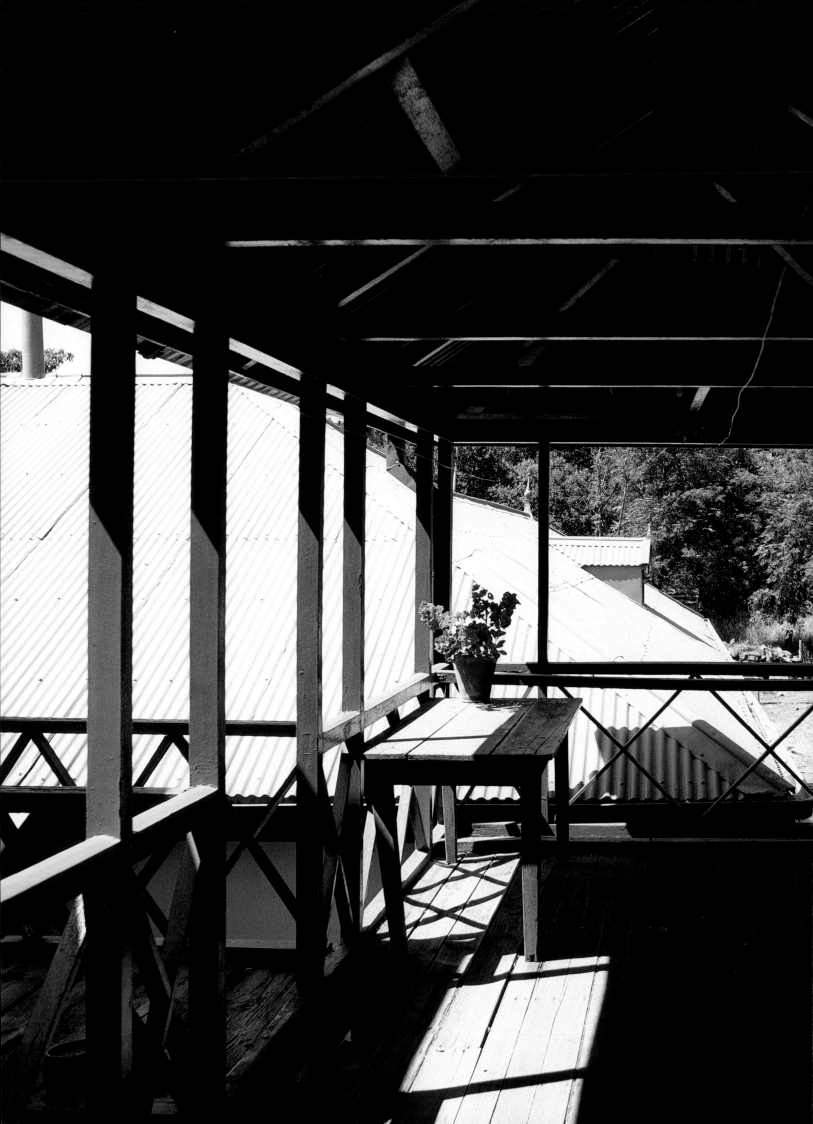

LEFT. The trellised sleeping porch. A reminder of the once widely popular and now almost forgotten South African habit of sleeping out of doors in summer. The two rondavel-shaped buildings below were the cool-houses – one for meat, the other for vegetables and fruit.

TOP. An early bathroom with an elaborate shower device.

ABOVE. Bathroom for the indoor (European) staff.

habitually indulged, he immediately set about building a new house in which to start married life. It was to be named Zwartkoppies Hall.

The original Zwartkoppies, probably the single-storeyed front half of the present Hall, was an unelaborate verandah house, erected, one surmises, by the same master-builder or builder-contractor employed by Lewis & Marks in the construction of their distillery. The architect is unknown, although some circumstantial evidence makes one wonder whether the design to which they worked was not produced by Tom Claridge. One of the 'tame Englishmen' of Kruger's republic, he had been commissioned by none other than Nellmapius himself to build the Krugers' Pretoria villa, completed in readiness for the President's return from Europe the previous year.[13] Certainly Marks was to turn to Nellmapius to provide architects when Zwartkoppies was substantially altered four years later.

At any event, working plans were produced and builders engaged. The rest was taken charge of by the new owner. In March 1885 Marks wrote off to Messrs Adler Bros in Durban with a list of requirements for the new 'dwelling house'. His instructions were firm. He was anxious to get on without delay and required immediate dispatch of goods as winter would shortly be approaching and carriage costs would be rising. The prudent businessman, whose capital at this stage was better employed elsewhere, is evident in such correspondence as survives and every penny was considered.

The commission, he wrote, was to be no more than two and a half per cent; he was to get the benefit of all discounts allowed by the people from whom Adlers purchased.[14] As a good customer – certainly a good potential customer – he probably carried some clout in this regard. Snags that had already been encountered in the construction of the distillery were to be avoided – an inferior brand of cement had been sent, had caked and was useless: 'Portland was ordered, see that this is sent.'[15]

The problems of ordering long-distance from the Transvaal in those pre-Rand, pre-railways days are not to be underestimated. For instance, when paint was ordered ('all oil and turps must be sent as well') for the rooms left unpapered, not only the quantities but even the actual colours were left to the suppliers with the precautionary measure of ordering ten per cent of the estimate again. Incorrect ordering would cause aggravating delays, some of which were not avoided. 'Increase order four mantelpieces – send two black, one white with grates,' reads one missive;[16] 'fifty foot more lightning conductor with fittings, one more electric bell', another. Moreover, such building methods inevitably resulted in detailings being somewhat extemporised. 'What kind of venetian blinds [shutters] can you obtain? If you have sufficient for all the casements, are they single or double and what are their colours?'[17]

The household furniture purchased by Marks and his wife in England at the time of their marriage arrived in Durban in time to leave with the main order.[18] They were transported by wagon ('See that the goods don't lie about on the road,' Marks had

written) up through the Natal Midlands, over the escarpment and by way of the Highveld road to Zwartkoppies, the last part of the route chosen by Marks to avoid arousing the hostility of the Pretoria storekeepers when they saw that he had ordered direct from Durban.[19] The materials arrived in May and the house took six months to build. The glass (from W H Holles in Durban) was fitted in early December 1885[20] and it seems to have been completed by March in time to welcome the cook, engaged by Mrs Marks in England, who arrived on the Pretoria-bound stage-coach.[21]

It was a pretty house, its trelliswork shading the french casements, stucco and shutters in the style so typical of Natal, the Orange Free State and Cape interior of this period. The internal arrangement was simple – a long passage fifty-eight feet by five feet (17,4 m x 1,5 m) down the centre with a range of rooms on either side.

The original Zwartkoppies pre-dates the discovery of gold on the Witwatersrand by a year. Four years later the house which at the time of building had over-extended Marks ('cost me thousands' is what he wrote at the time[22]) already required substantial extensions and improvements. By then there were three children and a fourth on the way. And by then Lewis & Marks were emerging as one of the so-called Big Ten of the post-Rand Transvaal. It was not simply a gold fortune. The cousins had diversified their interests widely in anticipation of the huge consumer demand that the burgeoning Rand would create. It was a vision whose most enduring monument is perhaps Vereeniging – 'the South African Sheffield', as Marks described it, on perceiving the potential of the location, the site of one of his collieries. They also speculated heavily in property through the African & European Company, ending up with freeholds representing 2 963 946 acres.[23]

Doubtless Marks's friendship with Kruger had been a help in all this. He always claimed that the English did not understand the Boer mentality[24] and it is interesting to speculate to what extent common cause rather than convenience fostered their association. Certainly it was not the last time that Boer and Jew were to perceive similarities in their national plight and make-up. In the pre-Rand days, Marks had privately lent the Transvaal government £5 000, a paltry figure by comparison with those which followed the unearthing of the Highveld's riches, but a more fortuitous gesture could hardly have been imagined. Henceforth it was, as Emden puts it, his passport to considerable influence in Pretoria: it would not have been expensive even if he had waived every repayment.[25] Other loans were to follow[26] with other lucrative monopolies in their wake, including an interest in the famous dynamite monopoly on which were centred so many Uitlander grievances.

So Zwartkoppies grew with the Marks fortunes. In May 1890 Marks wrote to Nellmapius: 'Please see your architects, the Hollanders, and ask them if they would like to come out to my farm and make plans for attaching a few rooms to my house.'[27] Marks offered them £25 for the work; they were required to produce plans for carpenters and painters to work by. The architects referred to are almost certainly De Zwaan

FARLEFT. Glazed door to the kitchen wing, with the bell board.

LEFT. The kitchen with its huge range.

BELOW. The hall, which links the double-storeyed section with the single storey beyond. Busts of Cecil Rhodes and Sir Bartle Frere stand below portraits of Roberts and Kruger. Marks seems to have got along well enough with all of them. The circular plush companionable and aspidistra are typical of the era; the hall originally contained an organ too.

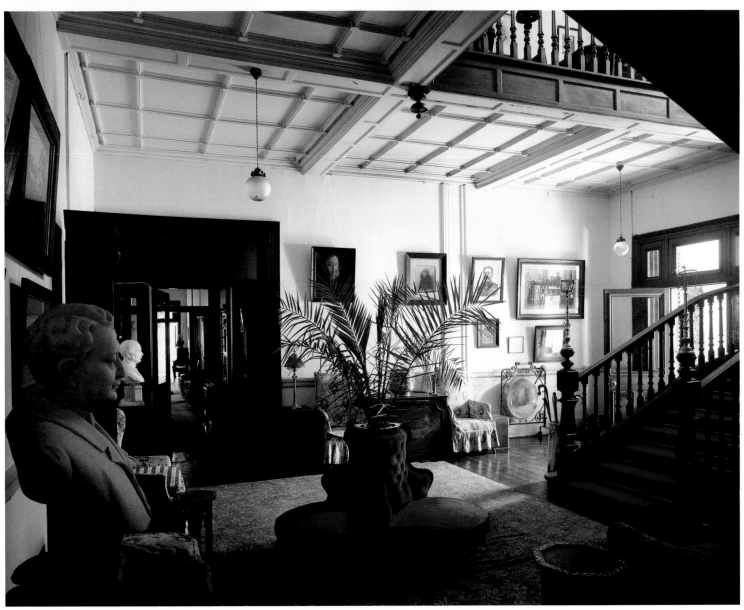

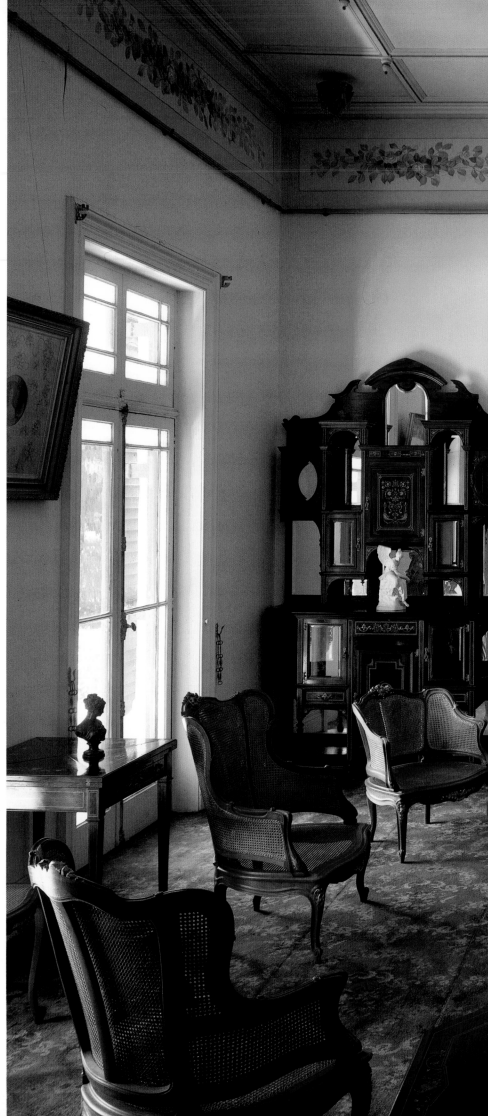

BELOW. Verandah.

RIGHT. The double drawing-room. Edwardian gilt, chandeliers and Maples. The frieze probably belongs to the 1891 redecoration; the fireplace cost £8.10. Even in its delapidated state the room retains its air of prosperous provincialism imported to the colonies. The portrait is of Paul Kruger, with whom Marks enjoyed a close relationship: the Van Wouw statue of the president, now in Church Square, Pretoria, was commissioned by him.

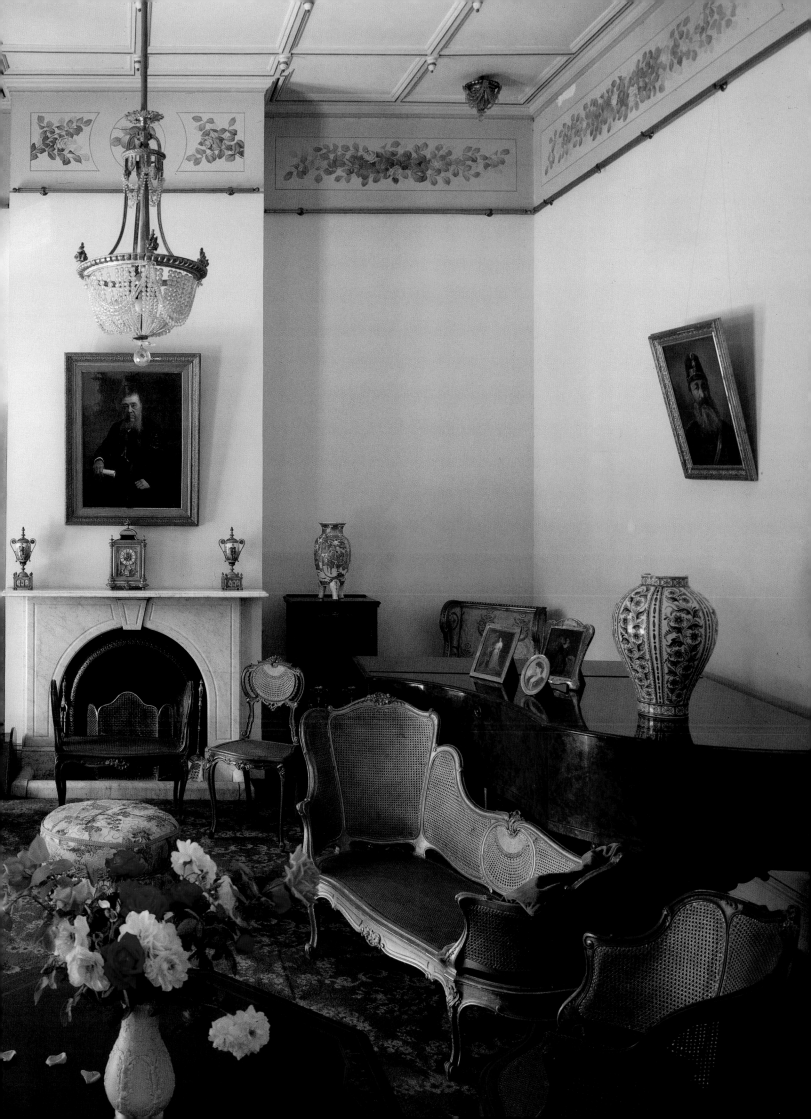

and Van Dyk,* both Hollanders who, like several of their compatriots, had been attracted to the fast-developing capital of the Boer Republic in the 1890s; the partners had their offices at the Old Pretoria Chambers. A year before, Nellmapius had bought land at Doornkloof where he commissioned De Zwaan to build him a house.[28] It was named Irene, after his daughter, and like the re-hashed Zwart-koppies it is typically Transvaal Republican, complete with spikes, air vents and wooden stoeps. The buil-der-contractor employed for the new additions to Zwartkoppies was the Scotsman, Kirkness,[29] whom Marks used in other Pretoria developments and who was engaged in building Wierda's Raadsaal on Church Square.

Until the present investigations are complete it is difficult to know for certain the extent of De Zwaan's efforts but this is what seems to have happened. Rather than give the old house a second storey, a double-storeyed block was grafted on behind it. The

entrance hall – complete with grand staircase – pro-vided the link. There were extra rooms downstairs, and vast kitchen and servants' quarters. Upstairs there were extra visitors' rooms and – pride of prides – a large billiard-room with a coved ceiling painted with pretty murals by an Italian artist.[30] Off this led a glass-enclosed porch and an airy, trellised sleeping porch. Outside, the old single-storeyed verandah was ex-tended to encircle the whole, and in an attempt to provide architectural cohesion, heavy (and pomp-ous, it must be said) *portes-cochères*, very much in the Transvaal Republican *beaux-arts* tradition, were added to the new and old entrances.

Not that the improvements ended there. By 1895 a new stable had been built – 'a splendid place',[31] according to Marks who rode every morning before breakfast – with stabling for fourteen horses and a coach-house which could hold more than five car-riages, including the family's smart American Spi-der.[32] The following year the house was wired up for electricity – 'a great improvement' – although being generated by water power the current drought made it initially impossible to use all of the lights all of the

The charm of colonial verandah houses clearly illustrated here. The huge cupboard is from Maples, the 'Sheraton' chairs, box-ottoman and splendid brass bed with its bedside table and chamber pot all typical of the Victorian bedroom.

* Later De Zwaan and Soff. The names of De Zwaan and Van Dyk appear in Marks's cash book of this period (entry 16.9.1890, p 208).

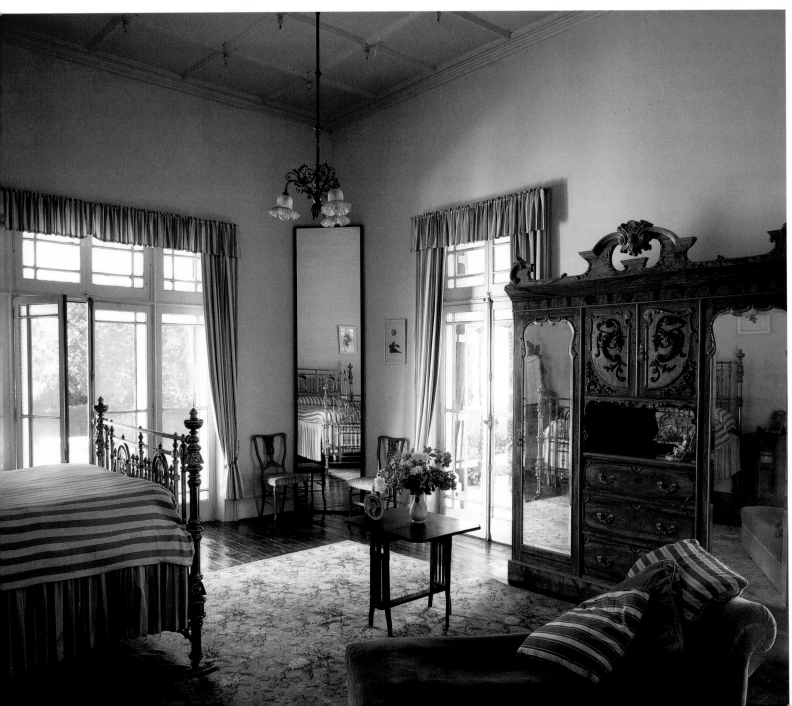

time.[33] Billiards, however, could now be played in the evening; in the tradition adhered to by almost all rural South Africa before ESCOM, the plant went off at ten o'clock.[34]

The following year a steam horse pump was acquired as it was 'too much for the boys to pump water out of the well the way they do now',[35] and by 1900 (the drought presumably broken) there was a swimming pool at the back of the house. 'It will contain about three million gallons of water when it's full,' wrote Marks to his son, Joe, 'so bring a nice bathing costume.'[36]

The new Hall required a large indoor staff. The Markses employed only Europeans, as was typical in the more affluent houses of South Africa of the day though rather a novelty, one assumes, in the Middleveld; they were almost always engaged through a London agency. There was MacCracken, the butler who also valeted for Sammy; Miss Lorimer, the governess; a small fleet of kitchen-maids, laundry-maids and parlour-maids (one of whom, a Scots lass, did the flowers), and coachmen and grooms. The head gardener was an Austrian (the remains of the formal gardens are still to be seen) and the kitchen garden was tended by an Indian. A Pole was in charge of generators – on one occasion losing an arm for his services, one is sorry to say – and the estate carpenter, Potts, was a Scot. It all sounds remarkably congenial: scones from Mrs Potts at her cottage on a Sunday morning were a regular treat for the Marks children.[37]

Beyond the gardens lay the great orchards and there were more at Pienaarspoort and Vereeniging. Marks was a great agriculturalist and innovator: he introduced the first grapefruit trees to the Transvaal – having sampled their fruit on the mailboat – and is also credibly acknowledged as having opened Rhodes's eyes at Zwartkoppies to the possibilities of the great Cape fruit export schemes.[38]

In charge of all these domestic complexities was Mrs Marks. Twenty years her husband's junior, she had been jettisoned into the wilds of Africa (as they must have initially seemed to her) from the suburbs of Sheffield. She took a great delight in the garden – roses and carnations were a Zwartkoppies speciality – and in her chickens which, with the help of an assistant, she bred as a hobby. The fresh eggs were her pride and joy but Marks used to chaff her gently, saying that each one had cost him a pound![39]

One must assume that to a large extent the interiors reflect her taste; certainly they also reflect Marks's in

part, for while she was away in London during the Anglo-Boer War, he had put in hand some redecoration. 'The front spare room,' he wrote to her, 'which will in future be the music room is now being painted and will look very pretty when it is finished. Panels are being painted on the walls which will look just like satin.* Will have the dining-room done too.'[40]

Colonial taste was invariably true to its metropolitan origins in tone if not in affluence, and just as Lionel Curtis described Melrose House – another prosperous Pretoria residence of the day – as 'decorated in the style of a city magnate at Highgate',[41] so too was Zwartkoppies, in its heyday, with its plush, Edwardian gilt and Sheraton, worthy of a prosperous, provincial industrialist. The atmosphere must have been unique – neither noticeably Hebraic nor noticeably Anglo-Saxon. The Markses celebrated only Passover, New Year and the Fast; Friday nights were not kept at Zwartkoppies and at Christmas there was a large Christmas tree at the Hall for the estate.[42]

The Anglo-Boer War was survived without calamity. Both sides allowed the family to remain at Zwartkoppies, although neither would guarantee their safety. Mrs Marks and her children initially departed with the Uitlander exodus and remained in England for some time before returning to a British-occupied Pretoria. Thereafter weekly hampers were sent to the British soldiers guarding the Hatherley blockhouse, and on at least one occasion a Boer commando appeared at the front door and requisitioned blankets and supplies, and took all the horses from the stables.[43]

Following the Peace of Vereeniging, the first decade of the new century saw increasing prosperity. At Louis Botha's instigation, Marks became a senator in the new Union parliament. Before the First World War the family moved to Johannesburg and Zwartkoppies was used only for weekends.

Marks died in 1920. A codicil to his will stipulated that the funeral be 'as simple as possible ... without wreaths or flowers and I wish to be buried as I have lived, without ostentation or parade.'[44] Elsewhere it was stipulated that Zwartkoppies remain intact for four generations. The pictures accompanying this chapter show the house in its now long untenanted state. It is soon to be handed over to the Pretoria museum authorities to ensure its preservation.

* Evidently a form of *trompe-l'oeil*. One wonders whether the artist was also responsible for the murals in the billiard-room.

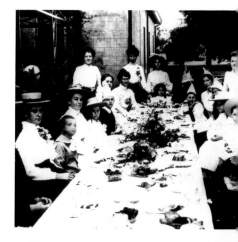

TOP. Children's birthday party at Zwartkoppies. Mrs Marks sits on the right of the birthday girl. Interesting to think that these children, only a generation away from a Lithuanian *shtetl*, are about to play 'Nuts in May' and are destined for an English public school education. (Jagger Library, UCT)

ABOVE. Sammy Marks, Lord Roberts, Lady Roberts and their two daughters (in full campaign fig) at Zwartkoppies during the Anglo-Boer War. (Jagger Library, UCT)

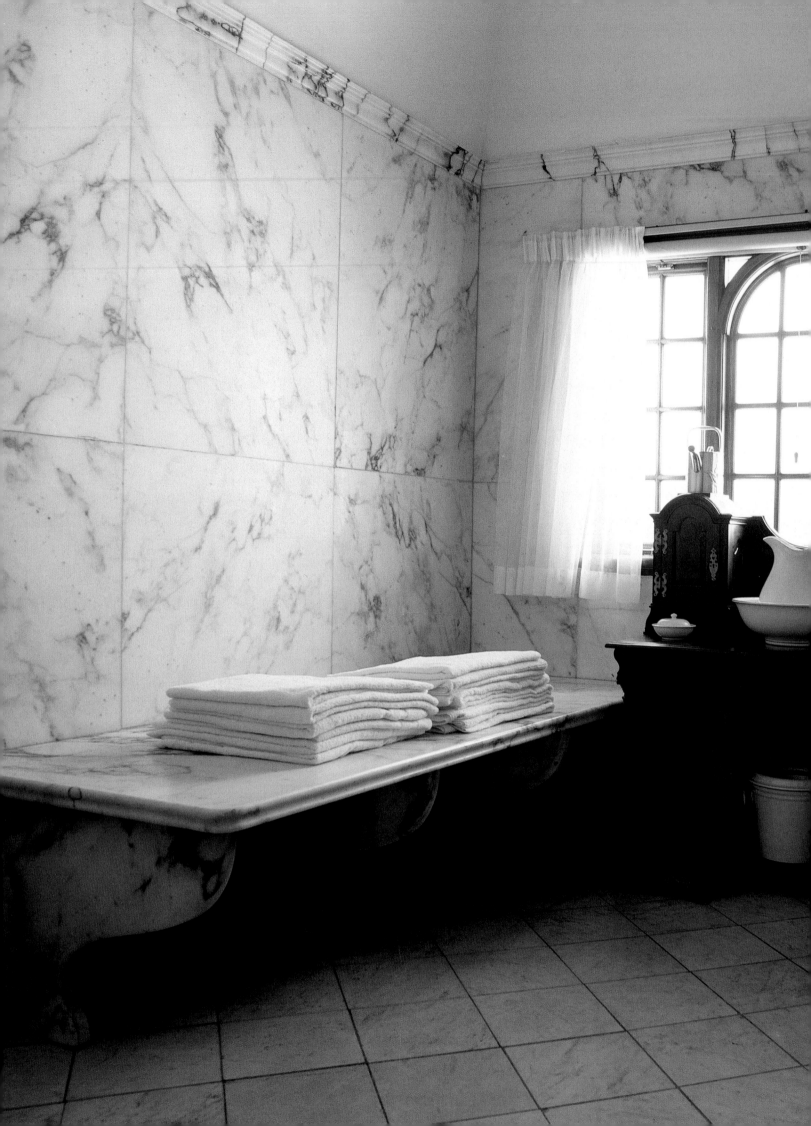

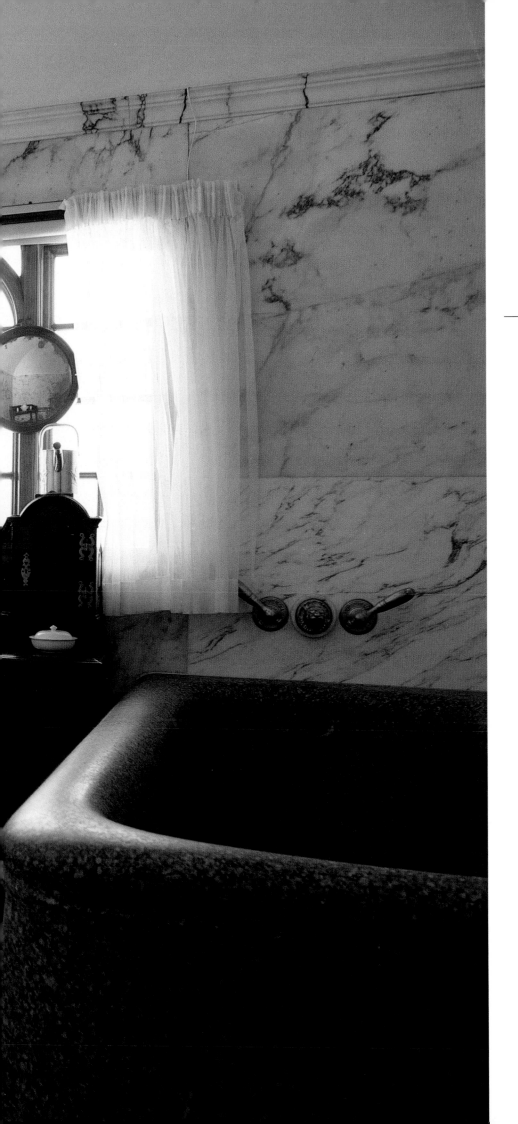

GROOTE SCHUUR

RONDEBOSCH, CAPE TOWN

When Cecil Rhodes – maker of millions and great builder of the Empire – purchased Groote Schuur in 1893 he really purchased the site. Like Tulbagh and Somerset and so many others before and after him, he had been captivated by the sylvan glens of Rondebosch and Newlands which stretched up to the spectacular eastern rockfaces of Table Mountain and Devil's Peak. He promptly set about buying up large chunks of neighbouring land, adding 1 500 acres to the original estate as well as great tracts of the mountainside towards Constantia Nek. It was not for his own pleasure. He intended to protect the mountainside from developers and permit others to enjoy it, natural beauty leading, as he reasoned, to spiritual upliftment. 'We broaden,' he said, 'because we look at the mountain,'[1] anticipating by a quarter of a century Smuts's philosophy of holism which was inspired, allegorically at least, by the same environs.

Rhodes was less satisfied with the house. At that time an avenue of tall stone pines, rather like the pre-war one at Bishops, led up from the Main Road at Rondebosch to The Grange – as the previous owner, Mrs John van der Bijl, had anglicized its name – a pleasant enough but undistinguished house exhibiting many features typical of the British Occupation period. He had been made aware from the outset that the house had been previously altered,[2] as Abraham de Smidt had produced a watercolour of it during his family's tenure, and it was generally agreed that within the existing structure there was a house of the Cape Dutch period into which the original barn or *schuur* had been converted. Rhodes was particularly, and for his day, most peculiarly, fond of Cape Dutch architecture and it was the spirit of this long-vanished house that he wished to recreate through restoration.

It was not merely a rich man's caprice: it was the vision of an extraordinarily original mind. For, after nearly a century of being considered horribly *démodé*, surviving examples of Cape Dutch architecture were in a sorry state indeed. We are now so used to hearing its beauties extolled and watching fortunes spent on its restoration that it is quite astonishing to realize that in the 1890s its champions, among both the Dutch and English communities, were few and Rhodes's predilection for it was looked at askance. 'Not in the *Dutch* style, surely, dear Mr Rhodes,' cried the colonial ladies, gloved hands raised in horror and indeed, even after Groote Schuur had been rebuilt, John X Merriman was to ask the architect why he had not built the prime minister a 'fine Tudor house'.[3]

But dear Mr Rhodes was having none of it. His detractors like to ascribe all sorts of sinister political motives to his architectural tastes – sucking up to the Bond has been a not uncommon interpretation – but he appears to have had a genuine sympathy for the early settlers and a respect for their heritage which he wished to foster in their descendants. This much even Mrs Koopmans de Wet was prepared to concede. Certainly a unified South Africa within the Empire remained one of the great goals. 'Through Art,' he would ruminate moodily, 'Pericles taught the lazy Athenians to believe in Empire,' and his architect credits him with a fondness of repeating (with what irony neither would ever know!) Christopher Wren's maxim that architecture has its political uses, that it builds a nation.[4]

But dreams of Empire notwithstanding, there is an equally compelling explanation provided by Rhodes's natural instinct in matters aesthetic. For despite all indications to the contrary – his sloppy appearance, his habit, notwithstanding his enormous wealth, of renting cheap, serviceable accommodation – it is clear that it was both sound and remarkably up to date. 'Perfect,' was Lady Cecil's verdict[5]; the *cognoscenti* agreed and the Duchess of Rutland, one of the leading Souls, enthusiastically cultivated his friendship. It is true that his Aunt Sophy's had provided a congenial escape from the somewhat gaunt vicarage of his childhood and that he had enjoyed the masculine elegance of collegiate Oxford where he had heard Ruskin lecture.[6] Yet these can hardly account for architectural preferences which might have come straight out of any treatise written by a contemporary Arts and Crafts enthusiast – an abhorrence of Victorian industrialism and the machine-made,[7] a penchant for vernacular or historical styles and a delight in the simple, primitive and barbaric, when 'imperfection meant perfection hid'.[8]

Nothing, therefore, could have been more fortuitous at this juncture than that his path should be crossed – quite literally as it so happened – by a talented young English architect seeking his fortune in the colonies. Herbert Baker had been placed opposite Rhodes at a dinner party, in a well-intentioned gesture on the part of his hostess that almost misfired. In the presence of the statesman he was overawed into silence and it was only a chance meeting on the slopes of Devil's Peak during an early morning ride some days later which salvaged the situation.[9] There was a prompt invitation to breakfast and Rhodes went out of his way to befriend the rather gauche young man.

He was fresh from the offices of Ernest George and Peto in London which were proving a positive nursery for many aspiring young architects whose names were to become associated with the Arts and Crafts movement – Morris, Shaw and Lutyens all passed through its portals – and he had the talent and ability to put into practice the enthusiasms and often inarticulate cravings of his client. Rhodes at the height of his power and prestige was ideally placed to be his mentor and patron. Not that it was simply a question of providing a catalyst: he was also to be his great teacher and just as Gertrude Jekyll was to open the eyes of Edwin Lutyens (Baker's friend and junior at George's offices) to the vernacular architecture, furniture and gardens of Surrey, so Rhodes was to pass on to Baker his enthusiasm for the Cape Dutch.[10] It was a fortuitous meeting indeed – as significant as that of Miss Jekyll and Mr Lutyens – and the commission to 'restore' Groote Schuur was as golden an opportunity as any architect could dream of. It was to launch his career as one of the architects of the Empire and it was to change the face of South African architecture for ever.

The quotation marks around 'restore' are deliberate and not facetious as has so often been the case in the past. As we know, Rhodes had been shown a

PREVIOUS PAGE. Rhodes's bathroom. The masseur's table is of marble and the massive bath is of local Paarl granite. It was generally felt that the bath was one of the few extravagances Rhodes allowed himself, though it is hard to believe that it can have provided anything more than a chilly dip on all but the hottest of February days.

ABOVE. Cecil Rhodes by the Duchess of Rutland. (William Fehr Collection)

RIGHT, TOP. Lady Walker's sketch (*circa* 1830) of the Cape Georgian or neo-classical house into which the original barn or *schuur* had been converted. Rhodes and Baker had never seen this illustration. (William Fehr Collection)

RIGHT, CENTRE. The 'rusticked' version (*circa* 1840) of the above, upon which Rhodes and Baker based their restorations, believing this depiction to show the house denuded of its Cape Dutch features.

RIGHT, BOTTOM. 'The Grange' *circa* 1880, typically anglicized with a Welsh slate roof. (Cape Archives)

watercolour of an earlier façade. It was dated 1825, but this is almost certainly incorrect and it is more probably *circa* 1832–1845.[11] Had Rhodes and his architect had the benefit of subsequent research, they would have realized that the house shown in the De Smidt watercolour was in fact a 'rustiked' version – and a most unhappy one at that – of the neo-classical residence into which the original building was transformed from its utilitarian origins.

As its name implies and as every South African schoolchild now knows, Groote Schuur was once a barn. Together with what later became known as Kleine Schuur and Onder Schuur (now Westbrooke), it formed one conglomerate known as De Schuur, the Dutch East India Company's granary established by resolution of Commander van Riebeeck and the Council of the Fort on 20 July 1657.[12] The post of Master (or 'Baas') of the Granary was a significant one and there was always a dwelling attached to it – Van Riebeeck's diary of October 1661 reports a lion having pushed open its door and snatched a dog.

However, this was apparently not the present house as evidence appeared during the restoration – and we shall have to take Baker's word for it – suggesting a large single room apparently divided by arches and arcades.[13] It was here that the Company's grain and tithes were stored for over a hundred years. In 1790, faced with economic collapse, the Company rapidly divested itself of its assets (Newlands House was another of its buildings sold off at this time) and De Schuur was sold for 53 000 guldens.[14]

In the absence of any further evidence it may be deduced that between 1791 and 1832 the barn was transformed into a flat-roofed Cape Georgian neo-classical residence (for a time fashionably renamed Mecklenburg) of the type once so popular at the Cape but of which so few, alas, remain. Who was responsible for it is not exactly clear: possibly Herholdt, the first private owner, or perhaps Van Ryneveld, the Chief Fiscal, who we know made substantial improvements to the estate during his ownership. At any event, by the time it was rented by Sir George Townshend Walker, returning to England via the Cape from Madras in 1830, it had assumed the rather handsome form depicted in a watercolour by his wife Helen.[15]

Grounds for idle speculation exist aplenty as to what course South African architecture may have taken had Lady Walker's sketch been to hand in 1893 but, given their aesthetic predispositions, it has to be said that both Baker and Rhodes were well suited to the fact that it was not. So, basing their assumptions (on the scantiest evidence as Baker actually admits)[16] that the De Smidt watercolour showed a Groote Schuur denuded of its Cape Dutch characteristics – gables, carved transoms and the like – the work got under way.

In other words the restoration was really something of an invention, but what an amazing one it proved! Baker replaced the pitched roof, and the two jutting wings (incorporating the single-storey *stoep-kamers* of Lady Walker's sketch) now boasted curvy, Cape Dutch-ish gables of his own invention. The main block remained fronted by the columned stoep – a

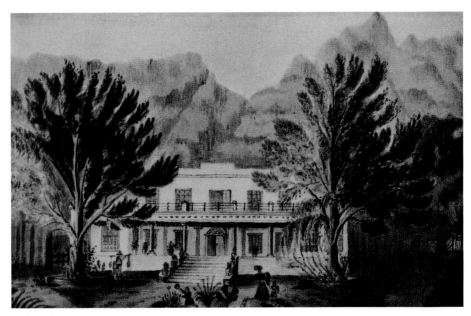

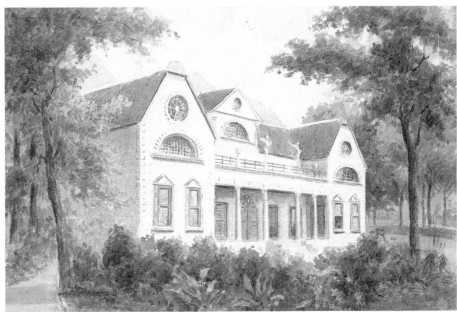

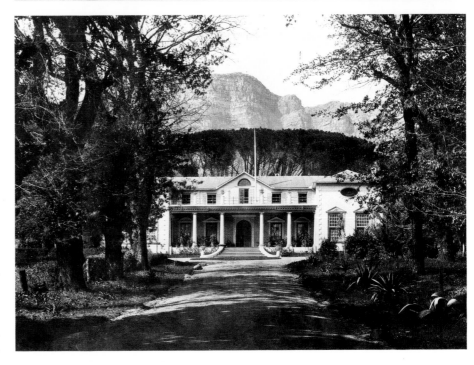

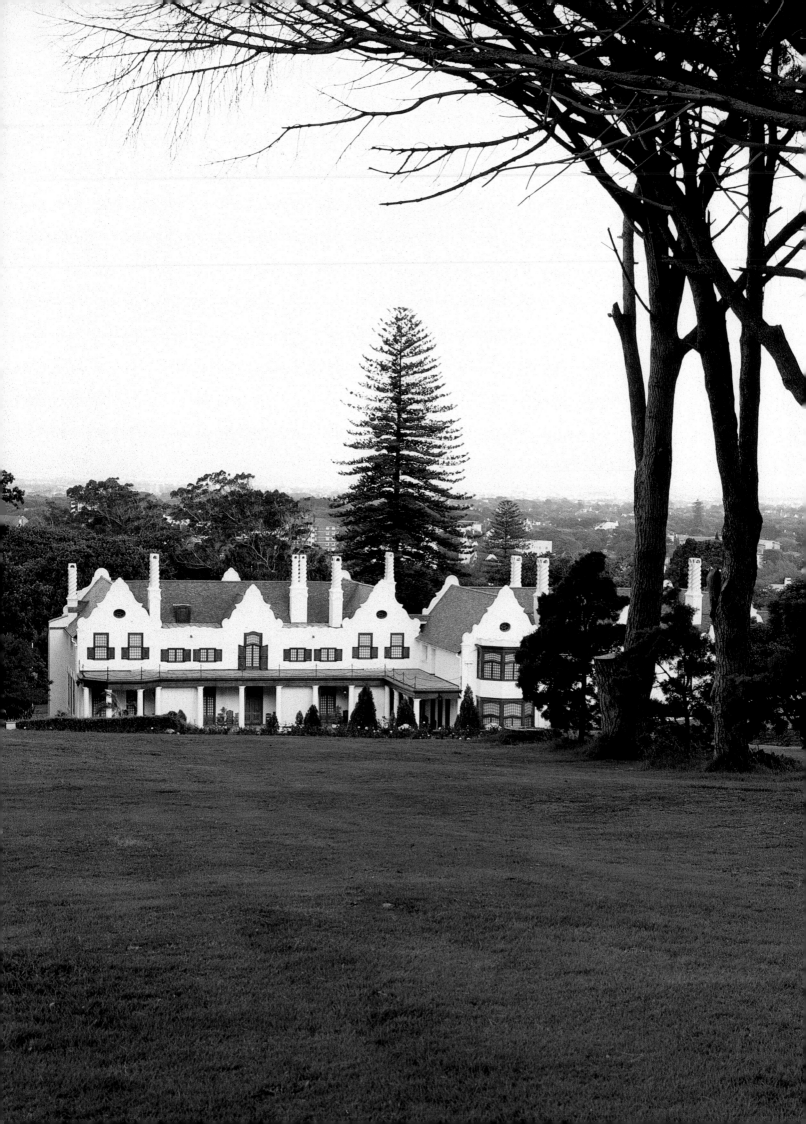

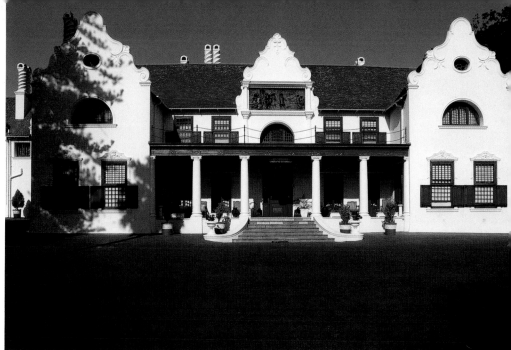

LEFT. The house seen from the pines above the formal terraces.

TOP. Baker's restoration *circa* 1896. Lots of teak and whitewash as Rhodes had stipulated, but John Tweed's ungainly metal plaque depicting Jan van Riebeeck's arrival at the Cape spoils an otherwise quite convincing invention. It is an immature mistake which no amount of sophistry on Baker's part about symbolism in architecture can mitigate.

ABOVE. The hydrangea horseshoe was Rhodes's idea, having dismissed Gertrude Jekyll's schemes as too bitty. Devil's Peak rises behind.

survivor of the neo-classical house – and was given a matching but smaller gable above it. The fenestrations remained more or less unaltered although the rather charming *oeil de boeuf* windows shot up into the new outer gables and the curious, very un-Cape Dutch half-moon windows of the De Smidt sketch were added in below. Fortunately the rather poorly integrated servants' wing to the left is obscured until the last minute by the avenue approach, but the whole is marred by a most ungainly metal plaque in the central gable depicting Van Riebeeck's arrival at the Cape. The work of John Tweed (who had more success with his foppish Van Riebeeck at the foot of Adderley Street and the equestrian Lord Kitchener on the Horse Guards in London), it is an immature mistake and no amount of sophistry on Baker's part about symbolism in architecture can alter this fact.

At the back of the house Baker had a freer hand. Having cleared away the squalid shambles of lean-tos and outhouses he was able to create a new façade with merely a nod to the Cape Dutch – a policy, incidentally, more truly Arts and Crafts, which dismissed as irrelevant notions of pure historical style. The colonnaded stoep of the front façade was repeated but gloriously enlarged and the servants' quarters – to the right now – were separated from the main block by a right-angled wing, terminating in the large teak oriel window which gives marvellous mountain views to the billiard-room below and Rhodes's bedroom above. I am perhaps unique among Baker's critics in my delight in the rear façade of Groote Schuur. Seen, as it must be, from the pines high above the formal terraces, any awkwardness that exists in the juxtaposition of the two blocks disappears. Instead, six sparklingly white gables and a forest of barley-stick chimneys rise above the teak and whitewash and yards of pinky-orange tiles. It is not Cape Dutch of course: it is a magnificent Edwardian fantasy. The Cape, agog at such artistic efforts within their midst (from the Prime Minister too!), took one look and was conquered. A new South African vernacular architecture had been created.

Where had it all come from? Obviously after only a year at the Cape, Baker's knowledge of Cape Dutch architecture must have been superficial for otherwise he would surely have noticed a total absence of double-storey buildings with gables. Yet, when appraising Baker's Cape Dutch, one realizes that everything in his background must have persuaded him otherwise. Owletts in Kent, where the Baker family had lived for generations, was close to several large Jacobean mansions complete with rows of gables above the second storey. As a student he had seen and sketched gables on the tall street fronts of Haarlem and Antwerp[17] and, even more significantly, George's practice was responsible for many of the elaborately gabled red brick 'Pont Street Dutch' terraces of Earls Court, Chelsea and Cadogan Square. Jacobethan had, moreover, been the popular style for the exteriors and interiors of many of the vast country houses built or altered in England since the 1840s (Sandringham being a typical example) and many of these boasted rows of gables, oriel windows and other features of which we find echoes in Groote Schuur.

BELOW. The back stoep in Rhodes's day, furnished as a room with slip-covered sofas and easy chairs. (Cape Archives)

RIGHT. The back stoep. The elaborately carved fanlight was a copy of an original in the Castle in Cape Town.

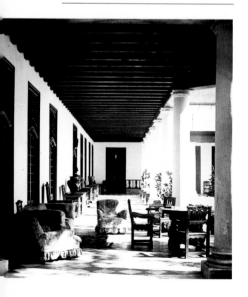

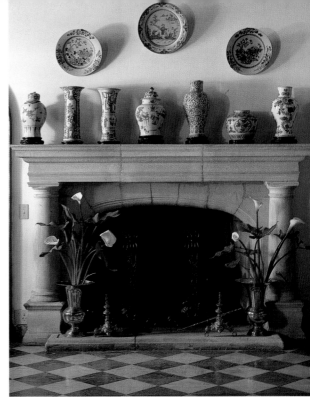

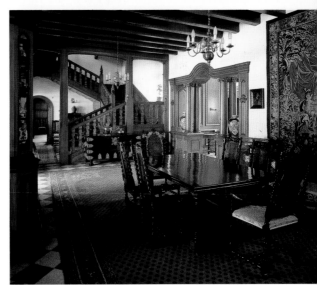

LEFT AND ABOVE. The hall. A host of Baker's signatures here in the curved screen with its chubby columns (similar to those at Kelvin Grove), the Dutch tiles used as skirtings, the distinctive banisters and the carved newels in the form of the Zimbabwe bird. Rhodes was fascinated by this unexplained (Phoenician, some said) artefact found in the mysterious Zimbabwe ruins.

TOP. The massive chimney-pieces were designed by Baker and very much to Rhodes's taste. The fire irons, like much of the metalwork at Groote Schuur and subsequent Baker houses, were the work of George Ness whom Baker had discovered hammering away in the dockyard workshops.

Certainly the interiors and the superb detailing owe much to George: the double drawing-room and music-room, in particular, have overtones of the more lavish aristocratic interiors of Jacobean England of which that architect was especially fond.[18] Decorated by Arthur Collie, a fashionable Bond Street firm,[19] they are most handsome in their way, if lacking the domesticity and agreeableness that Baker was later to achieve. It was during the building of Groote Schuur that George Ness was discovered hammering away in a workshop at the docks and began his association with Baker. His outstandingly handsome metalwork is one of the joys of Groote Schuur[20] and indeed most of Baker's other South African houses.

For the ground plan of the main block, Baker seems to have kept more or less to the original – a blocked-in H containing an entrance hall with two ante-rooms on either side (one of them, the music-room, is particularly pleasing) and beyond them two larger rooms, the two drawing-rooms to the north and the library and dining-room to the south. At the back he created a particularly handsome hall which contains a host of Baker signatures – the wooden screen with its chubby ionic columns supporting a curved cornice, the heavily carved transoms, the staircase with its distinctive banister and carved newels in the form of the Zimbabwe bird.

The house that survives today was actually Baker's second attempt.[21] Almost before his first restoration was completed, Groote Schuur caught fire. The household awoke in the early hours to the sight of burning thatch falling outside their windows. The alarm was raised. The Leicesters were summoned from Wynberg Camp, and someone pedalled off for the Rondebosch Fire Brigade. Within half an hour this gallant band (with courage high and hearts aglow, one likes to think) came galloping up the avenue to see the mansion burning furiously. Rhodes's spinster sister stood in her nightdress directing a jet of water at the conflagration. 'Keep cool, don't lose your heads,' is what she cried to the butler, named Mr Cook, and the more appropriately named footman, Mr Bell, as they dragged the treasures from the house. The roof was lined with zinc and asbestos, enabling much to be salvaged – the library, Lobengula's seal, the Dutch antiques, the Zimbabwe phallic totems, the tattered flags of the Matabele campaign, even the billiard table, were all rescued before the central core collapsed in a sooty heap.*[22]

It was rebuilt at once. Bitten by the home-making bug, Rhodes became absorbed in the project. Nothing was too much trouble. Guests would watch fascinated as he pottered about for hours arranging and rearranging his porcelain;[23] to the subsequent general amazement it was deliberations on door mouldings that delayed his departure for Parliament on the eve of the Jameson Raid.[24] From time to time the hall would resemble nothing so much as a bazaar, as vendors brought in more Dutch marquetry, more

* The household furnishings that went were not, I think, much of a loss. In 1891, when Rhodes first rented The Grange, they had been purchased in a quarter of an hour flat from Maples, who had obligingly filled the ballroom of the London hotel of Rhodes's secretary, Harry Currey, with a choice of three of each item requested.

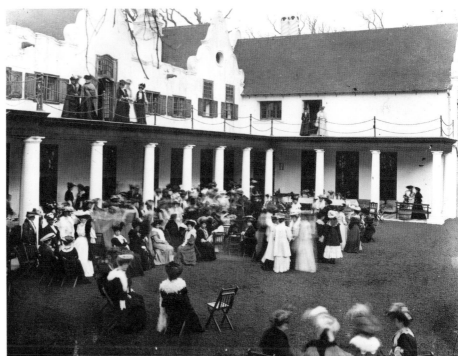

LEFT. The kitchen has every appearance of an artist's studio. The Dutch wall cupboard is typical of the Cape vernacular detail borrowed by Baker.

TOP. The morning after the fire. (Cape Archives)

ABOVE. Tea with Mr Rhodes. (Cape Archives)

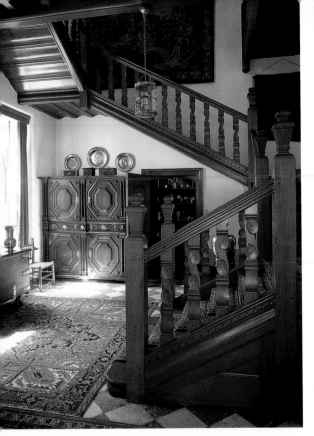

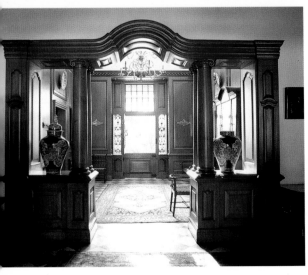

TOP. The back hall connecting the servants' wing with the main block. In the typical Victorian domestic arrangement the kitchen with its coal range and smells is kept well removed from the main rooms.

ABOVE. The screen from the back hall, showing the front door with its wrought-iron air vents.

RIGHT. Rhodes's study and that of subsequent prime ministers. Amongst the curios which survive here are Lobengula's seal, a *burghermeester*'s chair (which makes a surprise reappearance in the library of the Queen's Dolls' House), Jan van Riebeeck's drinking flask and a statue of Robbie Burns. No wonder Mrs Smuts felt as if she were living in a museum! The books are part of an unfinished library of every classical reference in Gibbon's *Decline and Fall*, commissioned by Rhodes from Hatchards and produced, appropriately enough, by Charles Dickens's granddaughter.

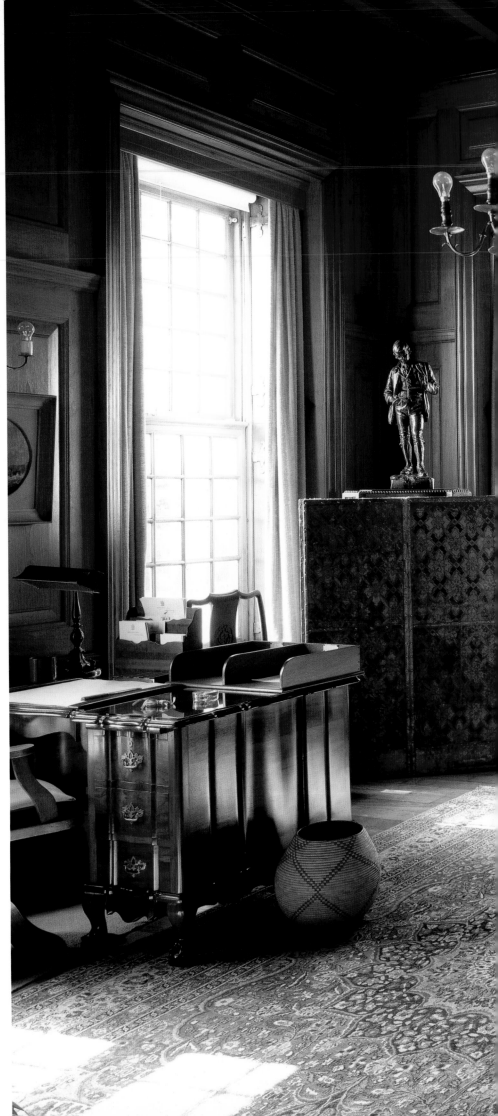

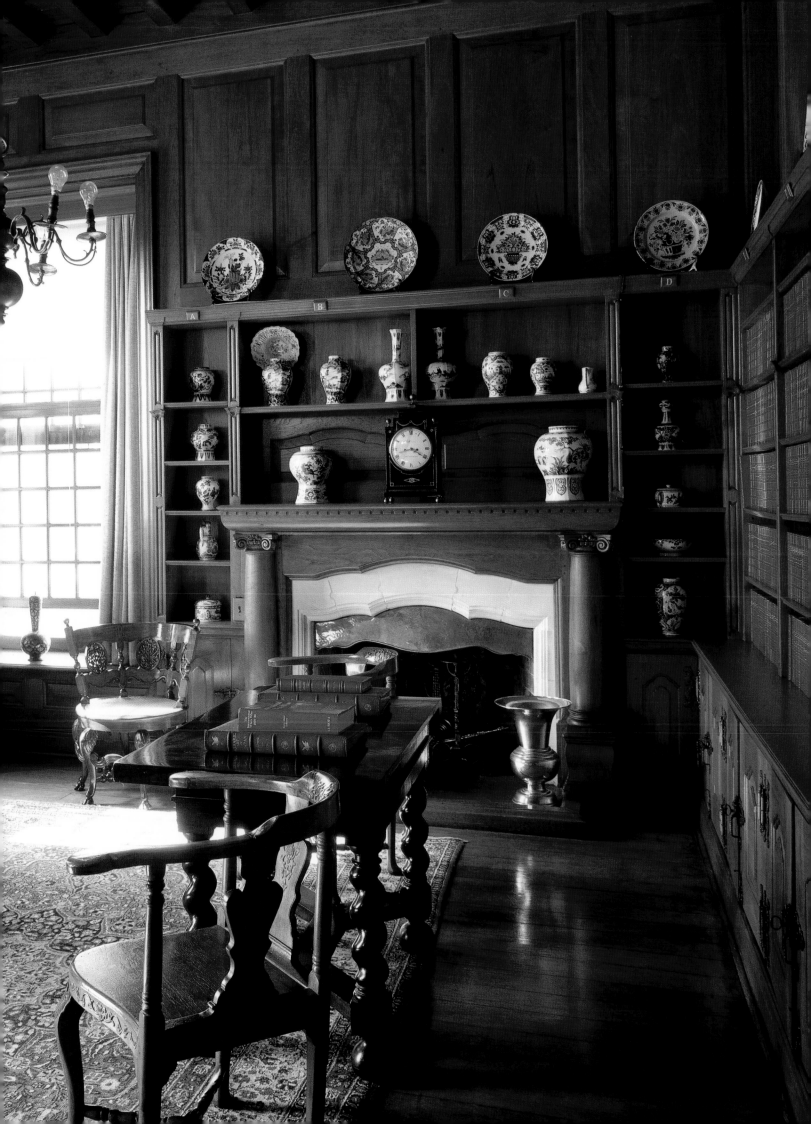

RIGHT. The double drawing-room, originally furnished with the help of Mr Collie's Bond Street firm and still owing much to Ernest George's taste. Lots of Dutch marquetry and the ubiquitous spittoons chosen by Baker for decorative rather than for expectoratory purposes. The frieze of cordovan leather is a riot of fruit and parrots. Handsome, but lacking the domesticity that Baker was later to achieve, even in his grander houses.

BELOW. The handsomely panelled anteroom or music-room. The two armoires are eighteenth-century Cape Dutch, the arums grow wild in the fields above the house. Baker's early furniture designs – evidenced in the table and in the supports for the spinet by the looks of things – were a reaction against the 'effeminacy and affectation' of the English Arts and Crafts movement.

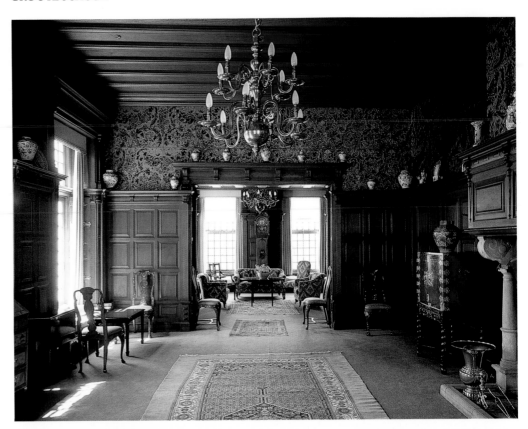

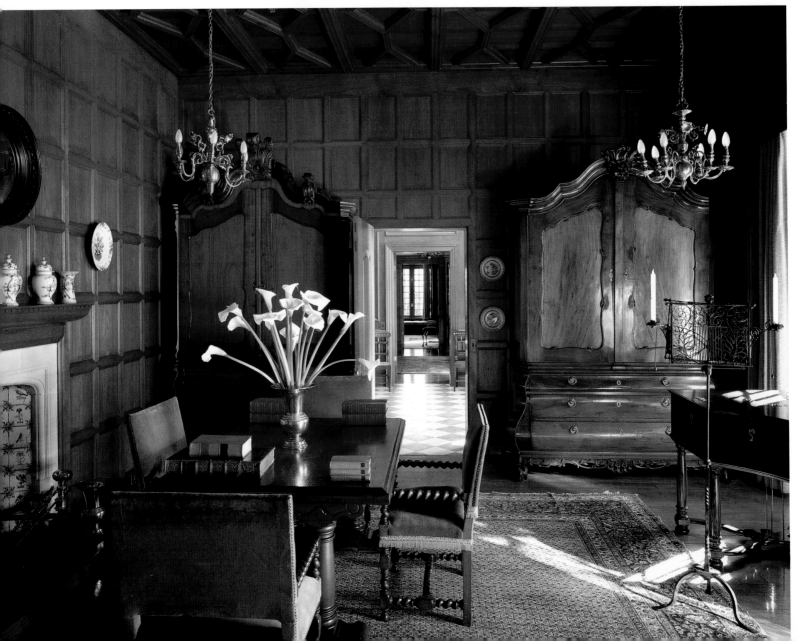

Delft, more carpets, more African curios and sundry other amazing wares. Local farmers were parted from their inherited kists and armoires with no regret as – fat cheques in hand – they wrote off happily for the Maples catalogue. Apart from one Reynolds there were almost no paintings, Rhodes leaving the collection of these, as he said (with a sly dig at the flashier Randlords) 'to rich men in their sumptuous London houses'.[25]

So it was and remains aggressively masculine – nicely apposite for the misogynist Rhodes, although there is now a bleak and uncheerful air about it, engendered for the most part by years of official, and transitory, residents who seem to have camped – sometimes without much relish – in what the respectful press habitually referred to as 'the lordly mansion'. Yet this atmosphere which Harold Macmillan noted and pinned on the Verwoerds' incumbency ('strangely grim when it might have been so gay,' was how he put it[26]) was absent in Rhodes's day when the house positively bulged with visiting celebrities, financiers, politicians, missionaries, colonial engineers, friends and just hangers-on, in what appears to have been one long informal house party. 'Freedom Hall', is the way Violet Cecil delightedly described it to her mother,[27] referring to the elastic timetable, the propensity of people to drop in at all times of day and the lack of 'proper [liveried] footmen' – the latter to the especial indignation of her maid.

Cape Town was *très gai* in the aftermath of the various reliefs of the Anglo-Boer War and Rhodes, just out of Kimberley, flung back his doors to the heroes and camp followers. The jolly party consisted of Jameson (ex-Ladysmith), the Duchess of Teck, Lord and Lady Edward Cecil, Lord and Lady Charles Bentinck (both husbands ex-Mafeking), Baden-Powell (likewise), the Rudyard Kiplings and various others.[28] They would frequently be joined by the Government House party led by Milner and the Duke of Westminster, his young ADC. Another regular, but less welcome, popper-in was the unscrupulous Princess Radziwill, then entertaining high hopes of becoming 'Queen of Rhodesia'.[29] Her carriage would trot up and Rhodes, purple in the face, would stalk off into the gardens. 'What can one do with you, Mr Rhodes?' she would coo with an ingratiating smile. 'Leave me alone,' came the irritated reply.[30] Of an afternoon as many as fifty people would take a dish of tea with Mr Rhodes on his stoep.

And as if this were not enough, Rhodes was as good as his word about owning all this for the sake of others. Every Saturday and Sunday the park was open and the Capetonians, ever ready then as now to take advantage of beauty provided by the Almighty or by someone else's munificence, flocked into the ground with their children and their picnics. They behaved very badly indeed. They picked the flowers, helped themselves to cuttings and the more quizzy would come right up to the house and peer through the windows – and even then Rhodes's stipulation was merely that they should not eat on the stoep. When his horrified guests remonstrated at this unseemly invasion, his mild rejoinder was 'Some men like to have cows in their park; I like to have people in mine.'[31]

The gardens were of course beautifully maintained. Baker had restored the formal terraces that led to the park and mountainside behind the house and conducted a lengthy correspondence with his friend Gertrude Jekyll as to the plantings.[32] Few of the schemes were carried out – too bitty for Mr Rhodes – although there are still acres of blue hydrangeas in the dell and a giant horseshoe, and also hedges of the blue plumbago of which he was so fond. The old eighteenth-century summerhouse which had belonged to the Rustenberg estate was restored* and two additional houses were built on the estate – one for John Blades Currey and his family who had been kind to Rhodes long before Kimberley[33] and another, Woolsack, a house in the woods for poets and artists, where Kipling 'hung up his cap'[34] for many Cape summers in a row.

The house which gave Rhodes so much pleasure did not afford him sanctuary in his last days. Sheltered from the south-easter, the still, almost foetid summer air of which Botha and Smuts were later to complain, exacerbated his asthma. Hounded to the bitter end by 'that Radziwill woman', he was removed to his humble cottage at Muizenberg in order that the sea air might make his breathing easier. His religious opinions were a source of secret alarm to the colonial chaplains. 'I am not an atheist,' he would explain patiently, 'but I don't believe in the idea about going to heaven and twanging on a harp all day. No. I wish I did sometimes, but I don't.' He died aged fifty-two. 'So much to be done, so little time to do it', were his reported last words. His body was taken back to Groote Schuur where it lay in state in the hall before being moved in a giant funeral procession north to the Matoppos. There, on World's View, the coffin was lowered into a sepulchre hewn into the hillside and sealed by a three-ton slab of granite.

In his will, before the preamble to the Rhodes Scholarships, the house was left to the Prime Minister of the future Federal Government of the States of South Africa, 'my intention being to provide a suitable official residence for the First Minister in that Government befitting the dignity of his position ...'[35]

That office having recently been abolished, the house is now destined to become a museum.

* Baker used its design in the Memorial to the South African dead at Delville Wood.

TOP. Louis Botha, Boer leader turned Imperial statesman, with his family at Groote Schuur before departing for the Peace Conference at Versailles. (Cape Archives)

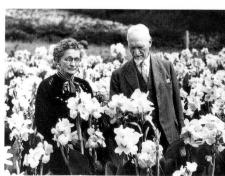

ABOVE. Field Marshal and Mrs Smuts ('Oubaas' and 'Ouma') amongst the cannas during the Second World War. The refugee Greek royals were part of the household at this time, much to Mrs Smuts's chagrin. 'Oh, Miss Bean,' she would exclaim, 'Do please find another house for them. The Princess keeps the Oubaas up until the early hours, and he needs his rest.' (*Cape Argus*)

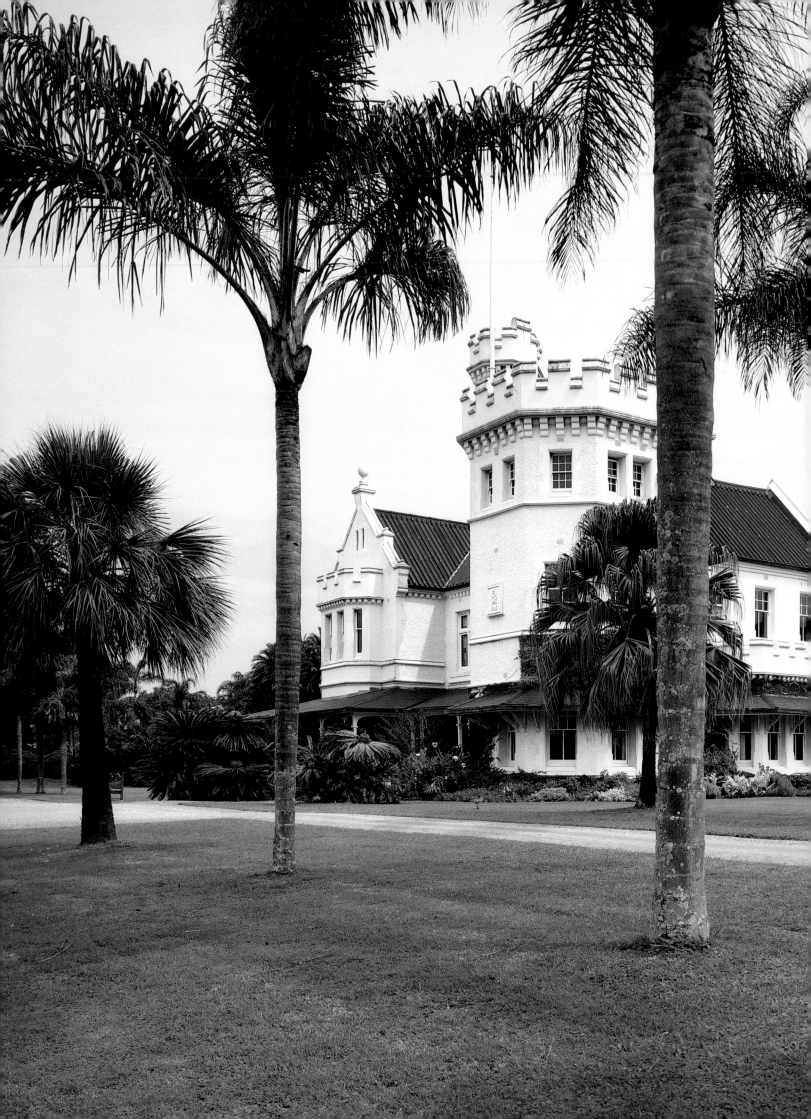

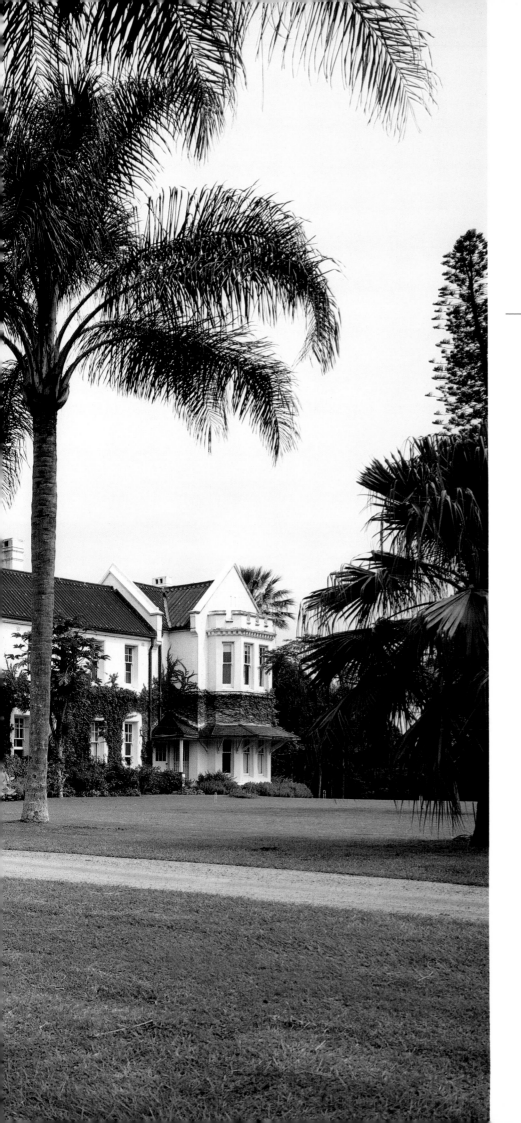

LYNTON HALL

UMDONI PARK, SOUTH COAST, NATAL

PREVIOUS PAGE. Lynton Hall – Paton (?), *circa* 1895. The apogee of colonial baronial – a nineteenth-century Scottish shooting lodge (with verandahs) set down in a palm park on the Natal south coast. Not all is sham battlements, however: the third-storey tower room was designed by Charles Reynolds to resist a native uprising, and the lookout turret above that was for spotting cane fires. Originally painted ochre and terracotta, the Hall was chosen by Group Captain Peter Townsend for the King's convalescence in 1952.

ABOVE. Sir Frank Reynolds by Roworth.

In an emergent society all commodity booms produce a class of newly rich commodity barons. And (usually sooner rather than later) newly rich commodity barons invariably build themselves impressive houses. In South Africa wine, diamonds, gold and ostrich feathers have all in their turn produced distinctive forms of architecture. So did sugar, which was grown on the north and south coasts of Natal from the middle of the last century.

The colonist of the nineteenth century would have difficulty in recognizing any more than a handful of the sugar palaces which survive today. Mount Inyama, near Tongaat and The Cedars near Renishaw are now ghosts of their former elegant selves. Ellingham, which does survive intact, belongs to a later period. But Lynton Hall is there all right: undiminished and unapologetic. Architecturally it is not merely a sugar palace. Along with Dolobran it represents the apogee of the colonial baronial phase, for here is nothing more nor less than a Scottish shooting lodge set down in a palm park in the midst of the subtropical bush of the south coast. A verandah, grafted onto the main block almost as an afterthought, is apparently the only concession to its location.

For their inspiration the architect and owner of the Hall had, like so many of their counterparts at home, turned their sights unashamedly towards Balmoral and that curious combination of Walter Scott romanticism and Coburg domesticity that seems to have struck such a sympathetic chord in the Victorian sensibility. But colonial sentiments aside, it must be said right from the start that far from providing a perfect target for the usual sneers of 'inappropriate' or even 'ridiculous' so often directed at similar metropolitan transplants, Lynton Hall is, in its way, an extremely successful design. The thick walls, high hall and south-facing drawing-room are, after all, far better suited to coping with the humid heat of the coastal bush than with the icy blasts of a crag or moor. Even in summer it is a cool and agreeable place. Moreover at Lynton the sham battlements and turrets so dear to the Victorian castle builders have a very genuine function, for at least one section – the tower room – was designed to ward off possible attack.

The Hall was built in 1895 for Charles Partridge Reynolds, director of Reynolds Brothers. Although the family had made a considerable fortune out of Natal sugar they were hardly *nouveau riche*. Lewis and Thomas Reynolds were younger sons of a minor but established county family with a scholarly tradition.[1] Like many younger sons they had set off to seek their fortunes in the colonies (two other brothers had gone to Australia), arriving in Natal in 1852. They had started a mill at Umhlali on the north coast and could justify a boast to have been making sugar in the colony from as early as 1854. In 1873 Lewis Reynolds had purchased the whole of the old Umzinto Company's mill at Sezela on the south coast for £5 000.[2] Derelict through mismanagement, it was an excellent buy. John Robinson, who passed it often on his travels, claimed that there was no better locality in Natal for the production of sugar.[3]

Lewis died the following year and Thomas with his two sons Frank, who was the elder, and Charles came south to work the estate. Progressive and enterprising, they prospered. In 1877 they renamed the mill T Reynolds & Sons which later became the famous Reynolds Bros Ltd.

In the mid 1890s Charles Reynolds decided to build himself a new house. In the absence of original plans or indeed any other records (for reasons which will become apparent) it must be assumed that Paton and Wishart were the architects. Then an established Durban firm, they were responsible for the additions to the kitchens in 1908, again in 1911 for the long pergola (which remains) and the greenhouse (which doesn't) and yet again in the 1930s for further additions to the staff wing.[4] Measures, drawings and plans survive from this work. The architecture of the whole – even the thirties' additions – is so much of a piece that it seems highly unlikely that the originals belong to the hand of another.[5]

The house was designed around a high hall complete with a wide, handsome staircase and upper gallery off which lead the bedrooms. The hall is very much in the Victorian Jacobethan genre, complete with a marble pavement, elaborate banisters, mullioned windows with coats of arms in stained glass, a plaster frieze, strapwork and a splendidly beamed ceiling. It was designed to impress and in a colonial society it must have. Not that it was a freak. It is very much in the tradition of the Gothic revival found in grander Natal houses of the second half of the nineteenth century: Overport House near Durban (*circa* 1861) and Coedmore (*circa* 1875) both boasted Gothic halls.[6]

Off the hall leads the drawing-room (originally the library and the drawing-room), the morning-room (as at Dolobran situated at the base of the tower) and the dining-room. Beyond the main block and the butler's stairs is the elaborate servants' wing: a pantry, kitchen, laundry, sewing-room, store-room, 'boys' changing-room' and scullery. A schoolroom with a sunny bay window was added in the 1930s as well as a linen-room, store-room and an extra dining-room for the then Mrs Reynolds's personal maid. Upstairs, behind the green baize door, were the day and night nurseries and more bedrooms.

The site chosen for the Hall was a hill about one and a half miles inland. It was chosen not only to catch every breeze off the Indian Ocean but also for its strategic advantages. The decade which preceded the Zulu War in 1879 had led to a widespread fear amongst the Natal colonists – 'strong, enduring and at times almost pathological', according to Brookes and Webb[7] – of a Native Uprising. Though this had subsided somewhat with the annexation of Zululand, C P Reynolds was far from sanguine about the quiescence of the Zulus. His fears were not entirely founded in ignorance: his father and uncle had been on quite intimate terms with Cetshwayo and both Charles and Frank had visited the royal kraal.[8] The tower room – typically castellated in the Scottish baronial tradition, as was that at Coedmore – was fitted out with a gun cupboard and had access to the large cast-iron water tank there suspended and from which the house was supplied. In short, the tower had been designed as a base for a final shoot-out in the event of an attack. The

turret above it with its flagstaff provides views of the cane fields way inland and was intended, and indeed used, as a look-out for cane fires.

The actual logistics of the building operation posed something of a problem. In the 1890s the railway had pushed south only as far as Isipingo and from there everything would have had to come by ox-wagon. Evidently C P Reynolds had no intention of involving himself in so laborious a process. He hired a lighter – a flat-bottomed vessel designed to negotiate Durban harbour in the days before major dredging – filled it with all the materials, sailed it south and beached it near the whaling station at Park Rynie. Sometimes after heavy storms, when the sand has been washed away, its skeleton is still to be seen: appropriately enough, the place has been known since as Lighter Bay. Labourers from the mill hauled the contents up to the site.

Lynton was completed in 1895. Its exterior was painted terracotta and ochre, a colour combination long since abandoned in deference to modern tastes; its interior was sombre with masses of Baltic pine and furniture of the Gothic revival type.

As Reynolds Bros prospered Charles Reynolds, complete with his castle, became something of a nabob in the district and his swashbuckling and increasingly autocratic behaviour became the subject of many a legendary tale. Colourful, even amusing as some of the anecdotes may seem in retrospect, it is evident that his relations with his employees were disgraceful – even by the accepted standards of the day. In the end there was a scandal. His brother's diary of 1908 reports an ultimatum received from the Natal Colonial Government warning that unless C P Reynolds retired from the management of Reynolds Bros they would cease all further allotment of indentured Indian labour.[9] The missive must have come as a bombshell. C P Smith, one of the board, went to 'Maritzburg in an attempt to placate the Government. Neither the family's connections (Thomas Reynolds had been a member of the Legislative Assembly) nor the considerable financial clout the company must have exercised had any effect. No quarter was to be given. In a letter following the visit, the Government advised that they had no intention whatsoever of even listing the complaint and demanded that the substance of the previous letter be complied with.[10] Legal advice was sought and urged Charles Reynolds's immediate retirement to avoid a public scandal.[11]

On 24 July a board meeting was called at Reynolds Bros. C P was informed that he was to retire as from 31 August. The directors of the company had agreed to take over the Hall and 2 000 acres for £10 000 in cash; his brother, Frank, was to succeed him on 1 September at a salary of £1 200 per annum.[12] In the contract Lynton and its staff were given free of charge for ten years with an option to purchase at the end of that time. This was duly exercised in 1919.[13]

In any family it would have been an awkward situation. Frank negotiated to buy out his brother's shares: they were offered at £45 000 payable over five years at six per cent. The furniture at Lynton as well as the livestock including a dairy herd were included for an

TOP LEFT. Lewis Reynolds in the Coldstream Guards during the First World War.

TOP RIGHT. Eileen Reynolds by Lenare.

ABOVE. Part of the extensive gardens in the 1930s. Already the bridges across the ponds have lost their 'Japanesy' chinoiserie railings which are visible in earlier photographs; and the Surrey school is in evidence in the beds and borders to the left.

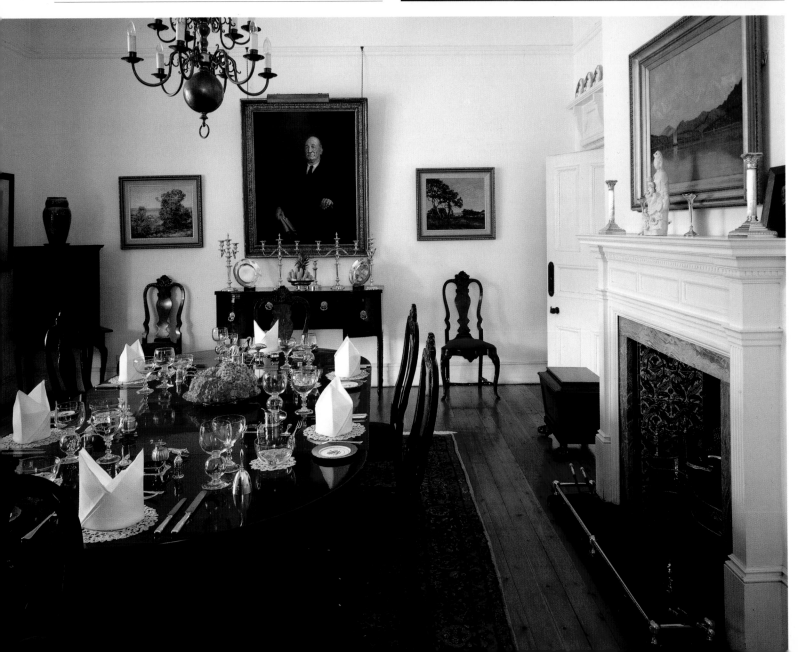

RIGHT. The Roworth portrait of Smuts hangs over a lion's skull transformed into an inkwell; this stands on a Zanzibar chest guarded by two elephant tusks.

BELOW. The dining-room showing the Queen Anne Revival fireplace with its superior 'art' tiles of Islamic design from the studio of William De Morgan. The plate rack above the door is another typical Arts and Crafts decorative touch.

FAR RIGHT. The hall with its marble floor and leaded windows with armorial crests.

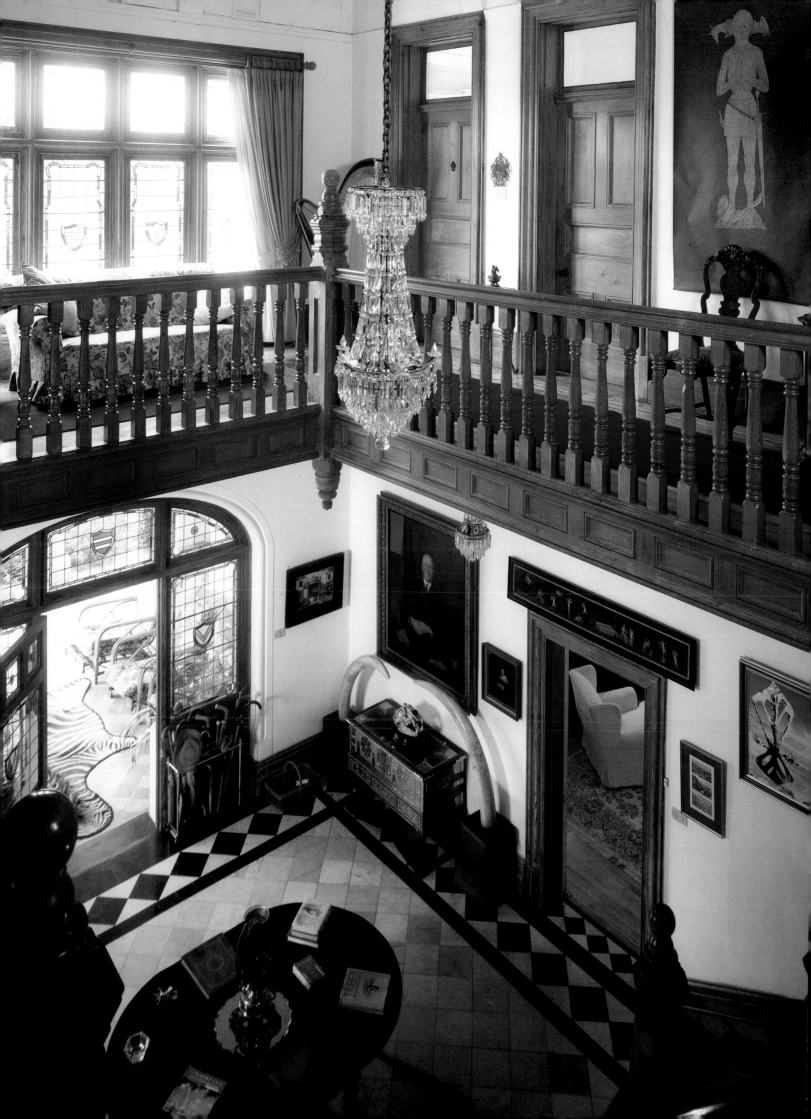

ABOVE. The upper gallery looking through the green baize door.

RIGHT. Gallery showing the Natal Gothic beams, Jacobethan strapwork and plaster frieze. The Waterford crystal chandelier dates from the early installation of electric light.

additional £1 200. At the end of October 1908 the entry in Frank's diary sadly but thankfully reads, 'I sent a wire accepting same [the offer] and so close the books ...'[14]*

Frank Umhlali Reynolds was of a very different mettle from that of his brother. Again we are in the realm of the beau ideal of colonial manhood. A prominent figure in the Natal sugar industry, he had fought with the NMR in the Anglo-Boer War. He was knighted in 1916 and in 1920, as a gesture of admiration for the hugely popular prime minister, he built a beach house on part of the estate for Louis Botha. It too was designed by Paton and Wishart but this time in the Cape Dutch style, the spirit of Union and Baker finally catching on in Natal. It was originally intended for Botha's private use but he died before its completion and his widow was given use of it for the rest of her life, whereafter, inspired by Lord Lee's contemporary example at Chequers, it was left, with a trust, to the future prime ministers of South Africa. The trust also maintained a bungalow near the beach which, much as Woolsack at Groote Schuur, was intended to be occupied by artists and writers. Edward Roworth, the painter, and Roy Campbell, the poet, both stayed there, nourished by large hampers sent down from the Hall. Some of Campbell's best known poems – 'The Serf', 'The Zulu Girl', 'To a Pet Cobra', 'The Zebras' and others – were written at Umdoni Park.[15]

Clearly Sir Frank loved Lynton. Immediately he moved in he made some alterations to the kitchen quarters, including the installation of a cold storage room. He also put in hand the elaborate gardens which in their day were some of the most magnificent in Natal. Laid out by a Mr Pope,[16] they were situated in the dell in the bush to the south of the house, wisely divorced from the Hall and its park. They comprised ten acres of watergardens, chinoiserie bridges, bamboos, palm walks, a rosary, sunken gardens and borders. Old photographs show a cheerful and spectacular combination of the Edwardian Japanese garden (remember we are in the era of *The Mikado* and *Madame Butterfly*) and the Surrey school all set down in the steamy Natal heat. Changing fashions have altered its design somewhat, though not the extent, and today it is the great banks of azaleas that are the garden's greatest glory.

Mourned by all, Sir Frank died in 1930. A few months previously his leg had been amputated and given an elaborate burial on the eighteenth hole of the Umdoni Park golf course where the view was, he considered, the most beautiful.

The estate passed to his son, Lewis. Educated at Radley and Christ Church, he had been Smuts's private secretary from 1922–1924 and was MP for the South Coast from 1930–1937 when ill-health forced his retirement. He married Eileen May, an heiress who as a child had worn a blue ribbon in her hair and prompted the brand name of the flour. In later life she dressed at Hartnell.

The 1920s and '30s were probably the heyday of Lynton. The Lewis Reynoldses were social and smart – the house was full of visitors and there was a vast and caste-ridden staff to look after them. The European contingent included Mrs Reynolds's personal maid and the nanny (for whom an additional dining-room was built as the two did not care to take their meals together), and Bill Lowrie, who had arrived with the first Rolls Royce as chauffeur and stayed on to become the estate manager.** The Indian members of the staff included the housemaids – like so many humming birds as they flitted about in their saris – two turbaned footmen who waited at table, a cook and a kitchen boy. For years there was a major-domo named Quoinsamy. There was a separate staff for the nursery. The more menial jobs such as floors and boots were done by a Zulu house boy and there were countless gardeners and stable hands. Twice monthly a long line of Indian women would move across the park from one end to the other, weeding the green acres.[17]

As with so many other things, the war put an end to all this. Despite ill-health Lewis Reynolds joined up at once (bribed the doctors, it was said) with the fervent patriotism so typical of Natal. It was a mistaken, if splendid, gesture; he had served with valour with the Coldstream Guards in the First World War and his services might now have been put to better use elsewhere. He collapsed and died early in 1940 after a routine route march from Hayfields Camp near Pietermaritzburg.

His widow met and married Major Wallace who was stationed in Durban and, securing a passage on a troopship in 1945, took her daughter and son with her to join him in Scotland. Lynton in her expressed opinion was now nothing but a white elephant. In fairness it should be remembered how little Victoriana was cherished at the time. All the furniture except for some of the large or family pieces was sold and the house shut up. Fortunately, Sir Frank's entail ensured that the house and grounds did not follow the contents under the auctioneer's hammer.

Dust-sheeted and deserted, Lynton Hall acquired with the years a little of the mystique of Sleeping Beauty's castle. In the late 1950s it was re-occupied by Lewis Reynolds's son and, after his untimely death in 1963, it remained largely untenanted until the late 1970s when his sister returned to live there. One event briefly shattered this serenity and provides a now almost unbelievable footnote to Lynton's and Natal's history.

King George VI's left lung had been removed in September 1951 and a bronchoscopy was performed in December. The operation was widely reported to have been a success and it was generally felt that convalescence was all that was needed.

* In fact the books on Uncle Charlie were not quite closed. Regarded as the black sheep of the family, the rest of his life remains something of a mystery until his death which, according to the present owner's Aunt Moll, occurred somewhere in South America where he was stabbed in the back by a jealous husband. He was brought home in a lead coffin – pickled in rum (Aunt Moll again) – and buried in the churchyard at Umzinto. The present owner has had the disconcerting experience of being roughly shaken from her slumbers and it is generally agreed that this must be the ghost of Uncle Charlie!

** It was not uncommon for Rolls Royces to be despatched from England complete with a chauffeur, much as – in the preceding generation – thoroughbred horses would often arrive with a groom (see, for example, the chapter on Kersefontein). In almost all instances these men remained in the country as settlers.

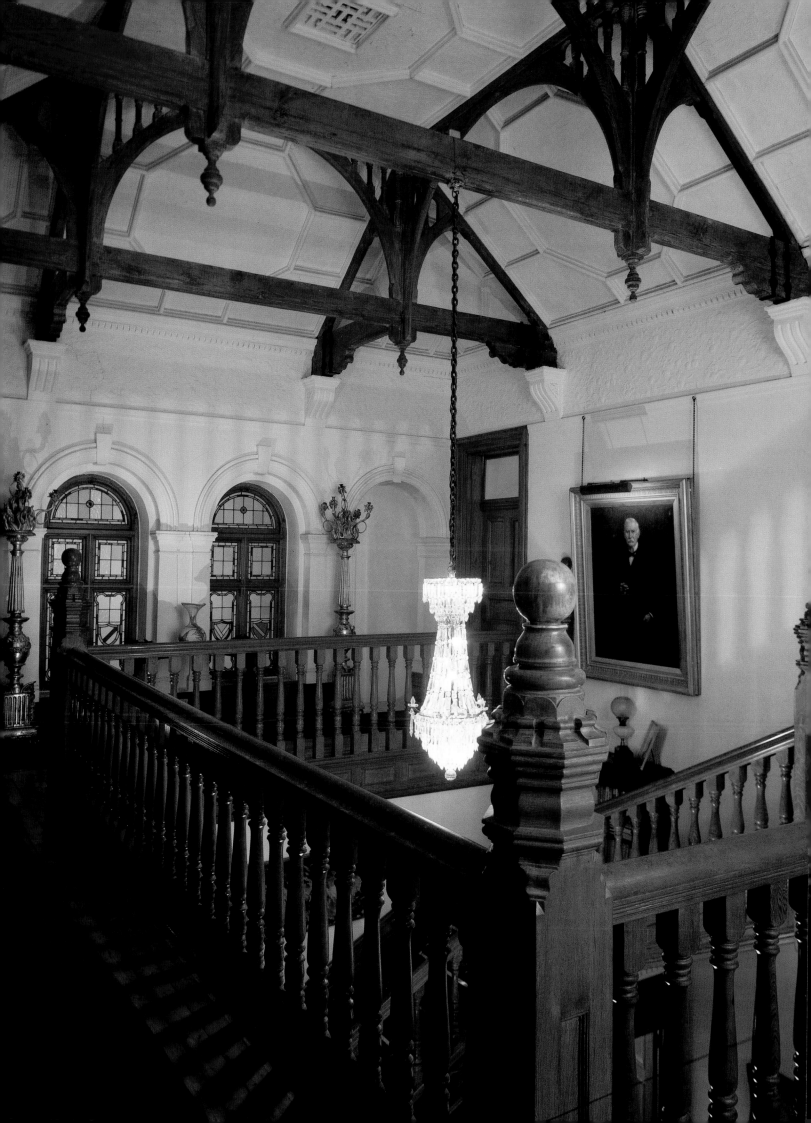

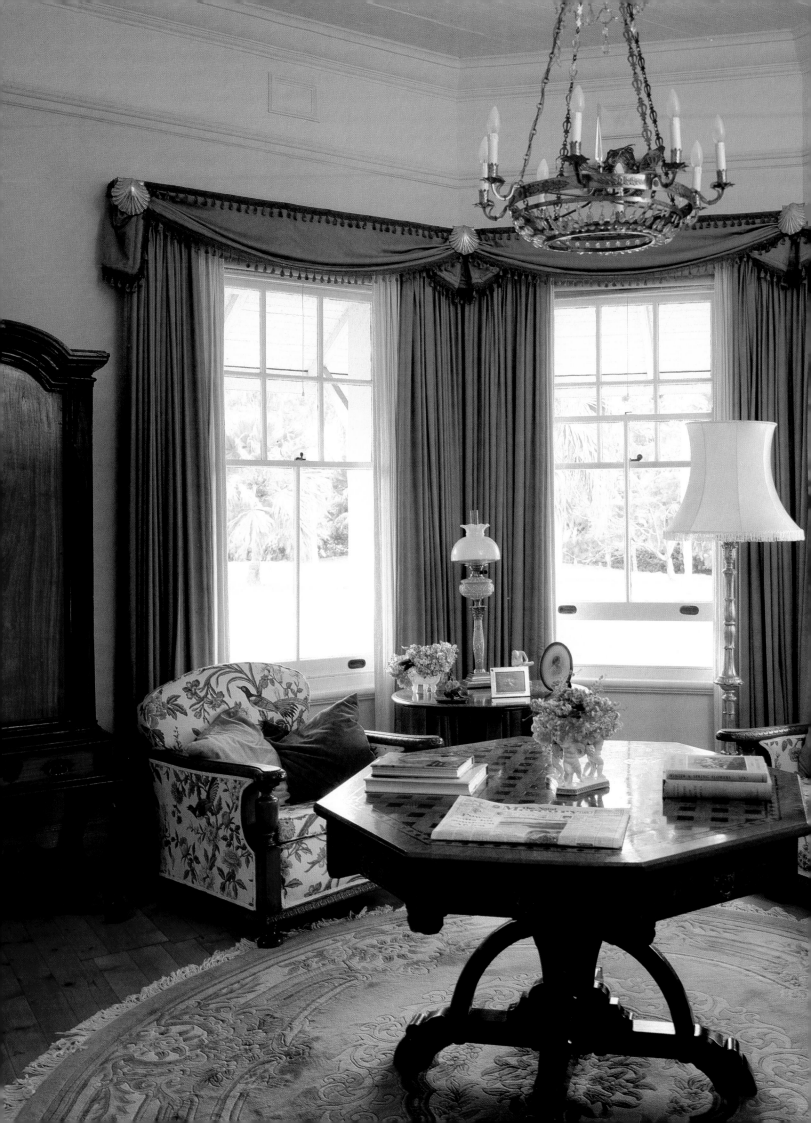

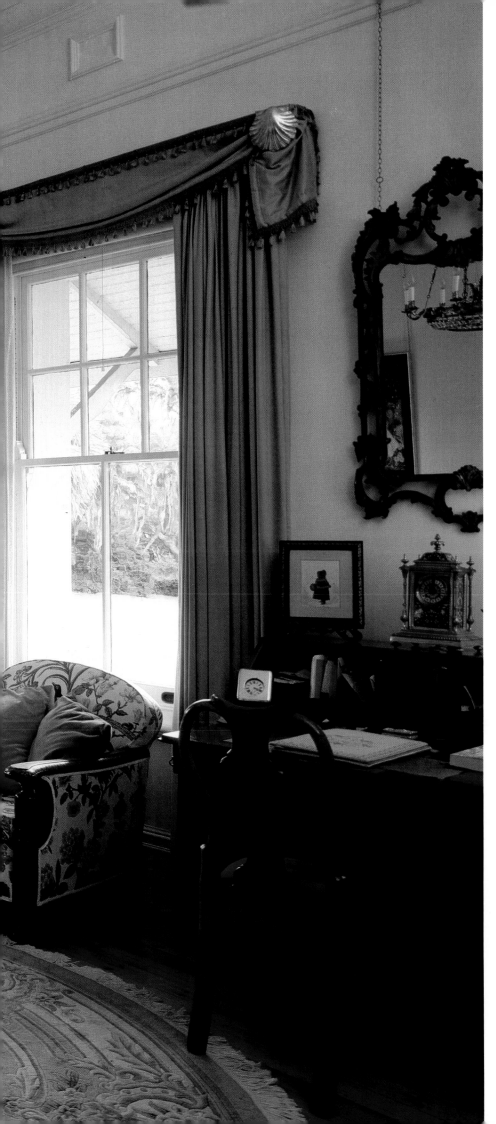

LEFT. The morning-room at the base of the tower. The wooden blinds provide shade from the too-hot morning sun; the Puginesque octagonal table survives from the original furnishing of the house.

BELOW. The drawing-room from the old library, showing the Queen Anne chimney-piece and the generous bay window that projects into the south-facing verandah for light rather than for sunshine.

ABOVE. View inland over the cane fields from the top turret.

ABOVE RIGHT. Spiral staircase to the top turret.

RIGHT. The Natal kitchen: tiled floor, scrubbed table, water filter and coal-fired Aga for cooking and hot water.

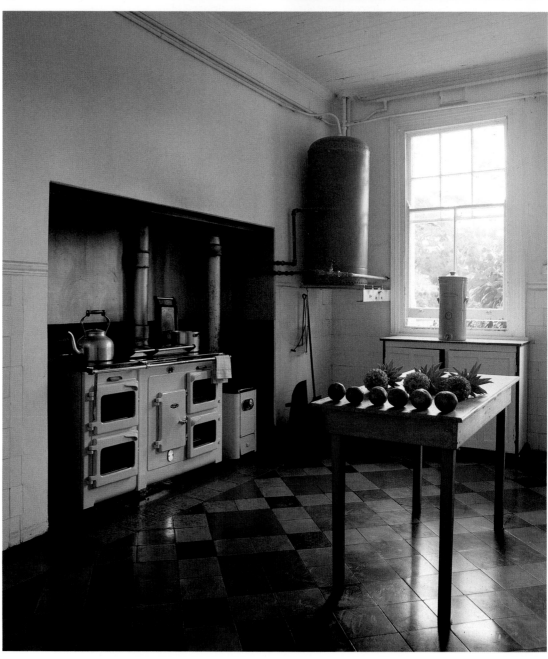

The Royal Family had visited South Africa in 1947 at Smuts's invitation and had received a rapturous welcome. The Nationalists fought and won the election of the following year mainly on the issue of colour. Nevertheless, republicanism was another of their platforms. Unlike Verwoerd, however, Dr Malan saw it as a long-distant project and certainly no other action of his is more indicative of his equivocal attitude than the decision he now took. Acting 'on a hunch' – having himself successfully convalesced there after a serious operation two years previously – he invited the King to come out and recuperate at Botha House.[18]

In the strictest confidence the Board of Umdoni Park Trust was apprised of an impending visit of 'utmost importance' on 2 January[19] and the official announcement was made on 8 January, indicating that the King would be accompanied by the Queen and the Princess Margaret. There were barely two months in which to prepare, an alarming situation not lost on Mrs Lowrie, the estate manager's wife, upon whom most of the work would fall. 'They can't come now!' was her immediate reaction, and it was picked up by the press and reported far and wide to the general merriment.[20]

Two weeks later Group Captain Peter Townsend, then Deputy Master of the King's Household, arrived to inspect thoroughly the facilities offered at Umdoni Park. He saw at once that Botha House was inadequate – 'unquestionably too small' – to accommodate the Royal Party. 'The King,' wrote Townsend, 'was most grateful to learn of their readiness to put Lynton Hall at the disposal ... of His Majesty.' Back in London, Townsend sent his 'somewhat comprehensive' proposals. 'I hope you will not find these ... too elaborate,' he wrote.

For the trustees it must have been the understatement of the year. Before the arrival three extra bathrooms were to be installed, two from existing bedrooms, one from a store room. Though the visit was quite unofficial the Household was far from small. The Hall was to accommodate the King, the Queen, Princess Margaret, two equerries, two ladies-in-waiting, four maids, the King's valet and detective. The morning-room was to be the King's study, the tower room his valet's workroom. Two footmen were to be accommodated in a double tent or rondavel especially constructed in the garden. The trustees' cottage (a note of regret here from the Group Captain that this too was required) was to house the King's private secretary, the King's doctor and one footman; Botha House the Queen's detective and one clerk; the caretaker's cottage one CPO writer, one masseur and two hairdressers.[21] The letter confirmed that the PWD was to supply furnishings, linen, plate and crockery. The South African Polo Association's offer of ponies was accepted and an anxious enquiry from Buckingham Palace confirmed that there was a Steinway grand in good condition at the Hall.

Alas, the frantic preparations lasted a mere three weeks. On 6 February, less than a month before the *Vanguard* was due to sail, the King died in his sleep. Lynton Hall was thus deprived of its most illustrious visitors, and romantic historians of an exotic setting for a further chapter in the ill-fated romance between Princess Margaret and Group Captain Townsend.

FAR LEFT. On the lawn after luncheon. Sir Frank (in straw boater, right) with Princess Marie Louise (second from left), 1923.

CENTRE. The Athlones set off to inspect the gardens, 1924.

ABOVE. Off to inspect the cane. Princess Alice boards the *ingolovane*.

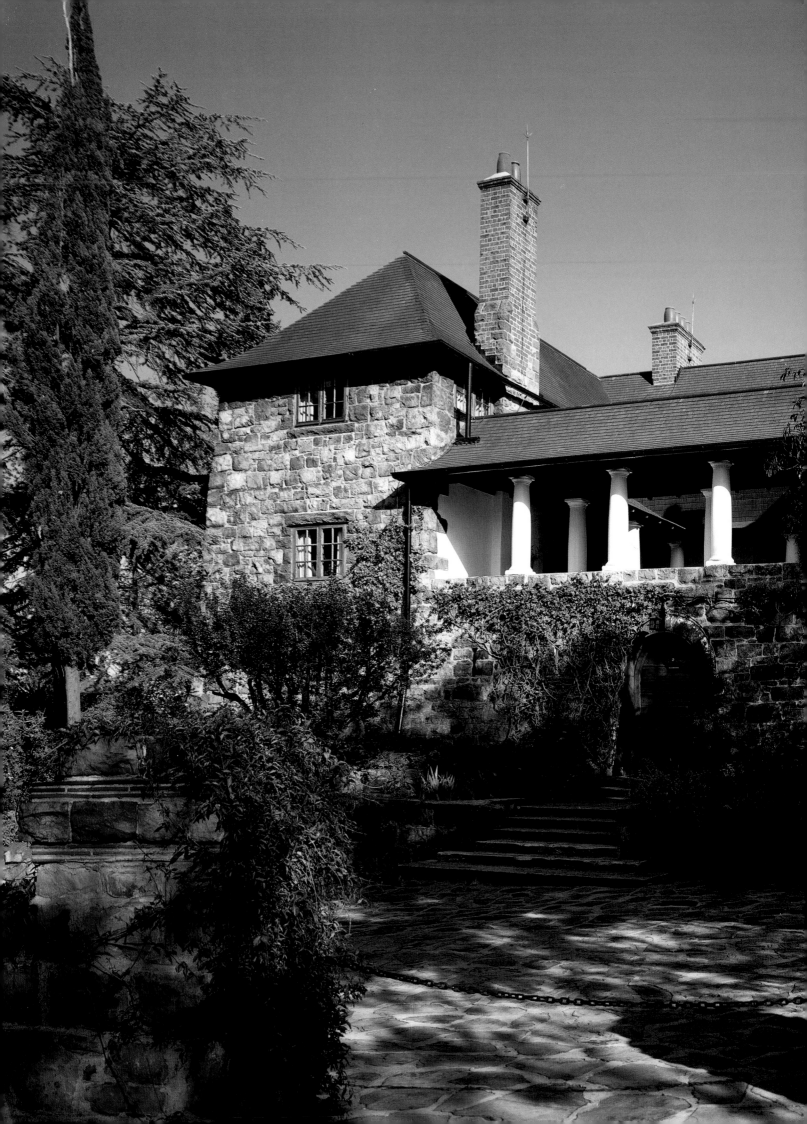

STONEHOUSE

PARKTOWN, JOHANNESBURG

PREVIOUS PAGE. Stonehouse – Baker, 1902. The teak casements, shingles and tall chimney-stacks are typical of the architect's gentlemanly Arts and Crafts style. The battered foundations and eaves and the carefully dressed and pointed local koppie stone are all designed to give the effect of the house 'growing' out of the ridge. Baker's Valley Road vernacular here at its best. The effect of the atrium's columns resting on the *piano nobile* obviously delighted Baker – it was a device he used again in Pretoria and New Delhi.

ABOVE. J M Solomon's sketch of Herbert Baker.

By 1901 the Anglo-Boer War was entering its final phase. Although the guerrilla warfare continued unabated, the Union Jack flew over Pretoria and Bloemfontein and it was held to be only a matter of time before a formal peace would be concluded. Reconstruction was in the air and the future unification of the South African colonies under the Imperial Crown was no longer a pipe dream.

The daunting task of salvage after the ravages of war was to fall on the shoulders of Sir Alfred Milner who, in the combined capacity of High Commissioner for South Africa and Governor of the Transvaal and the Orange River Colonies, ruled the two former republics as crown colonies until he left South Africa in 1905.

To assist him in his task he had picked a group of brilliant young Oxford undergraduates, soon to be dubbed Milner's Kindergarten. Milner's aims, however, extended beyond the realms of administration and economics. Like Rhodes, Chamberlain and Curzon, his imperial vision was shot with idealism – far removed, in spirit, from the purely mercantile imperialism of the late eighteenth and early nineteenth centuries, and to this end he invited Herbert Baker, whose work he had seen and admired in the Cape, to come north and aid in introducing a 'better and more permanent order of architecture' to the Transvaal.[1] It was a two-edged sword. On one hand 'a great Johannesburg, great in intelligence, great in cultivation, great in public spirit, means a British Transvaal'.[2] At the same time *Pax Britannica* would dispel not only the impermanent and transitory feeling of the Rand – it would also wipe away its tawdry, mining town atmosphere. As befitted its destiny, the Empire was to be of noble and beautiful design.

Baker was very well suited to Milner's invitation. Ensuring both status and security, it offered the promise of a new and very lucrative practice ('the prospect of abundant work' he openly admitted)[3] but dressed up in the moral guise which always appealed to him. He was also, it is quite apparent, acutely responsive to the romance of history in the making and fascinated by South Africa's climactic rise to nationhood. He was later to confide that it had been his good fortune to have known and worked with some of the chief actors in 'these stirring dramas' and to have had the opportunity of 'devoting my art to embody, in however small degree, their dreams in enduring monuments'.[4] This was the very architecture of Empire.

Fortuitously, he was well prepared. After his initial successes in reinterpreting Cape Dutch themes, Rhodes, with a perfect sense of timing, had sent his protégé on sabbatical to the Mediterranean to explore the classicism of antiquity. The brief commission (characteristically scribbled in pencil on a scrap of paper) was specific:

'I desire that you see Rome, Paestum, Agrigentum, Thebes and Athens. I am thinking of erecting a mausoleum to those who fell at Kimberley – a vault and a copy of Paestum. Your expenses as to trip will be paid; and in case I undertake any of these thoughts you will receive the usual architect's fee of 5 per cent. C J Rhodes.'[5]

The architecture which Johannesburg of 1901 boasted was everything that Baker despised – overgrown bungalows, lots of pre-cast and pre-fab and much that was jerry-built. 'Wimbledon', was Lord Rothschild's pronouncement,[6] and it was not meant as a compliment. In one respect, however, things had moved in the right direction. Eight years before, the amazing Florence Phillips had audaciously sited her new and opulent mansion, Hohenheim,* on the edge of the high ridge north of the town. All Johannesburg was agog at her choice ('Phillips' Folly' was the inevitable sneer) but others soon followed and by the outbreak of the Anglo-Boer War the Parktown ridge boasted a number of elaborate Victorian mansions.

Herbert Baker was not immune to the pangs of regret which beset many who leave the Cape for the Transvaal, and to start with he missed all the usual things – his friends, the Cape's beauty, his beach cottage at Muizenberg and so on.[7] Johannesburg appeared, on first acquaintance, to be brash, ugly and venal. Lionel Curtis, one of the Kindergarten, came to the rescue. He too had seen and admired Baker's work in Cape Town and he straight away took the architect to view the property he had recently purchased.[8] It was the last plot left on that section of the ridge, and comprised two acres of virgin koppie boasting only a blockhouse guarding the Old Pretoria Road (now Jan Smuts Avenue), just above the Valley Road intersection.

The view was spectacular, overlooking the forest of firs and bluegums planted by Hermann Eckstein years before (the Saxonwold) and forty miles on over the rolling grassland towards the Magaliesberg Mountains, 'ramparts of slaughter and peril' (in Baker's purple prose) where the war still raged. The extremes of the glorious Highveld climate merely enhanced the drama of the site, as Baker quickly appreciated in this evocative description of the Rand before industrialization:

'There perched on high, 5 700 feet above the sea, we lived in pure air from all the winds that blew, and above the frosts of winter that settled in the plains below. The almost daily thunderstorms in the summer months were formidable, but glorious to behold as they gradually dissolved and drifted away eastward in the evenings with the glow of the setting sun on the white dome-clouds fringed with lightning flashes; the landscape below was seen through spun veils of rain. There at latitude 26° S at midnight during a few weeks of the year we could see resting on the northern horizon – the Constellation of the Great Bear.'[9]

Curtis and Baker became fast friends. It was agreed that Baker should take over the land and build a house there in which the two and other bachelor friends could live together.[10] And so, as the South African spring of 1902 advanced into summer, Stonehouse, Baker's own and first Transvaal house, was built.[11] Modern and brilliantly suitable to its site, it proved, despite some retrospective protestations on his behalf, to be his great advertisement to many an aspirant

* Demolished in the 1960s.

Rand homeowner. In the first decade of this century there were to be many.

Baker was determined from the outset to design a house worthy of its position and seldom was he to be more successful. Made of the local hard, rough, koppie quartzite, which he instructed eight local masons[12] to quarry and dress to display its varied tints, the house rose, quite literally, from the 'ocherous, lichen-stained kopje',[13] its battered foundations and eaves enhancing this effect.

It was planned around a long-windowed hall or sitting-room (now the dining-room) with a gallery-cum-studio complete with barrel-vaulted ceiling above it. There were two double-storeyed wings on either side – the H-plan again – containing the dining-room (now the morning-room), a kitchen, pantry, scullery, larder and ironing-room, only once again re-futing the often-repeated nonsense of Baker's in-ability to provide adequate kitchen quarters. There were six bedrooms, one with a dressing-room, two bathrooms, a servants' room for the indoor white staff and servants' bathroom which probably lacked an in-stalled bath.[14] The stables and native compound were separate. To the north, facing the koppie terrace, the sun and the view, was a triple-arched stoep with a sleeping porch above it, and forming the entrance to the south, a white-columned atrium (which he had introduced with rather less ingenuity at Woolsack) under and through which steps led from the hand-some front door in the rock wall below.

The entrance façade is certainly the more interest-ing, for the fortress-like walls are unexpectedly relieved by the back row of columns of the atrium resting, as it were, on the *piano nobile*. One cannot dismiss the faint echo of the temple at Agrigentum, which Baker had seen and sketched on his tour and obviously delighted in.[15] It is a first little excursion into classicism – a minor and perhaps not fully re-hearsed finger-exercise in an otherwise most un-classical building – and one which he repeated with greater skill and panache in the Kimberley and Rhodes Memorials, the Union Buildings and years later with the Secretariats at New Delhi.

Stylistically, the whole is free from obvious Cape Dutch conceits (though Ness's handsome door-plates and chandeliers are again in evidence) and free too from the assorted fancy dress styles so beloved by many contemporary Edwardian architects. It is true that the mullioned casements, beamed ceilings and the tall, distinguished chimneys owe their stylistic allegiance to the vernacular architecture of Kent (Baker's home county), but overall it is remarkably original. Indeed, some would argue that Baker's Val-ley Road vernacular – of which Stonehouse was the prototype – was the first original contribution to South African architecture since the Cape Dutch buildings of the eighteenth century.[16]

Such houses – decent in the best sense of the word – were built for people of comfortable incomes with little taste for show and ostentation. Simple without being banal, understated yet with delightful detailing of superb craftsmanship, they belong to a civilized, less obvious generation with a strong sense of its own identity and, one feels quite certain, its own worth.

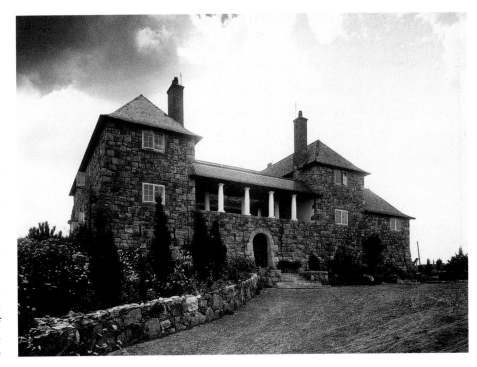

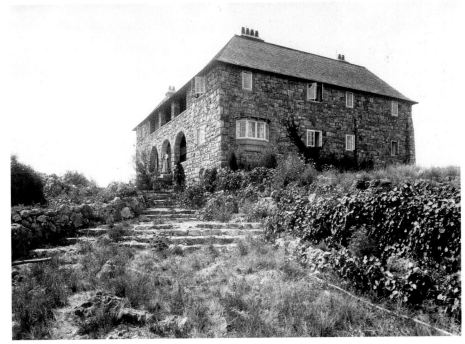

TOP. Before the garden grew, Stonehouse presented a fortress-like appearance on the ridge, the road sweeping right up to the front door. (Jagger Library, UCT)

ABOVE. The north façade with the arched loggia facing the view. Mrs Baker and her son ('Mummy Bear' and 'Baby Bear' to the still friendly Lutyens) stand on the steps. (Jagger Library, UCT)

LEFT. Baker's answer to the awkward problem of split levels was to make an entrance staircase rise up and around an atrium. Unjustly criticized as being unusable in the highveld winter, it was designed more as a happy architectural solution than as the nerve centre of the house.

BELOW. Atrium looking over the stairwell.

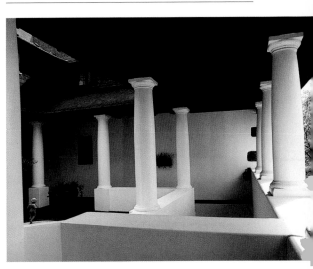

ABOVE. The front door.

RIGHT. The morning-room. Modestly proportioned, its coved ceiling, simple fireplace with blue-tiled surround, bay window and window seat create the domesticity that Baker sought and his clients desired. Something of the atmosphere of a Walter Crane illustration still lingers in this room.

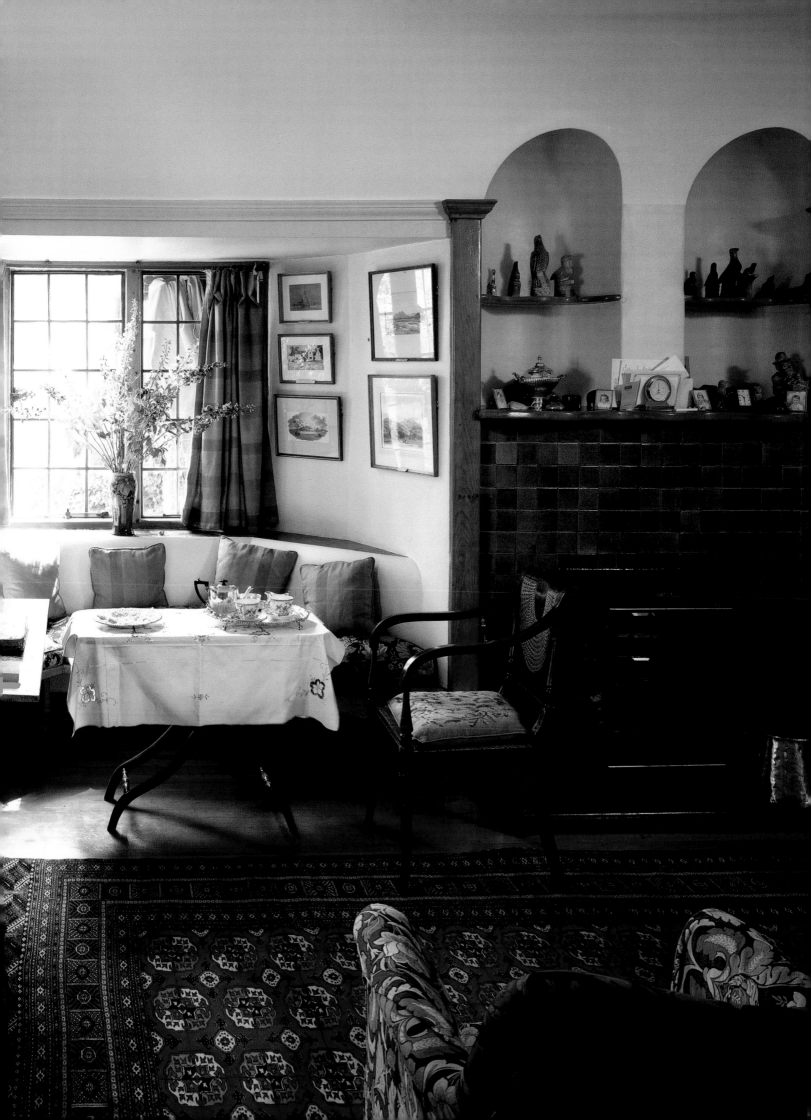

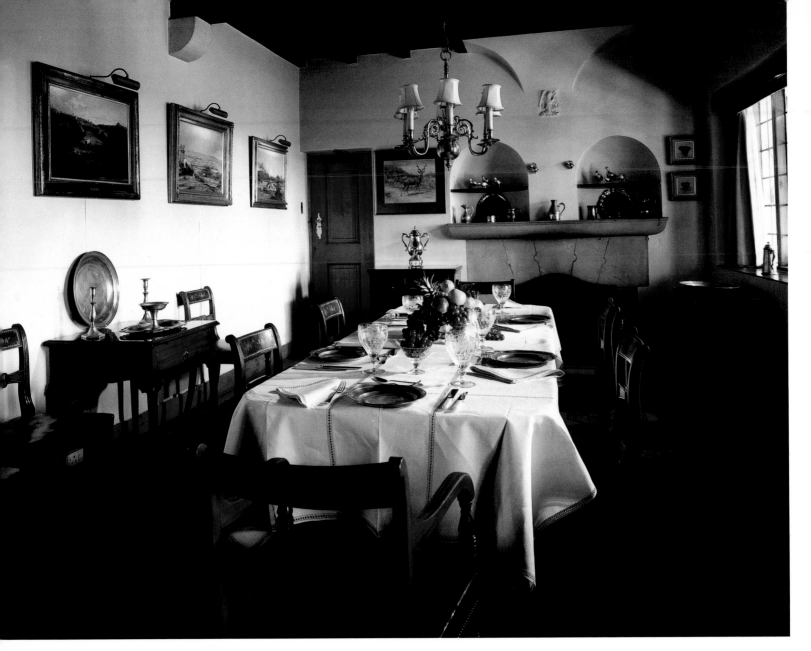

The dining-room, originally the Bakers' sitting-room. The beamed ceiling is the floor of Baker's old study above. The masculine fireplace and Ness's chandelier and door plates recall Groote Schuur. The Botticelli plaster angel appeared later in the boudoir Baker designed for the Princess Royal at Harewood House. The pictures to the left are by Thomas Baines.

Baker was to repeat this gentlemanly style many times (and it was to be much copied, with more or less success), and a photograph (*circa* 1905) taken from the bell-tower of St George's Parktown (also Baker designed) shows the ridge to the west already dotted about with what amounts to almost a village of Baker houses. No wonder Lutyens was a little envious of the 'villa-decked' vistas when he visited the Rand in 1910. 'The great practice you have made,' he wrote to his 'Dear Bear', 'is remarkable.'[17]

Stonehouse was never intended as a 'bungalow for impersonalities who [would] never make a home of it,' which was Baker's scornful comment in a letter to Duncan on some of his own efforts at Raisina Hill, New Delhi in 1917.[18] Instead its interiors were entirely agreeable – masculine, yet domestic, with the typical Baker touches – lots of natural polished wood, whitewashed walls, tapestries, blue and white china and Dutch antiques. As with nearly all of Baker's houses many of the furnishings and stuffs were supplied by Mrs Keightley of Kensington.[19]

It was here that Baker and Curtis set up house together with Balfour and Hitchens, and Stonehouse became a centre for the Kindergarten. They called him 'grandpa' (he gave them all about ten years) and

they gathered in the evenings, Saturdays and Sundays and for early-morning rides down Baker's bridle path and into the Saxonwold. The problems of reconstruction and the future of South Africa were planned and discussed and Stonehouse was, therefore, the first 'Moot House', pre-dating Feetham's Moothouse and the White House where Curtis, Duncan and Hitchens later lived, both Baker designed and regarded, incidentally, as somewhat inferior by the architect – the former suffering from 'less exciting air', the latter from 'less dramatic thunderstorms'![20]

Initially, opinion was much divided as to the artistic merits of the house, Johannesburg then as now being more susceptible to more flamboyant architectural innovations. 'Eccentric' was the best the majority would allow though, as we know, more discerning builders were soon to copy the new style. Other grudging praise usually carried with it the proviso that in time trees and shrubs and creepers would soften the building's severe, fortress-like appearance. And indeed, the plantings executed by the two successive chatelaines of Stonehouse – Mrs Patrick Duncan and Mrs George Mackenzie, both enthusiastic gardeners with, in the best colonial tradition, a strong English penchant for the picturesque – have ensured

that the house now stands most discreetly on its site, shaded by tall trees and creepers. Yet Baker does not seem to have envisaged this eventuality at all, and he and his wife, whom he brought as a bride to Johannesburg, planned a wild *kopje* garden around the house, with a rose garden, shrubberies and lawns planted thirty feet below, where the softer strata were blasted and soil was laboriously brought in.[21] His friend and gardening mentor, Miss Gertrude Jekyll, would have approved.

So informed contemporary praise was for Stonehouse in its original bleak setting and it was fulsome to a degree. Kipling, writing his bread-and-butter letter to Baker after a visit, admitted that he was amazed that a 'sordid municipality' like Johannesburg could produce such a place with its 'clean white boys'[22] and C R Ashbee (the noted Arts and Crafts designer) wrote ecstatically:

'I wipe out of my mind all foolish preconceptions as to the ugliness or vulgarity of upstart Johannesburg, for I have to-day seen ... Baker's own house springing like a jewel castle from out of the rock ... one of the most exquisite pieces of architecture I have seen ...'

Ashbee was not above placing it, in its 'classic [as he termed it] simplicity', alongside notable Italian villas and palazzi. '*Come e bella Architettura*!' he concluded enthusiastically, 'and what a climate for her.'[23]

The Bakers' three sons were born at Stonehouse and spent their childhood clambering up and down the *kopje* garden – in every way a little boy's paradise.[24] In 1913, following his appointment as assistant architect at New Delhi, Baker quit Johannesburg.

How he hated leaving Stonehouse and the thought of a stranger living there. It seems to have ranked alongside Owletts, the Baker family's house in Kent, in his affections and he insisted on his carefully chosen and arranged furniture remaining there. And it is not surprising, therefore, that when the opportunity arose for his old friend Patrick Duncan to take over the lease, Baker was not above easing out the current tenant. 'Please turn him out quick and get in,'[25] were his instructions, the dirty work falling on F L Fleming, his partner, since Baker habitually disliked dealing with lawyers whom, as a breed, he mistrusted.

To Baker's delight, Patrick and Alice Duncan moved in. 'Nice to feel that it is coming back into the family, as it were,' was how he put it, and it is interesting to note, in view of the accusations of stinginess often levelled at Baker, just how generously he treated his friends. How marvellously chummy it seems to have been! The lease was apparently indefinite at £25 (later £30) per month, halved when the Duncans moved to the Cape for the Parliamentary session and failed to sub-let, and less the full rental for any months that Baker might come and stay with his old friends.[26] Similarly, when the Duncans enjoyed staying at Sandhills, Baker's Muizenberg cottage, and made overtures to purchase, Baker wrote: 'Please buy the house at your own price. Then I shall be content.' With the Duncans at Sandhills and Stonehouse he felt he had no regrets over his 'absent homes'.[27]

It was only in the 1930s that the house was finally sold. By then it was quite obvious that Baker would never again settle in Johannesburg and 'all advised the "old man" to consolidate his possessions'. Still, even at this late stage he felt a brute at 'this home destroying' (the furniture was finally dispersed, some returning to Owletts), about doing Duncan out of a 'harbour in his old age' (he in fact died in office as Governor General, suitably ensconced in the Baker-designed Government House) and felt that Aitken, his lawyer, had been guilty of unforgivable cunning in producing as a buyer 'a successful speculator', one Mackenzie.[28]

In fact, far from precipitating the home destroying, Aitken had actually ensured the house's preservation. George Mackenzie not only maintained the house perfectly but his son has selflessly secured its survival as Parktown rapidly disappears under the encroaching tide of city office blocks.

The Bakers' drawing-room. Tapestries, Dutch antiques, South African Arts and Crafts furniture, blue and white porcelain and the stuffs chosen by Mrs Keightley in London. It was here that the Kindergarten would meet: Stonehouse was, in fact, the first 'Moot House'. (Jagger Library, UCT)

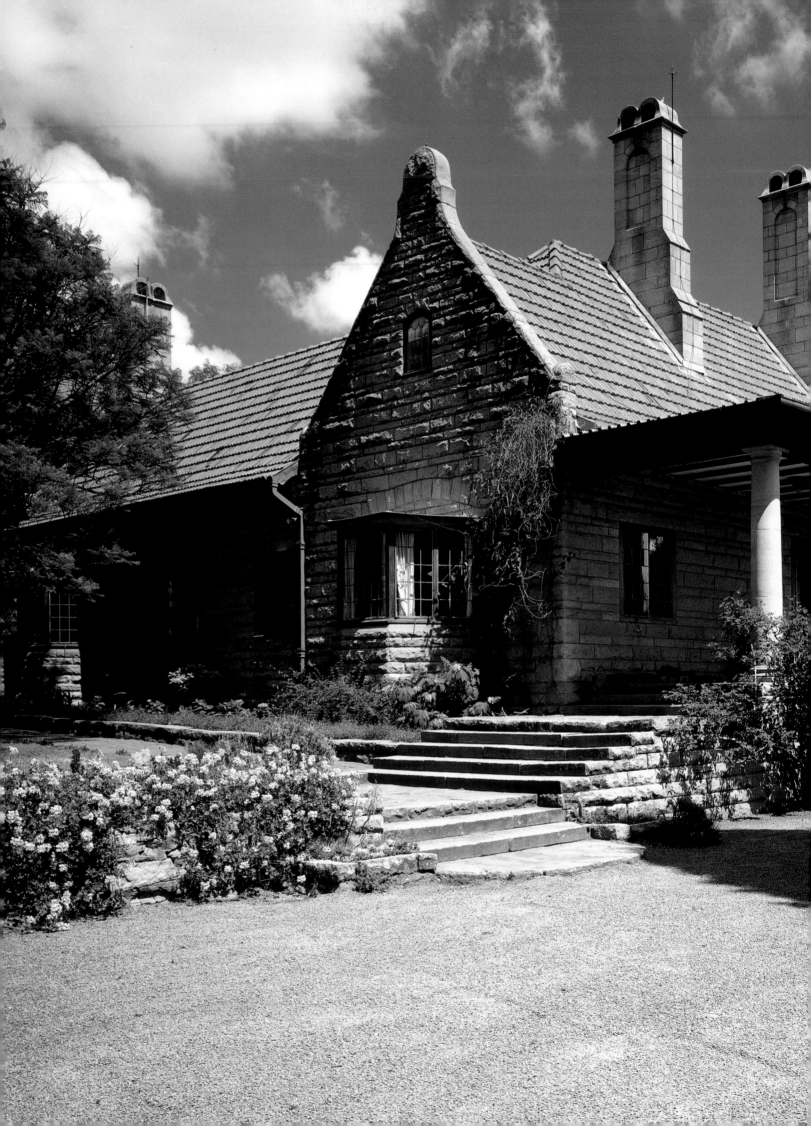

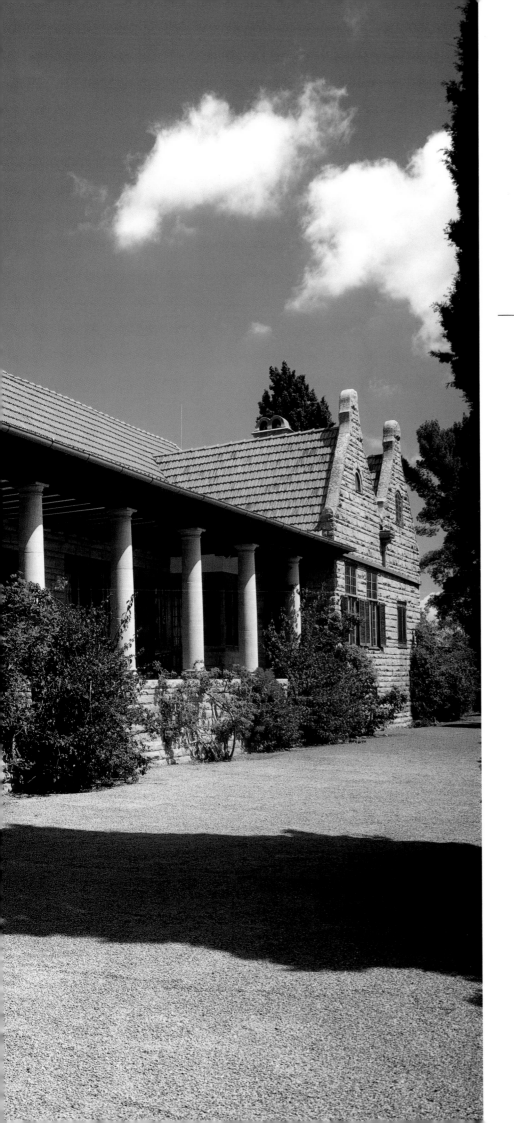

WESTMINSTER

WESTMINSTER, NEAR TWEESPRUIT,
ORANGE FREE STATE

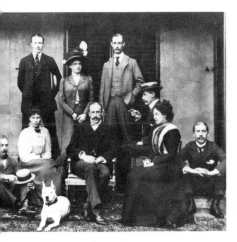

PREVIOUS PAGE. The 'Big House', Westminster – Baker, *circa* 1903. Mellow Free State sandstone, 'gentlemanly' chimneys, leaded teak casements, colonnaded stoep and mannered gables. Neither particularly Cape Dutch, nor English, but very colonial and appropriate: a truly South African house.

ABOVE. The young earl (standing, left) as ADC to Milner at Government House, Cape Town. (Cape Archives)

BELOW. The Big House from the rose garden.

RIGHT, TOP. Entrance porch with the ducal crest above it.

FAR RIGHT, TOP. On the Duke's instructions, the school was to double as a church on Sundays. Baker's synthesis of a place of learning and of worship (complete with bell tower and ducal crest) is particularly successful. The building is contemporary with St John's College, Johannesburg.

RIGHT, BELOW. The croquet lawn recovers from winter frosts and drought.

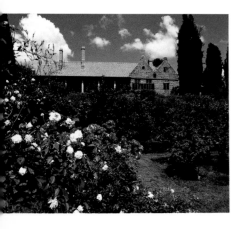

It was Edwin Lutyens who introduced Herbert Baker to Gertrude Jekyll. Both were good friends of his and he must have known that they were bound to get along well together. They did. In fact so much has been made of the Lutyens-Jekyll relationship that it is generally overlooked that Baker and Miss Jekyll also established a warm friendship which was maintained by correspondence while he was in South Africa. Like Lutyens, he respected her taste and her knowledge as a skilled craftswoman and expert gardener – at Baker's request, for instance, Miss Jekyll wrote lengthy instructions for the plantings at Groote Schuur – but his perception extended beyond this, and how nicely he defines her remarkable talents. For in his eyes, her outstanding gift was 'her power to see as a poet, the art and creation of homemaking as a whole in relation to Life; the best simple English country life of her day, frugal yet rich in beauty and comfort; in the building and its furnishings and their homely craftsmanship; its garden uniting the house with surrounding nature; all in harmony and breathing the spirit of its *creation*'.[1]

Therefore, while it is true Rhodes was Baker's chief mentor and influence, just as Miss Jekyll was Lutyens's, it must be conceded that Baker was not immune to the influence of Miss Jekyll nor the vernacular Edwardian style that her collaboration with Lutyens produced. Not that this detracts from his achievements, nor should it affect our appreciation of him. Few young architects – impressionable and enthusiastic – could have resisted the influence of so strong and original a character. And nowhere is the evidence of her influence more apparent or her lessons better learnt than in a colonial – and ducal – estate designed by Baker and set in, of all seemingly unlikely places, the rolling veld of the eastern Orange Free State.

Its history is as curious as its location. Central to Milner's plans for Reconstruction after the Anglo-Boer War was the settling of British farmers in the Transvaal and Orange River Colonies. He envisaged a significant anglicizing of the country districts which, together with the anticipated large British influx into the towns, would tip the balance of the white population – at any rate in the Transvaal – against the time when Responsible Government would have to be granted. 'If there are three men of British race and two of Dutch, the country will be safe and prosperous,' he wrote.[2]

In the Orange River Colony the area to be settled was the lush eastern crescent in the foothills of the Basutoland Mountains – the so-called Conquered Territories, which had been only sparsely populated by Europeans when the Basuto had been driven back over the Caledon River in the 1890s.

From the outset, Milner's policy was beset by obstacles, not the least of which was lack of funds. Of the £35 million loan approved by the British Government for Reconstruction only £3 million was set aside for the purchase of 'suitable land for suitable settlers'. Milner was aware of the difficulties and realized that if his plans were to have any chance of succeeding, it was 'necessary that private enterprise should back up the Government undertaking'.[3] They would require

the assistance of individuals with immense wealth, a love of or at any rate an interest in the well-being of South Africa and a shared enthusiasm for his imperial vision. In 1901 there was only one candidate who sprang instantly to mind.

Hugh Richard Arthur Grosvenor, second Duke of Westminster, was known almost from birth as Bendor. The nickname derived immediately from his grandfather's horse, Bend Or, which had won the Derby in 1880 but, like the horse's name itself, referred more generally to an ancient family rankle concerning a splendid piece of fourteenth-century litigation where, upon the evidence of a galaxy of medieval personages – Harry Hotspur, Chaucer and John of Gaunt included – the Court of Chivalry ruled in favour of the Scropes' rather than the Grosvenors' exclusive right to display the Bend Or (a gold diagonal stripe on a blue ground) in the coat of arms.

Over the centuries the Grosvenors had continued to do their duty as country gentlemen, serving their king, sitting in Parliament, and looking after and adding to their estates – quite often through judicious alliances. None was more so than that in 1677 when Sir Thomas Grosvenor married the twelve-year-old Miss Mary Davies who had inherited the Manor of Ebury which stretched from Oxford Street down the Thames, the area that now includes Mayfair, Belgravia and Pimlico. Valuable though its potential then appeared, no one could have foreseen the gold mine that it was to prove to their heirs two centuries later. Mary's great-grandson became the First Marquess of Westminster and it was he who employed Cubitt to lay out Belgravia. In 1874 Bendor's grandfather, the third Marquess, was created Duke.[4]

At the outbreak of the Anglo-Boer War Bendor, then an eighteen-year-old officer in the Blues, and blessed with good looks and boundless charm, was appointed ADC to Lord Roberts, Commander-in-Chief, South African forces. It was while he was in South Africa that his grandfather died and, his father having predeceased him, he inherited outright. Roberts already had the Dukes of Marlborough and Norfolk on his staff and this rather singular situation gave rise to the crack by Marlborough as he and Bendor lay under Boer fire on a blisteringly hot Free State koppie: 'Dukes cheap today'. Bendor was at Lord Roberts's side when he relieved Kimberley, captured Cronje and took Bloemfontein. And in his capacity as ADC, it was he who actually raised the Union Jack in Pretoria on 7 June 1900.[5]

It is evident that in South Africa the young Duke came into his own. He enjoyed the camaraderie of headquarters, the excitement and the danger and the responsibility. His great friendship with Winston Churchill began on the veld and he had the opportunity to further his acquaintance with Sir Alfred Milner, the great imperialist, whom he had served as ADC two years before and whom he greatly admired. His enthusiasm for the country was to last a lifetime. Years later his third Duchess, attempting to placate an increasingly temperamental husband, issued to close friends and family two lists of safe conversation subjects headed 'To be Puffed Up' and 'To be Run Down'. South Africa featured prominently in the former,

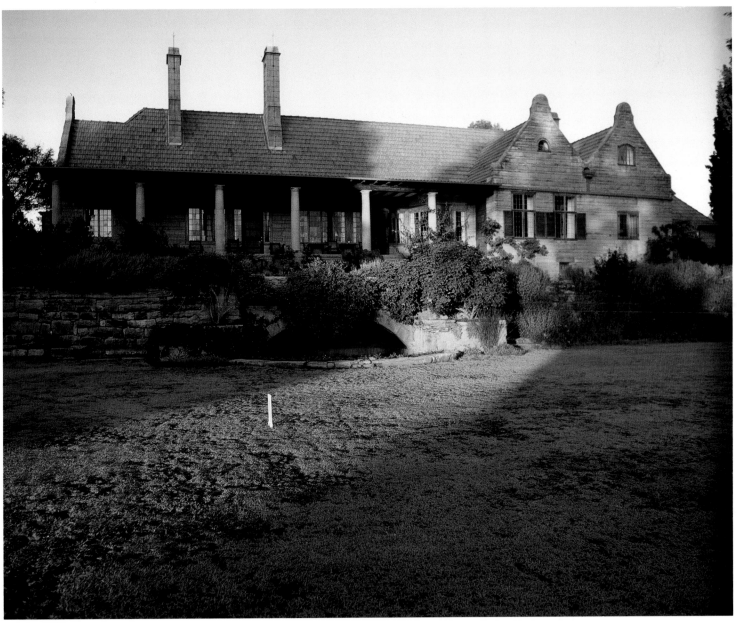

TOP. The stoep, protecting the main rooms from the bright Free State sun.
The furniture was originally designed by Baker for the FitzPatricks'
Free State farm.

ABOVE. Picking lavender for the house.

RIGHT. The High Hall, boasting a handsome stone fireplace.
The room is very 'Baker' with its Dutch antiques, English
and South African Arts and Crafts furniture, and blue and white china.
The beams and the Dutch wall cupboards with their
handsome hinges are a typical touch.

along with *ponticum* rhododendrons and the Marx
brothers.[6]

In 1902 the Duke took his first wife out to South Af-
rica on holiday. The country was as beautiful as he re-
membered and, encouraged by Milner and Leo
Amery, he purchased a large tract of fine, unimproved
grassland about equidistant from Thaba Nchu and
Ladybrand. The cost was about £8 a morgen. The es-
tate was to be portioned off into eighteen farms of
1 000 morgen each which were offered to settlers –
preferably married or with a mother or sister to keep
house – drawn from the Duke's Cheshire properties.
The farmhouses' designs were classed like
battleships (A, B, C) and named after various parts of
the Grosvenor estates – Belgrave, Eaton, Halkyn,
Beauchamp, Saighton, Eccleston and so on.

It was not to be the usual settler saga of hardship
and endurance and ultimate achievement over a hos-
tile environment. Each settler was to be greeted by a
farmhouse (which had cost the Duke about £1 500
each), a large cowshed and a storeroom and an
adequate supply of borehole water. The actual rent
arrangement seems to have been generous. A letter
from the Agent to a prospective settler in 1904 stated
the following terms: the farm was to be worked by the
tenant, the Estate providing all necessary plant,
machinery and seed as well as paying for labour, and
in addition a living allowance of £25 per month for
about a year was guaranteed; in return, the Estate was
entitled to a third of the net profits per annum,[7]
though this seems to have been waived or consider-
ably reduced in the first few years.[8]

There was apparently no doubt as to who the ar-
chitect for this new model estate would be. Baker,
now based in the Transvaal under Milner's sponsor-
ship, was already well on his way to becoming the ar-
chitect laureate of South Africa. The Duke had anyway
seen and admired Baker's work at the Cape – indeed,
as ADC to Milner, he must have actually lived in the
charming staff cottage designed by Baker in the
grounds of Government House in Cape Town – and
the architect's rich but frugal style must have ap-
pealed to a man who, despite knowing riches and
rarity almost beyond belief, was described by Coco
Chanel, his one-time mistress, as 'simplicity itself,
simple as a tramp'.[9] Certainly his South African house
could hardly have represented a sharper contrast
to the opulence of Grosvenor House in Park Lane
and to Waterhouse's overpowering mid-nineteenth-
century Gothic at Eaton.

It was a prestigious commission and for the Duke
Baker produced one of his most charming houses.
Simple, robust and handsome, it is enlivened by
some of the most delightful detailings and boasts a
quality of craftsmanship seldom equalled or surpas-
sed at any stage of South African domestic heritage.
Built of local sandstone – once cream, now yellow
– which Baker had strongly recommended to the
Duke as apposite to the site and which he insisted
should be most carefully worked, 'the quoins not
being dressed differently from other masonry',[10] the
'Big House' is again in Baker's Edwardian free style
with a happy and not improbable mixture of
Elizabethan English and Dutch conceits.

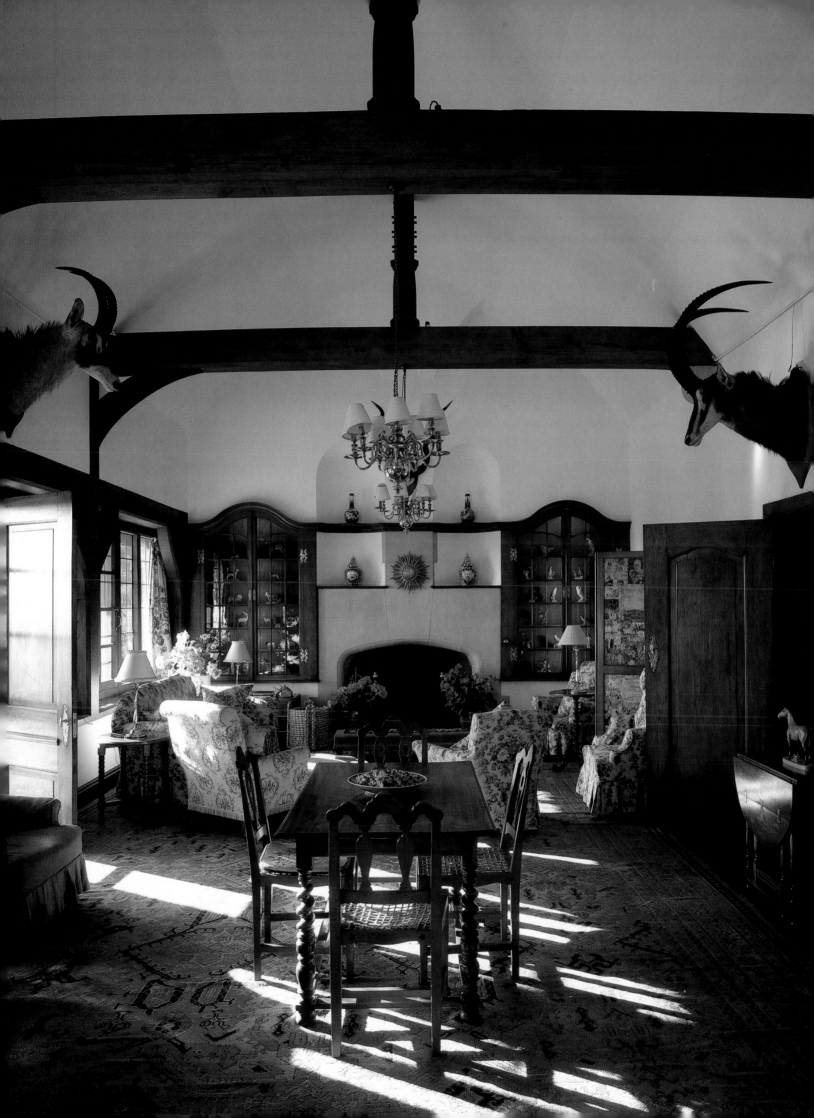

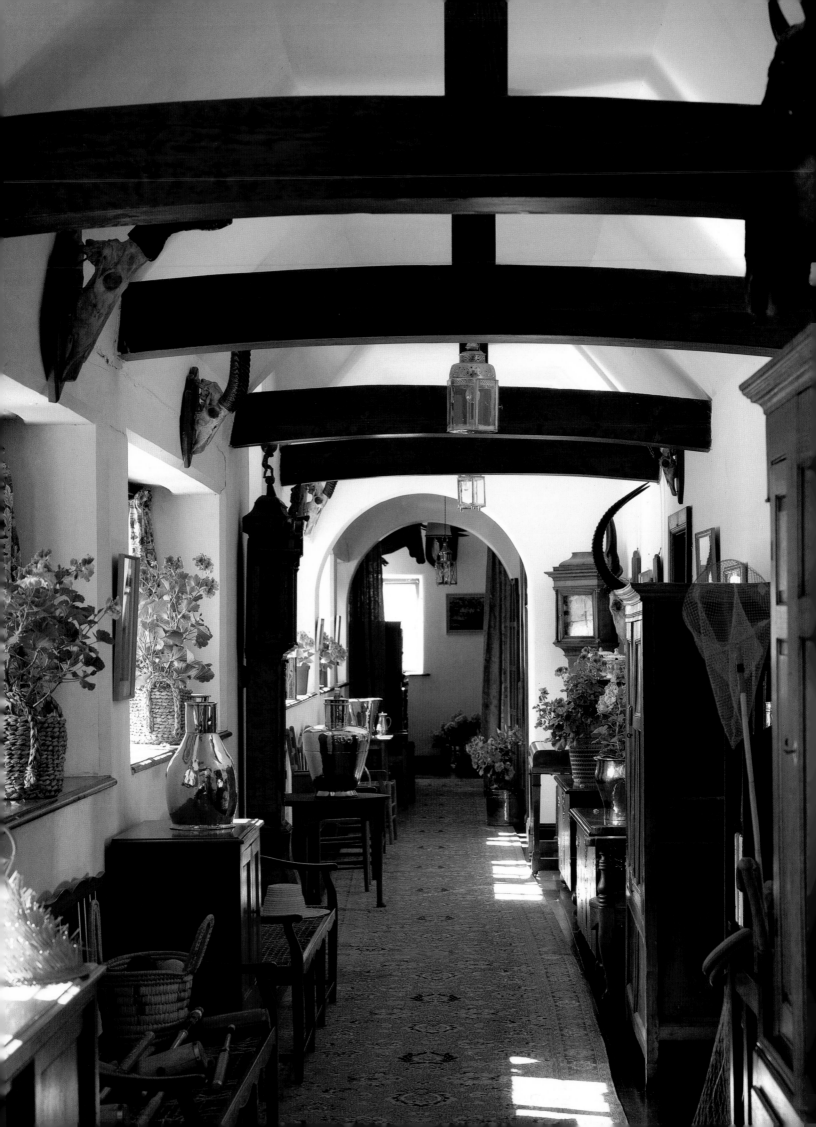

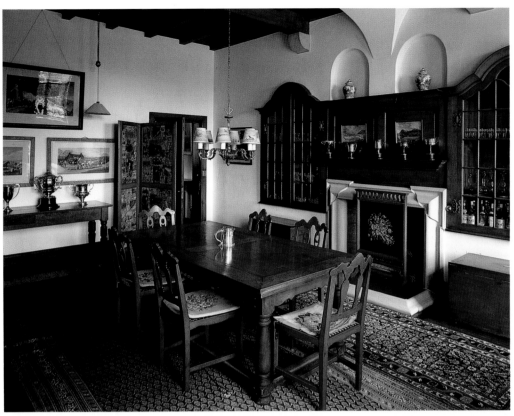

FAR LEFT. Gallery. Lots of Munstead Wood here with its beamed ceiling and long row of mullioned casements. A procession of antique and colonial furniture, lots of brass and cheerful country house paraphernalia. The trophies were shot by the Duke and his Agent; the runner was sent out from Eaton.

LEFT. The dining-room. Baker-designed tables and chairs, more wall cupboards, agricultural trophies and sporting prints from Eaton. The *découpage* butler's screen provides an authentic period touch. After the dispersal of the Miss Curreys' furniture from Welgelegen, Westminster is one of the last of Baker's South African houses to survive furnished as a piece and as he intended.

BELOW. The smoking-room, with trophies of the Westminster hunt. One of the few rooms in private South African houses, even of this period, to be designated thus: the stoep was the usual sanctuary for smokers.

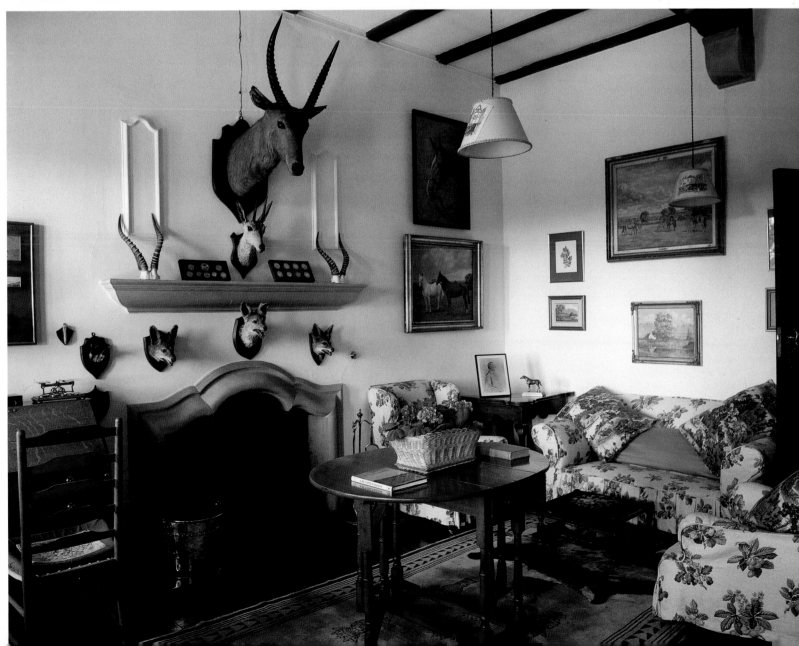

The basic plan is of an expanded U, the two projecting wings enclosing a gravel forecourt with a central porch containing a freestone panel bearing the ducal crest. The elegantly elongated gables recall those Flemish ones sketched by Baker on his student travels, and the Marseilles tiled roof sweeps boldly down forming low eaves over a long line of mullioned casements ('characteristic of an English Elizabethan country house'[11]) set between stone buttresses. On the garden front the doors and windows give on to a colonnaded stoep which protects the main rooms from the sometimes too dazzling Free State sunshine and provides views over the garden terraces towards the Korannaberg and the Maluti Mountains.

Much of the success of the Big House is due to its excellent proportions. Of the Baker houses it falls into a category mid-way between the grand houses such as Northwards and Government House and the small Valley Road vernacular type. The scale is consistent throughout. No games are played with small, dark entrances leading disjointedly to unexpectedly large rooms as they were at Marienhof;* the high hall is handsome without being overawing, and the smoking-room and bedrooms are domestic without being poky.

Moreover, the whole is most carefully planned and well thought out. Coming through the front door, one enters the long gallery which provides a delightful and uncontrived link between the kitchen quarters in the one wing and the bedrooms and bathrooms in the other. How boring a corridor would have been! With its beams and procession of Dutch antiques, colonial furniture, brass, china, trophies and cheerful country house paraphernalia, it owes a great deal to the gallery at Munstead Wood designed by Lutyens for Gertrude Jekyll and which Baker had already used, but with less success, at Rust en Vrede at Muizenberg. From the gallery one steps straight into the high hall with its handsome stone fireplace and vigorous cedar beams and trusses constructed with stout wooden pegs in the best Kentish tradition. The kitchen quarters are once again excellent, though in anticipation of there being 'no more than two' white servants employed, there is 'no servants hall' and the extra bedrooms in the attic were only intended for 'maids and bachelor guests'.[12]

In addition to the Big House, Baker designed the home farm buildings, a dairy, byre and stables and a school which, on the Duke's instructions, was to double as a church on Sundays. The stable yard was entered through a wide-arch gateway. Looseboxes are accommodated on two sides allowing the horses' heads to be seen (the Duke was specific on this point and indeed seems to have had a great deal more to say on the stables than the house itself),[13] while the third side comprised tack rooms and a hay loft in the roof, and the fourth a long stone wall with drinking troughs. The rustic air engendered by the orange tiles, the primitive doric columns and the shingle-clad, dormer-like gantry is surprisingly offset by a charming and unexpected Queen Anne Revival clock

* See Brenthurst.

tower which sports a weather vane of the Duke's horse 'Flying Fox' which had won the Derby in 1899. With internal finishes of the finest teak and iron stall divisions, brass racking rings and japanned star plates[14] and the like, it is small wonder that the stables alone cost £6 022.2.6, over £1 000 more than Baker's original estimate.[15]

In its way the schoolhouse is another minor masterpiece. Uncharacteristically, even Baker seems to have had doubts of his ability to design 'an efficient school which will easily be converted into a chapel and which, combined with the residence of the Master, shall have some church-like appearance in its architecture and be a characteristic building on the veld'.[16] But he pulled it off. Contemporary with the school buildings he was designing for St John's College, Johannesburg, it is made of the same squared random rubble as the Big House with casement windows again set between the buttresses and a bell tower at one end bearing the ducal insignia – a most successful architectural synthesis of a place of learning and a place of worship.

Needless to say, the logistics of such a project were daunting. The nearest railway was at Tweespruit, five miles (8 km) away, and it was only towards the end of the project that the line pushed through to Westminster, so named after a fairly strongly worded hint from the Duke's Agent, Colonel Byron, had been dropped to the Colonial Railways. Still, Baker's behaviour was hardly a help. Having been awarded the commission, he immediately recommended the appointment of a Clerk of Works. One suspects that he was reluctant to leave his lucrative opportunities in the Transvaal (Government House was in its embryonic stage during the Westminster construction) and not very sanguine at the prospect of frequent and certainly uncomfortable trips to environs so remote. 'I selfishly want, after eleven years of incessant work here, to take things a little more easily,'[17] he wrote rather petulantly to his partner, Massey, in Cape Town at the end of 1903. Byron, however, demurred. As Agent he was naturally far more interested in agricultural improvements, rightly considering the architect's fee to be high enough. It was a mistake. For thereafter every delay, every increased cost and every error – especially concerning the eighteen farmhouses which were poorly designed and jerry-built – was blamed by Baker on the lack of a Clerk of Works. The building commenced at the end of 1903; the Big House was only ready for occupation by March 1905 and the school completed in 1906.

As always in the best Arts and Crafts tradition, Baker took the keenest interest in the furnishings and, unmoved by such tiresome considerations as the need for simplification that so remote a location might reasonably have dictated, set up a most complicated network of suppliers. He personally collected some Dutch antiques for the Duke in the Cape. The rest he designed himself to be made up by Heal and Son of London (of whom Baker approved as not being a 'sweatshop'), a craftsman named Spooner in Chelsea, A B Reid in Cape Town and a crafts and furniture factory established by the Duke under Baker's aegis on the estate.[18] Mrs Stafford Keightley of Church

LEFT. The copper pots and pans were specially ordered by Baker to give character to the kitchen, here suffused in a warm glow from the sunshine reflected off the Marseilles tiles of the adjoining wing. With its coal-fired Aga, this kitchen has required little modernization in eighty years and only goes to refute once again the often-repeated nonsense that all Baker's kitchens were small, dark and inadequate.

BELOW. Bedroom. The beds and chest of drawers made by Heals to Baker's design, the ladder-back chairs produced by the furniture factory on the Estate. The corner wash-basin with its tiled surround was a detail often included by the architect. Very wholesome, and very modern for its day, it might be straight out of an instructive illustration in a pre-war Mrs Beeton. The Marsella counterpanes provide a typical period touch.

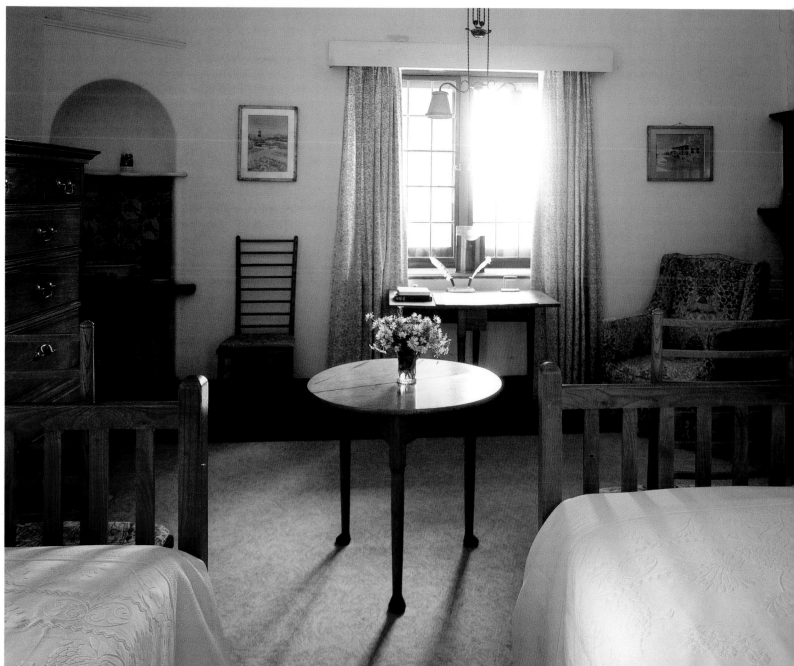

TOP. The stables: sweeping eaves, shingle-clad, dormer-like gantry and Queen Anne Revival clock tower with weather vane in the form of 'Flying Fox', the Duke's horse which won the Derby in 1899.

ABOVE. On the Duke's instructions the looseboxes were designed so that the horses' heads would face one another across the yard. The gravel is raked every morning and the beagles constitute the only pack in the Free State.

RIGHT. Stalls of finest quality teak.

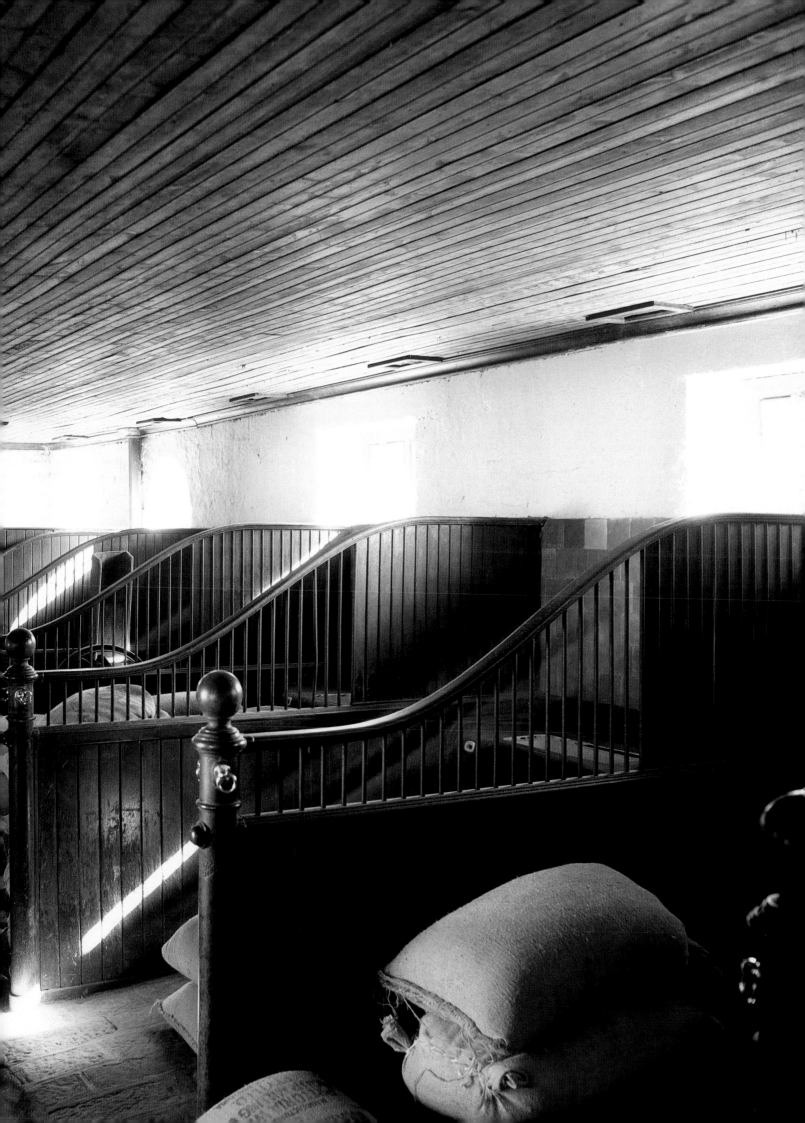

Street, Kensington, who had already won much praise for her work on both Sir Abe Bailey's and Sir George Farrar's houses and who knew 'what suits our style' chose the materials, stuffs, tiles and objects, with the Duchess having the final say on the chintzes.[19] Additional pieces and paintings were sent out from Eaton.

Such efforts, while undoubtedly adding to Byron's headaches ('Has Mrs Keightley dispatched the mattress from London to fit the Duke's bed being made in Cape Town?'), were definitely worthwhile. Baker had strong views on what was suitable for his interiors and never do his houses look as fine as when furnished and maintained as he originally intended. On the question of furniture design he wrote to Ashbee: 'It is my opinion that in the recent Arts and Crafts movement in England there has been a certain amount of affectation and effeminacy and that what we want more especially in a new country is a more sturdy and virile expression in Art ... our requirements at present being of a simple and primitive character.'[20] The interior furnishings at Westminster are almost the last in South Africa to survive as Baker intended.

There remained the garden. Baker sent a plan to Byron when the house was still at its foundation stage.[21] He envisaged a series of terraces with a croquet lawn, a rose garden below that and shrubberies, pergolas and a sundial beyond, the walls and terraces requiring special treatment 'creeping geraniums and hydrangeas and agapanthus in tubs'.[22] Walnuts, cedars and cypresses were recommended to keep the view green all year round, even in winter when everything else is frosted brown.

The Duke himself ordered tree-planting on an heroic scale – by 1925 over two million had been planted and the Free State veld has taken on something of the appearance of an English park. The Duke sent out from Cheshire two hundred thoroughbred horses, shorthorn cattle, merinos and foxhounds. The present beagle pack was started by the Duke's daughter, the Lady Mary Grosvenor, who now owns the property.

Was the enterprise a success? In some ways perhaps not. Many of the initial settlers didn't stay long, but then others replaced them. In time the leaseholds were sold off but the community remained English in character in fulfilment of the original intention, and no passing journalist has failed to gush about Westminster being 'a little bit of England in the middle of the Free State'. It is interesting to note that the first branch of the Progressive Party in the Orange Free State was formed in this constituency.

The Duke visited the estate fairly frequently and then after the First World War lost interest. Friends and people he felt deserved a holiday were sent out there and the visitors' book boasts an astonishing diversity of names. None was more glamorous than the Prince of Wales who stayed there in 1926 and who, to the fury of the then Agent, wisely bypassed the official entertainments (jugglers and a magician on the lawn and all smacking much too much of bread and butter one suspects) and accepted an invitation to an impromptu dance thrown by the local farmers' association after the scheduled polo match. The school/church was transformed into a ballroom, drinks were served out of the church hall teacups and the party was a roaring success. The royal limousine having got bogged down in the mud, the Prince arrived in the blacksmith's jalopy escorting glamorous twin sisters from Thaba Nchu. He enjoyed himself enormously and ended the evening by taking over the drums of the local band before, it is related, insisting on taking the sisters home. The whole district spoke about nothing else for weeks, fuel for gossip and speculation being amply provided by HRH signing the visitors' book and giving as his address 'Thaba Nchu!!'[23]

The house and estate survive in perfect condition as a result of the efforts of the Lady Mary Grosvenor, assisted by the Thatchers who for two generations have acted as her resident agents.

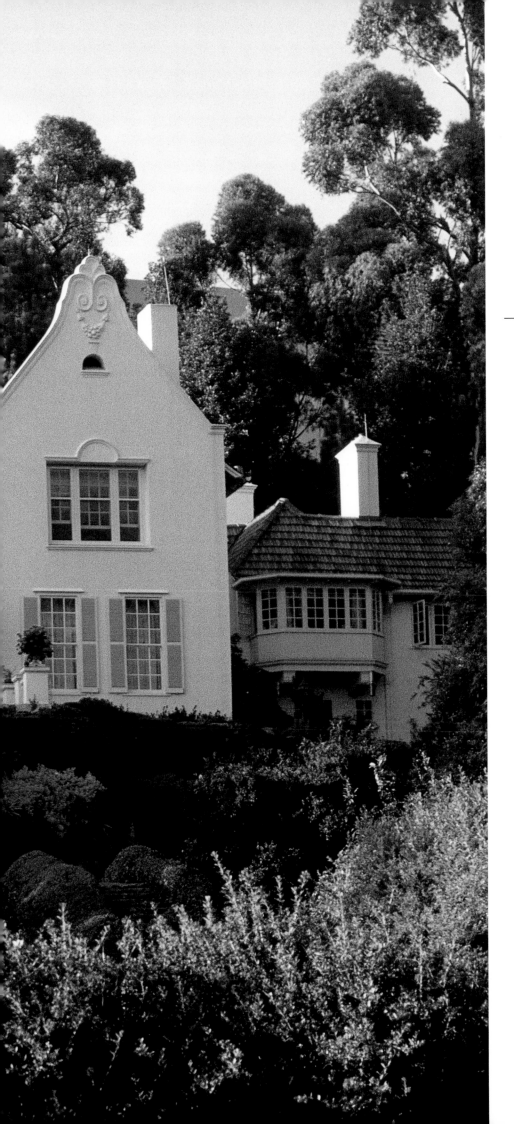

BRENTHURST

PARKTOWN, JOHANNESBURG

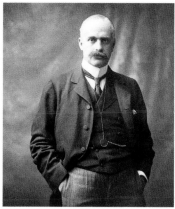

In 1904 the new director of Consolidated Goldfields needed a new house. Herbert Baker received the commission to design it and this came as a surprise to nobody, least of all himself. The company managed Rhodes's interests in gold mines and on the homeward voyage that was the first leg of his Mediterranean study tour in 1900, Baker had shared the same table on board with Rhodes and Birkenruth, manager for Consolidated Goldfields in Johannesburg and shortly to become director of head office in London. As was his habit, Rhodes spoke repeatedly of what was foremost in his mind, of the duty of the wealthy in the raw, undeveloped country and cities of South Africa to build beautiful houses not for show – which would have earned his instant opprobrium – but wherein to exercise 'the most excellent gift of hospitality'.[1] Here again was a notion to appeal to Baker – even domestic architecture could be hitched to the morally invested wagon of nation building. The idea was that strangers, pioneers, farmers and so on would see and hear the best of the country and its peoples instead of the worst which they might see and hear in the hotels of the towns amongst the 'grousers and gossipers of evil things'. Such were the high ideals to which the South African establishment at the turn of the century aspired.

Drummond and Marguerite Chaplin had set off from England in 1896 with high hopes of making their fortune in Southern Rhodesia, a phrase which, in the colonial context, is often erroneously taken to suggest origins which were either humble or low. Certainly the Chaplins were solidly county. His parents' home was Chavenage near Tetbury in Gloucestershire (Drummond and his sister hunted with what was then the Beaufort) and at the age of twenty-two he had behind him a brilliant academic career at Harrow and Oxford. His independent means, however, fell far short of the amount required for the sort of life both he and his wife envisaged, so with a sigh for the pleasures of inherited wealth that he would never enjoy ('what a bore money is') he embarked for the colonies.

His immediate plans, however, were thwarted by the Matabele whose rebellion coincided with his arrival at the Cape. Instead, he went up to the Rand where he landed a job as correspondent for *The Times* – the first to be appointed to the Transvaal, in view of the exceptional circumstances prevailing there in 1897.[2]

The post was not particularly lucrative and Chaplin was soon to give it up, but on the way back to England he decided to 'look up' Cecil Rhodes as he had been invited to do a year or so before when they had met following an Encaenia at Oxford. On the eve of their departure the Chaplins dined with Rhodes in Kimberley and Rhodes took an immediate liking to the young man and 'thought him very clever', as Marguerite Chaplin wrote home proudly. 'Isn't that nice?'[3]

It was much more than nice. For two years later when Chaplin was correspondent for the *Morning Post* in St Petersburg an offer came via Birkenruth to join Consolidated Goldfields as joint manager in Johannesburg. Rhodes was the instigator of this offer, merely on the strength of two meetings, and few more striking examples exist of his celebrated (and some say, notorious) impulsiveness in his judgement of men. In this case it was to pay off handsomely.

Chaplin proved highly successful. He combined not only a shrewd business acumen with excellent administrative abilities, but also possessed the sort of qualities that, right from the start, brought him to the fore as a public figure. By 1905 he was already president of the Chamber of Mines. After the first year his agreement was renewed (to his considerable advantage) and the London Board, delighted at having picked such a winner, agreed to build him a house in the style as befitted their MD in Johannesburg.

Discussions with Baker's Johannesburg firm began in July 1904 and Ernest Sloper, the partner, wrote to Chaplin in September advising that the cost of the new house and stables would be £16 000, exclusive of fees.[4] From the start Chaplin exhibited a praiseworthy reluctance to squander the company's money – in contrast to those for the Duke of Westminster, for example, the stables which were to accommodate 'five horses, two carriages, a motor, harness room and two grooms' rooms'[5] were to be a strictly functional brick-and-iron affair. And even then there was to be some extraordinary penny-pinching: 'We doubt whether kaffirs require a stove,' wrote Baker in 1905.[6] Chaplin may well, moreover, have been warned of Baker's penchant for allowing costs to escalate, particularly in the case of rich clients. In any event, he fixed a ceiling price for the house and almost immediately Baker was obliged to write back that there would have to be considerable modifications in the working drawings, the card room being scrapped as well as some of the more elaborate decorative finishes.[7] Baker respected Chaplin's judgement and may even have been a little in awe of him.[8] On completion, the total extras for the house amounted to a mere £508.5.10, despite 'innumerable other alterations and additions'.[9] Apparently savings were and had been possible.

A far more complicated and exacting relationship developed with Mrs Chaplin. Baker had always preferred to be given a free hand, more or less, with his commissions and, indeed, a number of the more important ones – Groote Schuur, Rust en Vrede and Westminster – had been undertaken without interference from wives and often with only the vaguest brief as to style and accommodation requirements from the client. In other cases, Baker had tried to circumvent what he saw as feminine whims destined to mar his carefully designed whole: Lady Lawley got short shrift for her attempts to furnish Government House and the Currey ladies were finally obliged to issue an ultimatum on the lack of mirrors (a typical Baker dictum) at Welgelegen.

Pretty and vivacious Marguerite Chaplin proved not quite such an easy pushover. At the little foundation stone-laying ceremony that she had got up – Lord Milner himself performing the honours – someone was heard to remark: 'Now Mrs Chaplin will be happy.'

Whereupon Milner, by now a close friend of the couple, was heard to chuckle and add: 'But she will never be contented.'[10]

PREVIOUS PAGE. Brenthurst – Baker, *circa* 1905. Sweeping gables and the triple-arched loggia of Summer Hall rise from an outcrop of the Parktown ridge. The double lower windows were at Mrs Chaplin's insistence and Baker was magnanimous enough to acknowledge them an improvement. The servants' wing (to the right) executed in a simpler Arts and Crafts style; the bay was, and is, the housekeeper's sitting-room.

TOP. Sir Drummond Chaplin.

ABOVE. Marguerite Chaplin.

Restless, insatiable, always asking for the moon, was Baker's epitaph for her,[11] though at the time of building his thoughts were probably a lot less charitable. She changed her mind constantly – one foot was to be added to the dining-room, two feet to the length of the hall, eighteen inches to the eastern stoep.[12] Baker fumed, the contractor absented himself, the builders complained: all these changes made it impossible to continue, they said. But Mrs Chaplin was unrepentant. India rubber should now be included under the drawing-room floor to make it 'springy for dancing';[13] in the kitchen Mrs Chaplin wants a granolithic floor, wants provision made for a bathroom for the menservants,[14] wants to alter the position of the hotplate, is undecided generally on the staining of the wood.[15]

Baker's suppressed irritation is easily detected in a note appended by way of explanation to a list of extras to Mr Chaplin: '... those which have been from time to time and after much discussion, definitely settled by Mrs Chaplin but which have involved so many changes in the plans and complicated measurements before it was possible to arrive at a definite price ... [involving] enormous amounts of labour to us.'[16]

For the Chaplins Baker designed a particularly handsome three-sided residence with a double-arcaded loggia between the projecting gable-ends, somewhat (in Baker's own words) Italian in design – though this despite some of his most elegant gables yet – but with a wing, 'rather Gothic in feeling' running out to one side, consisting of a high-roofed, bay-windowed hall or drawing-room. Marienhof, as the house was originally called, certainly illustrated Baker's eclecticism at its most unselfconscious and the architect was to be criticized – superficially one feels – for the mixture of styles. Rather rashly he sought to justify them by asserting in a somewhat grandiloquent way that the house truly reflected the characters of Drummond and Marguerite Chaplin as he saw them – he calm, reserved, scholarly and magnanimous;[17] she never satisfied and all that business about for ever asking for the moon, etc. It would have been simpler to say that the Gothic window in the high hall was just the exotic touch to appeal to Marguerite Chaplin – a not unreasonable alternative to the Lutyens-type oriel he had used in the hall at Northwards. He must, anyway, have been pleased with the effect, for the Gothic bay appears again at Government House, whose design had been evolving since 1902 and for which Marienhof was in several ways quite obviously a finger exercise. As at Government House the plan is well integrated, the awkwardness of the juxtaposition of the servants' wing which appears at Groote Schuur being happily absent. With its soaring gables, the north façade facing the view is acknowledged as one of the most graceful ever designed by Baker.[18]

In the company of Mrs Chaplin[19] (one suspects to avoid later recriminations) Baker cleverly positioned the house on the high ground on the extreme edge of one angle of the plot, facing the diagonal of the rectangle, as it were, so that extensive though the property is – forty acres in all – the house effectively looks across the greatest area of the grounds imaginable.[20]

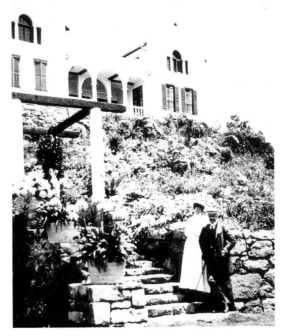

LEFT. Sir Drummond and Marguerite Chaplin below the recently completed Marienhof. Note the agapanthus and hydrangeas in tubs – a typical Baker dictum for his gardens.

BELOW. All smiles in the end ... Lady Chaplin with her architect (centre) and the newly completed Marienhof behind.

BOTTOM. Noordhoek, which Baker designed long-distance for the Chaplins in the early 1920s after their retirement from governing Southern Rhodesia. This is Delhi Baker rather than African Baker.

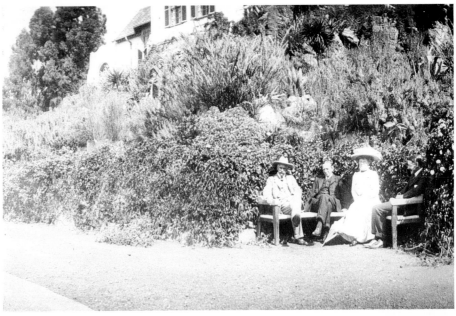

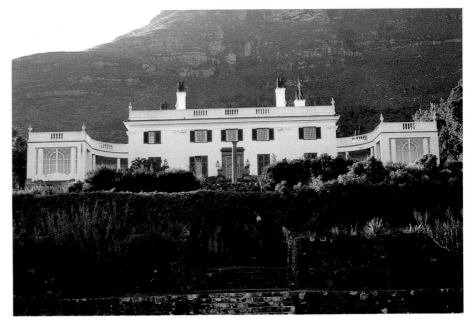

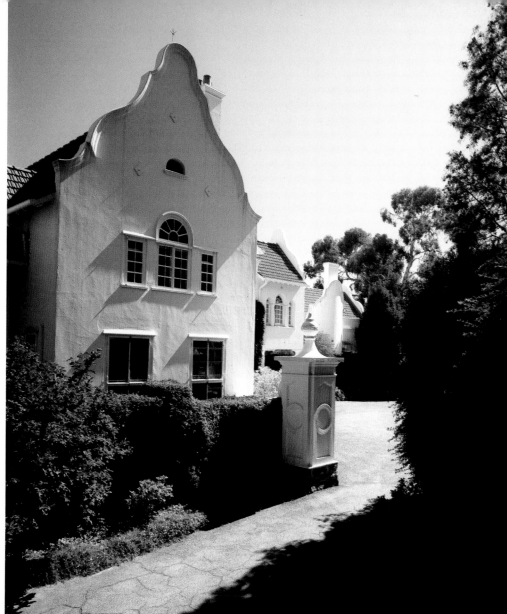

LEFT. As Baker perceived, the site favoured the designing of a beautiful garden. The flat area below the koppie was laid out in the Jekyll manner with lily tanks, borders, topiary and even a maze. Still clearly visible in the redesigned garden is Baker's main axis leading off into the gum trees.

ABOVE. Entrance court. A profusion of gables, and the successful integration of the servants' wing projecting southwards.

ABOVE. With his penchant for the primitive and masculine, Baker was not always adept at producing feminine touches. This rather charming fanlight incorporates Lady Chaplin's first initial (and, fortuitously, that of the first Lady Oppenheimer) and is fitted over a bedroom doorway.

RIGHT. Baker's answer to the highveld climate – cool in summer, sunny in winter – the Summer Hall furnished as a room, which is as he intended it should be, and still very much the nerve centre of the house in fine weather. The arch and two columns were repeated in the middle of the room to no particular effect and were later removed.

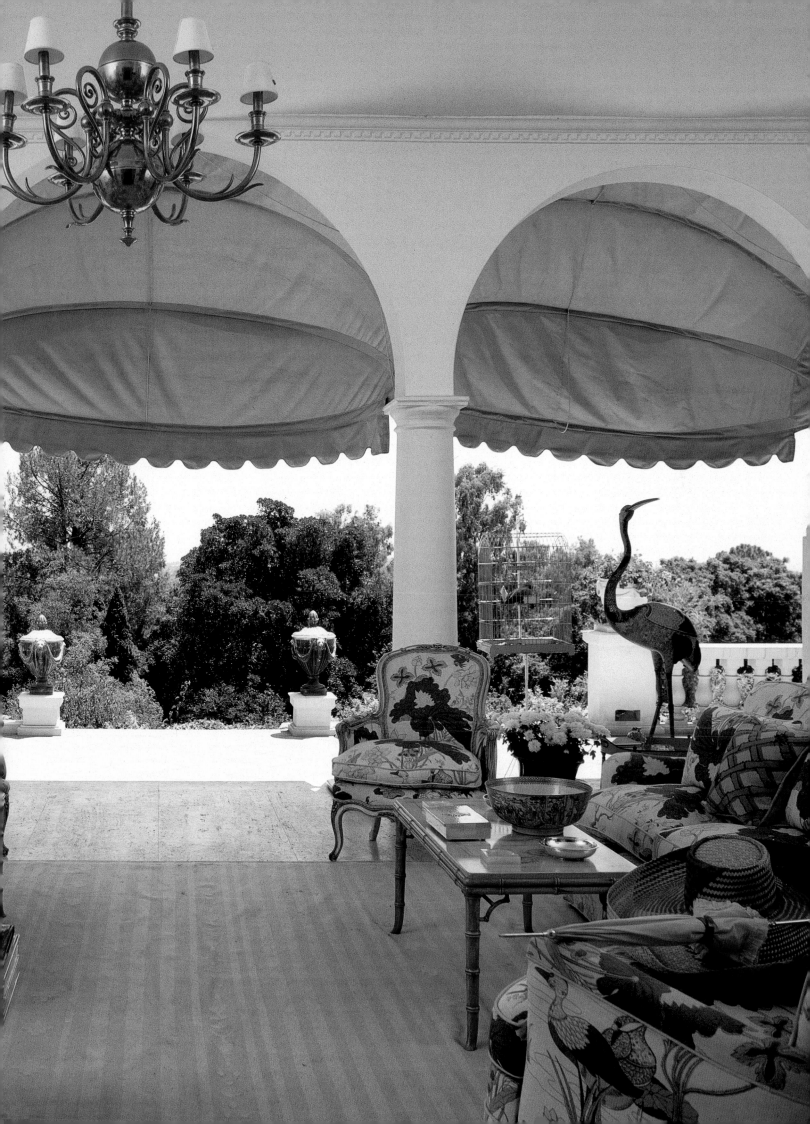

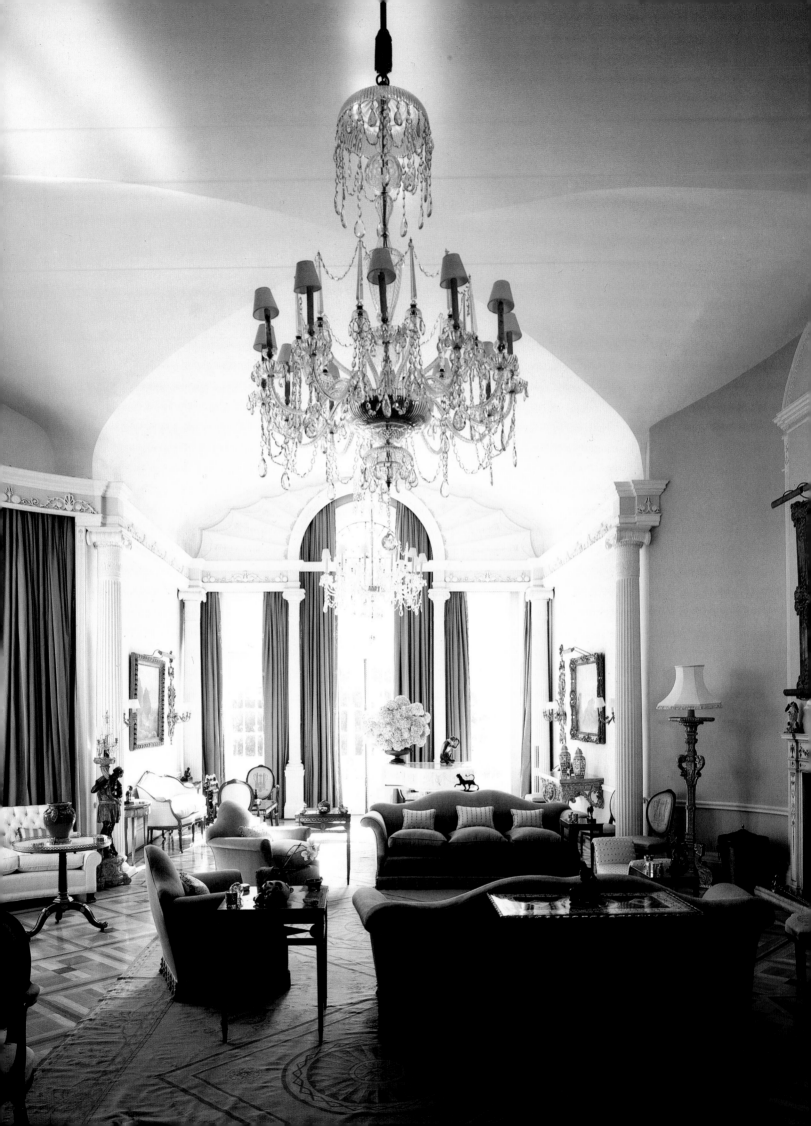

Although less dramatic than, say, Stonehouse or Northwards, the siting is nevertheless delightful. Again Baker's intention was for the building to perch on the edge of the 'picturesque kopje' (in consequence, the copper tape for the lightning conductors had to be carried some distance to find a suitable earth)[21] and strict instructions were issued to Duncan,* the Clerk of Works, that the koppie should not be damaged in the slightest degree, the stonework of the basement being carefully chosen to harmonize with it.[22]

As Baker and the Chaplins realized, the site favoured the design of a beautiful garden – one advantage of being situated below the ridge – and at great expense (£2 550) a garden of terraces, pergolas, herbaceous borders, cypress avenues, a lily tank and even a maze was laid out to Baker's design.[23] Even after the completion of the house, Baker took a keen interest in its progress and was not above gently denigrating Mrs Chaplin's efforts. 'The effect I wanted,' he wrote to her, 'was a very broad mass of flowers against a dark green background ... you cannot get a really fine herbaceous border in six foot which is the present width of the bed.'[24] The missive might have come from Miss Jekyll herself.

Right from the start the Chaplins fulfilled Rhodes's credo for the South African rich. Having striven to keep down the bill to be footed by Consolidated Goldfields, Chaplin allowed his wife to indulge her extravagances with the interiors and Marienhof was made beautiful by her taste. The house, as a friend of theirs wrote, 'was almost like a child to Marguerite'.[25] Neither were savers – they lived lavishly and in considerable style. Guests and visitors from overseas shared every meal and there were few places, as Chaplin wrote of his hospitality, 'where people will find the whole thing – waiting etc – better done'. The wine, from Chaplin's London merchant, and the food were superlative.[26]

This agreeable state of affairs was rudely terminated in 1913 when Jameson, in his capacity as President of the British South Africa (The Chartered) Company, offered Chaplin the administratorship of Southern Rhodesia. When Drummond broke the news to his wife she was horrified. Sir Roderick Jones, the future MD of Reuters, who was staying at Marienhof at the height of the 1913 strike, returned for dinner to find the household in an uproar – Chaplin highly agitated and Marguerite having shut herself in her bedroom in hysterics, declaring that nothing would induce her to give up her beloved Marienhof and transport herself to 'remote and barbarous Rhodesia'.[27]

In the end, of course, she relented. The Chaplins governed Southern Rhodesia until 1923 when they retired in a flood of goodwill to Noordhoek in the Cape where – at long distance from London and New Delhi – Baker designed them a new house.

Marienhof, which had until then been leased, was finally sold in 1922. The purchaser was Sir Ernest Oppenheimer, the financial genius who in 1917 had registered the Anglo American Corporation of South Africa. Sir Ernest immediately changed the estate's name to that of his former residence – Brenthurst. His son has suggested that this may well have been for motives of good old-fashioned household thrift** (the writing paper already ordered need not be wasted!)[28] but it is equally possible that the fearful incident in Kimberley, when Ernest Oppenheimer had narrowly escaped lynching by the mob during the anti-German riots that followed the sinking of the *Lusitania*, might have prompted this move. Certainly the war had quashed the fashionable Edwardian penchant for names, *objets* and matters German and, during the war years and immediately afterwards, the Oppenheimers were not least amongst prominent families throughout the English-speaking world to find German connections undesirable.

The Oppenheimers retained and enhanced the estate. At the outbreak of the Second World War the house was handed over to the Union Government as a hospital. Smuts, a great friend of Sir Ernest's, officially opened it in the middle of 1941 and shortly thereafter Jack Penn, a young army surgeon who had been working with Gillies, McIndoe, Mowlem and other skin speciality surgeons treating the casualties of the Battle of Britain, persuaded Sir Ernest's wife, Ina, to allow him to establish a plastic surgery unit there. Brenthurst was registered as a full military hospital under Jack Penn, the entire costs being met by the Oppenheimers. With Gibraltar closed, all serious casualties south of the Mediterranean were brought to South Africa and before the end of the war about three thousand had passed through the wards. Over six thousand operations had been performed.[29]

Towards the end of its term as a hospital, a fire broke out and destroyed part of the house. Under Sir Ernest and Lady Oppenheimer and his son and daughter-in-law, Mr and Mrs Harry Oppenheimer, the house was restored and the interiors sumptuously redecorated to suit post-war taste. If this is now of passing regret to students of architectural history, it is however notable that of all Baker's South African houses, Brenthurst is perhaps the only one which survives today in any significant fulfilment of Rhodes's original doctrine.

* Originally at Groote Schuur, he had been Clerk of Works for the Farrars (Bedford Court) and the Dale-Laces (Northwards).

** Modern sceptics of this theory would do well to recollect that this was an era when generations of colonial children were brought up to preserve their Christmas wrapping paper for re-use, confident that they were emulating the example set by the Royal Family. 'Frugality and economy,' enjoined the contemporary edition of Mrs Beeton, 'are virtues without which no household can prosper. Whatever the income, waste of all kinds should be most sternly repressed.'

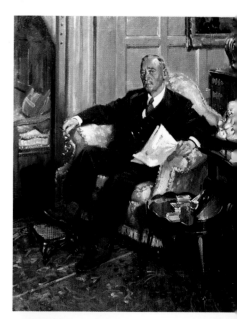

LEFT. After the fire and in keeping with post-war tastes, Baker's high and handsome hall was given the 'Vogue Adam' treatment by Imrie Loerincz, then the fashionable South African interior decorator. With its fine furniture, pictures, *objets d'art* and *objets de luxe*, and the Annigoni of Mrs Harry Oppenheimer over the fireplace, this room is destined to become as much a period piece as the hall at Dolobran.

TOP. Sir Ernest Oppenheimer by Cuneo. The teak wainscoting, inglenook and 'Curzon Street Baroque' décor of the pre-war Great Hall may be detected in the background.

ABOVE. Patriotic Johannesburg foregathers in wartime to hear Field Marshal Smuts open the Brenthurst Hospital from the pergola. Nurses line the terrace, and the Gothic bay of the Great Hall (similar to that at Government House in Pretoria) may be seen.

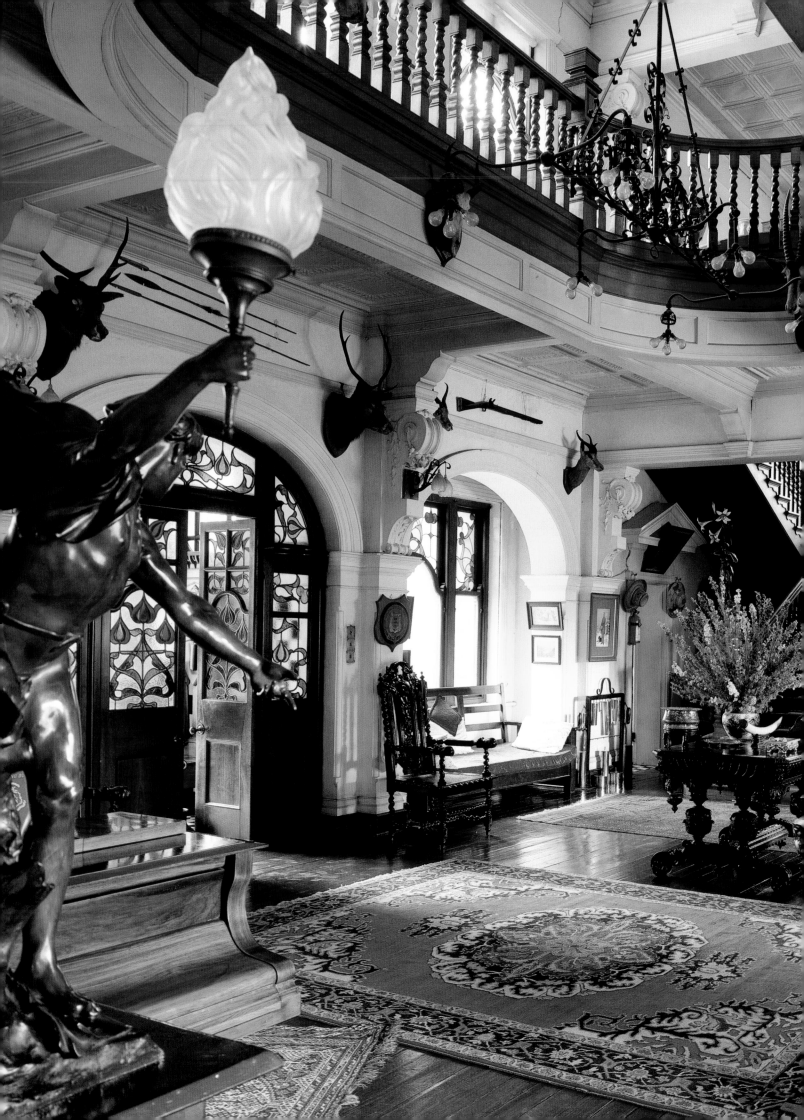

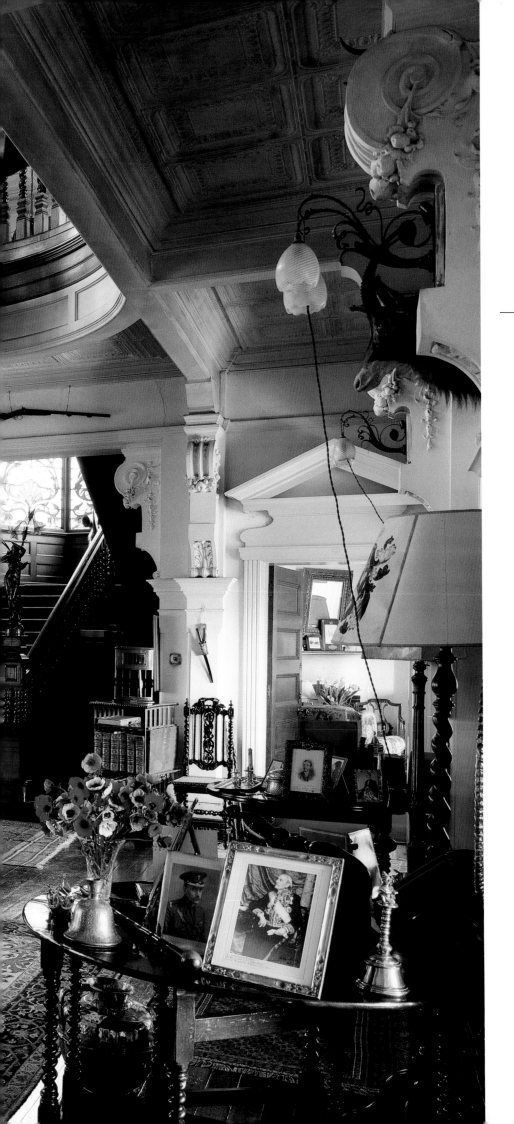

DOLOBRAN

PARKTOWN, JOHANNESBURG

PREVIOUS PAGE. Dolobran – Cope Christie, *circa* 1905. The hall expanded as a major living room of the house, overlooked by the upper gallery. Queen Anne Revival and art nouveau mixture – notice the door surrounds, the windows with their stained glass and the 'snowdrop' light fittings. The shells at the foot of the staircase guarded Mafeking in the siege.

ABOVE. Sir Llewellyn Andersson.

BELOW. The stables and coach-house, designed in more unadulterated 'Queen Anne' than the main house – applied timberings and a second weather vane.

In the years between the discovery of gold in 1886 and the outbreak of the Anglo-Boer War there were fortunes – fabulous by any reckoning – to be made on the Rand. The new rich, or what *The Star* of the late 1890s was already describing as the 'Upper Crust of Johannesburg' – people like the Thomas Cullinans, the George Farrars, the Hennan Jennings and the John Hays Hammonds – all sought residential exclusivity in Parktown.

It was, at the turn of the century, a semi-rural municipality not too remote but well removed from the brash, dusty mining town which had grown, all huggermugger, to the west, south and east.[1] Until Milner's decree of 1901 it had been run by a private company, complete with its own waterworks, sanitary services, electricity supply (from the plant at Hohenheim, the Phillips and later FitzPatrick home) and fire station. All the new houses and their grounds were substantial – the freeholds saw to this – and in spite, or perhaps because, of its situation in a Boer Republic their names, like those given to the streets, proclaimed overtly British sentiments. There was a grass oval, and the lanes and avenues were picturesquely laid out, gravelled and lined with trees and shrubs – perfect, as a society columnist noted, for carriages, riding and promenades. In short, a more salubrious neighbourhood was not to be found north of the Orange River. County colonial, though often with a cultivated heritage rather than a pedigree, was the intended general note; with time there was more than a hint of a glorified garden suburb. Appropriately, the whole area was securely fenced and entered by way of a gate near the present-day Clarendon Circle.

New rich did not necessarily mean *nouveau riche* with all its pejorative overtones, for by no means all the Randlords fell into the robber-baron archetype portrayed in popular histories. Though few would carry a torch for the likes of Joel, Barnato or Robinson, a gentler and altogether more pleasant breed existed alongside them.

The ethos of the Victorian gentleman – that curious combination of Sir Walter Scott's chivalrous knights and the God-fearing, sports-loving schoolboy envisioned by Dr Matthew Arnold[2] – had been exported wholesale to the colonies where, under the auspices of Empire, it had flourished with singular success.* Though its references were patently English – faithful to God, the Queen and the Empire, in addition to being reverent towards women, modest in demeanour and so on – it was quite possible in a lifetime for a successful immigrant of any class or nationality, a Jew or a Boer, to subscribe to it. And many did.

The spirit of duty and public service it vigorously espoused was entirely disposed towards England's imperial destiny – witness the Jameson Raid – and a colony (or even potential colony!) was to be directed and at the same time quite genuinely developed and enhanced towards the greater end. Imbued with such noble sentiments, great wealth could acquire an extra, almost moral cachet: influence in colonial affairs was obviously essential and in most cases (and

* The 'auspices' may well be said to account for its major and all too general colonial defect: its attitude towards inferiors of colour.

certainly in the Transvaal) influence could be wielded with money.

Rhodes, while recognizing and admiring all this and seeking to perpetuate the ethos through his scholarships, was himself, in the final analysis, not of the type. Milner's Kindergarten, while fostering the vision through shining example were, by the very nature of things, an imported variety of the species. So finally it is in men such as Llewellyn Andersson (Percy FitzPatrick, his close neighbour, was another) that one approaches the beau ideal of South African colonial manhood.

A man blessed with good looks and great personal charm, Andersson seems to have satisfied almost every criterion. His father, C J Andersson, the son of Llewellyn Lloyd, the well-connected but eccentric English bear-hunter, and a Swedish country girl whose patronymic he bore, was an outstanding naturalist, scholar and explorer of the subcontinent – second only in importance to Livingstone, was Smuts's verdict.[3] Baines was a close friend and a fellow-traveller and there is a splendid oil of his in the drawing-room at Dolobran showing Andersson pacifying the Damaras. C J Andersson's untimely death in the Kalahari left the family in somewhat straitened circumstances. Llewellyn was educated privately in Cape Town and came to the Rand via the Cape Civil Service in 1887.

He set up as an accountant and enjoyed immediate success, his firm (later known as Andersson & Whitely) doing the books of many of the top mining houses. Like many of his contemporaries, he speculated in gold, on the stock exchange and in property. For over forty years he owned all of what is now Hyde Park.

Parallel with his financial success was a distinguished military career which would have satisfied the most ardent imperialist. A volunteer member of the DEOVR at sixteen, he fought in the Basuto War and, as a leading member of the Reform Group at the time of the Jameson Raid, was in charge of the defence of Johannesburg from Hospital Hill to Langlaagte. For this last bit of patriotism he landed in Pretoria Gaol along with Phillips, FitzPatrick and the rest. During the Anglo-Boer War General Buller authorized him to raise the South African Light Horse, which he later commanded.

He served with the Grenadier Guards during the First World War, was severely wounded and taken prisoner on the last day of the battle of the Somme while attempting to take, almost single-handedly, a German post behind enemy lines. On the home front he had, in 1913 and on Botha's request, formed the Civic Guard of Johannesburg. His organization of it was superb and in times of civic unrest he had 4 000 men under arms. To these during the 1922 strike he added another twelve battalions of constables and was appointed Deputy Commissioner of Police. It was for these services that he received his knighthood.[4]

On top of all this he was a quite outstanding sportsman and shone in every field he chose: rugby (he played for Hamiltons and later captained Transvaal), gymnastics (he captained the Wanderers, the club he helped found in 1887), fishing, archery and

LEFT. Lady Andersson fords a river on safari.

BELOW. The side view shortly after the completion, showing the ogee and pagoda domes (the latter housing the bathroom and lavatory), the 'Tuscan' entrance, timbered gable, crestings and finials all rising out of the ridge on the koppie-stone foundations. The stained glass oriel hangs above the gravel sweep. (Africana Museum, Johannesburg)

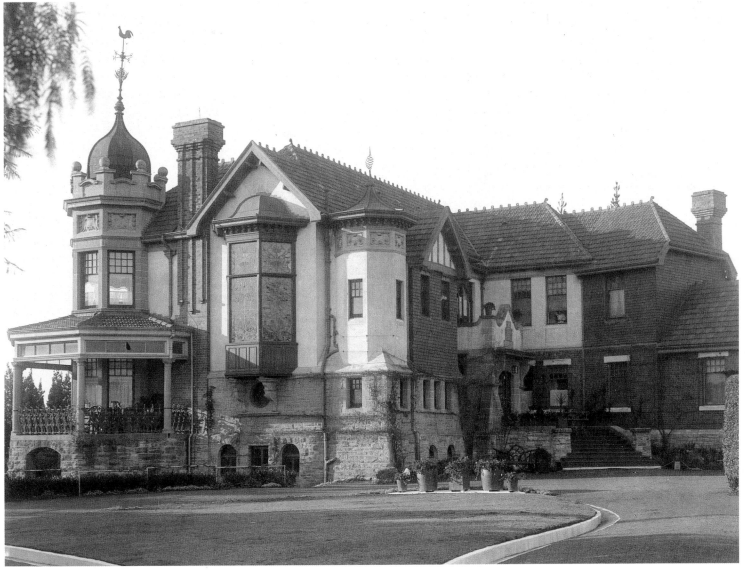

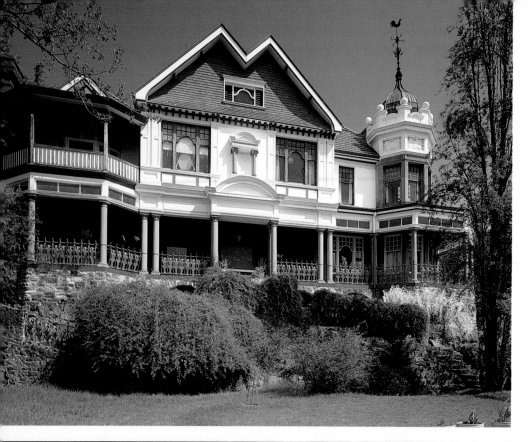

TOP AND RIGHT. Colonial Queen Anne Revival with balconies, Tuscan colonnades, cast-iron verandahs, tile-hung gables and the ogee dome (recalling the Vice-regal Lodge at Simla) 'pinned' to the extremity of the ridge by the weather vane.

ABOVE. The cast iron came from the verandah of the then recently demolished Corner House.

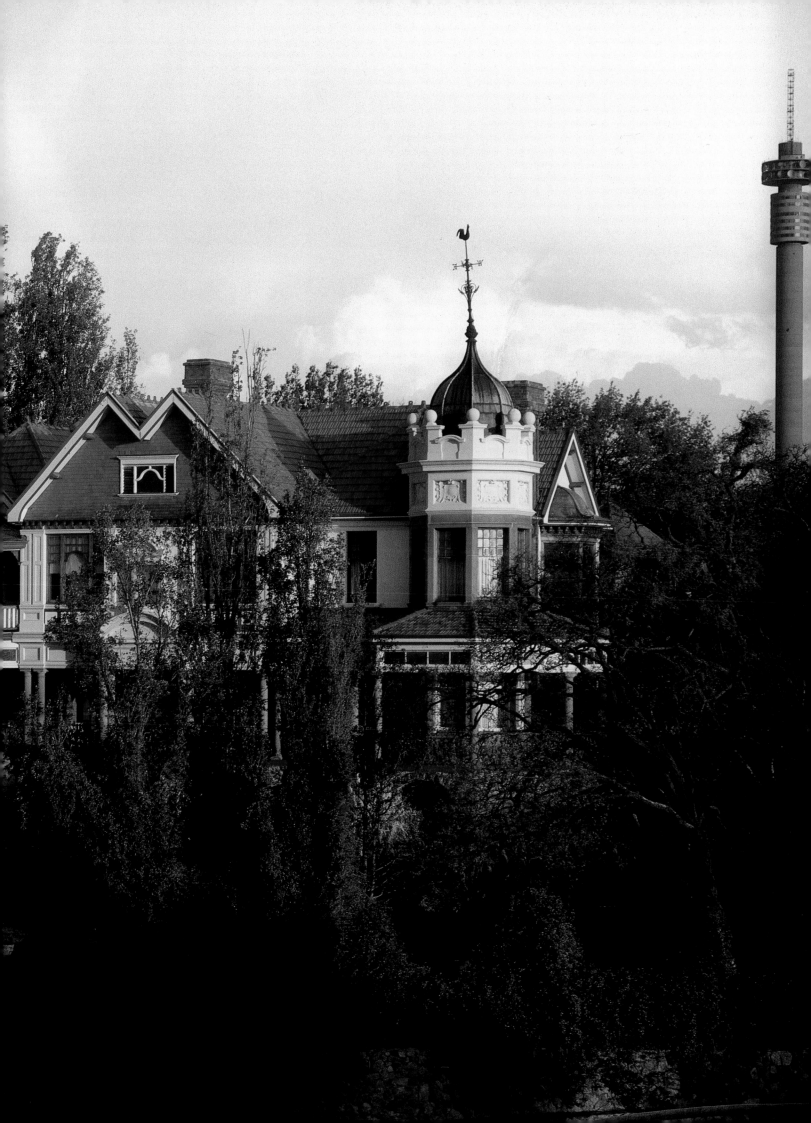

rowing.[5] Dr Arnold could hardly have wished for more. He was, besides, one of the finest shots in the country.

Though generalizations are justly dangerous it is quite reasonable to accept Mark Girouard's contention (for the evidence is overwhelming) that in the scale of values of a Victorian gentleman neither intellectual nor aesthetic qualities ranked especially high.[6] And it goes without saying, therefore, that they were hardly more prized by their colonial cousins. Without the sponsorship of Rhodes and Milner it is doubtful whether Baker would have enjoyed anything like the success in South Africa that he did. Still, in 1903 he was the fashionable architect in the Transvaal, and the Anderssons joined the queue of successful Johannesburgers whose thoughts had turned to house-building after the Peace of Vereeniging and who were clamouring for his designs.

Andersson must have been aware of the sort of style in which Baker was building, but clearly he hadn't anticipated anything like the schemes which arrived, complete with colour wash perspectives, in April 1903.[7] He didn't like them. He didn't like them at all. He didn't want shingles. He didn't want small windows. 'This is not the way,' he told Baker to his face, 'to build in Africa.' Light, air and sun was what was wanted.[8] Baker, riding the crest of his prestige and popularity, was very much put out by such criticisms and inferred that he had no intention of altering a thing. Months of stalemate ensued and finally the firm demanded payment for the work submitted – an old trick to persuade clients not anxious to incur extra expenditure to press on. Andersson, now thoroughly fed up, called his bluff, paid him off and went elsewhere.

Baker later regretted his intransigence ('extremely disappointed' was how he put it in a letter to Andersson[9]) and it is obvious why. The commission, no less than the site on the Parktown ridge, was a prestigious one. Moreover, an honest reappraisal would have revealed a design thoroughly undistinguished and one which would have made a most second-rate neighbour to Northwards, the Dale-Lace mansion just across what is now Oxford Road. Certainly the residence Cope Christie designed for the Anderssons after a strict briefing is as far removed from Baker's bland (it is suburban rather than gentlemanly) effort as it was possible to go.

J A Cope Christie was an English architect who had trained with George Fellowes Prynne. Both were FRIBA. Christie had gone to Rhodesia to work for the Chartered Company in 1896 and among other things had been responsible for the laying out of Umtali, then considered a model colonial town.[10] He came south in 1903, eager to benefit from the building boom. One suspects that Baker's formidable practice – to say nothing of some of his business methods – had not created an ideal climate for the newly arrived architect. The prestigious Andersson commission, together with the circumstances surrounding it, must therefore have seemed like a golden opportunity.

Ironically, both Baker and Christie had been trained and well versed through their respective apprenticeships in the enormously popular late

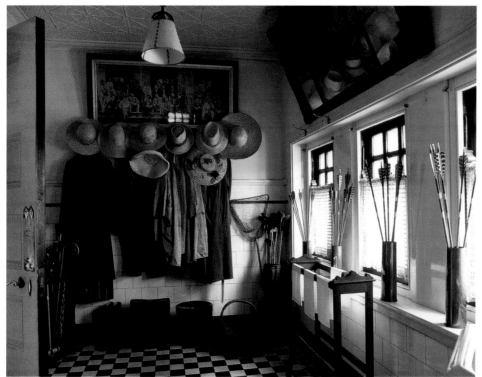

FAR LEFT. The curved front steps showing the 'Tuscan' entrance.

LEFT. Cloakroom adjoining the lavatory at the base of the pagoda turret. The photograph above the coats and hats shows the Reform Group in Pretoria Gaol after the Jameson Raid.

BELOW. Entrance hall showing the marvellous stained glass in art nouveau design and checker-board tiles on the floor and wall.

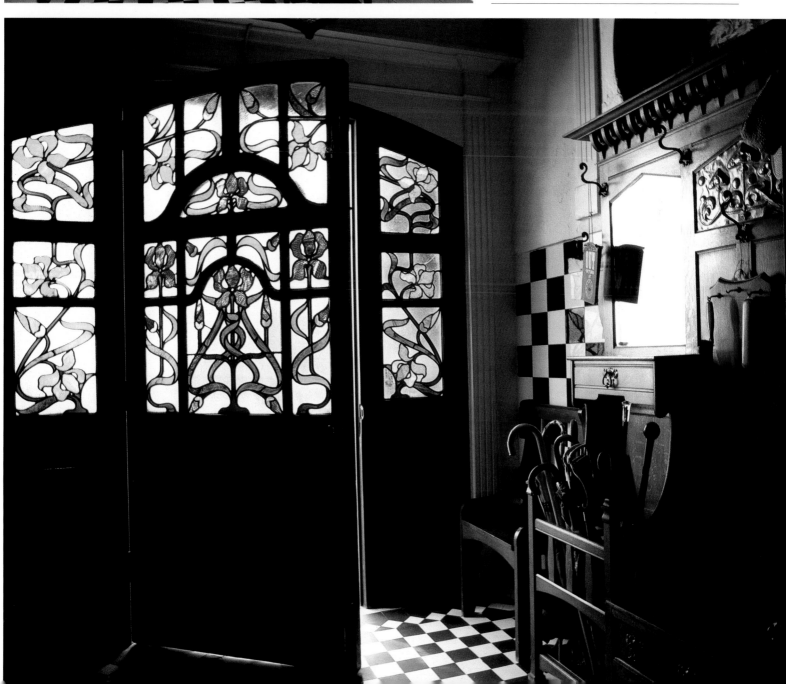

nineteenth-century English style, loosely and somewhat erroneously known as Queen Anne Revival.[11] But whereas Baker had sought to eliminate its effeminacy – as he saw it – with colonial boldness and crudeness and had succeeded in producing an individual and more modern version of it, Christie's solution was to opt for the festive brand of Queen Anne. This, for reasons only easily explained by the need to accommodate lots of sunshine, had transplanted itself from fashionable English seaside resorts to blossom afresh in the colonies. There, colonial sentiments and sheer colonial effrontery caused it to acquire all manner of exotic fancy dress – ogee domes, cast-iron finials and verandahs, Tuscan colonnades and oriental details, all cheerfully wedded to the English and Dutch red-brick architecture of the seventeenth and early eighteenth centuries. Simla, Melbourne, the Durban Berea, Bombay and other outposts all sprouted hybrids of this type. Their flamboyance, their siting (usually on a hill or crag to escape the tropical heat) and all too often their desire to impress have led to their subsequent dismissal as 'colonial baronial'. Certainly, as 'homely relief' to mid-Victorian Gothic, which is what Queen Anne was supposedly all about, such houses must fail. Yet for all its colonial opulence Dolobran* belongs firmly to the mainstream of Queen Anne Revival architecture. The Gothic Revival groupings, free-planning and asymmetry are all to be evidenced in the basic plan. There are plenty of the English domestic architectural details so beloved of the movement's espousers: the red brick and white plaster, the tile-hung gables that Nesfield employed, the applied Tudor timbering of Norman Shaw. Added to these are Tuscan references (the colonnaded verandah and front door), oriental references (the ogee dome and the pagoda roof of the side turret), and for good measure the fantastically elaborate cast-iron verandahs of the then newly demolished old Corner House which Andersson had purchased at an auction to embellish his new verandah and garden walls.

Sited on the edge of the koppie and appearing to rise out of it (the conceit of battered koppie stone foundations was blatantly copied from Baker), the audacious mixture of styles and asymmetry is more successful than could possibly be envisaged from any perspective drawing. Every bay, angle and recess in the basic design is fully exploited to add excitement to the elevation, the turret with its ogee dome – similar to the Viceregal Lodge at Simla** – apparently 'pinned' by the tall weather vane to the koppie's most northerly promontory. Taller chimney stacks might have produced a convincing colonial Cragside.

The entrance off a circular gravel carriageway – almost every large Parktown house had one – is up a wide curved staircase, through a small tiled vestibule and into the splendid central hall. Complete with oval gallery, it occupies about 900 cubic feet (24 m³). The Victorian idea of expanding the hall into something more than an empty core – first mooted by Sir Gilbert Scott and later taken up by Nesfield and Shaw who intended them as summer living-rooms – is here seen at its most elaborate. As at Ellingham, Northwards and Government House, Pretoria, the hall is very much the nerve centre of the house, a comfortably furnished room complete with inglenook fireplace; a room not only for receiving in, but for sitting, reading, playing the piano and dancing in. At one time Andersson even entertained the thought of placing the billiard table here.

Off this leads the splendid T-shaped staircase met at the half-landing by an oriel window of vividly coloured stained glass in an art nouveau design. It is lit most brilliantly by the African afternoon sun which floods the whole area in the richest shades. To one side is the drawing-room with its large octagonal bay (the base of the dome turret); on the other the dining-room, and extensive servants' wing. In addition to the kitchen there were four pantries – one for china, one for vegetables, one for wine (which locks securely) and one for that most Edwardian occupation, 'doing the flowers'.

Upstairs there were five bedrooms which, with their large windows, bays and sleeping porches, positively rejoiced in the sunny north views in contrast to the tiny casements planned by Baker. Indoor accommodation was provided for Lady Andersson's French maid, the Irish cook and Nanny.[12] Separate from the house was a large stable block, more unadulterated Queen Anne in design than the main house, and complete with coach-house and accommodation for the native servants.

The total cost was estimated at £15 000 and in the end extras came to only another £700 to cover the stable chimney, dovecot, electric installations and burglar alarms.*** The contract was signed in April 1905[13] and by August the roof was on.

In July Lady Andersson had left for London to select the furnishings. Andersson had been recommended a good agent, a Mr S H Chaplin, who could, as he wrote in self advertisement 'do the needful for you and save you money'.[14] Andersson was satisfied: 'I think it will be better for her to get everything at Home,' was the reply. 'I look to you to put the wife in the way of getting the best things at the cheapest prices and with the greatest discounts possible.'[15]

Armed with the plans and Chaplin's introductions, Lady Andersson went on a shopping spree. Grates and chimneypieces – either the massively handsome teak ones or the pretty Queen Anne type – came from Messrs Feetham. The wallpapers came from Messrs John Line & Sons – blue moire silk for the drawing-room ('use thick paste,' were Lady Andersson's carefully printed instructions), white and blue with a blue bow frieze for the best bedroom, green and white for No 4, red for the dining-room and so on.[16] Furniture and light fittings – elaborate art nouveau metal affairs with snowdrop or tulip-glass shades – came from William Bailey & Sons; and the bathroom fittings were the most modern to be had from Messrs Shanks & Co of Glasgow.[17] After some hesitation ('some quite reasonable stuff' being locally available) the stained glass, or 'cathedral glass' as it was often called, was ordered from Messrs Nicholl & Co.[18] Furniture for the

* Pronounced the Welsh way, D'lob-r'n.

** Though both probably owe their inspiration to Basil Champney's Pfieffer Building at Cambridge.

*** Even in 1905!

The staircase ranks with that at King's House, Durban, and Rhodes's sanatorium in Kimberley – all belonging to the same era. The art nouveau ladies carry delicate torchères of St Joseph lilies and the rhino on the landing was one of a pair shot off a left-and-right by Sir Llewellyn.

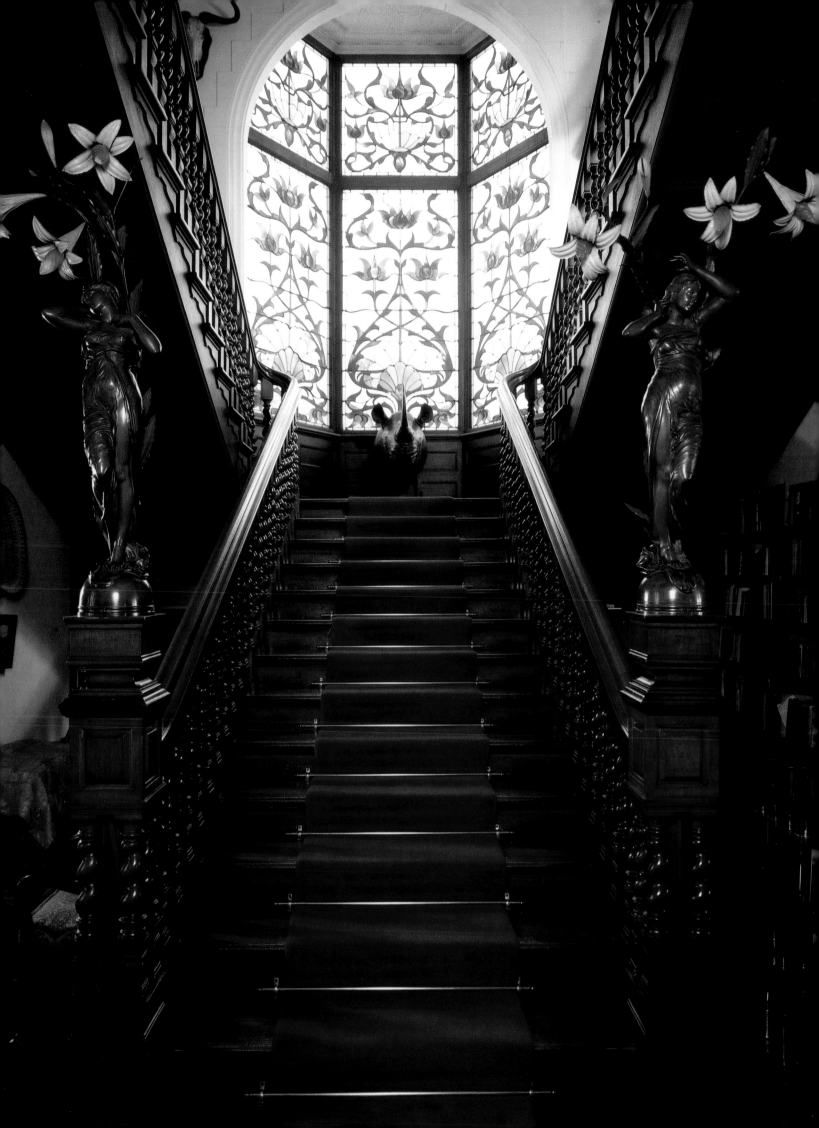

BELOW. Unique for Johannesburg, this room has hardly
altered since it was photographed for the *South African
Lady's Pictorial* shortly after the Anderssons moved in –
even the jardinière of bamboos has survived changing
fashions in flower arranging and only the karosses and
polar bear rug on the floor have departed through old age.
The portrait above the piano is of Lloyd Andersson and his
sister; the trophies were shot by Sir Llewellyn and Lady
Andersson on safari and mounted by Messrs Rowland
Ward, the London taxidermists.

RIGHT. Inglenook in the hall. Pampas grass behind the club
fender. The crests on the lampshades are of the Lloyd and
Mitford families.

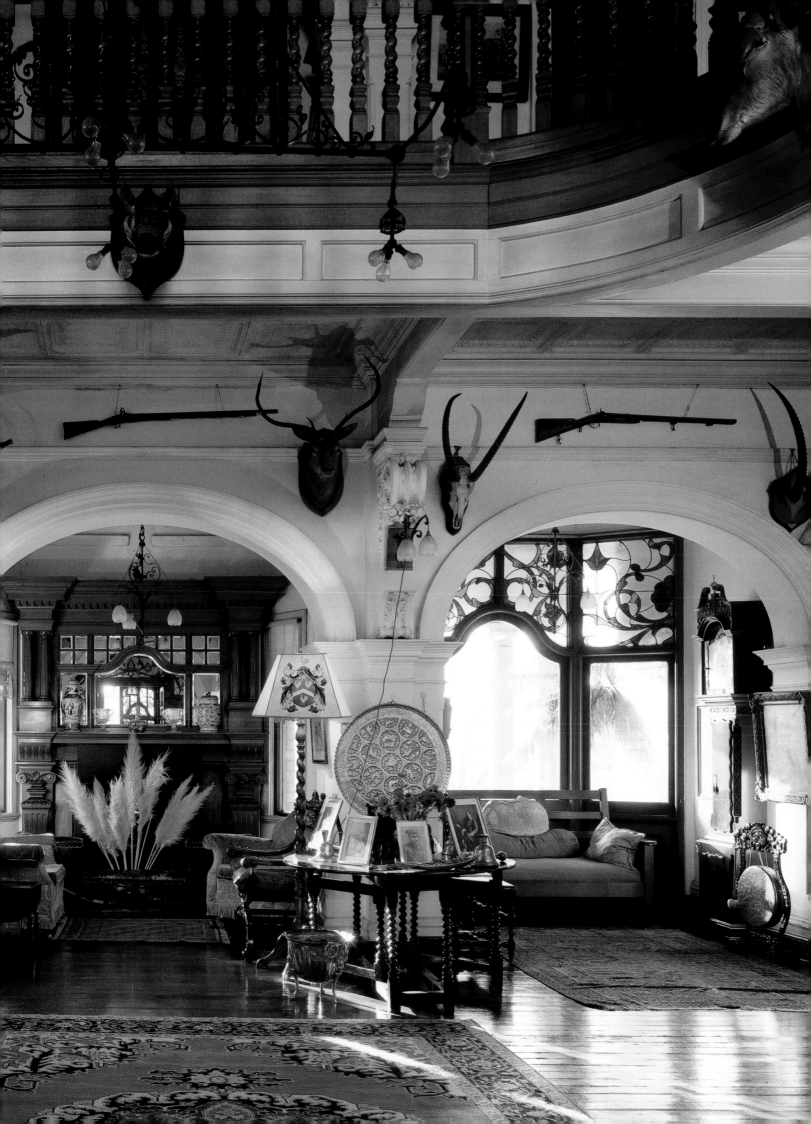

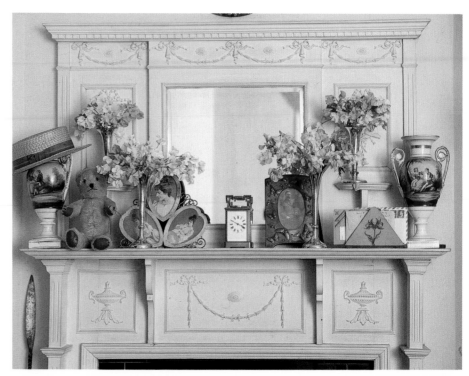

RIGHT. Pretty Queen Anne Revival fireplace in one of the bedrooms.

BELOW. The dining-room. Massive teak chimney-piece in the inglenook, Jacobean strapwork ceiling and the original fringed lamp over the mahogany table.

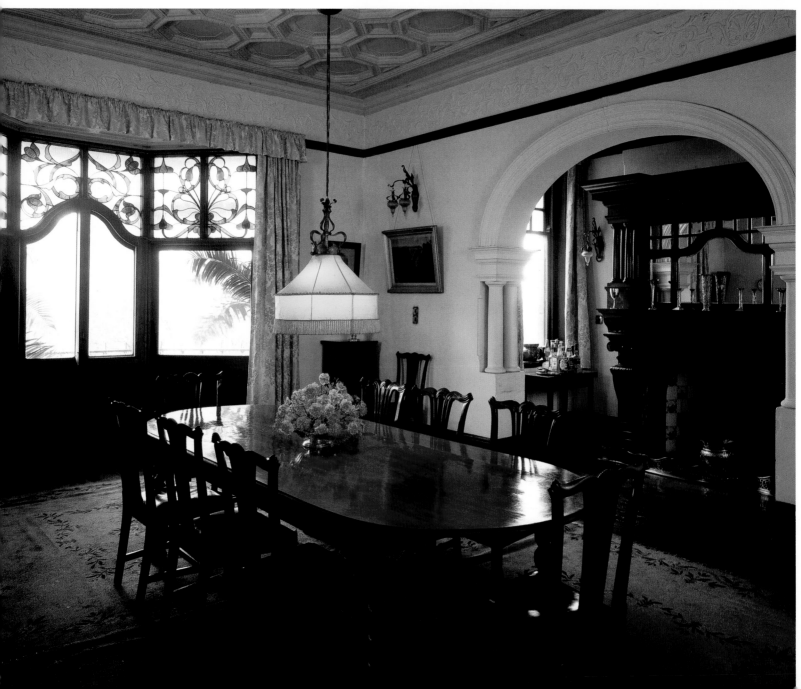

FARLEFT. Thomas Baines's very first depiction of the Victoria Falls, enscribed as such *in verso* to his friend C J Andersson, to confound the many other possessors of this work.

LEFT. With a Union Jack on the wagon and a missionary at his side, explorer C J Andersson holds parley with the Damaras while Baines sketches on for posterity.

verandah, croquet sets, garden fittings and even a pair of breeding swans came from The Army and Navy Stores.

In those days the well-to-do of Johannesburg were not bothered by such tiresome considerations as import duty, currency control and shipping delays. Every purchase was shipped by the agent and took six weeks at the outside to reach Johannesburg, via Delagoa Bay.[19] With the exception of some broken grates and mantels (for which Lloyds stumped up) everything arrived in perfect order with specific installation instructions to the contractor. The vast amount of stained glass was shipped from London in October and arrived in Parktown a mere twenty-three days later with only 'a few small cracks'. Payment for all the goods was made fourteen days after arrival in Johannesburg.

The final decorative touch for the interiors was to be provided by the trophies. Both Sir Llewellyn and Lady Andersson were excellent shots and spent many a holiday on safari in Mashonaland. The best of their bags were carefully parcelled up and sent to Rowland Ward, the famous London taxidermist. The packages were carefully labelled and the list seems endless: 'half rhino cow skin, half rhino bull skin, rhino cow head, hoof of a sabi, three zebra skins, a roan skin, a tsessebe skin, four rhino bull hoofs, an oribi head, ostrich skin and feet', and so on. And there was no end to the inventiveness of the suggestions from Messrs Rowland Ward in correspondence with Andersson.[20] Grisly though they may seem now, they were for many years familiar features in other colonial interiors. Rhino feet made good polished table tops; ostrich wings made good fire screens, two ostrich feet made a good umbrella-stand or, with an oak top, would hold a palm or a card tray. Buck hoofs could be fixed up as candlesticks and electric light stands; the feet of the rhino bull could make a tobacco jar; a door stop, or even a wastepaper basket.

In the midst of all these arrivals there was the usual fall-out with the contractors whose tardiness delayed final completion until February 1906. 'They seem determined to annoy me as much as possible,'[21] complained Andersson. All the furnishings had been stored in the stable pending completion and the final straw came when Lady Andersson discovered one of the workmen having lunch 'actually sitting on top of the grand piano dangling his legs'. Andersson threatened to employ others and invoke the penalty clause he had skilfully included in the contract[22] and a reasonably satisfactory end was made in a frosty atmosphere.

The couple, however, were delighted with the result and praised their architect to one and all.[23] But if Christie hoped that the house would prove his great advertisement he was, alas, to be disappointed. It proved, in fact, to be his Transvaal swan song. The depression in 1906 which ended the Parktown building boom coupled with the unbridled popularity of Herbert Baker forced him out of business and he returned to Rhodesia. Truth to tell, the style of the house, while not actually old-fashioned, looked backwards rather than forwards, even in 1906. Baker's designs, by way of contrast, were quite the opposite. In retrospect this need not mar our delighted appreciation of Dolobran but the house certainly belongs more happily in the last decade of the nineteenth century than, say, in the second decade of the twentieth.

Remarkably, the house survives today with many of its splendid interiors intact – an entirely salutary and almost unique effort on the part of one of the city's founding families.

THE PRESIDENSIE

FORMERLY GOVERNMENT HOUSE,
PRETORIA

B ritish sovereignty established over the Transvaal, a new Government House was needed in Pretoria. It seems to have been seen as a requirement in the broader scheme of things rather than an immediate necessity and, as late as January 1906, Lord Selborne was undecided for whom it was intended – the High Commissioner or the Lieutenant-Governor.[1] That Baker would be the architect, however, seems never to have been in question. It was, as we have seen, for just such a purpose that Milner had brought him to the Transvaal. It is unlikely, therefore, that the official commission came as any great surprise; indeed, the letter of appointment dated 29 July 1902 referred to personal, unrecorded interviews already held with Sir Arthur Lawley, the Lieutenant-Governor.[2]

Nevertheless, for Baker it was a great prize – 'one of the best bits of work in South Africa',[3] in his own words – quite on a par with Groote Schuur and unsurpassed in importance in his South African career, with the exception of the Union Buildings. Nowadays, with its interiors despoiled, its gardens rendered ugly through municipal plantings and its general air of a house that has too long been let, it is difficult to perceive to what great effect the Transvaal exchequer was depleted and the sort of house that Baker had envisioned. But early photographs do exist, as does a fascinating contemporary – though fictional* – description in John Buchan's *A Lodge in the Wilderness*. Buchan was one of Milner's Kindergarten and on friendly terms with Baker at the time when the working plans for Stonehouse and the early Transvaal commissions (of which Government House was the most important), were in the making.

In his novel Buchan describes a colonial mansion 'something in the Cape Dutch style with wide verandahs and cool stone pillars' perched high on an African ridge and surrounded by blazing gardens and orchards. The sun-shutters and beams are of cedar, the roofs of warm red tiles and the walls are washed a delicate pure white. Inside the heavy brass-studded doors there are great panelled halls floored with a mosaic of marble on which lie skins and karosses. The fireplaces are cavernous, the rooms set off by colonial furniture and curios. There is a well-stocked library, and the drawing-room, hung with flowered silks and brocades, opens onto a verandah full of wicker chairs.

'Standing, as I have seen it, against a flaming sunset, with the glow of lamplight from the windows, it is as true a fairy palace as ever haunted a poet's dreams.'

The whole house is 'embosomed with flowers', whether growing in brass-hooped mahogany tubs or cut and placed daily in the many silver bowls. But no heavy odours impair the virginal freshness: 'Luxury has been carried to that supreme art where it becomes a delicate simplicity.'[4] A colonial dreamhouse indeed.

The accommodation brief, as given by the PWD, was specific and modest enough. The house was to

provide eight bedrooms (exclusive of servants' bedrooms) and office accommodation for four clerks. The personal staff would consist of the Private Secretary and an ADC. The one extravagance was to be the hall – dimensions of eighty-five feet by thirty-five feet (25,5 m x 10,5 m) to ninety feet by forty feet (27 m x 12 m) were mentioned. The letter went on to state that the sum at present available was £25 000 and that should it be found impossible to keep within this limit a further £5 000 would be made available.[5] Should it be found impossible! By the time the building was completed an astonishing £94 000 had been spent on the house that seems to have differed only in detail from that originally envisaged by the PWD.

Few of Baker's other projects demonstrate more clearly his total disregard for budgets and estimates. Perhaps insouciance would be a better word. He regarded the job as 'important from every point of view'[6] and was determined that it should not suffer, as some of his other houses had, through skimping. His confidence and assertiveness had grown with his practice. The shy young man who had been awed into silence in the presence of Cape statesmen ten years before had developed quite a flair for making friends with key personages and with their support manipulating councils, treasuries and committees who worried about such tiresome things as budgets and expenses. It was this ability that initially made him so attractive to Lutyens as a collaborator on the New Delhi project.

At Pretoria, Baker had behind him the impressive sponsorship of Milner and Rhodes. It is evident from the correspondence in the PWD files that he had the Lieutenant-Governor, Sir Arthur Lawley, round his little finger. They seem almost to have been in cahoots to build the Government House of their dreams without irksome financial restrictions. Design, even order and build now, then bully the Treasury for money later, appears to have been the maxim. At times, Baker's interpretation of allocations and instructions and the firm's withholding of detailed estimates came close to open dishonesty. When, in 1906, the Treasury finally called for an inquiry the resulting memorandum by Hitchens, the Colonial Treasurer, is remarkable only for its lack of rancour. Perhaps he knew his place. 'Too many people seem to have been responsible ... no one person and no one department was responsible for deciding what was to be done and what was to be omitted,' he wrote.[7] Doubtless it was 'pointless' to apportion blame in different quarters but all the evidence points unswervingly at Baker.

The complicated saga may be told thus. Baker cogitated over the working plans during the spring and summer of 1902 – 1903. The foundations were flagged and pegged out in May 1903.[8] The following month Baker and Sir Arthur visited the site and decided there and then to move the house forward to the 'edge of the kopje', Baker's considerations of aesthetics overcoming those more practical, for the broad terrace in front of the house 'convenient for distributing people at receptions' was lost.[9] Doubtless, from the house, the aesthetic gain is great, but unlike the Parktown houses, the fall-away is so sudden and steep that the front is never perceived.

PREVIOUS PAGE. Government House, Pretoria, now the Presidensie – Baker, 1902–1906. Entrance façade: the forecourt dropped to make the elevation more impressive and to permit the requisite cloakrooms to be accommodated in the basement; the portico based on the Kat Balcony at the Castle. Baker's attempt to create a style at once national and imperial, and impressive without being ostentatious, is perhaps more obviously successful inside than out. We feel we have seen all this before, though doubtless it was very original and modern in Pretoria *circa* 1906. The jacarandas obscure most of the staff quarters to the left, designed in a more straightforward and simple Arts and Crafts style.

* The novel appeared in the year Government House was completed.

Then in August work was abandoned.[10] No reason was given at the time and it was supposed that in the period of Reconstruction funds were lacking. In fact it appears that privately Baker and Lawley had decided that the whole concept was far too meagre and inferior for their liking and that after a suitable delay building might commence on a more elaborate scale. In the meantime a great deal more land had been purchased (ninety acres from the Wesleyan Mission and forty-eight from a Mr Bourke at a total cost of £18 000[11]) and the thin end of the wedge inserted into the original budget by the firm's basing their fees for work already done on a figure of £45 000.[12] It was almost double the sum stipulated by the PWD.

During the next twelve months there were numerous, though unrecorded, discussions between Baker, Lawley and Adam Jameson, the new Commissioner of Lands and another willing supporter of such tactics. These discussions are referred to in a letter to Jameson in September 1904[13] which also records instructions from the Lieutenant-Governor to prepare a final set of drawings on the portion of the house which it was intended to erect and further to proceed with the specifications and quantities and call for tenders.

This, of course, was another little wedge cleverly inserted. For the set of brightly coloured plans subsequently bandied about showed the house constructed in three unlikely stages: the section sanctioned (ie within the initial budget) in red, a scheme of completion without the hall and peristyle in blue, and one with the hall and stoep included in yellow. Interestingly, the estimates given were £27 000, £40 000 and £50 000 respectively.

This is the first instance in which the hall and peristyle are regarded as separate extras – they were of course an intrinsic part of the original PWD specification – and anyway such proposals were a nonsense and probably intended as such. As Baker himself was quick to point out, in a letter of December 1904 in anticipation of a meeting between Milner and Lawley, the portion of the building proposed to be built was bound to look very ugly, with the kitchen blocks suddenly prominent instead of subordinate to the main front. The second scheme would look 'all right' but of course 'it would be a greater economy to build the Hall as the yearly expense and inconvenience of fixing a temporary ballroom would be saved'. For the first time the firm's designing of the extensive gardens is mentioned too.[14]

There are no records of the Lawley-Milner meeting but evidently not much persuasion was required. The letter from Baker, Massey & Sloper forwarding the three main tenders makes reference to a stipulation from the Commissioner of Lands that the limit of the cost of the building should be £39 000.[15] Additional tender figures for the house without the hall and stoep seem included merely as a formality. The contract, dated 14 March 1905, was signed with Edmanson & Thomas, despite a strong lobby from Baker for a preferred and higher tenderer. Mr Ellis, previously employed at Sir Abe Bailey's and by the Duke of Westminster, was taken on as Clerk of Works[16] and Baker instructed to submit a full statement of all the extras it was thought might be desirable.

LEFT. Milner's Kindergarten in the Great Hall. Baker (back row, second from right) stands next to Geoffrey Dawson (far right); Patrick Duncan sits to the left of Lady Selborne; and Lord Selborne, the Governor, sits in the wing-back chair.

BELOW. Baker's Great Hall has not been sympathetically treated and it is best recorded as he intended and as it survived until the Second World War – domestic yet grand. It was designed as the nerve centre of the house and doubled as a ballroom. The great beams are in the Kentish vernacular tradition; the portrait above the cavernous fireplace is of Edward VII. (Africana Library)

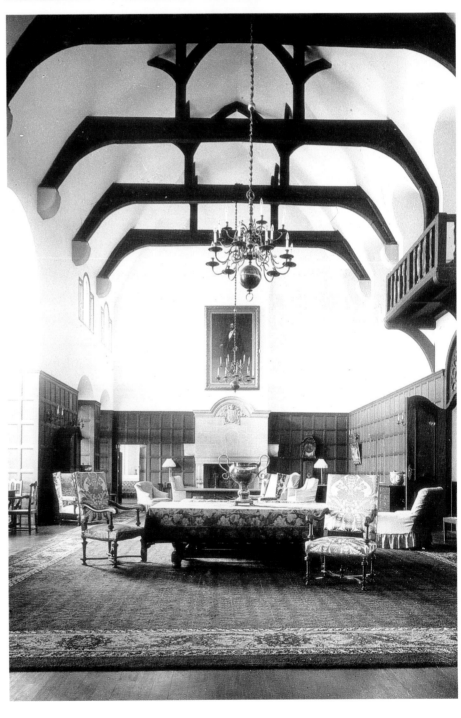

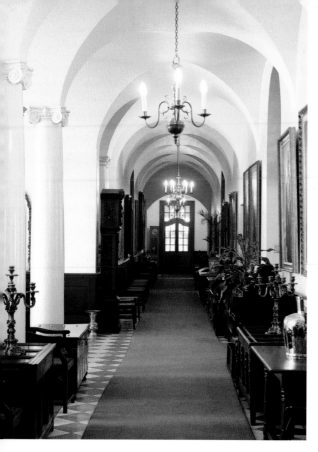

ABOVE. The main corridor with groined and vaulted ceiling. Furnished in the manner of a long gallery. The carpet which masks the marble floors was most certainly never intended by Baker.

RIGHT. Entrance staircase or 'Grand Vestibule' (the term was Baker's). The peristyle, the groined and vaulted ceiling, niches and marble floors provide imperial grandeur without gilt and reflect the lessons learnt from the Mediterranean sabbatical sponsored by Rhodes. Few would claim Baker as Lutyens's superior, but it is interesting to note that Government House, Pretoria, predates New Delhi by about twenty years. The placing of the Batavian chest to avoid an awkward balustrading is a typical Baker detail.

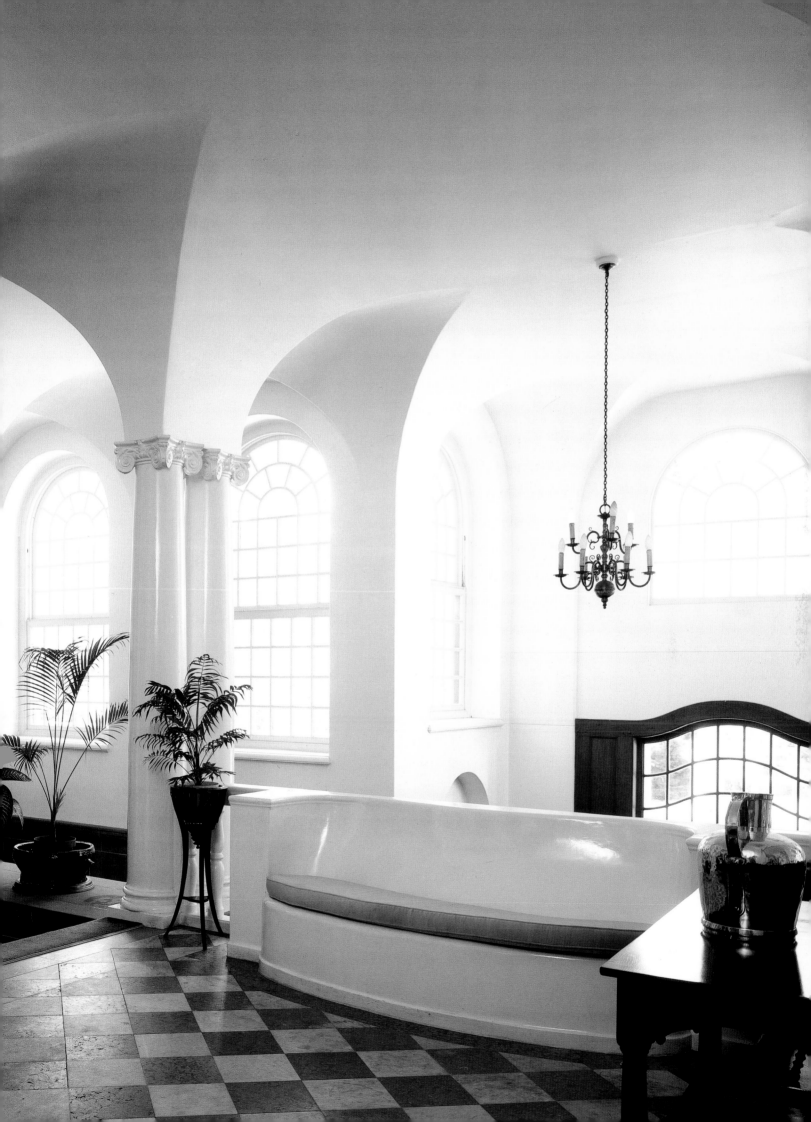

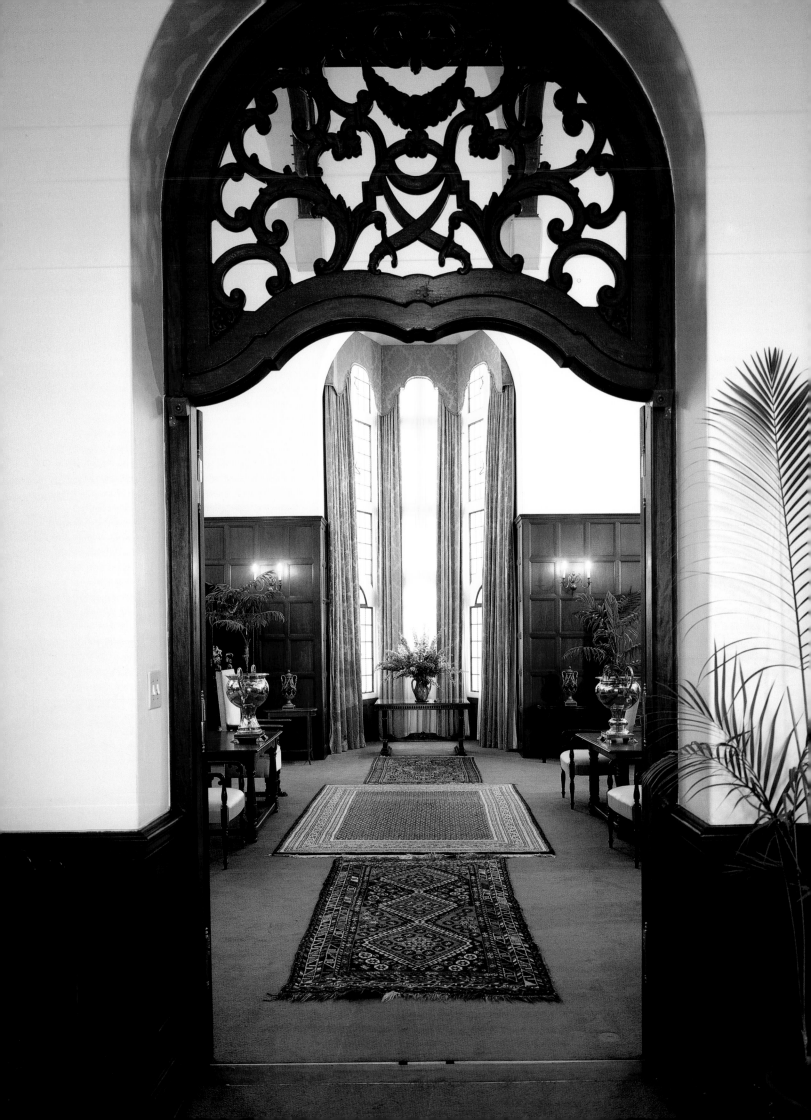

Among these were several specific requests from the Lieutenant-Governor (an extra ADC's bedroom in the basement, a refrigerating plant and cold room for HE's game),[17] several contingency amounts providing for more elaborate or local finishes (Craighall or Vereeniging tiles were suggested as a worthwhile alternative to the imported Marseilles ones)[18] and several unavoidable expenses such as a septic tank, it having been found impossible to connect the estate with the Bryntirion drainage system.[19] But the extras had multiplied. The hall and peristyle, by then without question 'an extra', were estimated at £4 756.17.1. The grounds which, as mentioned in the Jameson letter, the Governor had also entrusted to Baker, were shown at £5 000. Furniture, referred to for the first time in connection with the architects, was estimated at another £5 000.[20] The upshot of the matter was that after much correspondence between March and June 1905 almost all the additions were sanctioned, bringing the total estimate (including some monies already spent) to £68 000.*

Between July and September 1905, after the usual 'discussions with the Governor', various alterations and additions were noted: stone columns for the porte-cochère, an extra window in the boudoir, an extra plate safe in the pantry, a new servants' hall and alterations to the linen cupboards and sewing-room. It was pointed out that no special sum had been allowed for main and garden water supply. The stables, following Sir Arthur's comments, were estimated at £8 000, an increase of £3 500. Furniture, carpets and light fittings suddenly appeared at £9 000. The total additional requirement was £10 000 of which £7 460 had to be found. The long-suffering Executive Council approved it by vote in September 1905.[22]

Nor did the sum end there. The amount slowly crept up until the final figure, together with the land and only a few miniscule savings, was in excess of £93 500.[23]

Perhaps in the end one should just sit back and admire Baker's skill and nerve in manipulating one and all. It is impossible to believe that an initial estimate of £95 000 would have been received with anything other than horror and refusal.

Certainly the money had not been wasted. Government House, Pretoria, now the Presidensie, is a handsome and, for its date a modern, colonial residence. In a letter which accompanied his original plans, Baker wrote to Lawley: 'On the whole we think [that they] combine suitably and economically the somewhat conflicting private and public requirements of a Government House.'[24] More than anything else, Baker was adept at producing that delicate combination of the domestic yet grand. Nothing could have been more apposite for the new colony, especially where at least half the white population was likely to view askance Government House and all it stood for and disposed to take quick affront at the smallest hint of ostentation from the new governing cadre. To this end too, Baker's skilled synthesis of English and Dutch vernacular architectural style was nothing if not felicitous.

The approach is from the south-west, the long drive sweeping up a slight gradient to the forecourt in front of the house. Baker deliberately kept the forecourt below its natural level in order that the façade be improved by the additional height.[25] Its arched loggias rise above the stone foundations and the white gables – smaller, at Massey's suggestion,[26] than those at Rust en Vrede and more like those at Welgelegen, but plainer and more pleasing – soar impressively above them. To the left is the extensive servants' wing which, despite its size, remains subordinate to the main block by conforming, as at Marienhof,** to a simple, more cosy English Arts and Crafts style.

The forecourt levelling also provided space in the basement for the extensive cloakrooms necessary for large receptions but which Baker rightly saw as a great waste of valuable ground floor space.[27] From the porch, doubtless inspired by the Kat Balcony at the Castle in Cape Town, the visitor (having signed the Book) ascended an impressive staircase which rises to the *piano nobile* under a ceiling of begroined intersecting vaults supported by pairs of Ionic columns. The stoep and atrium or peristyle are similarly designed – this was an architectural conceit in which Baker clearly delighted, for his letters and working plans often contain little doodles of it in their margins. Probably it was a lesson learnt during his sabbatical in the Mediterranean, and one now used to excellent effect.

The heavy stonework, columns, marble floors and niches are full of imperial overtones and it is interesting to note that this building predates New Delhi – both Baker's Secretariats and Lutyens' Government House – by over twenty years. Imperial grandeur had been successfully achieved, and without resort to crystal and gilt.

At the top of the staircase is the long marble corridor, also begroined with intersecting barrel vaults and furnished in the Baker manner as a Long Gallery. Wide double doors with handsomely carved Cape Dutch-ish fanlights link the entrance approach with the Great Hall. Baker intended this and the adjoining stoep as the life centre of the house.[28] As at Dolobran, the late Victorian idea of a hall doubling as a living area-cum-reception room (and, in this instance, as a ballroom) had here reached its colonial apogee. The double-height room is made the more handsome by the lavish teak wainscoting to fourteen feet, the Gothic bay, the minstrels' gallery and the arch-braced collar beam roof springing from the stone corbels which jut out some way down the wall. It is easy to see Lutyens' influence here and, given their parallel careers and close friendship, it would be impossible

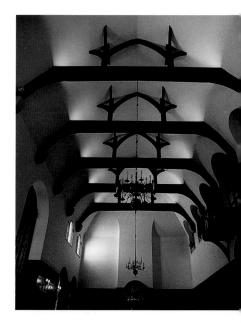

LEFT. Main approach to the Great Hall. Baker's eclecticism is not unsuccessful, with the Cape Dutch-ish double door and fanlight, the English beams, wainscoting (in teak) and the Gothic bay. The brass chalices were a Baker hallmark in his bigger houses, as were the turquoise Linware vases designed to hold monumental flower arrangements.

ABOVE. The beamed ceiling of the Great Hall, with the minstrels' gallery to the right.

* Of the original £50 000 reserved in the PWD loan account, £30 000 had been transferred to supplement the insufficient amount provided for the Bryntirion Scheme, leaving £20 000. In the estimate for the year 1904 to 1905, a further sum of £40 000 was provided under the heading 'Extraordinary Expenditure for Government House' bringing the total provision to £60 000. Still another £8 000 was voted in the estimates for the financial year 1905 to 1906, again under the heading 'Extraordinary Expenditure for Government House'.[21]

** Government House, Pretoria and Marienhof, Johannesburg (see Brenthurst) are contemporary and should be viewed in conjunction.

ABOVE. The last of Princess Alice's 'Dutch' garden.

RIGHT. The stoep. The peristyle repeated with the atrium (now canvassed) to provide light for the Gothic bay. As at Groote Schuur, it was intended as an important centre of the house. Originally furnished with wicker chairs, it enjoys spectacular views over the koppie's edge a few yards away and then 'across Africa' – views that had caused Mrs Alfred Lyttelton to 'set her heart' on the Bryntirion site in the early days of the British occupation of Pretoria.

to deny it. Perhaps more generously one can recognize the vernacular architectural heritage of Kent with which Baker had been familiar since childhood.

Off the Great Hall lead the other rooms providing the sort of accommodation considered necessary by an imperial proconsul: a drawing-room and boudoir leading onto the stoep with its atrium to light the Gothic bay, a billiard-room, HE's study, a waiting room, an office for the private secretary and an office for the military secretary. Upstairs were a charming morning-room and loggia overlooking the entrance, nine bedrooms (two with their own dressing-room and bathroom *en suite*, two with their own dressing-room only) and two further bathrooms.

The servants' quarters themselves conformed to elaborate Edwardian requirements: a kitchen, a scullery, a dairy, a glass, china and second cook's pantry, a larder, a still-room, a servants' hall, a housekeeper's room, a sewing-room, a silver strongroom, a flower-room, a 'knives' and a 'boots'. There was a housekeeper's bedroom and nine indoor maids' rooms; they shared one bathroom and two lavatories. The five indoor menservants had bedrooms (and one bathroom and two lavatories) in the basement along with an ADC's bedroom (a bathroom for him was added later), two clerks' offices, box-rooms, a gunroom, two wine cellars, the cold store-room and coal and wood store-rooms.[29]

Up an avenue of jacarandas were the elaborate and prettily designed stables and mews conforming to Lawley's requirements.[30] They comprised ten stalls and a loosebox (in best teak), five visitors' horse-boxes and five boxes for the horses of the guard at the entrance, a sick box, a guard room, an NCO's room, two kitchens, two parlours, a coach-house, a harness room, a cleaning room, a carpenter's workshop, a loft, four bedrooms, a dormitory for the guard, a bathroom and lavatory, and 'kaffirs' quarters' fitted with bunks. It is interesting to note that as late as 1906 there was provision for only one 'motor-house' and even in the following year a letter from Baker to the Secretary for Public Works forwards the following most untypical twentieth-century domestic complaint: 'The second coachman finds that the big opening in his scullery gives more exposure than he cares about to the sun and dust.'[31]

There remained the furnishings and the gardens. Baker had impressed upon Lawley the horrors of Maples and the advisability of leaving the furnishings to himself. The aesthetic advantages were there for all to see at Groote Schuur, Rust en Vrede and Westminster; the décor of Sir George Farrar's Bedford Court was the talk of all fashionable Johannesburg. Baker also managed to insinuate that this would prove the most economical method.[32] The matter of the furnishings was brought to a head by Warings, the well-known London firm (whom Baker despised), soliciting for the prestigious contract. Sir Arthur put the case in a strongly worded minute,[33] though privately warning of the need to keep Baker within the authorized limit.[34] The Treasury agreed. The firm's fees were five per cent upon the cost of all furniture and furnishings ordered and ten per cent on furniture designed by Baker himself.[35]

RIGHT. Sir Oswald Birley's portrait of the Earl of Athlone is without doubt the finest of all those that hang at the Presidensie.

FAR RIGHT. Princess Alice by Neville Lewis. (Johannesburg Art Gallery)

BELOW. Baker's design (if not planting schemes) still to be seen in the garden, whose laying out (including levelling and blasting) cost £7 000 in 1906.

As usual Baker's formula was elaborate: furniture made to his own designs in the Cape and London, Dutch antiques for the wide corridors and vestibules, George Ness for the brass fittings and metalwork and Mrs Keightley of 17 Church Street, Kensington, for the rest. 'In all respects treat the house exactly like a private house,' he wrote to her.[36] She was advanced £5 000 by the Crown Agents in December 1905 (her fee came out of the usual trade discounts) and the furnishings were shipped between the July and November of 1906.

It was not Lady Lawley, however, who made the final choices and arrangements. The Earl of Selborne had replaced Milner as High Commissioner and Lieutenant-Governor of the new colonies. He and his wife were the first occupants of the house and to Baker's relief it was the Countess who furnished it. Reading between the lines, one realises that he had not been very sanguine about Lady Lawley's taste and was irritated by her interference and purchases of 'old pieces' which fitted in not at all with his schemes. The Countess, a woman of great taste, was sympathetic with Baker's concern to design and maintain the building and its interiors as a piece. Baker gives her all the credit for Government House and was delighted that Princess Alice and Lady Duncan left everything 'as Lady Selborne and I had originally planned it'.[37] In the end all the furniture from the old Government House which Baker had firmly been instructed to re-use was consigned by him to the servants' hall and bedrooms.[38]

As with the interiors, so with the gardens. In 1904 Baker wrote to the Secretary for Public Works:

'In the past history of architecture and particularly at the present time, it is almost universally considered as much the duty of the Architect to design a garden and the general laying out of the surrounding site, as to design the house itself and its internal fittings. In our own case our capacity to do work of this kind is a result of years of work, study and travel.'[39]

In consultation with the forestry department as to what trees would do best, gardens in the Jekyll manner were laid out – lawns, alleys, gravel paths, pergolas and herbaceous borders. There were extensive kitchen and picking gardens and the koppie garden was treated with natural plantings of indigenous flowers. For years the garden was lucky in the house's incumbents, and Baker continued to send advice long after his departure from South Africa. Princess Alice enthusiastically organized the plantings in the borders, laid out a formal 'Dutch Garden',[40] put in a swimming pool and inaugurated the habit of throwing garden parties at jacaranda time, leaving the lawns carpeted with purple. The Duncans, also enthusiastic

gardeners (seventy-five were employed in their day), continued this practice. Four thousand guests would attend, cakes and soft drinks would be served in the atrium and on the lawn in the giant marquee, two thousand tots of whisky, fifty gallons of iced coffee, and 'three times as much tea as ever', as Alice Duncan wrote happily to her son,[41] were consumed. The genial Sir Patrick, top-hatted and smiling, chatted to one and all. The Eastern Province-born Lady Duncan, in a trailing frock of jacaranda chiffon with a long sash in three shades of bougainvillea (which excited much favourable comment), extended a gloved hand here and there. 'Patrick in his glory and Alice in Wonderland!' old Mrs Hofmeyer – ever ready with a bucket of cold water on such occasions – was once overheard to declare unobligingly.* Only a generation ago such an occasion would generally have been accepted as a regular high point in the social calendar.

After the Republic, Government House remained in use for the residence of the State Presidents; its prestige as the fulcrum of constitutional power and society diminished with the prestige of the office. In the 1970s it was renamed the Presidensie** and finally, with the scrapping of the Westminster system of government, it has become redundant – a handsome white elephant possibly destined as a museum. It had fulfilled its function for a brief half-century and now as the Empire, destroyed by the very forces it sought to accommodate, slips from living memory into recorded history it is perhaps worth recollecting as a postscript the views of one of its main architects on the delicate relationship between nationalism and imperialism which he sought to express in this and other of its official buildings:

'Our rule confers order, progress and freedom within the law to develop national civilizations on the lines of their own tradition and sentiment: so in architecture there is infinite scope within the limits of order, true science and progress for the widest self-expression in every field of art; but without the orderly control of the great principles, there might result a chaos in the arts such as in governments which History records our rule was ordained to supersede.'[42]

Sic transit gloria mundi: thus passes all worldly glory.

TOP. Sir Patrick Duncan. (Jagger Library, UCT)

ABOVE. Alice Duncan. (Jagger Library, UCT)

* The poor Duncans were hard put to keep both sides happy – appearing too grand to the Afrikaners and not nearly grand enough to the English, accustomed to royal or at least aristocratic proconsuls. When I asked Miss Lucy Bean if she could verify Mrs Hofmeyer as the originator of this famous pre-war put-down, her answer was emphatic: 'Never – she wasn't quick enough for that.'

** Apparently at the behest of Mrs Diederichs, who was also responsible for the refurnishing.

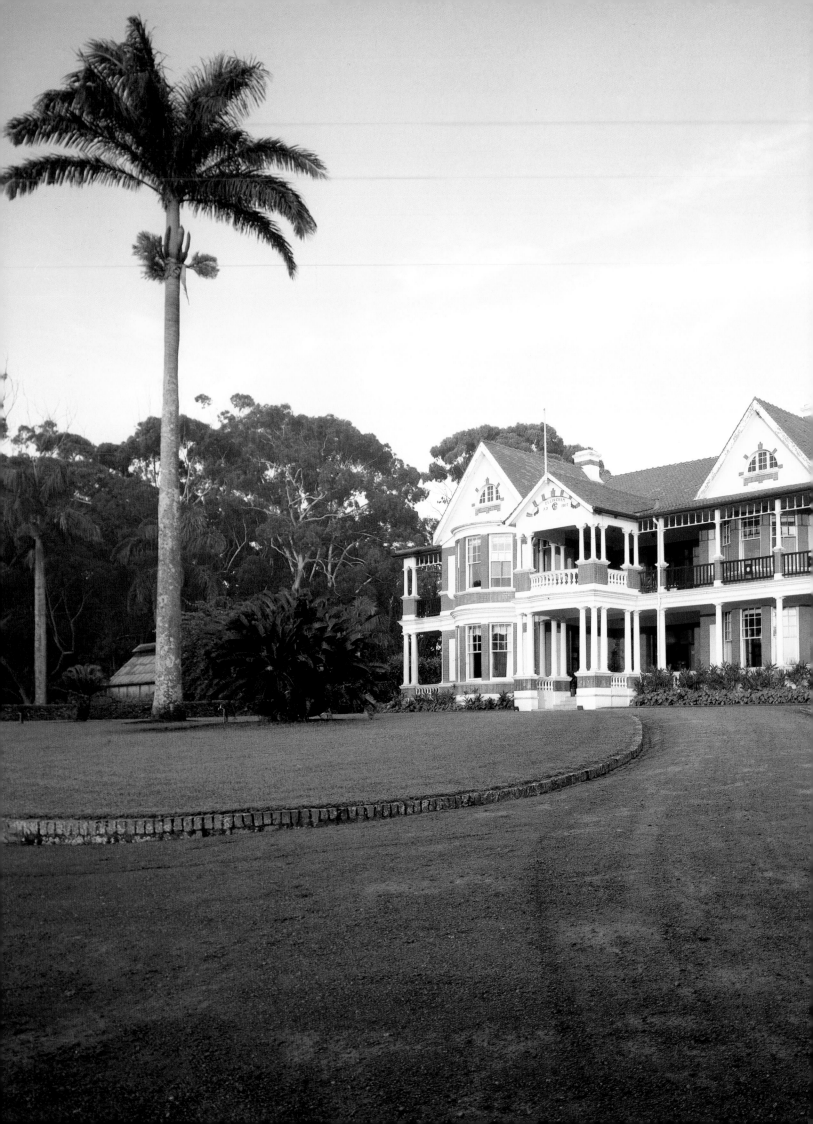

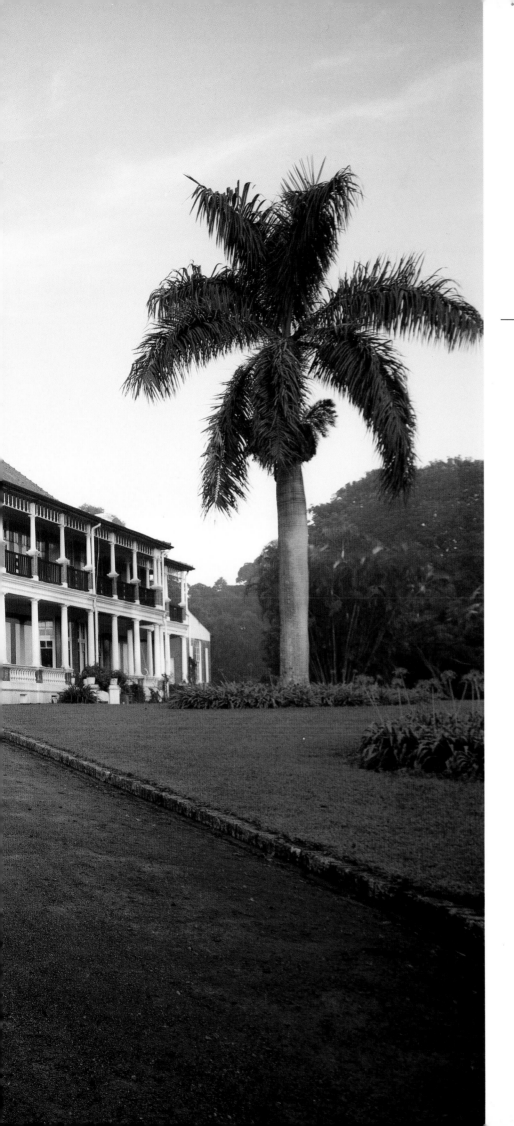

ELLINGHAM

RENISHAW, SOUTH COAST, NATAL

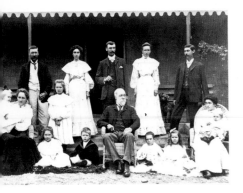

PREVIOUS PAGE. Ellingham – J J H Lübke, *circa* 1917. Late Queen Anne Revival in 'Maritzburg' brick and tiles, made impressive by Tuscan colonnades and projecting *porte-cochère* and sleeping-porch above. Not a hint of Cape Dutch revival in patriotic Natal, let it be noted, even at this late stage. It was Gwelo Goodman who made it popular between the wars with his work at Tongaat.

ABOVE. Samuel Crookes surrounded by his family at Cypress Hill. SF and his first wife, Louisa, and their children are at right.

BELOW. Shoot for the Governor General, the Duke of Connaught. 1921. The guns . . .

BOTTOM. The beaters.

RIGHT. View to dining-room. S F Crookes was one of Natal's finest shots. The trophies are his, the mounted teaspoons are bisley awards.

In colonial eyes of three generations ago, gentility afforded the display of the many tangible forms, in worldly values, of respectability – a state more or less unconstrained by considerations of station or fortune. It was attainable (by the respectable) either through inherited wealth or that resulting from honest endeavour, an emergent and unpopulous colonial society perforce attaching less social stigma to those 'in trade' than its metropolitan counterpart. Ellingham, solid and predictably impressive, had been built by the rich son of an early Natal settler. It had taken a previous generation of drudgery and enterprise to afford the gentility now imposingly arrived at. Certainly, social betterment had gone hand in hand with improved fortunes and, indeed, was to continue into the next generation when at Selbourne Park, Vernon Crookes attempted, as some people saw it, to 'out-Lynton Lynton'.*

Yet the whole is remarkably innocent of anything smacking of the *parvenu* (or ethnic originality one might add) which might well have produced something more fascinating for the student of architectural history but which, in its day, would certainly have occasioned the censure of the majority of such ladies and gentlemen of Alexandra and the adjoining Natal counties who came to call on the owners in their new residence. There is nothing flash about Ellingham. Despite the fact that the house dates from the First World War it is still essentially the *moral* house** of the previous century – its tone, its very aesthetic ethos, firmly rooted in Victorian middle-class respectability.

And how should it be otherwise? In the years just before and after 1850 when a quarter of a million people left Britain annually, the most obvious destination for prospective emigrants lay straight across the Atlantic in North America. The choice of so obscure and distant a colony as Natal, however elaborate the propaganda, must have been occasioned in part by a sentiment which preferred a British colony to a foreign country and in part by a disinclination, however small the personal capital, to become part of the distressed flood to the United States. Alan Hattersley's contention – gently denigrated by Wilson and Thompson – that 'almost all Natal settlers hoped to stamp the pattern of Victorian respectability on the new land' is not without a significant kernel of truth.[1]

Clearly as much could be said for the two Crookes brothers, Charles and Samuel, and they were both as typical of the early Natal settler type as you could hope to find: stout-hearted, God-fearing (in their case Anglican), Yorkshire yeomen with a village education and no capital (they arrived in 1860 with ten shillings between them);[2] what used, in fact, to be called salt of the earth until that expression became debased through misapplication.

They were not Byrne settlers but their removal had been encouraged and, under the scheme of the new Natal Legislative Assembly which replaced speculative immigration, sponsored by family friends who

* See Lynton Hall. In their first generation Lynton and Ellingham may be fairly said to represent the difference between county and provincial in a colonial setting.
** The term is Mark Girouard's.

had been. Joseph and Fanny Landers were also from Finningley in Yorkshire. They had arrived in Natal in 1850 and in 1857 had been granted land at the mouth of the Mpambanyoni River. They named it Renishaw, after the Sitwell's house in Derbyshire, and there began to cultivate and mill cane in a primitive way.[3] Having apprenticed himself to a wainwright and blacksmith in Durban, Samuel Crookes moved south and in 1865 opened his own premises on the postcart track at Mount Prospect near them. The business prospered nicely and before the end of the year he persuaded their son, Thomas, to lease him twenty acres of land and he, too, took up sugar cultivation in a small way.

Quickly convinced that Natal's future lay in sugar, Samuel's enterprise seems, in retrospect, to have been quite remarkable. In 1867 he married young Miss Fanny Landers and in 1872 he purchased the farm Old Ellingham near Umkomaas. During the next two decades he gradually bought up small planters' holdings or infant sugar estates (two, Maryland and Renishaw, actually from his Landers brothers-in-law) and each time followed a policy, costly though it seemed at the time, of concentrating all the milling machinery on one property.[4] A true Yorkshireman, he liked to pay cash for everything and though doubtless this resulted in not a few lost opportunities early on, it did at least place his business on a very sound footing.[5] The slumps were weathered; at one stage transport-riding and speculations on the diamond and gold fields provided ready cash. In 1898, however, the railway reached Park Rynie and, with a siding built at Renishaw where all the milling had by then been concentrated, the future was assured. At the beginning of the 1890s Samuel Crookes & Sons (the future Crookes Brothers) was working with a four-roller mill producing between 200 and 250 tons per season. At the end of the Anglo-Boer War the crushing outfit was increased to a six-roller mill and in 1907 an eleven-roller mill – the first in Natal – and a battery of centrifugals were installed.[6] The capacity of the factory soared to an impressive 5 000 tons per season.

Old Samuel never lived to see it. He had died the previous year peacefully sitting on the verandah of his unpretentious colonial bungalow, Cypress Hill, and surveying, it is to be hoped, his marvellously increased domains with satisfaction. His three sons took over the business, building impressively on the foundations he had laid, and acquired neighbouring estates of their own.

Fred, the second son, known as 'SF', purchased a property near Park Rynie from a Mr Abrahams, a large landowner in the district. He named it Ellingham after the farm where he was born.[8] It enjoyed panoramic views of the coast and he continued buying up adjoining farms so that in the end the estate stretched almost as far as Kelso and well inland. The virgin Natal grassland was put under sugar. Fred was a great amateur engineer: the estate was soon criss-crossed by a network of tramlines and bridges and flourished.

Renishaw House, where SF and his wife, Louisa – daughter of Joshua Landers and therefore his first cousin – began married life, was destined for the factory's chief engineer. A new house was needed.

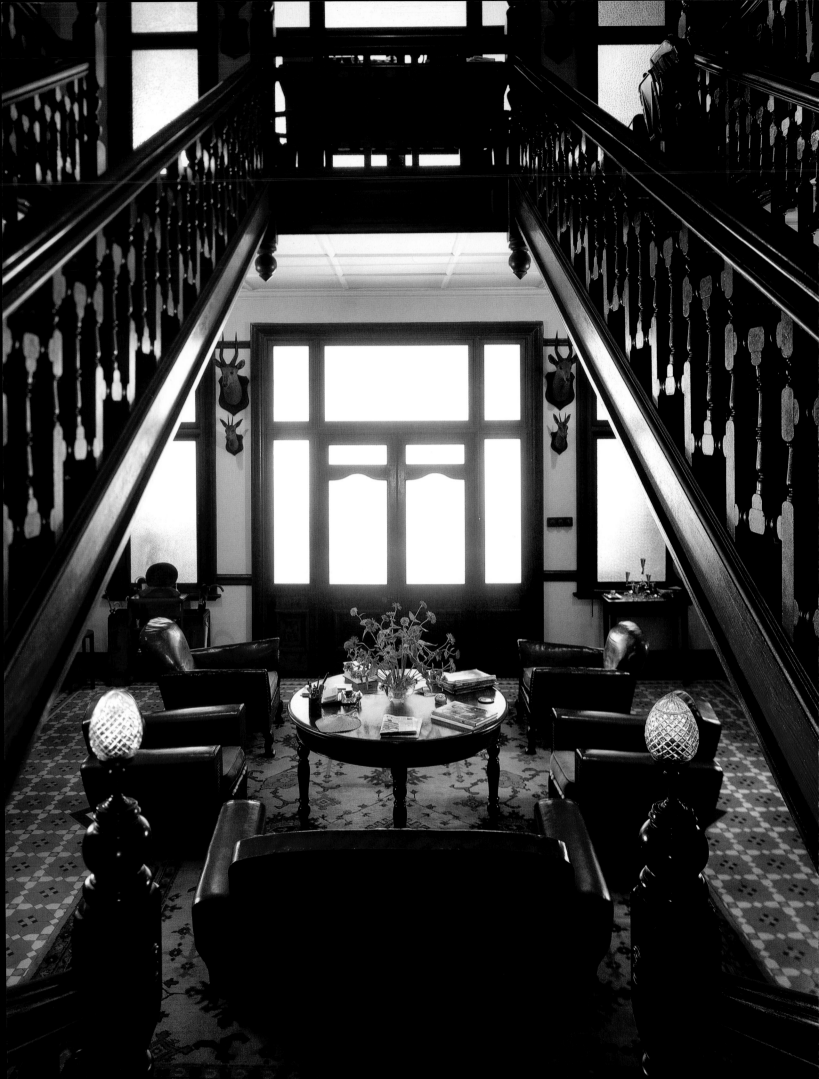

His brother George lived ten miles inland at The
Cedars, a verandahed Victorian mansion as imposing
as its name,* which he had bought from his uncle,
Thomas Landers, in 1900. Quite naturally, SF wanted a
house every bit as splendid as that. He commissioned
its design from J J H Lübke, a Durban architect chiefly
involved with speculative housing but also executing
private commissions.[9] One of the most notable (for
purposes of comparison at least) was a house built in
Essenwood Road in Durban for Mrs Jessie Flanders in
1914–15[10] which was very much a finger exercise for
Ellingham and, from a look at the designs, a necessary
one at that.

For Crookes Lübke designed a handsome, bay-
windowed residence in the colonial version of the
Queen Anne Revival. The many-windowed house
with its warm Maritzburg face brick and contrasting
white plaster facings is enclosed by a ten-foot (3-m)
wide double verandah comprising a rather elegantly
proportioned Tuscan colonnade complete with
white plaster balustrading and heavy cornice on the
ground level, and wooden railings incorporating a
discreet, Liberty's-inspired art nouveau detail above
it. The two gables thrust forward, the one over the
drawing-room bay actually breaking through the line
of the verandah. With their diocletian attic lights, plain
barge-boarded ends and topping of pinky roof tiles,
these owe much to Richard Norman Shaw, the
mannered brick trimmings on the gables' chimney
stacks and porch (a definite weakness in the latter
case) adding a typically arty-crafty touch.

The general note of 'sweetness and light' is un-
doubtedly there, yet the gaiety provided by the trellis-
work and cast-iron decorations on similar (earlier)
houses in Pietermaritzburg, Kimberley and else-
where is firmly suppressed in an effort, it must be
said, to impress. To this end the building is altogether
successful though fortunately, as at the Governor's
Marine Residence in Durban (now King's House),
its siting on a promontory not only provides distant
ocean views and the benefit of sea breezes in the
humid heat, but also mitigates a tendency towards
pomposity, occasioned mostly by the *porte-cochère*
and ungainly gabled sleeping-porch above it.

The ground plan is somewhat similar to that of The
Cedars[11] and comprises two distinct units – front and
back – each surrounding a central hall, only here the
double-height front hall contains a double staircase
reversing off a common single flight (again as at
King's House) and a gallery on the first floor, off
which doors lead to the bedrooms. The back hall is on
two separate floors and a back staircase and a bath-
room and lavatory on both floors separate it from the
front.

The main hall and verandah – both very much
intended as living areas – are paved with Minton
encaustic tiles, a Victorian touch and something of a
period anomaly even in 1916, though quite rightly
deemed more suitable in the tropical heat than in an
English country vicarage. In addition there is a

* The Cedars survives, though its marvellous Victorian furnish-
ings are gone and its elaborate gardens are a ghost of their former
selves.

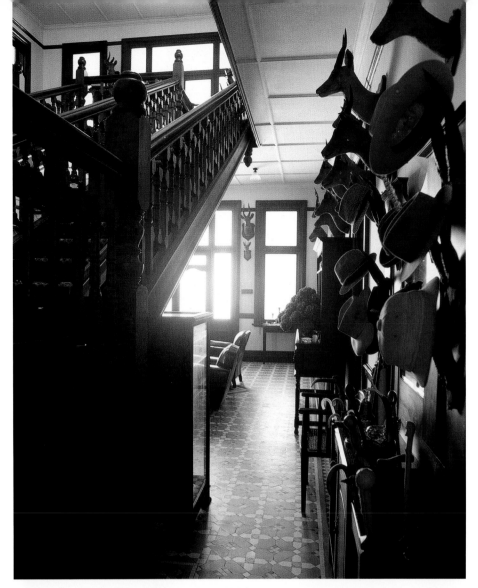

LEFT AND ABOVE. The Hall with its double staircase. Lots of trophies, teak and the
floor of Minton encaustic tiles. The leather sofa and chairs enhance the colonial country club
or officers' mess atmosphere.

TOP. Hall. The hat stand is made from bucks' horns.

RIGHT. Store room.

BELOW. The Natal kitchen. Coal-fired Aga for cooking and hot water, wooden table scrubbed down daily, tiled floor and walls. The checker-board frieze on the wall was a modern, and perhaps rather extravagant, touch for 1917.

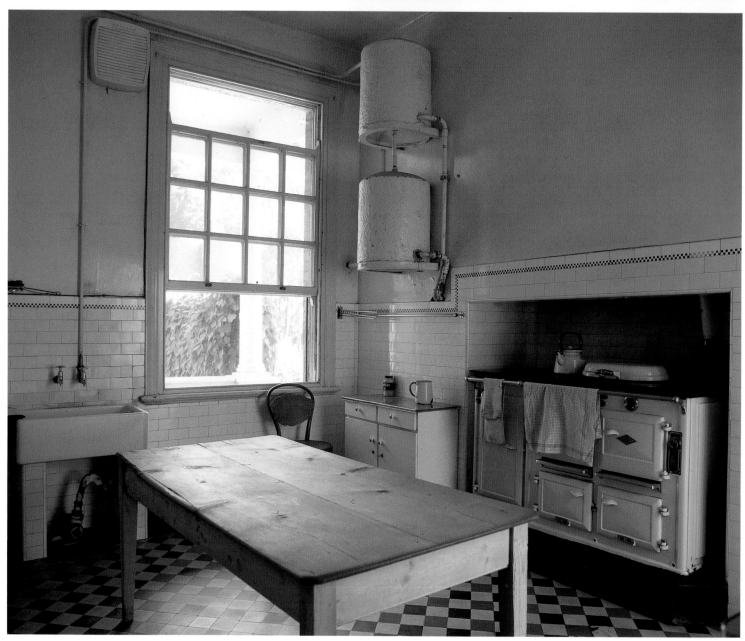

FAR LEFT. The telephone booth adjoining the business-room.

LEFT. Bathroom. Rather gaunt, without a touch of glamour, and reeking of Pears soap and godliness.

FOLLOWING PAGE. The generous tiled verandah. The country club atmosphere again, with lawns, palms and tibouchina trees beyond.

drawing-room, a morning-room, a business-room (complete with its own telephone booth), a study and a dining-room. The kitchen quarters are extensive. Apart from a chauffeur who lived in a house at the back entrance to the estate, the Crookes' kept no European staff; the Indian servants were housed elsewhere on the property and the governess was given one of the bedrooms off the back upper hall.[12]

The house was begun in 1917, by which time all the outbuildings were already completed, and built more or less by labour in the permanent employ of Crookes Brothers.[13] The face bricks came from the Coronation Brick Yard, those for the internal walls were fired in kilns at Ellingham and Monte Video.[14] SF Crookes himself supervised the operation, together, it would seem, with Mr Temperman, the company's carpenter who was responsible for much of the woodwork, including some fine joinery on the main staircase.[15] Evidently the house was completed before wartime shortages necessitated too many compromises, but the stained glass, clearly shown in Lübke's wash perspective for the front and upper verandah door and surrounds, is missing. 'Where is the Cathedral glass, Mrs Crookes?' Temperman was heard to lament in his thick Irish brogue, but none ever appeared.[16]

The family moved in in 1918, though it was not the first Mrs Crookes, who had so carefully chosen the site, who took her place behind the array of tea-time silver. Much loved, an experienced whip and the star of the local gymkhanas, she had died unexpectedly in 1916. It was SF's second wife, Mary, who had seen the building materialize from the drawing boards.[17]

The interiors were filled with unelaborate Edwardian furniture – 'comfortable' as the Duke of Connaught, the then Governor General, put it after he stayed at Ellingham for a shoot in 1921;[18] the hall was hung with a splendid array of trophies. Through the efforts of the present owner, Mr Percy Crookes, these have survived unscathed. As at Lynton, the house was set in a park-like enclosure and, in the style of many of

the larger north and south coast houses of the era, is romantically approached up an avenue of palms.

I suspect that to most modern readers Ellingham is perfectly representative of a still-remembered but now almost vanished style best described as 'Natal colonial'. The appellation is not entirely correct, for the term 'colonial' should more accurately belong to the pre-1910 era, but the trophies, the gleaming teak, the Mappin & Webb, the coal-fired Aga, the scrubbed kitchen tables, the faded cretonnes, the wicker, the bedheads and the washstands all constitute the endearing domestic setting of the last colonial world inhabited by that cheerful breed who wrote 'C of E' next to religion and 'Michaelhouse' or 'Hilton' next to school. It was a breed who sang without misgivings the verse in a favourite hymn*

The rich man in his castle
The poor man at his gate
God made them high or lowly
And order'd their estate;

whose world opinions were formed by *The Illustrated London News* and *The Sketch*; who shopped for the best British products under the arcades and awnings of Durban's West Street stores; who loudly distrusted the views of Mahatma Gandhi and Dr Malan alike; who sent their sons off to two world wars; and who every year listened to the King's Christmas broadcast over the swooshing airwaves as they sat with their fruit cake and mince pies in the sticky, subtropical heat.

If the sun was setting they, from the comfort and security of their red-polished verandahs, were unaware of night's certain approach. For no chill winds caused doubts and introspections, and besides, to their eyes at least, the heaven's colours had never been more glorious.

* Mrs C F Alexander's much-loved 'All things bright and beautiful'. The verse is deleted from the current hymnal.

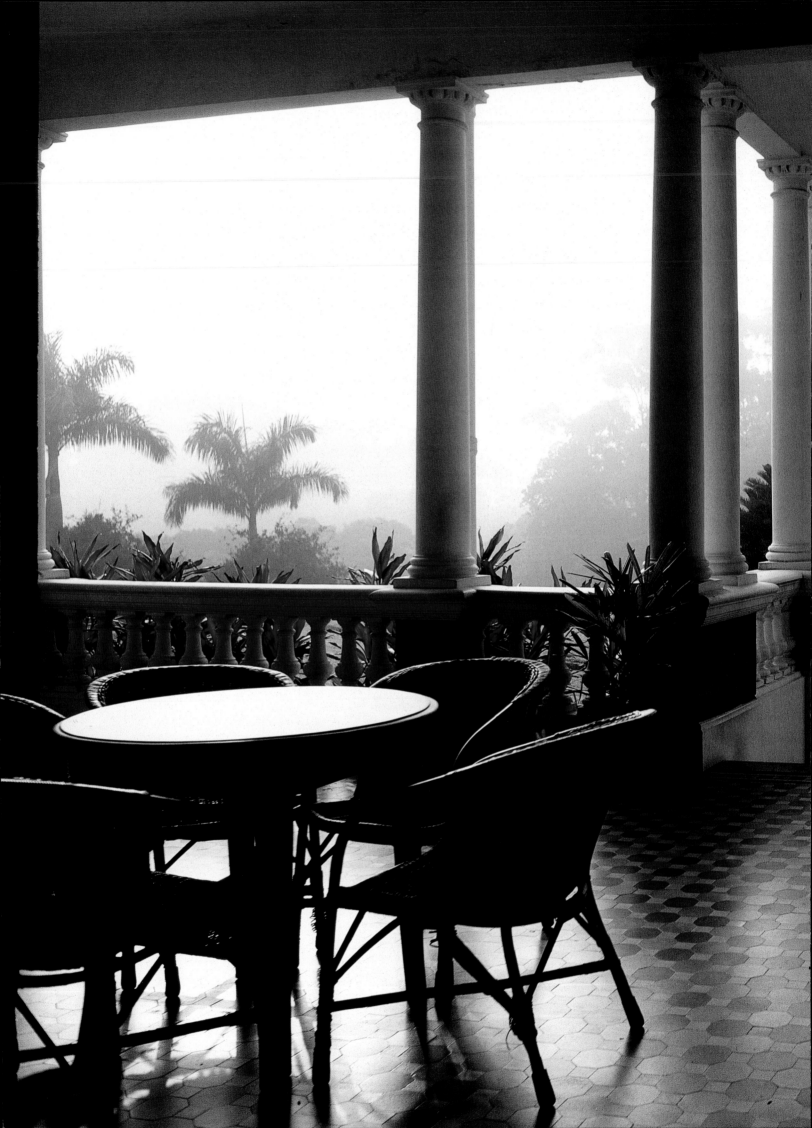

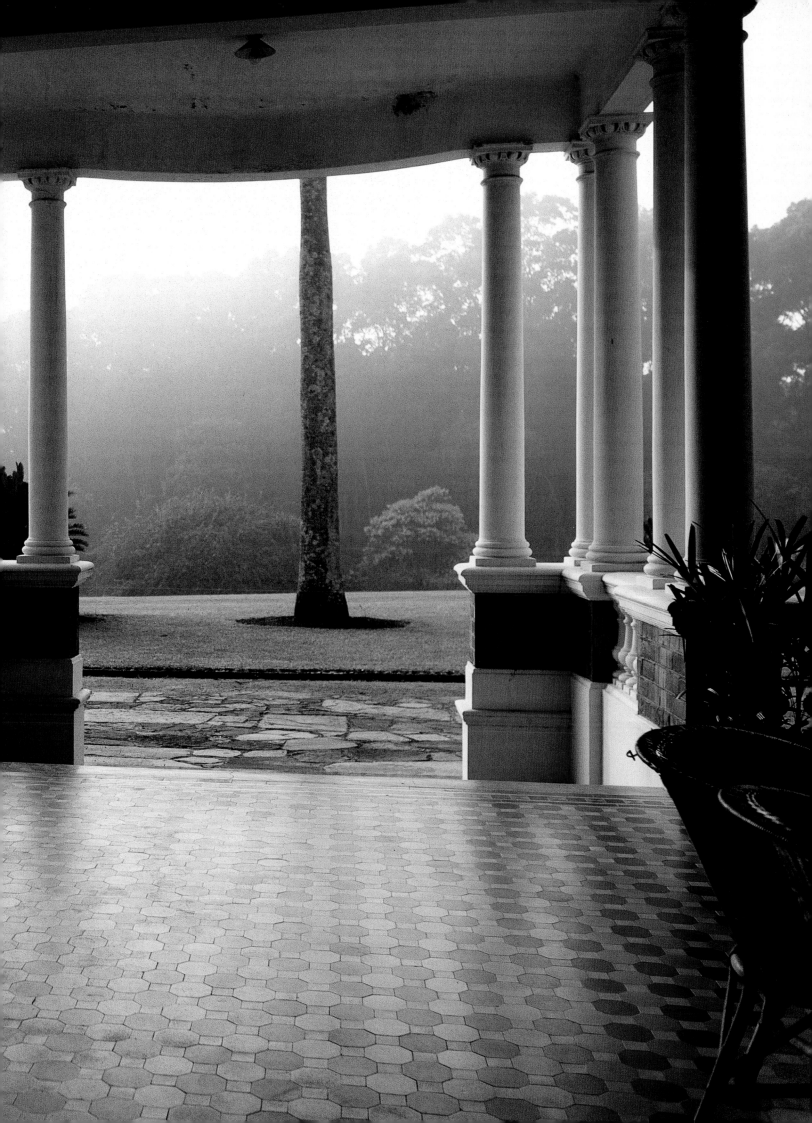

GLOSSARY OF TERMS

NOTE: the spelling of High Dutch in old records is variable. In the text the spelling follows that of the original documents as far as possible.

AFDAK: additional room to the main structure, usually with a sloping roof of a slighter pitch.

AGTERKAMER: long room behind the *voorkamer* in a typical Cape Dutch house, sometimes referred to as *galderey* or *gaandereij* (and the English 'gallery' after 1830) in the grander manor houses.

BOTTELARIJ/BOTTELRY: a place for bottling or a storage room; still room.

BRANDSOLDER: see SOLDER.

BROEKIE LACE (literally 'knickers lace'): South African colloquial usage (generally post-war) for cast-iron verandah decorations and crestings.

BYWONER: poor white or unlanded family who farmed a portion of an estate, traditionally paying rent of one third of produce in kind.

COMBUYS (Afrikaans *kombuis*): kitchen.

DROSTDY: see LANDDROST.

FRIBA: Fellow of the Royal Institute of British Architects.

GAANDEREIJ/GALDEREY: see AGTERKAMER.

GUILDER/GULDEN: unit of currency in use at the Cape under Dutch rule. In 1823 it was worth one third of a Rix dollar, then worth 1s 6d.

HEEMRAAD: a district council assisting the *landdrost* in the local court, which consisted of himself and three *Heemraaden*, in the administration of the rural districts under the Dutch rule.

HOFSTEEDER: Cape Dutch manor house, evidently not restricted by size or importance.

HOLBOL: Afrikaans (and now English colloquial) for concavo-convex; used of moulding designs on Cape Dutch gables, parapets, etc.

HOUSE BOY: African house servant (not necessarily youthful), usually in charge of more menial tasks such as the floor, boots, etc. (now obsolete).

INGOLOVANE: Zulu (and English colloquial in Natal) for a manually propelled railway trolley or 'bogey'.

JONKERSHUIS: dwelling for the eldest son, invariably forming part of the *werf* surrounding a Cape Dutch manor house.

KADEL: a small bed, without hangings.

KAMER: a room; hence *slaapkamer* (bedroom), etc.

KERKRAAD: the parish council of a Dutch Reformed church.

KNECHT: foreman (and still often applied thus in twentieth-century Afrikaans colloquial usage) or overseer. Although white, his general social status was well below that of an Agent or manager (the English equivalent), with his wife often being paid to perform some of the duties traditionally associated with a housekeeper in large English houses (such as mending, bottling, etc.). A family that provided the *knecht* from one generation to

the next was sometimes referred to as a *makfamilie*. *Ons wit mense* (our white folk) was also Cape colloquial for this genus.

KOMBUIS: see COMBUYS.

LANDDROST: magistrate who has jurisdiction over a particular magisterial district. His residence was styled the *drostdy*.

LINKERHAND: to the left, or left hand side.

LORDS XVII: the Directors of the Dutch East India Company (*Vereenigde Oost Indische Compagnie*, hence VOC).

LUSTHUIS: a summer house or (as in *villégiature*) a house for 'summering in', as were Rustenburg, Rondebosch, and Ryk Tulbagh's Newlands.

MAKFAMILIE: see KNECHT.

MORGEN: a Dutch land measure, approximately 2,2 acres, roughly regarded as the amount of land that could be ploughed in a morning.

MUIDS: a Dutch measure of capacity consisting of four *schepels* and weighing just under two hundred pounds.

MUURKAS: a wall cupboard, often embellished with a carved surround.

NMR: Natal Mounted Rifles.

OPHAALGORDYN/OPHAALDER: Cape eighteenth-century equivalent of a Roman blind or festoon curtain.

OPSTAL: buildings or other improvements on a farm (excluding the land).

OVERSEAS: general South African colonial (and subsequent) usage for 'abroad'. Particularly after the Second World War, used for England and the United Kingdom, hitherto referred to as 'Home' by English-speaking colonials, some of whom may have never been there.

PAKHUYS: packing shed.

PWD: Public Works Department.

QUITRENT GRANT: that system of land tenure introduced in 1732 by which occupancy was given on a lease of fifteen years, after which it had to be renewed. Gradually a system of *perpetual quitrent* evolved, and by a proclamation of 1813 holders of these 'loan places' were given leave to convert these titles.

REGTERHAND: to the right, or right hand side.

RIETDAK: a reed ceiling, usually consisting of 'Spanish' reeds (*spaansriet*) two to three centimetres in diameter. These were laid on the beams, which were of finished or unhewn tree trunks, according to circumstances.

RIX DOLLAR: monetary unit at the Cape, first issued by the Dutch East India Company. In 1770 it was worth the equivalent of four English shillings; by 1824, when it was decided to introduce British currency, it had sunk to only 1s 6d in value.

ROOD: a Dutch linear measure equal to 12,4 feet; also *square rood*, which equals approximately 150 square feet.

SECUNDE: the deputy governor or second-in-command of the Cape during the regime of the Dutch East India Company.

SHTETL: a small village mostly occupied by Jews in the Pale of Settlement.

SOLDER: an attic, often with a mud floor to protect the house below from burning thatch (hence *brandsolder*).

STOEP: Dutch for raised platform in front of a house, sometimes covered by a pergola. Also for a flat-roofed colonnade attached to the front of neo-classical Cape Dutch houses and later much used by Herbert Baker.

STOEPKAMER: a single-storeyed room which flanked the stoep.

STOOKHUYS: curing shed or kiln.

VILLÉGIATURE: see LUSTHUIS.

VOORKAMER/VOORHUYS: entrance or front room of a Cape Dutch house.

WERF: farmyard.

NOTES ON SOURCES AND REFERENCES

CA	Cape Archives Depot, Cape Town
CJ	Court of Justice
CO	Colonial Office
CSC	Registrar, Supreme Court, Cape Town
DO	Deeds Office, Cape Town
DRCA	Dutch Reformed Church Archives, Cape Town
DSAB	Dictionary of South African Bibliography
GH	Government House
MOIC	Master of the Insolvency Chamber
MOOC	Master of the Orphan Chamber
NA	Natal Archives Depot, Pietermaritzburg
OCF	Old Cape Freeholds
OSF	Old Stellenbosch Freeholds
PRO	Public Records Office, London
RLR	Receiver of Land Revenue
SAL	South African Library, Cape Town
SG	Stellenbosch Grants
SO	Slave Office
1/STB	Magistrate, Stellenbosch
T/	Transfer
TA	Transvaal Archives Depot, Pretoria
UCT	University of Cape Town
VRS	Van Riebeeck Society Publications Series
ZK/8/4/1	Register of Grants and Transfers, 1658–1805

REFERENCES

INTRODUCTION

1. Letter Princess Alice – Queen Mary, 1926, quoted in Alice, Princess: *For My Grandchildren*, p 176.
2. Letter Evelyn Waugh – Ann Fleming, 10.3.1958 in Amory, M (ed): *The Letters of Evelyn Waugh*.
3. Valentyn, F: *Description of the Cape of Good Hope* (VRS, vol 1), pp 149–51.
4. Letter of Lady Anne Barnard in Fairbridge, D: *Lady Anne Barnard at the Cape*, p 36.
5. Diary of Lionel Curtis, 23.10.1900 in Curtis, L: *With Milner in South Africa*, p 139.
6. Fairbridge: *op. cit.* pp 22 and 65.
7. Letter Lionel Curtis – his mother, 13.3.1900 in Curtis: *op. cit.* p 16.

VERGELEGEN

1. DO OCF vol 1 324 1.2.1700.
2. Theal, G McC: *Willem Adriaan van der Stel and Other Historical Sketches*, p 208.
3. Valentyn, F: *Description of the Cape of Good Hope* (VRS, vol 1), p 151.
4. As printed in the *Korte Deductie* and *Contra Deductie*.
5. Theal, G McC: *op. cit.* p 210 citing the *Korte Deductie and Contra Deductie*.
6. Valentyn: *op. cit.* vol 1, p 149.
7. Published in *The Cape of Good Hope Annual Register, Directory and Almanac, 1837*.
8. Valentyn: *op. cit.* vol 1, p 151.
9. *Vide* Theal: *op. cit.* pp 218–19.
10. According to Tas and Kolbe, *vide* Theal: *op. cit.* p 219.
11. Letter from the Lords XVII, Amsterdam – the Governor and Council at the Cape of Good Hope, October 1706 in Fairbridge, D: *Historic Farms of South Africa*, pp 138–9.
12. Letter from the Council of Policy at the Cape – the Lords XVII, Amsterdam, dd 15.4.1707 in Fairbridge: *op. cit.* pp 141–2.
13. Stavorinus, J: *Voyages to the East-Indies*, vol 2, pp 88–9.
14. Gutsche, T: *No Ordinary Woman,* p 342.
15. Lionel Phillips Papers quoted in Fraser, H M: *The Story of Two Farms*, p 40.
16. Gutsche: *op. cit.* pp 171 and 226–8.
17. Fraser: *op. cit.* p 29.
18. Cook, M: 'Vergelegen, Cape Province' in *Country Life*, 7.1.1965.
19. Fraser: *op. cit.* p 36; see also Cook: *op. cit.*
20. Gutsche: *op. cit.* p 360.
21. Quoted in Gutsche: *op. cit.* pp 393–4.
22. Information Sotheby's, South Africa.
23. Townsend, P: *Time and Chance*, p 179.

IDA'S VALLEY

1. DO T/4696, 15.2.1775.
2. Erskine, F and Cairns, M: *Notes on Ida's Valley*.
3. CA MOOC 13/1/9 no 8 and MOOC 8/15 no 23.
4. DO T/5247 14.4.1780.
5. CA MOOC 13/1/9 no 8.
6. CA ZK 8/4/1 G112 1.1.1683 and OSF vol 1, no 49, 1692.
7. Smuts, F (ed): *Stellenbosch Three Centuries,* pp 51–5.
8. Theal, G McC: *Willem Adriaan van der Stel and Other Historical Sketches*, pp 172–3.
9. CA MOOC 8/3 no 55, 28.11.1713 and 1/STB 18/30 (unpaginated, about halfway through).
10. CA MOOC 8/15 no 23.
11. Information supplied by G Fagan (architect, restoration) to P Erskine (owner) based on structural evidence.
12. *Vide* Trotter, A and Fairbridge, D *et al*.
13. Fransen, H: *Three Centuries of South African Art*, pp 61–2.
14. I am indebted to Major P Erskine for access to his researches on this subject.
15. DO T/77 29.5.1812.
16. CA MOIC 2/272.
17. DO T/206 2.8.1822.
18. *Ibid*, nos 66–9.
19. *Ibid* (unnumbered).
20. CA MOIC 2/272.
21. DO T/134 17.2.1834.
22. DO T/4453 2.7.1908.
23. Headlam, C (ed): *Milner Papers* vol 2, p 105: letter Milner – Lady Edward Cecil 1.7.1900.
24. *Interview*: Mrs Lavinia de Klerk (*née* Struben), Cape Town, 12.6.1985.
25. Houston, D: *Valley of the Simonsberg*, pp 15 and 48–54.

LIBERTAS

1. Fouche, L. (ed.): *The Diary of Adam Tas*, p xvii.
2. DO Stellenbosch Freeholds, vol 1, SG Diagram 5/1689.
3. DO Stellenbosch Freeholds, vol 1, SG Diagram 21/1692.
4. DO Stellenbosch Freeholds, vol 1, SG Diagram 26/1693.
5. DO T/403, 3.11.1696 and T/404 3.11.1696.
6. A theory with which Hans Fransen agrees (Robertson, M: *Notes on Libertas*).
7. DO Stellenbosch Quitrents 9/5 vol 6, Fol 4, 1.8.1822; see Stellenbosch Farm Register, Farm nos 286, 287, 288, 289, 290.
8. Fouche: *op. cit.* p xvii.

9. *The Diary of Adam Tas*, 4.7.1705.
10. DO T/1477, 22.8.1722 and CA 1/STB 18/32.
11. I am indebted to Marian Robertson for her painstaking research on the house and the murals. Her work on the former now substantially queries the standard belief that it was never Tas's (Robertson: *op. cit.*).
12. CA MOOC 7/1/8.
13. CA MOOC 7/1/45.
14. *Interview*: Mrs R Blake, Libertas, July 1984.

STELLENBERG

1. CA Map 1/960.
2. DO OCF vol 1 250, 15.10.1697.
3. DO T/429/11.11.1697.
4. Cairns, M: *Notes on Stellenberg* and De Bosdari, C: *Cape Dutch Houses and Farms*, p 43.
5. Pearse, G: *Eighteenth Century Architecture in South Africa*, p 144; Fairbridge, D: *Historic Houses of South Africa*, p 71.
6. Archives, Amsterdam: *Colonial Archives* 4032, Briewen en Papieren van de Caap de Bonne Esperance, p 1194.
7. Archives, Amsterdam: *Notariële Archives* 8466, 3.3.1717.
8. DO T/1192/31.2.1717.
9. DO T/1970/2.2.1730. I am indebted to M Cairns's notes on the Weltevriend deduction.
10. DO T/2084/4.11.1732.
11. DO T/2527/21.11.1742.
12. Borcherds, P: *An Autobiographical Memoir*, p 15.
13. DSAB III, p 231.
14. CA MOOC 7/1/13 1 and 1½.
15. CA CJ 3059, no 14.
16. CA MOOC 7/1/35.
17. Böeseken, A J: 'Die Nederlandse Kommissarisse in die 18de Eeuse Samelewing aan die Kaap,' in *Archives Yearbook for South African History, 1944*. I am indebted to Dr A Böeseken for additional information.
18. 'Rapport van Imhoff' in Böeseken: *op. cit.* p 124.
19. Fransen dates this 1793; *vide* Fransen, H: *Three Centuries of South African Art*, p 108.
20. Quoted in De Puyfontaine, H: *Louis Michel Thibault, 1750–1815*, p 106.
21. Fransen: *op cit.* pp 59-61.
22. *Interview:* P Brooke Simons (daughter of Dean of Cape Town), December 1985.

MORGENSTER

1. Fraser, M: *The Story of Two Farms*, p 29.
2. DO T 839/28.5.1711. Dutch East India Company to Jacob Mallang (sic) 'De Morgenster', no. 3 Hottentots Holland, a portion of Vergelegen 171 morgen 765 sq roods. The actual transfer is missing from the DO volume for that year; this is from the register volumes.
3. Theal, G McC: *History of South Africa*, vol 3, p 331.

4. DO T 1680/9.5.1725.
5. CA 1/STB 18/31 (unpaginated, unnumbered).
6. *Ibid.*
7. CA MOOC 7/1/25 no 37, pp 109–13.
8. DO T 7004/5.2.1796.
9. DO T 7550/18.1.1799.
10. DO T65/1.5.1807.
11. DO T111/11.4.1885.
12. *Interview*: Mrs P Heap, Somerset West, March 1985.
13. Cairns, M: *Notes on Morgenster*. See also Morkel, P: *The Morkels*, p 23.
14. *Interview*: Mrs Shirley Bairnsfather Cloete, Morgenster, August 1984.
15. Plans for these and subsequent alterations are lodged with Revel Fox & Partners, Cape Town. Further alterations are being undertaken at time of publication.

TUYNHUIS

1. Sackville-West, V: *English Country Houses,* pp 9 and 30.
2. Bird, W: *State of the Cape of Good Hope*, p 157.
3. Thompson, J N: *The Story of a House*, p 7.
4. St Pierre, B de: *Voyage to the Isle of Mauritius*, p 231.
5. Tachard, P: *A Voyage to Siam*, p 52.
6. Valentyn, F: *Description of the Cape of Good Hope*, p 107.
7. *Interview*: G Fagan (architect, restoration), Cape Town, 5.6.1985. See also Bax, D and Koeman, C: *Argietektoriese Skoonheid in Kaapstad se Kompanjiestuin 1777–1805*.
8. *Ibid.*
9. Fransen, H: *Three Centuries of South African Art*, pp 95–6.
10. Fairbridge, D: *Lady Anne Barnard at the Cape*, p 31.
11. Diary of Samuel Hudson, 18.12.1799 and letters Lady Anne Barnard – Earl of Macartney, 9.1.1800 in Fairbridge, *op. cit.* p 139; and Lady Anne Barnard – Henry Dundas, 16.2.1801 in Robinson, A (ed): *The Letters of Lady Anne Barnard*, p 260.
12. Diary of Samuel Hudson, 18.12.1799.
13. Lady Anne Barnard – Earl of Macartney 9.1.1800 in Fairbridge, *op. cit.* p 139.
14. Lady Anne Barnard – Henry Dundas 16.2.1801 in Robinson, *op. cit.* p 260.
15. CA MI/3251.
16. Lady Anne Barnard – Earl of Macartney 12.3.1800 in Fairbridge, *op. cit.* p 183.
17. Diary of Samuel Hudson, 18.1.1800 and letter Andrew Barnard – Earl of Macartney 11.1.1800 in Fairbridge, *op. cit.* p 155.
18. 'Government House, Cape Town' in *Good Words* (1900).
19. *Ibid.*
20. Diary of Samuel Hudson – quoted in Lewcock, R: *Early Nineteenth Century Architecture in South Africa*, p 55.
21. CA GH 26/12/118. Letter Somerset – Bathurst 9.10.1824.

22. PRO CO 113/14 21.8.1819.
23. PRO CO 48/131 S/M 1084; 1/675; it is visible in De Meillon's watercolour.
24. PRO CO 344/17 23.2.1828 and others.
25. PRO CO 221/63 6.12.1824.
26. CA CO Warrant no 194 of 1814.
27. Cory, G E: *Rise of South Africa*, vol 11, p 120.
28. Millar, A: *Plantagenet in South Africa*, p 228.
29. CA GH 28/20 30.11.1842.
30. CA CO 48/135 S/M 1811; 1/1696.
31. CA M 3/26.
32. Alice, Princess: *For My Grandchildren*, p 171.

RUSTENBERG

1. CA ZK 8/4/1 G 128 1.1.1683.
2. Even in official documents; *vide* Roelof Pasman's will CA MOOC 8/1 no 15.
3. CA, Series J. *Opgaaf Stellenbosch*.
4. DO OSF 133 vol 1 1699 27.2.1699.
5. *The Diary of Adam Tas*, 5.8.1705; 13.8.1705; and 2.2.1706.
6. 'Dagregister van een reis door Commissaris Cnoll na het Warme Bad', reproduced in *Collectanea* (VRS 5), p 61.
7. DO T/2496 8.2.1742 and T/2497 8.2.1742.
8. *The Diary of Adam Tas*, 23.7.1705.
9. CA, Series J. *Opgaaf Stellenbosch*.
10. *Ibid*.
11. CA ZK 8/4/1 T/6072.
12. DO T222/1810 but *vide* the Stellenbosch *Opgaaf* from 1804 and CA M3/405 which shows the farm divided and Brink on the lower portion. (Beikov, G: *Notes on Rustenberg*.)
13. DO T258/1810.
14. Fraser, M: *The Story of Two Farms*, p 8.
15. CA MOIB 2/625 no 45. 14.6.1845.
16. *Ibid*.
17. CA SO 6/109, pp 58–9.
18. *Vide* Theal, Cory *et al*.
19. CA MOIB 2/625.
20. *Merriman Papers*, South African Library. Letter Merriman – J B Currey 15.10.1886.
21. *Merriman Papers*, South African Library for this period.
22. Houston, D: *Valley of the Simonsberg*, pp 99–110.

SIDBURY PARK

1. *Vide* Nash, M D: *Baillie's Party of 1820 Settlers*, chap 1.
2. Albany Museum, 2592 (e) *Lieut. Daniell*; and Hockly, H E: *Richard Daniell* in *DSAB* 1, pp 204–5.
3. CA CO 8542 contains the correspondence pertinent to the Daniell party.
4. CA A1939 1/1/2 Baptisms, Marriages and Deaths Register of Senior Colonial Chaplain to the British Civil Establishment, Cape of Good Hope, p 24.
5. DO Albany Title Deeds vol 3: farm 286 and 287.
6. DO Albany Quitrents vol 2, no 1, 7.1.1826.
7. Lanham, W B in Pretorius, D J: *The Land of the Settlers*, p 21.
8. I am indebted to Mr Berrington, present owner of Sidbury Park, for his researches during the restoration of the house.
9. *Vide* the *Cape Town Gazette* 44/1828 where a tender called for zinc roofing for the Worcester Drostdy.
10. *Berrington Papers*, Sidbury Park: copy of a letter dated February 1846 from a visiting doctor from the Cape. Original destroyed. See also sale notices, *Graham's Town Journal* 17.2.1855; 6.10.1857.
11. *The Diary of Rev. Francis Owen* (VRS no 7), p 142.
12. CA MOIB 2/738 114: 14.12.1850 and MOIB 2/680 65: 12.7.1848.
13. DO Albany Title Deeds, vol 3: farm 288.
14. DO Albany Quitrents vol 2, no 20, 12.10.1826: farm 288; T/57 3.5.1831.
15. *The Diary of Rev. Francis Owen* (VRS no 7), pp 142–3.
16. Albany Museum, SMD 648. Letter Mrs Rice Smith dd 4.9.1839.
17. Somerset – Bathurst, 24.4.1817, quoted in Hockly, H E: *The Story of the British Settlers of South Africa*, p 15.
18. CA CO 8542. Report supporting Daniell's request for an extended land grant.
19. Thom, H B: *Die Geskiedenis van die skaap boerdery in Suid Afrika*, p 168, and others.
20. Slater, L: 'Story of Sidbury' in *The 1820*, October 1982, p 15.
21. *Graham's Town Journal*, 2.11.1838.
22. Letter Mrs Rice Smith, *op. cit*.
23. Lewcock dates this as late 1830s, *vide* Lewcock R: *Early Nineteenth Century Architecture in South Africa*, p 186.
24. CA GH 22/2 no 126. Memorial Richard Daniell, 24.1.1848.
25. DO T/150 17.1.1848.
26. DO T/320 25.11.1856.
27. Sale notices *Graham's Town Journal* 6.10.1857; see also DO T/532 31.12.1859.
28. *Graham's Town Journal* 7.7.1857.
29. Morse-Jones, E. J: *Roll of the British Settlers in South Africa*, p 25 and pp 89–90.

KERSEFONTEIN

1. *Vide* CA RLR 53/2 no 208 and others.
2. DO T/4370 13.8.1770.
3. CA ZK 8/4/1 II CV 470 and 472 of 1744.
4. DO T/4370 13.8.1770.
5. Hoge, J: *Personalia of the Germans at the Cape 1652–1806*, pp 265–6.
6. *Ibid*: p 265.
7. *Melck Papers*, Kersefontein.
8. CA STB 1/14 6.10.1749.
9. DO T/2877 28.7.1750.
10. Stavorinus, J S: *Voyages to the East Indies*, vol 2, p 66.
11. CA MOOC 7/1/25 no 39.

12. Stavorinus: *op. cit.* p 67.
13. *Interview:* Martin (VII) Melck, recorded by Robertson, M for SABC 'A Time to Build' (1973).
14. Smuts, F (ed): *Stellenbosch Three Centuries*, p 256.
15. CA MOOC 7/1/25 no 39 and 7/1/28 no 49.
16. CA MOOC 7/1/28, p 27 9.10.1778.
17. H Cloete – H Swellengrebel: 'News from the Cape for 1787–1788' in *Briefwisseling van Hendrik Swellengrebel Jr oor Kaapse Sake*, p 396.
18. *Interview:* Mrs Marieta Macnab (*née* Melck), Johannesburg, 1.12.1983 recalling the stories told her by her great-aunts *c.*1905.
19. CA C182 3.4.1789, p 423 and 21.4.1789, p 441.
20. PRO, London no 1/323 in *Letters Cape of Good Hope,* pp 741–51.
21. Lichtenstein, H: *Travels in Southern Africa* (VRS), pp 62–6.
22. *Interview:* Mrs Marieta Macnab, Johannesburg, 1.12.1983.
23. DO T/313 22.5.1801 and T/334 8.6.1801.
24. DO T/114 17.6.1808.
25. *Interview:* Martin (VII) Melck, Kersefontein, 31.8.1983.
26. *Ibid.*
27. Millar, A K: *Plantagenet in South Africa,* p 156.
28. *Melck Papers,* Kersefontein. Memoirs of Mrs E Ruperti.
29. *Interview:* Mrs Marieta Macnab, Johannesburg, 1.12.1983.
30. *Interview:* Mr Martin (VII) Melck, Kersefontein, 31.8.1983.

BARVILLE PARK

1. Lewcock, R: *Early Nineteenth Century Architecture in South Africa,* pp 176–81.
2. Information supplied by Mrs M D Nash, Albany Museum.
3. Shaw, W: *Story of My Mission in South Eastern Africa,* p 164; and in Sadler, C. (ed): *Never a Young Man,* p 92.
4. Supplement to the *Graham's Town Journal:* 20.8.1835.
5. DO T/1486 8.12.1842.
6. DO T/738 and T/739 28.7.1840.
7. *Dell/Norton Papers,* Barville Park; also Langham-Carter, R: 'The Campbells Are Coming' in *Historical Society of Port Elizabeth, Looking Back,* March and July 1981.
8. Nash, M D: *Baillie's Party of 1820 Settlers,* p 13.
9. House of Lords, Records Office, 238 Anno 39 Geo III, 1.7.1799.
10. St George's, Hanover Square, London: Parish Register entry 480, 2.7.1799.
11. Parish of St John's, Newfoundland: Marriage Register, p 27, no 109.
12. Keppel-Jones, A (ed): *Philips, 1820 Settlers,* p 249: letter Mrs Philips dd 27.6.1825.
13. *Dell/Norton Papers,* Barville Park: letter Cypress' Messor – Gen Campbell, 1820.
14. *Dell/Norton Papers,* Barville Park.
15. CA MOOC 8/37.

16. Long, U (ed): *The Chronicle of Jeremiah Goldswain* (VRS) vol 1, p 122.
17. *Private Buck Adams's Narrative* (VRS 22), pp 135–6.
18. *Graham's Town Journal:* 9.5.1846. Despatch from Col Somerset, McLuckie's Farm, Kariega, 3.5.1846.
19. Recorded by Miss E Norton (present owner), transcript *Dell/Norton Papers,* Barville.
20. *Graham's Town Journal:* 9.5.1846. Col Somerset's official despatch, McLuckie's Farm, Kariega, 4.5.1846.
21. *Graham's Town Journal:* 9.5.1846 from Mr S W Dell, 5.5.1846.
22. *Graham's Town Journal:* 23.5.1846.

ZORGVLIET

1. Walton, J: *The Josephine Mill and its Owners,* pp 9–10.
2. CA OCF 1/49.
3. CA ZK 8/4/1 T/4664.
4. CA ZK 8/4/1 T/5460 and T/5744.
5. CA ZK 8/4/1 T/5744.
6. CA ZK 8/4/1 T/6148.
7. CA ZK 8/4/1 T/6552.
8. Fransen, H and Cook, M: *The Old Buildings of the Cape,* pp 77–8.
9. *Interview:* D Picton-Seymour, Cape Town, July 1984; also Comfield's sketch, Fehr Collection.
10. CA CO8.
11. DO SG Diagram 46/1815.
12. DO T/167 15.12.1815.
13. Suasso de Lima, J (compiled by): *The Census of the Municipalities of Cape Town and Greenpoint,* 1855.
14. CA MOOC 7/1/245, p 123.
15. CA MOOC 6/9/87.
16. An endless list of deductions and transfers in the Deeds Office from 3.5.1860 (DO attached T362/1815.)
17. *De Zuid Afrikaan,* 17.12.1863.
18. CA 3/CT 7/1/2/1 *et seq* 1866, 1867, 1868.
19. Avray Tipping on Wyatt's 'Ashridge', quoted in Clark, K: *The Gothic Revival,* p 88.
20. *Vide* Kenneth Clark's celebrated work, *op. cit.* p 113.
21. Photograph in possession of present owner.
22. DO diagram attached to T/279 15.7.1861.

BROADLANDS

1. Robinson, A. (ed): *The Letters of Lady Anne Barnard,* p 109.
2. CA MOOC 8/13 no 8.
3. DO OSF vol 1 10 Folio 204 10.9.1711 and transfers following.
4. *Interview:* Mrs Gee (owner, 1940s), Hermanus, 6.1.1984.
5. DO T/213 16.5.1855.
6. Mathew, Chevens and Bryant (printers): *Loyalty and its Reward,* p 4.

7. DO T/121 5.11.1854 but the sale took place six years before: *vide* Heap, P: *The Story of the Hottentots Holland*, p 63.
8. *Government Gazette*: 13.3.1855.
9. *Commercial Advertiser and Cape Town Mail*: 27.3.1857: letter Lady Stanford – the editor.
10. Letter Sir Robert Stanford – the Hon John Montague, Secretary to Government, dd 15.2.1851 in Mathew, Chevens and Bryant: *op. cit.* p 17.
11. CA CSC 2/1/1/87 no 16 ii dd 27.5.1859.
12. CA CSC 2/1/1/87.
13. DO T/213 16.5.1855.
14. *Government Gazette*: 13.3.1855.
15. Stellenbosch Voters' Roll 13/23 in Morkel, P W: *The Morkels*, p 20.
16. DO T/268 16.12.1876.
17. Fransen, H and Cook, M: *The Old Houses of the Cape,* p 196.
18. *Interview:* Mrs O Hewatt (*née* Viljoen), Somerset West, 27.3.1985.
19. Morkel: *op. cit.* pp 22–3.
20. DO T/341 29.3.1888.
21. *Interview:* Mrs J Rawbone-Viljoen, Elgin, May 1985; see also Heap: *op. cit.* pp 77–8.
22. *Interview:* Mrs O Hewatt, Somerset West, 27.3.1985.
23. *Cape Argus*: 24.11.1913.
24. *Interview:* Mr R Cameron and the Hon Mrs O'Neill, Broadlands, 27.3.1985.

HAWTHORNDEN

1. DRCA: *Register Wynberg DRC Church* 17.1.1871.
2. Spence's death notice: *Cape Times,* 24.2.1910.
3. DO OCF Grant 133 1.12.1683.
4. DO T/231 14.7.1685.
5. DO T/226 30.8.1685.
6. DO T/542 10.10.1701.
7. DO T/543 10.10.1701.
8. DO T/1287 24.4.1719 Adriaanus van der Stel to Coenraad Feijt; Frans van der Stel had died the preceding year.
9. CA MOOC 8/4 no 2 14.11.1720.
10. DO T/4475 27.4.1772 and note in margin DO T/5249. I am indebted to Margaret Cairns's 'Notes on Springfield Convent' in *CABO*, vol 2, no 2, pp 15–18.
11. CA CJ2914 21.2.1780.
12. DO T/5249 1.5.1780.
13. DO T/5661 10.9.1782.
14. DO T/6884 12.12.1794.
15. Cairns, M: *op. cit.*
16. *Ibid.*
17. DO T/472 15.12.1881.
18. Discoveries during the restoration in the 1970s by Munnik, Visser, Black, Fish and Partners confirmed the theory of M Cairns that the house was built on the old Dutch foundations.
19. *Wynberg Times*: 7.10.1882.
20. *Interview*: D Picton-Seymour, 17.2.1984.
21. *Wynberg Times*: 7.10.1882.
22. *Ibid.*
23. *Ibid.*

24. Letter dated January 1853 in Murray, J: *In Mid-Victorian Cape Town: Letters from Miss Rutherfoord,* p 35.
25. *Wynberg Times*: 7.10.1882.
26. Plans lodged at Munnik, Visser, Black, Fish and Partners.
27. DSAB III (R Ovendale), pp 717–9.
28. Weinthal, L: *Memories, Mines and Millions,* pp 19–20.
29. *Ibid*, pp 27–31.
30. Emden, P H: *Randlords*, pp 116–8.
31. Gutsche, T: *No Ordinary Woman*, chap 5.
32. *House of Lords Parliamentary Debates*, vol 50, 22.6.1922, pp 1126–40.
33. Weinthal: *op. cit.* p 191.
34. Emden: *op. cit.* p 121.
35. *Interview*: Count Natale Labia, 14.2.1984.
36. *Cape Times*: 8.11.1929. A second letter appeared on 9.11.1929.

TWEEDSIDE LODGE

1. *Cape Times*: 25.11.1889. *Cape Argus*: 25.11.1889.
2. *Ibid.*
3. Conversation with Gertrude Buist (Logan's daughter) in Starke, A: 'Out of the Slumber: Matjiesfontein' in *Fair Lady*, 18.2.1970.
4. *Annexures to the Votes and Proceedings of the Cape House of Assembly*, A3–'93. Letter Rose Innes – Rhodes, 8.11.1892.
5. *Men of the Times*, p 500.
6. *Logan Papers*, Matjiesfontein.
7. *Men of the Times*, pp 499–500.
8. Parker, E: *Historic Matjiesfontein*, p 1.
9. *Ibid.*
10. *Interview*: Major John Buist (Logan's grandson), Matjiesfontein, 7.6.1985.
11. *Logan Papers*, Matjiesfontein.
12. *Interview*: Major John Buist, Matjiesfontein, 7.6.1985.
13. *Logan Papers*, Matjiesfontein.
14. *The South African Review*: 5.1.1894, p 10.
15. Churchill, Lord Randolph: *Men, Mines and Animals in South Africa*, p 35.
16. Picton-Seymour, D: *Victorian Buildings in South Africa*, p 179.
17. *The South African Review*: 5.1.1894, p 10.
18. Letter Olive Schreiner – Havelock Ellis, 25.3.1890 in Cronwright-Schreiner, S C (ed): *The Letters of Olive Schreiner, 1876–1920*, p 179.
19. *Men of the Times*, p 499.
20. Picton-Seymour: *op. cit.* pp 171–9.
21. *Men of the Times*, p 499.
22. *Interview*: Major John Buist, Matjiesfontein, 7.6.1985.
23. Viney, G E: *A New Look at the Logan Crisis*. (UCT Thesis, 1975), chap 2 (*passim*).

ZWARTKOPPIES HALL

1. Extract from the unpublished 'Reminiscences of the Second Earl of Selborne' in Robertson, M: *Interview Dolly Meisels*, MS Jagger Library, UCT.
2. DSAB vol 1, p 515.
3. Katzew, H: 'The Remarkable Sammy Marks', in *Jewish Affairs*, April 1950, p 25.
4. Emden, P.H: *Randlords*, p 210.
5. Katzew: *op. cit.* p 24.
6. Selborne: *op. cit.* and Emden: *op. cit.* p 222.
7. Helme, N: *Irene*, p 12.
8. Robertson, M: *Memo on S Marks* (containing research from Standard Bank Archives), MS Jagger Library, UCT, pp 1–6.
9. *Marks Papers*, Kaplan Institute, UCT B2/5, p 207. Marks – Barnet Lewis, 29.10.1883.
10. *Marks Papers*, Kaplan Institute, UCT C4. Marks – T W Beckett, 15.12.1883.
11. Robertson, M: *Samuel Marks – A Brief Résumé of his Life*. Jagger Library, UCT, p 2.
12. *Acte van Transport* No 1884/221 25.3.84 no 289 Pretoria, ward Aapies River.
13. Picton-Seymour, D: *Victorian Buildings in South Africa*, p 283.
14. *Marks Papers*, Kaplan Institute, UCT B2/6, pp 6–7. Marks – Messrs Adler Bros, Durban, 13.3.1885.
15. *Marks Papers*, Kaplan Institute, UCT B2/6, pp 36–7. Marks – Messrs Adler Bros, Durban, 10.4.1885.
16. *Marks Papers*, Kaplan Institute, UCT B2/6, p 17. Marks – Messrs Adler Bros, Durban, 26.3.1885.
17. *Marks Papers*, Kaplan Institute, UCT B2/6, pp 56–7. Marks – Messrs Adler Bros, Durban, 10.4.1885.
18. *Marks Papers*, Kaplan Institute, UCT B2/6. Marks – Messrs Adler Bros, Durban, 14.3.1885.
19. *Marks Papers*, Kaplan Institute, UCT B2/6, pp 6–7. Marks – Messrs Adler Bros, Durban, 13.3.1885.
20. *Marks Papers*, Kaplan Institute, UCT. Marks – W H Holles, Durban, 9.11.1885.
21. *Marks Papers*, Kaplan Institute, UCT. Marks – Messrs Dow & Co, 11.3.1886.
22. *Marks Papers*, Kaplan Institute, UCT. Marks – F Schuster, 8.3.1886.
23. Emden: *op. cit.* p 210.
24. *Ibid*.
25. *Ibid*, p 209.
26. Robertson, M: *Samuel Marks: op. cit.* p 8.
27. *Marks Papers*, Kaplan Institute, UCT. Marks – A H Nellmapius, 5.5.1890.
28. Picton-Seymour: *op. cit.* p 295 and p 301.
29. *Marks Papers*, Kaplan Institute, UCT. Cashbook 29.5.1884–31.12.1891, entry dd 12.1.1891, p 220.
30. Robertson, M: *Interview Dolly Meisels*, 9.3.1984, transcription MS, Jagger Library, UCT, p 37.
31. *Marks Papers*, Kaplan Institute, UCT B2/12, p 78. Marks – L Marks, 30.9.1895.
32. Robertson, M: *Interview Dolly Meisels: op. cit.* p 13.
33. *Marks Papers*, Kaplan Institute, UCT, B2/12, pp 436–7. Marks – L and M Marks, 22.11.1896.
34. *Marks Papers*, Kaplan Institute, UCT, B2/12. Marks – L and M Marks, 29.11.1896.
35. *Marks Papers*, Kaplan Institute, UCT B2/14, p 7. Marks – L and M Marks, 15.12.1897.
36. *Marks Papers*, Kaplan Institute, UCT, B2/16, p 13. Marks – Joe Marks, 26.9.1900.
37. Robertson, M: *Interview Dolly Meisels: op. cit.* p 37.
38. *Ibid*: p 4; and Katzew: *op. cit.* p 26.
39. *Ibid*: p 27.
40. *Marks Papers*, Kaplan Institute, UCT, B2/16. Marks – B Marks, 26.6.1901.
41. Curtis, L: *With Milner in South Africa*, p 131.
42. Robertson, M: *Interview Dolly Meisels: op. cit.* p 18.
43. *Ibid*: p 1.
44. Katzew: *op. cit.* p 27.

GROOTE SCHUUR

1. Baker, H: *Cecil Rhodes by his Architect*, p 33.
2. Baker, H: *Architecture and Personalities*, p 30.
3. Baker, H: *Cecil Rhodes by his Architect*, p 25.
4. *Ibid*: p 10.
5. Milner, Violet, the Viscountess: *From My Picture Gallery, 1886–1901*, p 141.
6. Baker, H: *Cecil Rhodes by his Architect*, p 11.
7. *Ibid*: pp 25–6.
8. *Ibid*: p 15.
9. *Ibid*: pp 19–20.
10. *Vide* Gradige, R: *Dream Houses, the Edwardian Ideal*, chap 7.
11. Cook, M: 'The House of Groote Schuur, Onder Schuur and Klein Schuur' in *Africana Notes and News* vol 5, no 2, p 36.
12. 'Resolutiën van den Commandeur en Raden van het Fort de Goede Hoop 1652–1662' in Leibbrandt, H: *Précis of the Archives*, p 137.
13. *Groote Schuur, the Residence of the Right Hon Cecil John Rhodes* (London 1896) and *Cape Times*: 16.12.1896.
14. HGO: 'The History of Groote Schuur', in *Africana Notes and News*, vol 5, no 2, p 31.
15. Cook: *op. cit.* pp 37–8.
16. Baker, H: *Cecil Rhodes by his Architect*, p 21.
17. Reproduced in Greig, D: *Herbert Baker in South Africa*, pp 21–2.
18. Gradige: *op. cit.* p 133.
19. *Baker Papers*, Jagger Library, UCT, BC/206 1896, letter dd 20.5.1898.
20. Baker, H: *Cecil Rhodes by his Architect*, pp 26–7.
21. *Baker Papers*, Jagger Library, UCT, BC/206 1898 and 1899.
22. *South Africa*: 9.1.1897.
23. Milner: *op. cit.* p 141.
24. Baker, H: *Cecil Rhodes by his Architect*, p 30.
25. *Ibid*: p 14.
26. Macmillan, H: *Pointing the Way*, p 152.
27. Letter Lady Edward Cecil – Mrs F A Maxse, 2.10.1899, quoted in Milner: *op. cit.* p 142.
28. *Ibid*: p 211.
29. Harding, C: *Far Bugles*, p 87.
30. Radziwill, Catherine, Princess: *Cecil Rhodes, Man and Empire Maker*, p 108.
31. Milner: *op. cit.* p 141.

32. Baker, H: *Architecture and Personalities*, p 16.
33. *Ibid*: p 30.
34. *Ibid*: p 29.
35. Stead, W T (ed): *Last Will and Testament of Cecil Rhodes*, pp 13–16.

LYNTON HALL

1. *Reynolds Papers*, Lynton.
2. Osborn, R F: *Valiant Harvest*, p 303.
3. Robinson, J: *Notes on Natal*, p 114.
4. *Reynolds Papers*, Lynton.
5. *Paton Plans*, Architectural Library, University of Natal.
6. Kearney, B: *Architecture in Natal, 1824–1893*, pp 30–1.
7. Brookes, E H and Webb, C de B: *A History of Natal*, p 114.
8. *Interview*: Mr G Reynolds, Durban.
9. NA CSO 245, p 545: Principal Under-Secretary – Messrs Reynolds Brothers, 24.6.1908.
10. NA CSO 245, p 705: Principal Under-Secretary – Messrs Reynolds Brothers, 10.7.1908.
11. *Reynolds Papers*, Lynton: Diary of Sir Frank Reynolds, dd 17.7.1908.
12. *Reynolds Papers*, Lynton.
13. *Reynolds Papers*, Lynton: Diary of Sir Frank Reynolds, dd 8.12.1919.
14. *Ibid*: 27.10.1908.
15. Alexander, P: *Roy Campbell*, p 56.
16. *Reynolds Papers*, Lynton.
17. *Interview*: Jane Reynolds, Lynton, 27.3.1984.
18. Townsend, P: *Time and Chance*, p 191.
19. Osborn, R F: *Umdoni Park – Gift to the Nation*, p 57.
20. *Ibid*.
21. *Reynolds Papers*, Lynton. Copy of the Townsend Memorandum.

STONEHOUSE

1. Baker, H: *Architecture and Personalities*, p 47.
2. *The Times*: 9.1.1902.
3. Baker, H: *Architecture and Personalities*, p 48.
4. *Ibid*: p 3.
5. Baker, H: *Cecil Rhodes by his Architect*, pp 15–17.
6. Rothschild, F, Baron: *Three Weeks in South Africa*, p 96.
7. Baker, H: *Architecture and Personalities*, p 48.
8. Curtis, L: *With Milner in South Africa*, p 329.
9. Baker, H: *Architecture and Personalities*, p 49.
10. *Ibid*: p 48.
11. *Baker Papers*, Africana Library, vol 1. Baker – Brown, 19.12.1902.
12. *Baker Papers*, Africana Library, vol 1. Baker – Brown, 23.10.1902.
13. Baker, H: *Architecture and Personalities*, p 48.
14. *Interview*: Mr and Mrs Ian Mackenzie, Stonehouse, 24.5.1983.
15. *Vide* Plate 38 in Greig, D: *Herbert Baker in South Africa*, p 104.
16. *Ibid*: p 140.

17. Lutyens – Baker, 26.12.1910 in Hussey, C: *The Life of Sir Edwin Lutyens*, p 216.
18. *Duncan Papers*, Jagger Library UCT. BC 294. Baker – Duncan, 12.12.1917.
19. *Baker Papers*, Africana Library, vol 1. Baker – Mrs Keightley, 26.9.1902.
20. Baker, H: *Architecture and Personalities*, p 50.
21. *Ibid*: p 48.
22. *Ibid*: p 50.
23. *Mackenzie Papers*, Stonehouse. Ashbee, C R: journal entry dd July 1903, Johannesburg (copy).
24. Letter H E Baker (Sir Herbert's son) – author, dd 4.11.1983.
25. *Duncan Papers*, MS Jagger Library UCT. BC294. Baker – Duncan, 14.10.1916.
26. *Duncan Papers*, MS Jagger Library UCT. Aitken – Duncan, 21.9.1932.
27. *Ibid*: Baker – Duncan, 21.10.1916.
28. *Duncan Papers*, Jagger Library UCT. BC294. Baker – Duncan, 20.9.1934.

WESTMINSTER

1. Baker, H: *Architecture and Personalities*, pp 15–16.
2. Headlam, C (ed): *The Milner Papers*. Memorandum Milner – Maj Hanbury Williams, 27.12.1900.
3. *Ibid*: Milner – Duke of Westminster, 21.1.1902.
4. *Vide* Westminster, Loelia Duchess of: *Grace and Favour* and Field, L: *Bendor: The Golden Duke of Westminster*.
5. Field: *op. cit*. p 56.
6. Westminster, Loelia Duchess of: *op. cit*. p 190.
7. *Grosvenor Papers*, Westminster. Byron – Garnett, 23.7.1904.
8. *Grosvenor Papers*, Westminster. Webster, G: 'Story of a Westminster Farm'.
9. Quoted in Baillén, C: *Chanel*, p 40.
10. *Baker Papers*, Westminster. Baker – Col Byron, 3.2.1904.
11. *Baker Papers*, Westminster. Baker – Col Lloyd, 10.11.1903.
12. *Baker Papers*, Westminster. Baker – Col Lloyd, 9.11.1903.
13. *Baker Papers*, Westminster. Baker – Col Byron, 4.4.1904.
14. *Baker Papers*, Westminster. Baker – Col Lloyd, 12.9.1904.
15. *Grosvenor Papers*, Westminster. Accounts.
16. *Baker Papers*, Westminster. Baker – Col Byron, 15.6.1905.
17. *Baker Papers*, Africana Library, Johannesburg. Baker – Massey, 4.12.1903.
18. *Baker Papers*, Westminster. Baker – Col Lloyd, 4.4.1904 and 16.5.1904.
19. *Baker Papers*, Westminster. Baker – Col Byron, 16.1.1905.
20. *Baker Papers*, Africana Library, Johannesburg. Baker – Ashbee, 17.7.1903.
21. *Baker Papers*, Westminster. Baker – Col Byron, 20.1.1904.
22. *Baker Papers*, Westminster. Baker – Col Byron, 22.9.1905.

23. *Grosvenor Papers*, Westminster. Visitors' Book. The story as told to Mr M Thatcher (present Agent) by his mother. It appears in a slightly different form (for obvious reasons) in Ahrenson, T: *The Royal Ambassadors*, pp 95–6.

BRENTHURST

1. Baker, H: *Cecil Rhodes by His Architect*, p 68.
2. Long, B K: *Drummond Chaplin*, p 20.
3. *Ibid*: p 28.
4. *Baker Papers*, Africana Library, Johannesburg. Baker – Chaplin, 7.9.1904.
5. *Ibid*.
6. *Baker Papers*, Africana Library, Johannesburg. Baker – Chaplin, 21.2.1905.
7. *Baker Papers*, Africana Library, Johannesburg. Baker – Chaplin, 12.9.1904.
8. Baker, H: *Architecture and Personalities*, p 53.
9. *Baker Papers*, Africana Library, Johannesburg. Baker – Chaplin, 13.5.1906.
10. Baker, H: *Architecture and Personalities*, p 35.
11. *Ibid*: p 53.
12. *Baker Papers*, Africana Library, Johannesburg. Baker – Chaplin, 7.1.1905.
13. *Baker Papers*, Africana Library, Johannesburg. Baker – Chaplin, 26.1.1905.
14. *Baker Papers*, Africana Library, Johannesburg. Baker – Chaplin, 17.3.1905.
15. *Baker Papers*, Africana Library, Johannesburg. Baker – Chaplin, 21.2.1905.
16. *Baker Papers*, Africana Library, Johannesburg. Baker – Chaplin, 2.6.1905.
17. Baker, H: *Architecture and Personalities*, p 53.
18. By Doreen Greig, for instance; *vide* Greig, D: *Herbert Baker in South Africa*, p 129.
19. *Baker Papers*, Africana Library, Johannesburg. Baker – Chaplin, 29.11.1904.
20. *Baker Papers*, Africana Library, Johannesburg. Baker – Chaplin, 13.5.1906.
21. *Baker Papers*, Africana Library, Johannesburg. Baker – Chaplin, 4.7.1905.
22. *Baker Papers*, Africana Library, Johannesburg. Baker – Duncan, 29.11.1904.
23. *Baker Papers*, Africana Library, Johannesburg. Baker – Chaplin, 27.10.1904 and 13.5.1906.
24. *Baker Papers*, Africana Library, Johannesburg. Baker – Mrs Chaplin, 13.3.1905.
25. National Archives of Zimbabwe: CH 8/2/1 Fo 461 – unsigned, written by 'a friend'.
26. Long: *op. cit.* p 93.
27. *Ibid*: p 182.
28. Hocking, A: *Oppenheimer and Son*, p 106.
29. *Ibid*: pp 191–5. *Interview*: Mrs H Oppenheimer, Johannesburg, 30.11.1983.

DOLOBRAN

1. Benjamin, A; Chipkin, C; Zar, S; Aaron, H: *Parktown*, chap 1.
2. *Vide* Mark Girouard: *The Return to Camelot*.
3. Smuts, J; Foreword in Wallis, J: *Fortune My Foe*.
4. *Andersson Papers*, Dolobran.
5. *Cape Times Sports and Sportsmen*, p 157.
6. Girouard, M: *The Victorian Country House*, pp 13–15.
7. Baker's plans are at Dolobran.
8. *Interview*: Mrs A Andersson, Johannesburg, 10.5.1983.
9. *Andersson Papers*, Dolobran. File 4. Baker – Andersson, 5.10.1904.
10. *S A Sports and Sportsmen*, p 200 and *S A Who's Who* 1908.
11. *Vide* Mark Girouard: *Sweetness and Light: The Queen Anne Revival*.
12. *Interview*: L Andersson in Benjamin *et al*: *op. cit.* p 44.
13. *Andersson Papers*, Dolobran. File 4. Andersson – Cope Christie, 11.4.1905.
14. *Andersson Papers*, Dolobran. File 4. Chaplin – Andersson, 4.8.1905.
15. *Andersson Papers*, Dolobran. File 4. Andersson – Chaplin, 2.8.1905.
16. *Andersson Papers*, Dolobran. File 4. Andersson – Cope Christie, no 582.
17. *Andersson Papers*, Dolobran. File 4. No 508.
18. *Andersson Papers*, Dolobran. File 4. Andersson – Chaplin, 7.10.1905 and 20.10.1905.
19. *Andersson Papers*, Dolobran. File 4. Andersson – Chaplin, 2.8.1905.
20. *Andersson Papers*, Dolobran. File 4. Andersson – Chaplin, 6.11.1905.
21. *Andersson Papers*, Dolobran. File 4. Nos 663, 664 and 673.
22. *Andersson Papers*, Dolobran. File 4. Andersson – Cope Christie, 23.1.1906.
23. *Andersson Papers*, Dolobran. File 4. No 798.

THE PRESIDENSIE

1. TA PWD vols 109 and 110 2/161. Selborne – Jameson, 13.1.1906.
2. TA PWD vols 109 and 110 2/161. Director of Public Works – Baker, 29.7.1902.
3. TA PWD vols 109 and 110 2/161. Baker – Capt Harvey, 17.2.1905.
4. Buchan, J: *A Lodge in the Wilderness*, pp 12–14.
5. TA PWD vols 109 and 110 2/161. Director of Public Works – Baker, 29.7.1902.
6. *Baker Papers*, Africana Library C11. Baker – Massey, 26.1.1905.
7. TA PWD vols 109 and 110 21/161/6. Hitchens Memorandum dd 28.2.1906.
8. TA PWD vols 109 and 110 3/161.
9. TA PWD vols 109 and 110 2/161. Baker – Col Fowke, 22.5.1903.
10. TA PWD vols 109 and 110 2/161. Baker – Col Fowke, 24.8.1903.
11. *Ibid*: p 2.
12. *Ibid*: p 3.
13. TA PWD vols 109 and 110 2/161. Baker – Jameson, 10.9.1904.
14. TA PWD vols 109 and 110 2/161. Baker – Col Glyn, 5.12.1904; the plans survive in the PWD files.

15. TA PWD vols 109 and 110 2/161. Letter from Baker, Massey & Sloper dd 14.2.1905 contains the three tenders.
16. TA PWD vols 109 and 110 2/161. Baker – Secretary PWD, 15.2.1905.
17. TA PWD vols 109 and 110 2/161. Baker – Secretary PWD, 26.2.1906.
18. TA PWD vols 109 and 110 3/161; p 14.
19. *Ibid*: p 11.
20. *Ibid*: p 16.
21. TA PWD vols 109 and 110, 3/161.
22. TA PWD vols 109 and 110 3/161; p 14.
23. *Ibid*: p 32.
24. *Baker Papers*, Africana Library c11. Baker – Sir Arthur Lawley, 22.1.1903.
25. *Ibid*.
26. *Baker Papers*, Africana Library. Baker – Massey, 30.1.1905.
27. *Baker Papers*, Africana Library, c11. Baker – Sir Arthur Lawley, 21.1.1903.
28. Baker, H: *Architecture and Personalities*, p 51.
29. Plans in Transvaal Archives Depot as well as Baker specifications (TA PWD vols 109 and 110 2/161; p 23).
30. TA PWD vols 109 and 110 2/161. Baker – Secretary PWD, 20.2.1906.
31. TA PWD vols 109 and 110 2/161. Baker – WJG for Secretary PWD, 11.3.1907.
32. TA PWD vols 109 and 110 2/161. Sir Arthur Lawley – Patrick Duncan, 16.8.1905.
33. TA PWD vols 109 and 110 2/161. Minute from Sir Arthur Lawley – Patrick Duncan, 16.8.1905.
34. TA PWD vols 109 and 110 2/161. Sir Arthur Lawley – Jameson, 22.11.1905.
35. TA PWD vols 109 and 110 2/161. Baker – Secretary PWD, 4.12.1905.
36. *Baker Papers*, Africana Library. Baker – Mrs Keightley, 2.2.1906.
37. Baker, H: *Architecture and Personalities*, p 51.
38. *Baker Papers*, Africana Library. Baker – Mrs Keightley, 2.2.1906.
39. TA PWD vols 109 and 110 2/161. Baker – Capt Harvey, 10.11.1904; and Baker – Jameson, 10.9.1904.
40. *Duncan Papers*, Jagger Library, UCT. E23.4.6. Lady Duncan – Princess Alice, 1.10.1941.
41. *Duncan Papers*, Jagger Library, UCT. E13.1.6. Lady Duncan – Andrew Duncan, 28.10.1938.
42. Baker, H: 'The Architecture of Empire'. Papers and drawings, property of H E Baker, Owletts, Cobham, Kent. Quoted Irving, R G: *Indian Summer*, p 278.

ELLINGHAM

1. Hattersley, A: *The British Settlement of Natal*, p 120; also Wilson, M and Thompson, L (ed): *The Oxford History of South Africa*, p 379.
2. Gill, F: *The Story of the Crookes Family*, p 11.
3. Letter Beryl Cook (S Crookes's great-granddaughter, after interview with P Crookes, present owner) – author, 30.5.1985.
4. Gill: *op. cit*. pp 13–14.
5. B Cook – author, 30.5.1985.
6. *South African Sugar Journal Annual 1925*, p 79.
7. Gill: *op. cit*. p 30.
8. B Cook – author, 30.5.1985.
9. *Telephone interview*: B Kearney, Durban, 28.3.1984; also Hillebrand, M: *Aspects of Architecture in Natal, 1880–1914*.
10. Plans in Architectural Library, University of Natal, Durban.
11. *Interview*: P Crookes (present owner), Ellingham, 25.3.1984. Lübke's plans are at Ellingham.
12. *Ibid*.
13. *Ibid*.
14. B Cook – author, 30.5.1985.
15. *Interview*: P Crookes, Ellingham, 25.3.1984.
16. *Ibid*.
17. B Cook – author, 30.5.1985.
18. *Crookes Papers*, Ellingham. Duke of Connaught – F Crookes, 3.8.1921.

PRIMARY SOURCES

PRIVATE PAPERS

Andersson Papers, Dolobran, Johannesburg.
Baker Papers: Africana Library, Johannesburg;
 Jagger Library, Cape Town; State Archives,
 Pretoria; Westminster.
Berrington Papers, Sidbury.
Chaplin Papers, Noordhoek.
Crookes Papers, Ellingham, Renishaw.
Dell/Norton Papers, Barville Park, Port Alfred.
The Diary of Samuel Hudson, South African Library,
 Cape Town.
Duncan Papers, Jagger Library, Cape Town.
Grosvenor Papers, Westminster.
Logan/Buist Papers, Tweedside Lodge,
 Matjiesfontein.
Marks Papers: Jagger Library, Cape Town; Kaplan
 Institute, University of Cape Town (limited).
Melck Papers, Kersefontein, Berg River.
Merriman Papers, South African Library,
 Cape Town.
Reynolds Papers, Lynton Hall, Umdoni Park.

OFFICIAL RECORDS

AFRICANA LIBRARY, JOHANNESBURG
Photographic collection.

CAPE ARCHIVES DEPOT, CAPE TOWN
Baptisms, Marriages and Deaths Register
 of the Senior Colonial Chaplain to the
 British Civil Establishments, Cape of
 Good Hope.
Colonial Office.
Dagregister of the Council of Policy at the Cape of
 Good Hope.
Government House.
Map Collection.
Master of the Orphan Chamber.
Opgaaf Rolle.
Photographic collection.
Register of Grants and Transfers, Deeds Office.
Resolution of the Council of Policy at the Cape of
 Good Hope.
Slave Office.

DEEDS OFFICE, CAPE TOWN
Albany Quitrents.
Albany Title Deeds.
Farm Registers.
Old Cape Freeholds.
Stellenbosch Freeholds.
Stellenbosch Quitrents.
Transfers.

DEEDS OFFICE, PRETORIA
Acte van Transport.

NATAL ARCHIVES DEPOT, PIETERMARITZBURG
Colonial Secretary.

NATIONAL ARCHIVES OF ZIMBABWE, HARARE
Chaplin Papers.

NEDERDUITSE GEREFORMEERDE KERK
IN SUID-AFRIKA ARCHIVES
Church Register.

TRANSVAAL ARCHIVES DEPOT, PRETORIA
Public Works Department.

PUBLISHED DOCUMENTARY SOURCES

AMORY, M (editor): *The Letters of Evelyn Waugh* (London, 1980).
BARNARD, A: *South Africa a Century Ago (1797 – 1801)* (Letters written from the Cape of Good Hope and Extracts from a Journal) (Cape Town, 1913).
CNOLL, C: 'Dagregister van een Reis door Commissaris Cnoll na Het Warme Bad', in *Collectanea* (VRS 1, 5).
CORY, G E (editor): *The Diary of Rev. Francis Owen* (VRS 1, 7).
CRONWRIGHT-SCHREINER, S C (editor): *The Letters of Olive Schreiner, 1876 – 1920* (London, 1924).
FOUCHE, L (editor): *The Diary of Adam Tas* (London, 1914).
GORDON-BROWN, A: *The Narrative of Private Buck Adams, 7th Dragoon Guards* (VRS 1, 22).
HAMMOND-TOOKE, W D: *The Journal of William Shaw* (Cape Town, 1972).
HEADLAM, C (editor): *The Milner Papers* (London, 1931 – 1933).
LEWSEN, P (editor): *Selected Correspondence of J X Merriman* (VRS 44).
LICHTENSTEIN, M: *Travels in Southern Africa in the years 1803 – 1806* (VRS 1, 10, 11).
LONG, V (editor): *The Chronicle of Jeremiah Goldswain* (VRS 1, 27, 29).
MENTZEL, O: *A Geographical-topographical Description of the Cape of Good Hope* (VRS 1, 4, 6, 25).
MURRAY, J: *Mid-Victorian Cape Town: the Letters of Miss Rutherfoord* (Cape Town, 1953).
ROBINSON, A (editor): *The Letters of Lady Anne Barnard to Henry Dundas, 1793 – 1803* (Cape Town, 1973).
STEAD, W T (editor): *The Last Will and Testament of Cecil Rhodes* (London, 1902).
SWELLENGREBEL, H: *Briefwisseling van Hendrik Swellengrebel J R oor Kaapse Sake, 1779 – 1792* (VRS 2, 13).
VAN DER HEIDEN, J and TAS, A: *Contra-Deductie, ofte Grondige Demonstratie* (Amsterdam, 1712).
VAN DER STEL, S: *Journal* (Dublin, 1953).
VAN DER STEL, W A: *Korte Deductie van Willem Adriaan van der Stel* (Amsterdam, 1706).

OFFICIAL PUBLICATIONS

Annexures to the Votes and Proceedings of the Cape
 House of Assembly, A3 – 93.
British Hansard.
House of Lords, Parliamentary Debates.
House of Lords Records Office, 238 Anno 39 Geo III,
 1.7.1794.
South African Hansard.
SUASSO DE LIMA, J (compiler): The Census of the
 Municipalities of Cape Town and Green Point
 1855.

REFERENCE WORKS

Cape Times Sports and Sportsmen (Cape Town,
 1929).
Debretts Peerage.
Dictionary of South African Biography vols 1 – 4.
 (Cape Town, 1972).
HOGE, J: *Personalia of the Germans at the Cape*
 (Union of South Africa Archives Yearbook,
 1946).
LEIBRANDT, H: *Précis of the Archives of the Cape of Good
 Hope.*
Men of the Times (Johannesburg, 1905 and
 1906).
MORSE-JONES, E: *Roll of the British Settlers in South
 Africa* (Cape Town, 1969).

PAMA, C: *Genealogies of Old South African Families*
 (Cape Town, 1981).
South African *Who's Who.*
THEAL, G McC: *Records of the Cape Colony . . . from the
 Manuscript Documents in the Public Records
 Office, London* (London, 1897 – 1905).
Who's Who.

NEWSPAPERS

Cape Argus, Cape Town
Cape of Good Hope Almanac and Directory
Cape Times, Cape Town
Cape Town Gazette
Cape Town Mail
Commercial Advertiser
The Friend, Bloemfontein
Good Words (1900)
Government Gazette
Graham's Town Journal, Grahamstown
The Natal Mercury, Durban
Sam Sly's Journal
South Africa
The South African Commercial Advertiser
The South African Review
The South African Sugar Journal Annual, 1925
The Star, Johannesburg
The Times, London
Wynberg Times, Cape Town
De Zuid Afrikaan

SECONDARY SOURCES

ALEXANDER, P: *Roy Campbell* (Cape Town, 1982).

ALICE, PRINCESS, COUNTESS OF ATHLONE: *For My Grand-children* (London, 1966).

BAILLÉN, C: *Chanel Solitaire* (London, 1973).

BAKER, H: *Architecture and Personalities* (London, 1944).

BAKER, H: *Cecil Rhodes by his Architect* (Oxford, 1938).

BEIKOV, G: 'Notes on Rustenberg' (unpub.).

BENJAMIN, A; CHIPKIN, C; ZAR, S; AARON, H: *Parktown* (Johannesburg, 1972).

BIRD, W: *State of the Cape of Good Hope* (London, 1823).

BOËSEKEN, A J: 'Die Nederlandse Kommissarisse in die 18de Eeuse Samelewing aan die Kaap', in *Union of South Africa Archive Yearbook, 1944.*

BORCHERDS, P: *An Autobiographical Memoir* (Cape Town, 1861).

BROOKES, E H and WEBB, C DE B: *A History of Natal* (Pietermaritzburg, 1965).

BUCHAN, J: *A Lodge in the Wilderness* (Edinburgh, 1906).

BUCHAN, J: *Memory Hold the Door* (London, 1940).

CAIRNS, M: 'Notes on Hawthornden' (unpub.).

CAIRNS, M: 'Notes on Morgenstêr' (unpub.).

CAIRNS, M: 'Notes on Springfield Convent' (CABO vol 2, no 2).

CAIRNS, M: 'Notes on Stellenberg' (unpub.).

CAIRNS, M and ERSKINE, F: 'Notes on Ida's Valley' (unpub.).

CHURCHILL, LORD RANDOLPH: *Men, Mines and Animals in South Africa* (London, 1892).

CLARK, K: *The Gothic Revival* (London, 1928).

COOK, M: 'The House of Groote Schuur', in *Africana Notes and News,* vol 5, no 2 (Johannesburg).

COOK, M: 'Vergelegen, Cape Province', in *Country Life,* 7 January 1965.

CORY, G E: *The Rise of South Africa* (London, 1910 – 1930).

CURTIS, L: *With Milner in South Africa* (Oxford, 1951).

DE BOSDARI, C: *Anton Anreith, Africa's First Sculptor* (Cape Town, 1954).

DE BOSDARI, C: *Cape Dutch Houses and Farms* (Cape Town, 1953).

EMDEN, P H: *Randlords* (London, 1935).

FAIRBRIDGE, D: *Historic Farms of South Africa* (Oxford, 1931).

FAIRBRIDGE, D: *Historic Houses of South Africa* (Cape Town, 1922).

FAIRBRIDGE, D: *Lady Anne Barnard at the Cape* (Oxford, 1924).

FIELD, L: *Bendor: The Golden Duke of Westminster* (London, 1983).

FRANSEN, H: *Three Centuries of South African Art* (Johannesburg, 1982).

FRANSEN, H and COOK, M: *The Old Buildings of the Cape* (Cape Town, 1980).

FRANSEN, H and COOK, M: *The Old Houses of the Cape* (Cape Town, 1965).

FRASER, H M: *All that Glittered: The selected correspondence of Lionel Phillips* (Cape Town, 1977).

FRASER, H M: *The Story of Two Farms* (Johannesburg, 1981).

GILL, F: 'The Story of the Crookes Family' (unpub.).

GIROUARD, M: *Life in the English Country House* (London, 1978).

GIROUARD, M: *The Return to Camelot* (London, 1981).

GIROUARD, M: *Sweetness and Light: The Queen Anne Revival* (Oxford, 1977).

GIROUARD, M: *The Victorian Country House* (Oxford, 1971).

GRADIGE, R: *Dream Houses: The Edwardian Ideal* (London, 1980).

GREIG, D: *Herbert Baker in South Africa* (Cape Town, 1970).

GUTSCHE, T: *No Ordinary Woman* (Cape Town, 1966).

HARDING, C: *Far Bugles* (London, 1933).

HATTERSLEY, A: *The British Settlement of Natal* (Cambridge, 1950).

HEAP, P: *The Story of the Hottentots Holland* (Cape Town, 1970).

HELME, N: *Irene* (Irene, 1976).

HGO: 'The History of Groote Schuur' in *Africana Notes and News,* vol 5, no 2 (Johannesburg).

HILLEBRAND, M: 'Aspects of Architecture in Natal' (Unpublished thesis, Natal University, 1975).

HOCKING, A: *Oppenheimer and Son* (Johannesburg, 1973).

HOCKLY, H E: *The Story of the British Settlers of South Africa* (Cape Town, 1948).

HOUSTON, D: *Valley of the Simonsberg* (Cape Town, 1981).

HUSSEY, C: *The Life of Sir Edwin Lutyens* (London, 1953).

IRVING, R G: *Indian Summer* (Yale, 1981).

KATZEW, H: 'The Remarkable Sammy Marks', in *Jewish Affairs,* April 1950 (Johannesburg).

KEARNEY, B: *Architecture in Natal, 1824 – 1893* (Cape Town, 1973).

LANCASTER, O: *Home Sweet Home* (London, 1939).

LANCASTER, O: *Pillar to Post* (London, 1939).

LANCASTER, O: *The Pleasure Garden* (London, 1977).

LANGHAM-CARTER, R: 'The Campbells are Coming', in *Looking Back,* March/July 1981 (Port Elizabeth).

LEIBRANDT, H C V: *The Defence of W A van der Stel* (Cape Town, 1897).

LEWCOCK, R: *Early Nineteenth Century Architecture in South Africa* (Cape Town, 1963).

LONG, B K: *Drummond Chaplin* (London, 1941).

MAASS, J: *The Gingerbread Age* (Toronto, 1957).

MACMILLAN, H: *Pointing the Way, 1959 – 1961* (London, 1966 – 1973).

MATHEW, CHEVENS and BRYANT (printers): *Loyalty and its Reward* (Cape Town, 1859).

MEINTJES, J: *General Louis Botha* (London, 1970).

MILLAR, A: *Plantagenet in South Africa* (London, 1964).

MILNER, VIOLET, THE VISCOUNTESS: *From my Picture Gallery* (London, 1951).

MORKEL, P W: *The Morkels: Family history and family tree* (Cape Town, 1961).

MUTHESIUS, S: *The High Victorian Movement in Architecture* (London, 1972).

NASH, M D: *Baillie's Party of 1820 Settlers: A collective experience in emigration* (Cape Town, 1982).

OSBORN, R F: *Umdoni Park: Gift to the nation* (Durban, 1967).

OSBORN, R F: *Valiant Harvest* (Durban, 1964).

PARKER, E: *Historic Matjiesfontein* (Matjiesfontein, 1978).

PEARSE, G: *Eighteenth Century Architecture in South Africa* (London, 1933).

PICTON-SEYMOUR, D: *Victorian Buildings in South Africa* (Cape Town, 1976).

PRAZ, M: *An Illustrated History of Interior Decoration* (London, 1964).

PRETORIUS, D J: *The Land of the Settlers* (Grahamstown, 1956).

RADZIWILL, PRINCESS CATHERINE: *Cecil Rhodes, Man and Empire Maker* (London, 1918).

ROBERTSON, M: 'Notes on Kersefontein' (unpub.).

ROBERTSON, M: 'Notes on Libertas' (unpub.).

ROBINSON, J: *Notes on Natal* (London, 1872).

ROTHSCHILD, BARON FERDINAND DE: *Three Weeks in South Africa* (London, 1895).

SACKVILLE-WEST, V: *English Country Houses* (London, 1942).

SADLER, C (editor): *Never a Young Man* (Cape Town, 1967).

SERVICE, A: *Edwardian Architecture* (London, 1977).

SHAW, W: *Story of my Mission in Southern Africa* (London, 1860).

SLATER, L: 'Story of Sidbury', in *The 1820*, October 1982 (Port Elizabeth).

SMUTS, F (editor): *Stellenbosch Three Centuries* (Stellenbosch, 1979).

SMUTS, J: *Holism and Evolution* (London, 1925).

STANTO, P: *Pugin* (London, 1971).

STAVORINUS, J S: *Voyages to the East Indies* (London, 1798).

ST PIERRE, B DE: *Voyage to the Isle of Mauritius* (London, 1775).

STARKE, A: 'Out of Slumber: Matjiesfontein', in *Fair Lady*, 18 February 1970 (Cape Town).

TACHARD, P: *A Voyage to Siam* (London, 1688).

THEAL, G M: *Willem Adriaan van der Stel and Other Historical Sketches* (Cape Town, 1913).

THOM, H B: *Die Geskiedenis van die Skaap Boerdery in Suid-Afrika* (Amsterdam, 1936).

THOMPSON, J N: *The Story of a House* (Cape Town, 1968).

TOWNSEND, P: *Time and Chance* (London, 1978).

VALENTYN, F: *Description of the Cape of Good Hope* (VRS, Cape Town, 1971).

VAN DER HEIDEN, J and TAS, A: *Contra-deductie, ofte grondige demonstratie van de valsheit der uitgegevene deductie, by den Ed. Heer Willem Adriaan van der Stel* (Amsterdam, 1712).

VAN DER STEL, W A: 'African Gardeners' and Agriculturalists' Calendar', in *Cape of Good Hope Almanac and Directory 1837* (Cape Town).

VAN DER STEL, W A: *Korte Deductie van Willem Adriaan van der Stel, gewensene extraordinaris Raat van India, en Gouverneur aen Cabo de Bon Esperance* (Amsterdam, 1706).

VINEY, G E: 'A New Look at the Logan Crisis' (Unpublished thesis, UCT, 1975).

WALLIS, J: *Fortune my Foe* (London, 1936).

WALTON, J: *The Josephine Mill and its Owners* (Cape Town, 1978).

WEINTHAL, L: *Memories, Mines and Millions* (London, 1929).

WESTMINSTER, LOELIA, DUCHESS OF: *Grace and Favour* (London, 1961).

WILSON, M and THOMPSON, L (editors): *The Oxford History of South Africa* (Oxford, 1969).

WOODWARD, C: 'From multi-purpose parlour to drawing room: the development of the principal *voorkamer* in the fashionable Cape house, 1670–1820', in *Bulletin of the South African Cultural History Museum*, no 4 (Cape Town, 1983).

INDEX

Personal titles are given, wherever possible, in the latest form: thus Sir Herbert Baker, even though at the time referred to in the book he was plain Mr Herbert Baker. Houses which are the subject of the principal chapters are set in capitals.